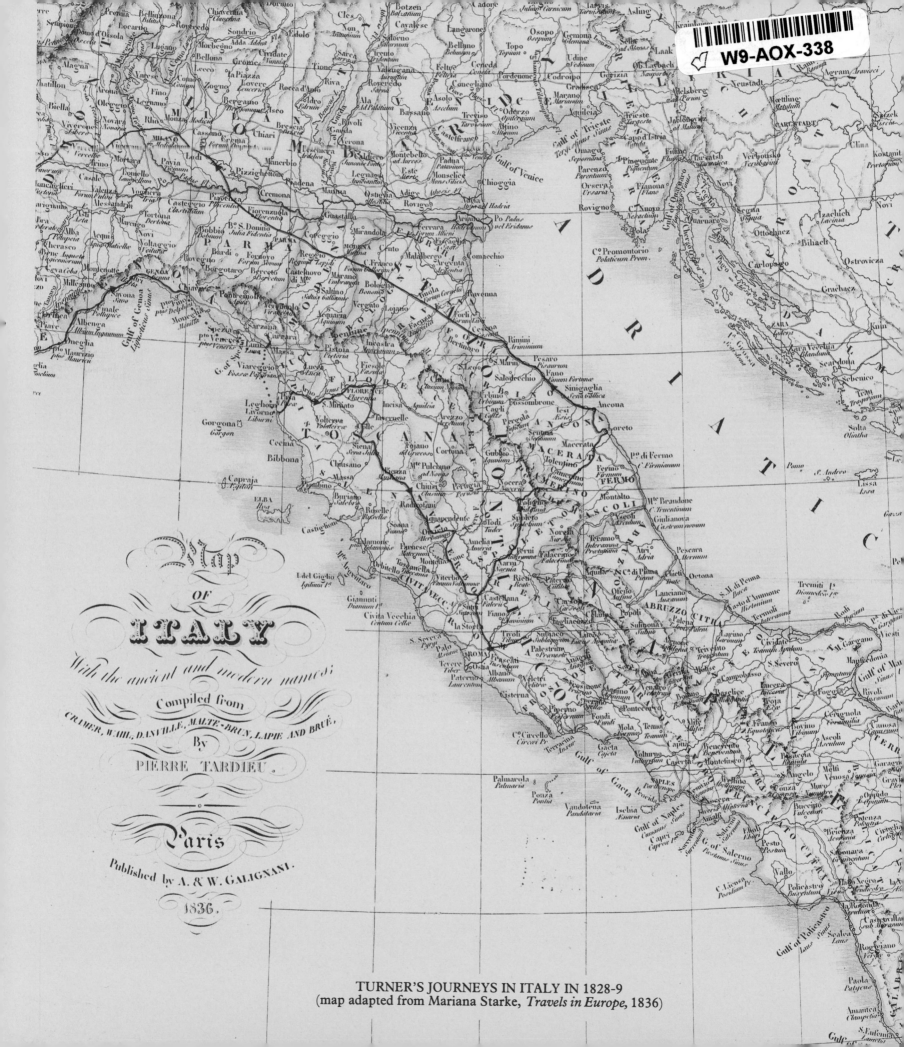

Map
OF
ITALY
With the ancient and modern names;
Compiled from
CRAMER, WAHL, DANVILLE, MALTE-BRUN, LAPIE AND BRUÉ.
By
PIERRE TARDIEU.
Paris
Published by A. & W. GALIGNANI.
1836.

TURNER'S JOURNEYS IN ITALY IN 1828-9
(map adapted from Mariana Starke, *Travels in Europe*, 1836)

TURNER IN THE SOUTH

ROME, NAPLES, FLORENCE

TURNER IN THE SOUTH
ROME, NAPLES, FLORENCE

CECILIA POWELL

PUBLISHED FOR
THE PAUL MELLON CENTRE
FOR STUDIES IN BRITISH ART
BY
YALE UNIVERSITY PRESS
NEW HAVEN AND LONDON
1987

For Nick

Designed by John Nicoll
Set in Scantext Plantin by Facsimile Typesetters
and printed in Great Britain by
Frank Peters Ltd., Kendal, Cumbria

Library of Congress Cataloging-in-Publication Data

Powell, Cecilia.
 Turner in the South.

 Bibliography: p.
 Includes index.
 1. Turner, J. M. W. (Joseph Mallord William),
1775-1851—Criticism and interpretation. 2. Turner,
J. M. W. (Joseph Mallord William), 1775-1851—Journeys—
Italy. 3. Italy in art. 4. Italy—Description and
travel—1801-1860. I. Title.
N6797.T88P68 1987 759.2 86-26673
ISBN 0-300-03870-4

Preface

When Stendhal produced the second version of his *Rome, Naples et Florence* in 1826 it was — as is usual in such circumstances — rather longer than the first edition of 1817. The reverse process has occurred with *Turner in the South* which is essentially a condensed version of my thesis 'Turner on Classic Ground' (Courtauld Institute of Art, 1984). Turner scholars who want to explore the subject in greater detail may need to consult that thesis and I have indicated in the notes at the end of the present book the occasions where such consultation might be useful. The thesis also contains substantial appendices expanding and correcting the entries in Finberg's *Inventory* which relate to Turner's sketchbooks of 1819 and 1828. These appendices are not reproduced here as such (for reasons of space and because they would be of little interest to the general reader) but I have nevertheless drawn upon my new identifications and transcriptions throughout my discussions of Turner in Italy.

Quotations from Farington's Diary appear by gracious permission of Her Majesty The Queen. I am also grateful to the Royal Academy, the Trustees of Sir John Soane's Museum, and John Murray Ltd for permission to quote from material in their possession. My photographic acknowledgments appear in a separate list, but an additional note about some of my illustrations is also called for. 1987 sees the opening of the Clore Gallery for the Turner Collection at the Tate Gallery, and it is here that the sketches and drawings in Turner's bequest to the nation are henceforth to be housed.

My doctoral research was aided by a very welcome travel grant from the Central Research Fund of the University of London in 1982 and it has been possible to publish my research in its present form through the generosity of the Paul Mellon Centre for Studies in British Art. I am extremely grateful to both these foundations, as I am also to John Nicoll of Yale University Press for the enthusiasm and energy which he has put into creating this book.

Over the years I have been unusually fortunate in those who have taught me. Besides guiding my undergraduate studies in Cambridge, Joyce Reynolds was also responsible for making sure that I spent six months in Italy at a suitably impressionable age; Eve King's inspiring lectures on Turner stimulated me to spend many more hours at the bicentenary exhibitions of 1974-5 than I would otherwise have done; and Michael Kitson was the most sympathetic of PhD supervisors, contributing many invaluable suggestions and insights and ensuring that I kept my eyes on both the wood and the trees.

Many other people have also helped me in different ways with this book, some by providing advice, information or practical assistance, some through their encouragement and friendship, and I should like to express my gratitude to all of the following: Jacqueline Bayes, the late Gerda Blau, Eileen Campbell, Andrew Clary, Francesco and Rosanna Farinella, Ann Forsdyke, Cyril Fry, John Gage, Carol Gardiner, Paul Goldman, Craig Hartley, Evelyn Joll, Annie Lyles, Dottoressa Giulia de Marchi, Dimitri Michaelides, Virginia Murray, Joan Newman, Bruno Paoli, Vivien Perutz, Bruce Robertson, Beverley Stern, Anne Tennant, Mrs R. Turner, Luciana Valentini, Barry Venning, Hilary Williams, Andrew Wilton and Edward Yardley.

I am especially grateful to John Allitt for enabling me to hear some of the glorious music

of Johann Simon Mayr and to Bridget A. Wright of the Royal Library at Windsor Castle for alerting me to a persistent misreading of the manuscript of Farington's diary at the point where Farington records Turner's pronouncement on his first visit to Italy (see below, p. 89). On his return to London Turner did not exclaim over Venice, as has always previously been thought; the places he mentioned as 'fine' were actually the beauty spots in central Italy which are discussed in the present book: Tivoli, Nemi, Albano, Terni.

The reasons why Venice does not figure in my book will be immediately apparent upon a moment's reflection. The unique qualities of Venice meant that it provided Turner with experiences of a very different kind from those he enjoyed in the rest of Italy, and the whole subject of Turner and Venice has, in any case, already received detailed attention.

Some of the material in Chapters 1, 8 and 9 of this book has already been presented in the pages of *Art History* and *Turner Studies* and I am very grateful to John Onians and Eric Shanes for having first published it. These sections appear here, however, in a newly written and updated form.

I should never have completed this project had I not enjoyed the constant help and support of my husband, to whom the book is dedicated. He has cheerfully put up with having 'to live in Past Times as well as Present' (to quote Samuel Rogers) and it was entirely thanks to his dauntless driving through the highways and byways of Italy that I was able to share in Turner's experiences of treading in the steps of the ancients.

Photographic Acknowledgments

Plate 152 is reproduced by gracious permission of Her Majesty The Queen. The authors and publishers of this book would also like to thank the following: Thomas Agnew & Sons: 1, 114; *11*. Archivi Alinari, Florence: 43, 68, 73-4, 104-5, 108-9, 111, 127. The Trustees, The Cecil Higgins Art Gallery, Bedford, England: 54. The Williamson Art Gallery & Museum, Birkenhead: 80. City of Birmingham Art Gallery: 175-6. The Trustees of the British Library: 106-7. The Trustees of the British Museum: 10, 16-23, 26, 28-9, 32-4, 38, 42, 47-9, 51, 55, 59-60, 64, 67, 72, 77-8, 85-7, 89, 92, 103, 117, 124-5, 129, 139-42, 158, 162; *2-8, 13-15, 17-18, 40*. The Syndics of the Fitzwilliam Museum, Cambridge: 116, 136. Christie's: 98, 177; *16*. A. C. Cooper Ltd: 83, 177. Courtauld Institute of Art: 5, 11, 13-15, 30-1, 35-7, 39-41, 44-6, 50, 52-3, 56-8, 62-3, 70-1, 75-6, 79, 81-2, 84, 88, 90-1, 93-7, 101-2, 112-13, 115, 118-23, 126, 128, 131-4, 137, 143-8, 161, 163-9, 171-2. Courtauld Institute Galleries: 63. L. T. Edwardes Esq.: 120. Richard L. Feigen, Chicago, Illinois: 61. Cyril Fry Esq.: 12. Glasgow Art Gallery & Museum: 172. Godfrey New Photographics: 130. Niedersächsische Landesmuseum Hannover: 121. The Henry E. Huntington Art Gallery, San Marino: 9. The Leger Galleries Ltd: 135; *25*. Musée des Beaux-Arts, Lille: 155. The Trustees of the National Gallery, London: 7, 66, 160. The National Trust: 4, 5, 41, 134. Photo Studios Ltd: 152. The Earl of Rosebery and the National Galleries of Scotland: 159, 174. Stuart B. Schimmel: 12. The Trustees of Sir John Soane's Museum, London: 83, 130. Sir Michael Sobell: *11*. The Trustees of the Tate Gallery, London: 2-3, 6, 8, 27, 65, 149, 156-7, 170, 173, 178-80; *9-10, 12, 19-24, 26-39*. Eileen Tweedy: 138, 154. The Uffizi Gallery, Florence: 99-101. The Trustees of the Victoria & Albert Museum, London: 138, 153. Ville de Paris, Musée du Petit Palais, Paris: 70. Virginia Museum of Fine Arts, Richmond, Virginia: 151. The Yale Center for British Art, New Haven: *1*.
Numbers in italics refer to the Colour Plates

Contents

Chapter 1

THE LURE OF ITALY

When John Ruskin was born, in February 1819, J. M. W. Turner was already a highly successful man in his early forties. He had been elected a Royal Academician when he was only twenty-six and he was now the Academy's Professor of Perspective. His oil paintings and watercolours were constantly before the public's gaze — at the Academy itself, in his own gallery at Queen Anne Street, in exhibitions put on by his patrons — and they attracted a good deal of critical attention. So, too, did the many published engravings after his work. He had travelled widely in England, Wales and Scotland and had paid two visits to the Continent. However, he had not yet been to Italy. In the summer of 1802 he had taken advantage of the Peace of Amiens to spend several weeks in France and Switzerland, but there had been no time to go further than the Val d'Aosta. The war with Napoleon had then been resumed, putting a lengthy continental tour out of the question for more than a decade. In 1819 he decided it was time to study Italy properly.

By Turner's day the British had been visiting Italy seriously for several generations. To understand Turner's own desire to see Rome, Naples and Florence and his whole relationship with Italy, both as a real place and as a construct of his mind, it is essential to consider why they had done so. The answer is succinctly provided by Joseph Addison, writing in 1705:[1]

> There is certainly no Place in the World, where a Man may Travel with greater Pleasure and Advantage, than in *Italy*. One finds something more particular in the Face of the Country, and more astonishing in the Works of Nature, than can be met with in any other Part of *Europe*. It is the great School of Musick and Painting, and contains in it all the noblest Productions of Statuary and Architecture, both Ancient and Modern. . . .
> There is scarce any Part of the Nation that is not Famous in History, nor so much as a Mountain or River, that has not been the Scene of some extraordinary Action.

The riches of Italy made it the climax of the eighteenth-century Grand Tour. Rome was the artistic capital of the western world, a universal museum and academy. Painters, sculptors and architects flocked there to study its classical sculptures and ancient buildings; they also looked intently at the paintings, statues and architecture of the High Renaissance and later. The number of British artists travelling to Italy greatly increased during the period between 1740 and the French Revolutionary War, and included two painters whom Turner particularly admired, Richard Wilson and Joshua Reynolds. Both visited Italy in the 1750s and derived inspiration from their experiences throughout the rest of their lives. Under the combined influence of Claude and Italy itself Wilson went on to become the first important British painter to specialise in landscape, whilst Reynolds's visit had a sequel that was even more important for British culture. As a founder member and first President of the Royal Academy, he had tackled the problem of bringing Britain into the mainstream of European art.

If the careers of Reynolds and Wilson served Turner as role models, his own work in the years before 1819 formed the best possible preparation for a first sight of Italy: from his youth he had been studying and copying Italian scenes by other artists. As a boy scarcely in his teens he had based a watercolour on part of an aquatint of Naples by Paul Sandby. For

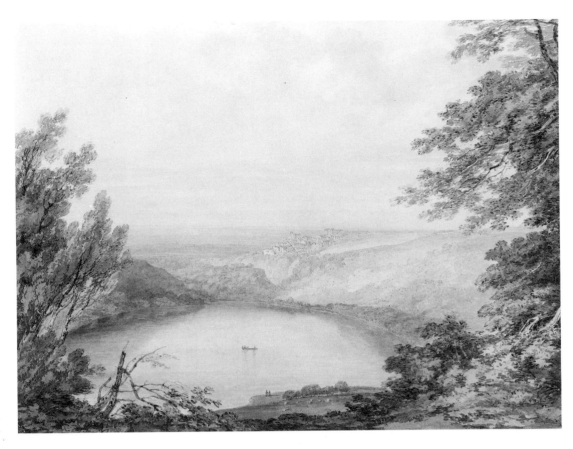

1. J. M. W. Turner and Thomas Girtin after J. R. Cozens, *Lake Nemi, with Genzano*, pencil and watercolour, *c.* 1796, 16 × 21¼ in., private collection

2. *Aeneas and the Sibyl, Lake Avernus, c.* 1798 (B & J, 34), oil on canvas, 30⅛ × 38¾ in., Tate Gallery, London

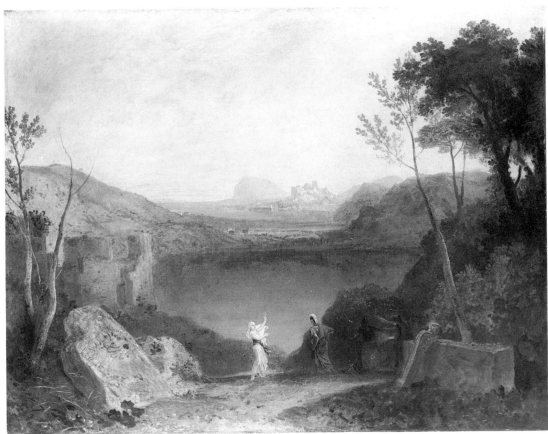

some three years, in about 1795-8, he and Thomas Girtin had spent their evenings (and earned a little money) making finished drawings from the sketches which J. R. Cozens had drawn on his Italian journey of 1782-3 (Plate 1).[2] When he first started painting in oils, he copied two scenes of Lake Nemi and Tivoli by Wilson.[3] In about 1798 and again in 1814-15

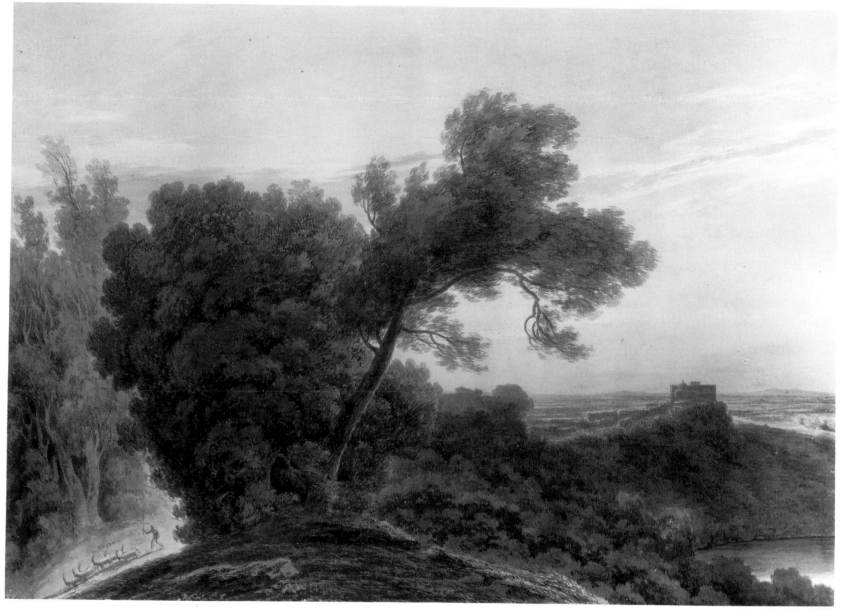

3. J. R. Cozens, *Lake Albano and Castel Gandolfo,* *c.* 1783-8, watercolour, $19\frac{1}{4} \times 26\frac{3}{4}$ in., Tate Gallery, London

he had been required to produce an oil painting of Lake Avernus from a large sketch by his patron Sir Richard Colt Hoare (Plate 2 and Colour Plate 1).[4] He must also have had opportunities of seeing some of J. R. Cozens's magically evocative finished watercolours of Italy (Plate 3), not to mention landscapes by some of the other British artists who had visited Italy in the second half of the eighteenth century, such as Thomas Jones, Francis Towne, Jonathan Skelton and William Pars. Italy also entered his consciousness in another and more important way, through his study of the work of Claude Lorrain.[5] Turner's admiration for Claude is first recorded in May 1799, when he was deeply moved by the two paintings imported into England from the Altieri collection in Rome (Plate 4), and Claude's influence on his work has been discerned even earlier than this, in 1798. Between the 1790s and 1819 Turner must have seen many fine examples of Claude's work in loan exhibitions and English private collections. He was passionately attached to several of those in the Angerstein collection (now in the National Gallery in London) and to the *Landscape with Jacob, Laban and His Daughters* owned by his patron Lord Egremont (Plate 5). Claude's influence on Turner is usually explained in terms of pictorial effects and compositional formulae, the representation of the sun and the rendering of light. In the context of the present study, however, another factor needs to be emphasised. Claude's paintings depicted Italy — albeit an idealised Italy or, as Turner himself put it in 1811, one 'made up of bits'.[6]

3

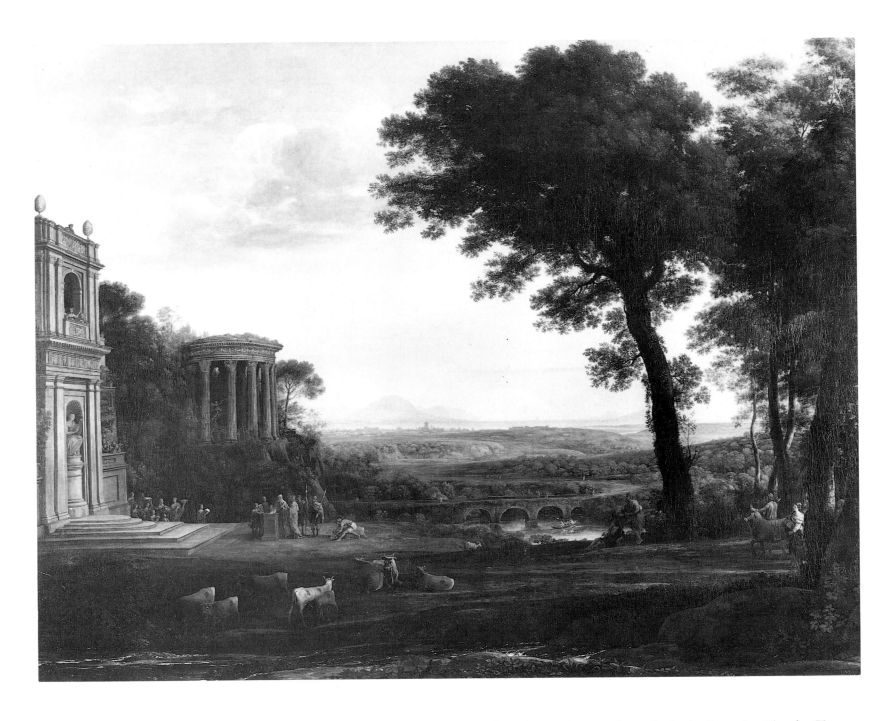

4. Claude Lorrain, *Landscape with the Father of Psyche sacrificing to Apollo*, 1663, oil on canvas, $68\frac{1}{2} \times 86\frac{1}{2}$ in., The National Trust, Anglesey Abbey

Through studying works by other artists, and particularly those by Claude, Turner became familiar at second hand with the essential ingredients of the Italian countryside. He grew to know its enduring natural formations, the characteristic shapes of mountains, plains and vegetation. He also had to think about the transient, yet equally characteristic, forces that vitalise the earthly phenomena — Italy's warm sunlight and her glowing, sparkling or hazy atmosphere. Claude's paintings had depicted imaginary landscapes, distilled out of his sketches from nature in the Roman Campagna. Wilson's paintings had been closely based on his topographical studies but reached out towards an ideal Italy which existed somewhere between past and present (Plate 6). In 1819, Turner devoted himself to recording in detail the realities that lay behind Claude's and Wilson's paintings. He sketched incessantly wherever he went, even when travelling or in the depths of winter. The 1819 pencil sketches have been criticised for being factual rather than imaginative, but these drawings should not be approached with the wrong expectations.[7] Turner's early training in topographical drawing made it inevitable that he should go to Italy with a determination to make direct records of what he saw, rather than use it as a springboard for

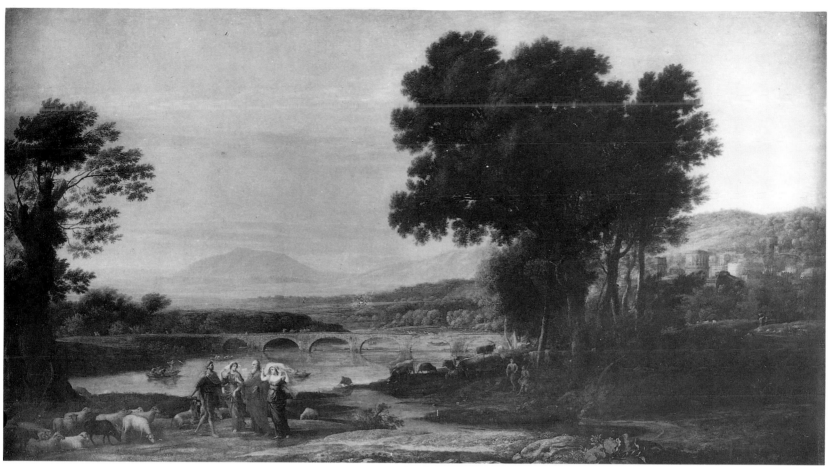

5. Claude Lorrain, *Landscape with Jacob, Laban and His Daughters*, 1654, oil on canvas, 56½ × 99 in., The National Trust, Petworth House

6. Richard Wilson, *Rome: St Peter's and the Vatican from the Janiculum*, 1753-4, oil on canvas, 39½ × 54¾ in., Tate Gallery, London

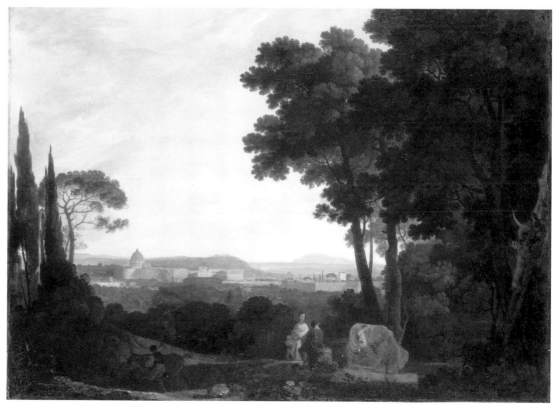

his imagination. On his second visit to Italy, however, his position was very different. In 1828 he made far fewer topographical sketches; he had digested his Italian experiences sufficiently well to embark on oil paintings, created directly on the canvas and in a studio. Intensive fact-gathering gave way to the painting of imaginary Italianate landscapes, so

that Turner's two visits to Rome as a middle-aged man form a microcosm of his general development as an artist, the pattern of his entire life.

Turner's prolific activity in sketching the Italian countryside in 1819 reflects his habits on his sketching tours from the 1790s onwards. It also stemmed from the fact that travelling through Italy presents the visitor with a magnificent variety of scenery. After crossing the Alps and almost inevitably seeing 'the remains of a falling of earth and rocks . . . which inspired a dreadful idea of such a catastrophe', the traveller encountered a 'delightful prospect, rich in every species of grain, in the most delicious fruits, with an atmosphere soft and sweet, a clear and serene sky' so that he could not help exclaiming, 'this is surely "a land flowing with milk and honey"'.[8] In the Apennines he found 'barren mountains and dreary wastes', 'a wild naked Prospect of Rocks and Hills, worn on all Sides with Gutters and Channels, and not a Tree or Shrub', while nearer to Rome there were 'many beautiful Scenes of green Mountains and fruitful Vallies'.[9] In short, the countryside of Italy partook of elements from the sublime, the picturesque and the beautiful. It reminded visitors now of Poussin, now of Salvator Rosa, now of Gaspar Dughet, now of Claude, while the peasants might be seen as Arcadian or as reminiscent of Teniers.[10] Turner's omnivorous sketching of Italy embraced all her varied aspects and he did not confine his interest to any single predetermined ideal. He himself was reminded not only of the work of Claude and Wilson, but also that of Dughet; and on two occasions he sketched scenes that reminded him of Cuyp.[11]

The Italian countryside also attracted interest because of its historical associations. The classically educated Addison filled his *Remarks on Several Parts of Italy* (1705) with quotations from the Latin poets relating to all the famous geographical sites, and he had taken special pleasure in examining these descriptions on the spot during his own travels and comparing 'the Natural Face of the Country with the Landskips that the Poets have given us of it'.[12] His poem 'A Letter from Italy' of 1701 had included the famous lines:[13]

> For whereso'er I turn my ravish'd eyes,
> Gay gilded scenes and shining prospects rise,
> Poetic fields encompass me around,
> And still I seem to tread on classic ground;
> For here the muse so oft her harp has strung,
> That not a mountain rears its head unsung,
> Renown'd in verse each shady thicket grows,
> And every stream in heavenly numbers flows.

Reflections on the past were even more often excited by ruins than by nature. It was while musing amidst the ruins of the Capitol in 1764 that Edward Gibbon had conceived the idea of *The Decline and Fall of the Roman Empire* (1776-88), and the appeal of a site was usually commensurate with its importance in history. One later traveller who was unable to visit Paestum reflected: 'Perhaps there is no great cause for regret; for, however fine the ruins may be, there is no story of the olden time to make them particularly interesting. . . . it is the deeds that have been done, and the men that did them, — the Scipios, and the Catos, and the Brutuses — that invest the ruins of Rome with their great charm and interest.'[14] These words were written by Henry Matthews, the brother of Byron's close friend Charles Skynner Matthews, and many travellers would have agreed with him. Certainly the extent to which the visitor was moved by his first sight of Rome was in direct proportion to his knowledge of ancient history. The following exclamations from Henry Sass's *Journey to Rome and Naples in 1817* (1818) — a book which Turner owned and whose author he knew well — should make the average modern tourist feel pretty inadequate:[15]

What various feelings animated me! What throbs filled my breast, when about to visit the country of the Horatii and Curatii, of Junius Brutus, of Mutius, of Cincinnatus, of Camillus, of Virginius, of Fabricius, of Regulus, of Scipio, of the Gracchi, of Caesar, Cicero, and Seneca, of Brutus, and Augustus, of Virgil, Horace, Ovid, and Quintilian, of

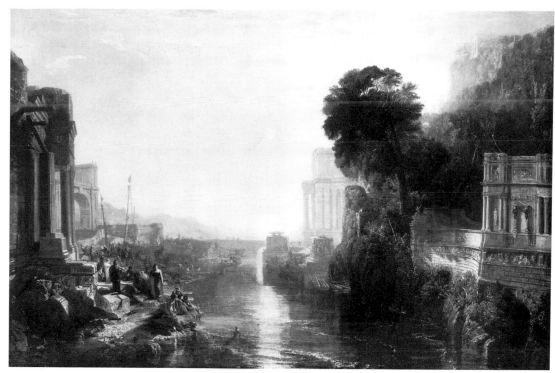

7. *Dido building Carthage; or the Rise of the Carthaginian Empire*, 1815 (B & J, 131), oil on canvas, $61\frac{1}{4} \times 91\frac{1}{4}$ in., National Gallery, London

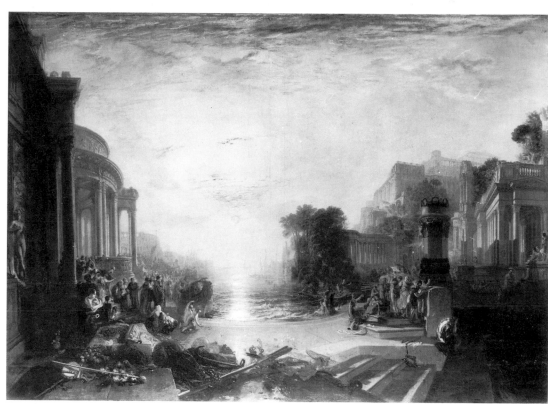

8. *The Decline of the Carthaginian Empire*, 1817 (B & J, 135), oil on canvas, 67 × 94 in., Tate Gallery, London

the Antonines! What delight to range over the hills of Rome — the Palatine where Romulus was found — the Aventine where the Romans so often made a stand for liberty — the Capitoline where sat an assemblage of gods, as the Roman Senate has been described.

In the years before 1819 Turner had painted a number of pictures with subjects from the Bible, classical literature or mythology but only three classical history paintings. All three were concerned with the rise and fall of Carthage and its rivalry with the Roman Republic — *Snow Storm: Hannibal and his Army crossing the Alps* (RA, 1812) and the monumental seaports, *Dido building Carthage* (RA, 1815) and *The Decline of the Carthaginian Empire*

7

(RA, 1817; Plates 7 and 8). This choice of subject had its origins in the rise of Napoleon and the war between France and England: Napoleon had set himself up as Emperor with laws and institutions based on those of Rome and seemed intent on rivalling the Romans in his conquests; but he had also, like Hannibal, crossed the Alps and marched upon Rome itself. However, the story of Rome and Carthage continued to fascinate Turner long after the Napoleonic Wars were over. Both *Regulus* (Colour Plate 27) and *Palestrina* (Plate 156) — which were painted on his 1828 visit to Rome — are related to the Punic Wars and Hannibal, and at the end of his life he returned to the subject of Rome and Carthage, as personified in Virgil's *Aeneid.* The very last paintings he exhibited at the Royal Academy in 1850 were concerned with Dido and Aeneas. Only for a short while in the late 1830s did he attempt any subjects from Roman history that were totally unrelated to Carthage, and his themes then tended to be ones that had been treated by earlier British artists. *Cicero at his Villa* (RA, 1839; Plate 163), for example, took a subject painted many times by Wilson while *Ancient Rome — Agrippina landing with the Ashes of Germanicus* (also RA, 1839; Plate 173) followed a theme painted by several artists including Benjamin West.

Turner's range of subjects from Roman history was thus noticeably limited. His themes nearly always derived from a contemporary focus of attention or from earlier paintings, and the extent of his knowledge of classical history and poetry can only be guessed at. There are, however, plenty of clues: the books in his library, references in his own writings, the quotations or sources he appended to the titles of exhibited paintings. Turner was a self-educated man but it is clear that he was extremely widely read in a variety of subjects and had a remarkably retentive memory. Modern interpretations of his paintings are based on the firm belief that he had read and digested the books in his own library and was also conversant with contemporary attitudes not only in the arts but also in literature and science.

Turner's visits to Rome took place at a time when there was a sudden upsurge of continental travel by the British and a corresponding spate of guidebooks and travel books.[16] The most influential guidebook to Italy published in England in the early nineteenth century was *A Tour through Italy* (1813) by the Rev. John Chetwode Eustace (1762?-1815) and it is not surprising to find that Turner was well acquainted with this book.[17] Its author was a classical antiquary who was concerned 'to trace the resemblance between Modern and Ancient Italy, and to take for guides and companions in the beginning of the nineteenth century, the writers that preceded or adorned the first. Conformably to that character, the Author may be allowed to dwell with complacency on the incidents of ancient history, to admit every poetical recollection'.[18] This approach provided him with frequent opportunities for historical analysis and many a moralising reflection on the erstwhile greatness and subsequent degradation of Italy which were sometimes expressed in passages of truly purple prose. In the years following 1813, writers on Italy copied both Eustace's lines of thought, at one moment emphasising the aspect of change, at the next moment stressing the continuity of the present with the past. The former attitude tended to be all-embracing, the latter confined to certain particulars of life. Henry Matthews voiced the thoughts of many people on the Roman Forum when he wrote:[19]

> Nothing can be more striking, or more affecting, than the contrast between what it was — and what it is. There is enough in the tottering ruins which yet remain, to recal [sic] the history of its ancient grandeur; while its present misery and degradation are obtruded upon you at every step. Here Horace lounged; — here Cicero harangued; — and here now, the modern Romans count their beads — kill their pigs — cleanse their heads — and violate the sanctity of the place by every species of abomination.

The domestic utensils, furniture and ornaments unearthed at Pompeii, on the other hand, stimulated the thought that 'there is nothing new under the sun'[20] and many Protestant travellers to Italy were convinced that Catholicism had been shaped by the practices of the pagan religion of the ancient Romans. Turner himself later owned a book on this whole subject, the Rev. J. J. Blunt's *Vestiges of Ancient Manners and Customs, discoverable in*

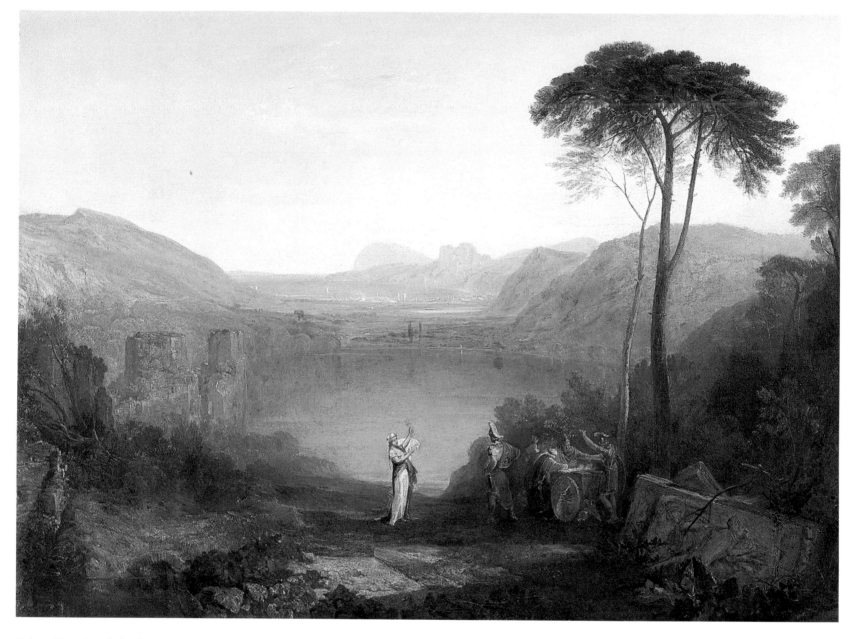

Colour Plate 1. *Lake Avernus: Aeneas and the Cumaean Sibyl*, 1814-15 (B & J, 226), oil on canvas, 28¼ × 38¼ in., Yale Center for British Art, Paul Mellon Collection

Modern Italy and Sicily (1823) which, as will be seen, had a very important influence on his thought from the mid-1820s onwards.[21]

Meanwhile, present-day Italy also held considerable fascination in its own right. There was much that was unpleasant or squalid about modern Italian life but it often presented extremely picturesque sights, as both artists and writers were quick to observe. When British artists resumed the practice of working in Italy after Waterloo, painters such as Charles Lock Eastlake, Penry Williams, Thomas Uwins, Joseph Severn and James Atkins very soon developed a taste for painting genre scenes, following the example of such continental practitioners in this field as J. P. Hackert (1737-1807), Bartolomeo Pinelli (1781-1835), J. Kaisermann (1765-1833) and Léopold Robert (1794-1835).[22] The British painters and their patrons found three subjects especially attractive: the complex ceremonies of Roman Catholicism which were strikingly different from what British Protestants were used to; peaceful and colourful country scenes; and the thrilling exploits of Italian *banditti*. Turner's paintings show clearly that he shared the contemporary interest in all these subjects. Catholic practices are an essential ingredient of *Forum Romanum* (RA, 1826; Colour Plate 22). The *View of Orvieto* (1828; Plate 149) and *Modern Italy — the Pifferari* (RA, 1838; Plate 172) reflect his appreciation of the picturesqueness of rural life in modern Italy. His watercolour *Lake Albano* (*c.* 1828;

9

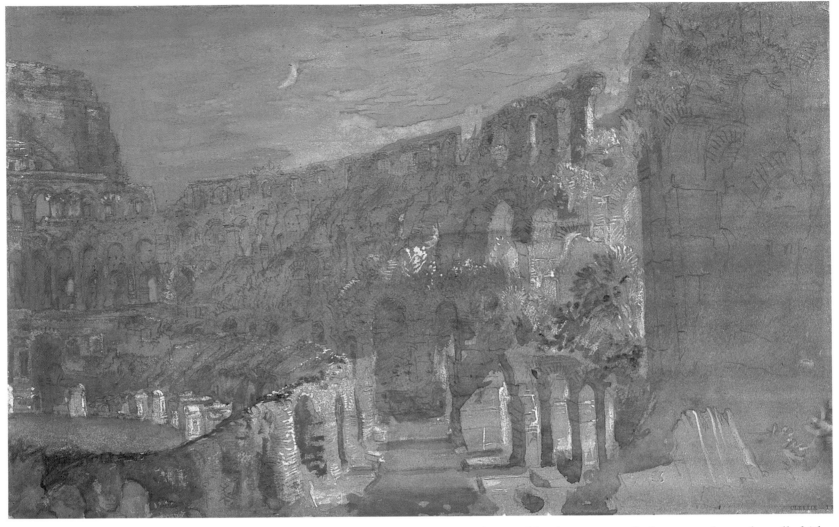

Colour Plate 2. The Colosseum by moonlight, 1819 (*RCSt*, 13), pencil, watercolour and bodycolour on white paper prepared with a grey wash, 9 × 14½ in.

Plate 135) can only be fully understood in the context of what may almost be called 'the *banditti* industry' of the 1820s.[23]

Turner's interest in present-day Italy did not replace his concern with classical subjects, however, and the Italian subjects he exhibited at the Royal Academy were often very traditional compared to the paintings of his contemporaries. At the 1839 Royal Academy, for example, he exhibited the two paintings just referred to as having their roots in the eighteenth century, *Cicero at his Villa* and *Agrippina landing with the Ashes of Germanicus*. These were a far cry from the twenty or so depictions of modern Italian life (peasants, convents, brigands and so forth) which were exhibited there by Eastlake, Thomas Uwins, William Havell, William Collins and a host of lesser painters. The following year saw Turner exhibiting *Neapolitan Fisher-Girls surprised bathing by Moonlight* (Plate 9) alongside eight or ten paintings by other artists of peasants at Naples or other southern Italian towns. Here again Turner's painting was quite different from those of his fellow-artists. Despite its professed subject matter, *Neapolitan Fisher-Girls* is essentially a mood picture and is completely lacking in romantic story or Victorian sentimentality. One of the most important characteristics of Turner's paintings of Italy in the 1820s and 1830s is the variety that is found both in the paintings as a group and within individual paintings: he continually combines references to earlier art and stylistic novelties of his own, allusions to the past and depictions of the present. In the last analysis, it is the range and complexity of Turner's responses to Italy, both intellectual and aesthetic, that distinguish his depictions of that country most clearly from those of his contemporaries. His response was simultaneously the product of his highly complex personality and the result of his insatiable need to record everything he saw. No other British artist in Italy could match him in the quantity or variety of his sketches and none was endowed with his genius.

10

<center>★　★　★　★</center>

This summary of the different attractions of Italy — art and nature, past and present — was stimulated by a quotation from Addison's *Remarks on Several Parts of Italy,* a book written over a hundred years before Turner set foot in that country. Surely, it may be argued, a visit to Italy in the nineteenth century was very different from one in the eighteenth? This is undoubtedly true, but it is less true for 1819 and 1828 than for later in the century. Turner's visits to Rome occurred during what has been described as the 'Indian Summer of the Grand Tour',[24] and it was to be a little while before the increasing affluence of the middle classes, the railway and eventually Cook's tours conspicuously altered the character of British travel in Italy. Victorian ideas about Italy are reflected in many works of art and literature, and when these are compared with works of the eighteenth century, it is clear that Turner's affinities are very much with his predecessors. Dickens's *Pictures from Italy* (1846), for example, may be compared to Smollett's *Travels through France and Italy* (1766) — both were based on descriptive letters which were intended to entertain their readers back home. Smollett's letters describe his travels through modern Italy in vivid (and often petulant) detail, but they are nevertheless typically eighteenth-century in their underlying concern with the past. The author pays close attention to antique statuary, he quotes from classical authors, he reflects on the customs of the ancient Romans. Dickens, on the other hand, was almost exclusively concerned with present-day experiences. It is only when finally confronted by the Colosseum that he makes any overt reference to antiquity at all and the reader becomes suddenly aware that the country through which the author has been travelling all this time had once been the heart of the Roman empire.

The contrast between Dickens and Smollett may be paralleled in the realm of British painting, not only in the growth of interest in Italian genre scenes already referred to, but also in the behaviour and reactions of individual artists in the 1830s and 1840s. Samuel Palmer's letters from Italy of 1837-9, for example, are singularly lacking in references to

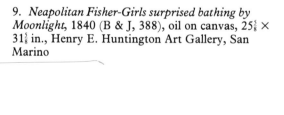

9. *Neapolitan Fisher-Girls surprised bathing by Moonlight,* 1840 (B & J, 388), oil on canvas, 25⅝ × 31⅝ in., Henry E. Huntington Art Gallery, San Marino

the past, or reflections upon it. Furthermore, the happiest period of Samuel and Hannah Palmer's hard-working and curiously unromantic Italian honeymoon seems to have been the two months which they spent far away from the famous and fashionable sites — at a remote hamlet thirty miles from Naples, where they studied nature intensively and lived very simply.[25] Turner's Italian experiences were of quite a different order and his 1838 and 1839 pairs of paintings on the subject of ancient and modern Italy and Rome had a very different rationale from Palmer's *Ancient Rome* and *Modern Rome*, painted in that city in 1838 (Plates 175 and 176).[26] Turner's sketches, watercolours and oil paintings show his attitudes to Italy to have been firmly based in those that had been current in his youth. By the 1830s, as was indicated above, his attachment to earlier ideals marked him off considerably from most of his contemporaries.

Another development in British attitudes to Italy that occurred in Turner's lifetime was the change in taste regarding Italian works of art. Turner himself devoted much of his attention in Italy to the contents of churches, museums and galleries but, although his taste had been formed by the canons of the eighteenth century, his gaze was by no means exclusively focused on the exemplars held up by Reynolds. For Reynolds, and similarly for the second President of the Royal Academy, Benjamin West, the chief purpose of an artist's trip to Italy was to learn from 'the Antique, Michael Angelo and Raphael', while attention could also profitably be directed towards the Venetians and Bolognese.[27] However, in the hundred years following Reynolds's visit to Italy the reputation of the Bolognese school declined sharply, the authenticity of many supposed works by Raphael and Michelangelo was questioned, and there was an increasing interest in the painters who had preceded Raphael. Whereas the eighteenth-century visitor to Florence would usually go straight to the Tribuna, when Ruskin visited Italy in 1845 to gather material for *Modern Painters* volume II his first objectives in Florence were Giotto's tomb and the Fra Angelicos in S. Marco. 'Give me Pinturicchio & Perugino', he wrote, '& you shall have all the Raffaelles in the world.' In the Campo Santo at Pisa he met two French artists who had been studying 'the old paintings of the right sort' for two years: 'they say . . . that there is nothing at Bologna'.[28]

In the early nineteenth century, then, the taste of the visitor to Italy was far less homogeneous than it had been in the eighteenth. Changes in taste are always difficult to monitor and nowhere more so than here. Taste itself changes very gradually and most early nineteenth-century travellers and writers of guidebooks clung to conventional opinions.[29] The changes that did get recorded did not necessarily affect everybody at the same time, or to the same extent. There are also tantalising gaps in the story. What, for example, was Samuel Palmer's reaction when in the late 1830s he saw Donatello's *St George*, about which he had written so rapturously in 1828 on the basis of a reproduction? His letters from Florence never mention it. Moreover, the new concern with early painting inevitably mingled historical considerations with genuine appreciation. Goethe may appear ahead of his time in looking at Mantegna, Francesco Francia and Perugino as early as 1786, but it is clear that he did so in order to discover whence 'the later painters drew their strength'.[30] The same would have been true for many British travellers as well. On the other hand, when, very shortly after this, Flaxman studied works by Uccello and Donatello, Duccio and Orcagna, there can be little doubt that he was drawn to them by their own power. It is equally clear that Fra Angelico attracted Blake, George Richmond and Samuel Palmer for spiritual, aesthetic and emotional reasons, not historical ones.

Several of Turner's colleagues left records of their studies in Italy which provide valuable data on taste at the time of his own visits. They also demonstrate that traditional tastes managed to coexist with the new taste, sometimes even among artists of the same generation. The painters studied by William Etty in 1822 were almost entirely those that an eighteenth-century visitor would have looked at — Michelangelo and Raphael, Titian and Veronese, Correggio, the Carracci, Guido Reni.[31] David Wilkie visited Italy only three years later. Although he admired the work of the painters just mentioned, he also looked at the work of Foppa in Milan and at frescoes he believed to be by Giotto in the Campo Santo

at Pisa. At Florence he considered paintings by Ghirlandaio and Cimabue in S. Maria Novella, and works by Masaccio and Fra Angelico. Sometimes he found the early paintings curious, 'rude' and reminiscent of the work of 'the Chinese and Hindoos' and his comments make it clear that their interest was limited to 'the foundation they laid for the great works which have followed'.[32] Soon after this, however, visitors to Italy started to head for less accessible towns that had not been noticed in the eighteenth century but were rich in early works of art. The Callcotts visited Orvieto in 1828 and George Richmond studied the fifteenth-century frescoes at Subiaco in the later 1830s.[33] Meanwhile, an increasingly wide range of engravings had become available to British lovers of Italian painting. These included Thomas Patch's *Life of Masaccio* (Italy, 1770-2), William Young Ottley's *Series of Plates engraved after the Paintings and Sculptures of the Most Eminent Masters of the Early Florentine School* (1826) and Carlo Lasinio's *Pitture a fresco del Campo Santo di Pisa* (republished in England, 1828).

Turner's behaviour was very typical of the 1820s. He sought out and commented on works of the Early Renaissance that he would probably not have looked at had he travelled to Italy at the outset of his career, but he never lost his respect for Raphael and Michelangelo. His interest in the early painters, in 1819 and in 1828, had both an historical and an aesthetic aspect. If he visited Orvieto on the advice of the Callcotts, he used his own eyes to assess the debt which Michelangelo owed to Signorelli's *Last Judgment* there and to decide that the master had not always improved upon his borrowings.[34]

★　★　★　★

Turner's decision to visit Italy in 1819 was the product of several different influences: the patronage of Sir Richard Colt Hoare, the publication of *Childe Harold's Pilgrimage* canto IV, Turner's own illustrations for James Hakewill's book, *A Picturesque Tour of Italy*, and the encouragement of Sir Thomas Lawrence. These influences were interrelated but are best discussed individually.

The historian Sir Richard Colt Hoare (1758-1838) was Turner's most classically orientated patron: he had travelled extensively in Italy and Sicily in the 1780s and 1790s and was widely read in classical literature and history. His contribution to Turner's classical education in the 1790s and later cannot be over-emphasised, providing, as it did, a counterbalance to Turner's study of Claude and J. R. Cozens. On the one hand he fed Turner with important ideas, for it was through Colt Hoare that Turner first became conversant with the attitude towards Italy that blended topography and historical argument in the manner already touched upon above.[35] Equally influential was his large and varied collection of works of art that depicted Italy. Colt Hoare himself had made over five hundred sketches in Italy and Sicily, and Turner would certainly have seen many of these on his visits to Stourhead. It was from one of his patron's own sketches that Turner produced his two paintings of Lake Avernus in c. 1798 (Plate 2) and 1814-15 (Colour Plate 1). Colt Hoare would also have shown Turner his fine Piranesi etchings, especially the *Vedute di Roma*, and his watercolours of Italy which included works by Abraham-Louis Ducros and John 'Warwick' Smith, both of whom he had known personally.[36] Moreover, Colt Hoare was a keen collector of books on Italian history and topography and he himself wrote a number of works describing his tours. Turner owned his slim volume, *Hints to Travellers in Italy* of 1815, and we may guess that it was a gift from his patron.[37]

The eighteenth-century Grand Tourist had invariably read guidebooks to prepare himself for his travels and it could have been Sir Richard Colt Hoare who introduced Turner to two important publications on Italy. These were the illustrated volume, *Select Views in Italy* by John 'Warwick' Smith, William Byrne and John Emes (1792-6), and Eustace's *Tour through Italy* mentioned above. Colt Hoare's own book, *A Classical Tour through Italy and Sicily* (1819), was designed as a supplement to Eustace's work: the latter had died in 1815 while in Italy gathering material for another volume and Colt Hoare felt that his own interests were identical to those of his forerunner, 'the recollection of former

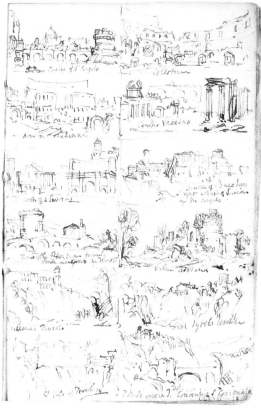

10. Sketches from J. Smith, W. Byrne and J. Emes, *Select Views in Italy* (*It. guide book*, 18 and 19), pen and ink, each page 6½ × 4 in.

times, and a comparison of those times with the present'.[38] Turner undoubtedly studied both the *Select Views* and Eustace's *Tour* in detail. He made minute copies of all seventy-two illustrations in the *Select Views* in his small *Italian guidebook* sketchbook (see Plate 10). He also assembled twenty-two pages of notes from Eustace's book in the same sketchbook.[39] The exact date of all these memoranda is hard to ascertain. However, Turner's notes were definitely made not from the first edition of Eustace's book (1813) but from the 1815 or 1817 edition, and he would not have made what amounts to a personal pocket guidebook unless an actual visit to Italy were imminent.[40] Turner's notes and sketches were probably made *c.* 1818, when he was producing his watercolours for Hakewill's *Picturesque Tour of Italy*. That work drew on both the *Select Views* and Eustace as sources and Hakewill could easily have lent Turner his copies. Turner's notes from Eustace are exclusively factual — lists of names, places to be visited — and they totally ignore all the moralising arguments that constitute a large part of the book and were so dear to Colt Hoare. Turner must have assimilated Eustace's attitudes through conversations with Colt Hoare, perhaps around 1814-15 when he was painting the second *Lake Avernus*. Subsequently, when a visit to Italy was becoming an actual possibility, he read quickly through Eustace's *Tour* itself, picking out specific pieces of information that could be useful. This was often Turner's practice when preparing for a tour and his sketchbooks show that in 1818 he was keenly looking out for books on Italy. As already mentioned, he owned a narrative by one of his friends, Sass's *A Journey to Rome and Naples* (1818). He also bought Reichard's *Itinerary of Italy* (1818), a pocket guidebook which he took with him to Italy in 1819.[41]

Sir Richard Colt Hoare played a vital part in nourishing Turner's interest in Italy on both a visual and an historical level, and there is no doubt that Turner himself appreciated this. Shortly before his first visit to Italy he painted two large watercolours which reflect the classical education which he had received on his visits to Stourhead — the nostalgic and visionary *Landscape: Composition of Tivoli* (RA, 1818) and *Rise of the River Stour at Stourhead* (?1817; RA, 1825).[42] However, there is nothing to suggest that Colt Hoare was directly connected with Turner's visit to Italy itself.

The publication of canto IV of *Childe Harold's Pilgrimage* in the spring of 1818, on the other hand, must have contributed enormously to Turner's interest in Italy at this moment. Byron was at the height of his powers, unrivalled in popularity with the reading public; both his name and the word 'Italy' were on everybody's lips. Dr Johnson had remarked, in Turner's infancy, that 'A man who has not been in Italy, is always conscious of an inferiority' and there can have been few moments in history when this was truer than in 1818: Turner was not the man to allow himself to feel inferior for long. What is more, his work shows a strong sympathy with Byron over a considerable period of time and had already done so by this date. Lines from canto II of *Childe Harold* (1812) probably influenced the scenes depicted in Turner's two Greek paintings of 1816, *The Temple of Jupiter Panellenius restored* (Plate 61) and *View of the Temple of Jupiter Panellenius . . .* Canto III (1816) must have encouraged him to visit the field of Waterloo and the Rhineland in the summer of 1817.[43] Just at the time when canto IV was published, Turner was engaged in painting his series of watercolours for Hakewill's *Picturesque Tour of Italy*. One of these, *Cascade of Terni* (Plate 11), is infused with Byronic feeling and shows exactly what canto IV describes:

> The roar of waters! — from the headlong height
> Velino cleaves the wave-worn precipice;
> The fall of waters! rapid as the light
> The flashing mass foams shaking the abyss;
> The hell of waters! where they howl and hiss,
> And boil in endless torture; while the sweat
> Of their great agony, wrung out from this
> Their Phlegethon, curls round the rocks of jet
> That guard the gulf around, in pitiless horror set . . .

Horribly beautiful! but on the verge,
From side to side, beneath the glittering morn,
An Iris sits, amidst the infernal surge,
Like Hope upon a death-bed, and, unworn
Its steady dyes, while all around is torn
By the distracted waters, bears serene
Its brilliant hues with all their beams unshorn:
Resembling, 'mid the torture of the scene,
Love watching Madness with unalterable mien.

(lxix, lxxii)

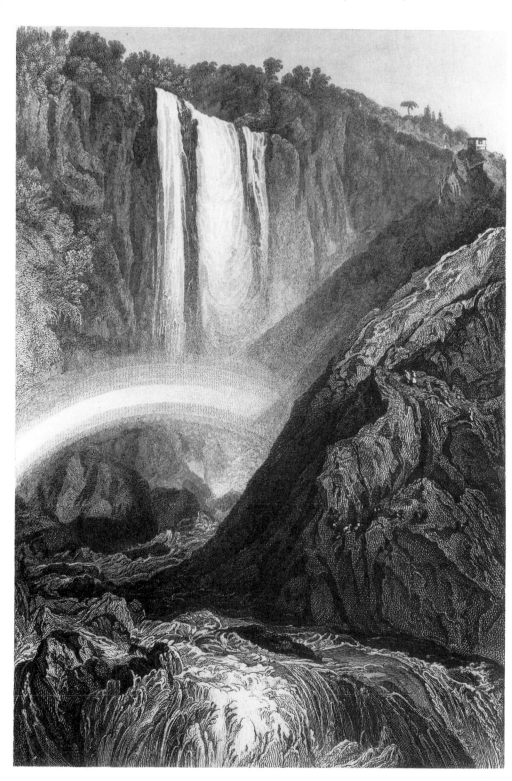

11. John Landseer after Turner, *Cascade of Terni*, 1819
(R, 145), engraving, 8½ × 5⅝ in.

It is unlikely that Turner visited Terni or anywhere else in Italy in 1819 simply because of Byron's verses: both poet and painter pursued a well-trodden path. All the same, Turner's 1819 sketches sometimes show a response to Italy akin to that expressed by Byron. The pale and magical watercolours of Venice, so different from the rest of Turner's work on the 1819 tour, truly recreate Byron's 'sea Cybele, fresh from ocean, . . . At airy distance'.[44] In Rome, it is difficult not to associate Turner's coloured sketch of the Colosseum by moonlight (Colour Plate 2) with Byron's celebrated verses:

> Arches on arches! . . .
>
> . . . the moonbeams shine
> As 'twere its natural torches, for divine
> Should be the light which streams here to illume
> This long-explored but still exhaustless mine
> Of contemplation; and the azure gloom
> Of an Italian night, where the deep skies assume
>
> Hues which have words, and speak to ye of heaven,
> Floats o'er this vast and wondrous monument,
> And shadows forth its glory. . . .
>
> (cxxviii-cxxix)

Byron's long section on the Colosseum inspired many foreign travellers to visit it by night and read his poetry aloud there.[45] The experience of the Colosseum at night-time must surely have recalled some of Byron's phrases to Turner's mind in 1819.

Turner's oil paintings of Italy often demonstrate that he shared Byron's sensibilities, in particular his ability to see beauty even in what was ruined and decayed. In 1832 he exhibited *Childe Harold's Pilgrimage — Italy* (Colour Plate 35) with the following lines from canto IV:

> — and now, fair Italy!
> Thou art the garden of the world.
> Even in thy desert what is like to thee?
> Thy very weeds are beautiful, thy waste
> More rich than other climes' fertility:
> Thy wreck a glory, and thy ruin graced
> With an immaculate charm which cannot be defaced.
>
> (xxvi)

Some of his other Italian paintings, such as *The Bay of Baiae* (RA, 1823), illustrate this verse equally well. For Turner, as for Byron, it was impossible to oppose ancient and modern Italy in crude terms of good and bad, beautiful and ugly. The so-called glorious past was not without its grimmer side, as his misquotation accompanying *Venice, the Bridge of Sighs* (RA, 1840) made clear:

> 'I stood upon a bridge, a palace and
> A prison on each hand' — *Byron.*

Meanwhile Turner's sensitivity to the ghostly beauty that still hovers round the remains of a great city is shown by the fact that on two occasions he used Byron's opening lines of verse xxvii:

> The moon is up, and yet it is not night;
> Sunset divides the sky with her.

Turner's adaptations of these lines accompanied *Modern Rome — Campo Vaccino* (Plate 174) at the Royal Academy in 1839 and *Approach to Venice* in 1844 and in both cases they carried a metaphorical as well as a literal meaning. In just the same spirit William Hazlitt had recently described the air of Rome as 'like the mingled breath of spring and winter, betwixt life and death, betwixt hope and despair'.[46]

The sensibility which enabled Byron, Turner and Hazlitt to find beauty in the ruined sites and overgrown countryside of Italy marks them off from the many writers of the preceding century — and of their own day — who found the neglected and depopulated Italian countryside depressing and unattractive. James Thomson's lurid descriptions in his poem *Liberty* will be quoted in Chapter 10 in the context of Turner's 'ancient' and 'modern' paintings of 1838 and 1839. They are matched by Smollett's description of the Campagna:[47]

> The view of this country in its present situation, cannot but produce emotions of pity and indignation in the mind of every person who retains any idea of its ancient cultivation and fertility. It is . . . naked, withered down, desolate and dreary, almost without inclosure, corn field, hedge, tree, shrub, house, hut, or habitation . . .

Both Thomson's and Smollett's attitudes may be contrasted with Hazlitt's:[48]

> Italy is not favourable to the look of age or of length of time. The ravages of the climate are less fatal; the oldest places seem rather deserted than mouldering into ruin, and the youth and beauty of surrounding objects mixes itself up even with the traces of devastation and decay. The monuments of antiquity appear to enjoy a green old age in the midst of the smiling productions of modern civilization.

The final similarity between Byron's and Turner's responses to Italy is their overall sense of irresolution. Prose writers like Smollett or, in Turner's own day, Lady Morgan had to take a stand — praising one thing, condemning another. But poets may legitimately show themselves being swayed now this way, now that, and they carry their readers' emotions with them. In *Childe Harold's Pilgrimage* canto IV Byron alternately depresses and elates his readers, describing cruelty, failure or tragedy and then evoking scenes of incomparable beauty or telling a heroic tale. As a mature artist Turner did exactly the same — most overtly in his paired Italian paintings of 1838 and 1839 which are discussed in Chapter 10. In the 1830s Turner's interest in the artists who had helped to shape his ideas on Italy became deeper and stronger, as that chapter will show: their art still influenced him but in more complex ways. The same was true of Turner's interest in Byron. The 1818 *Cascade of Terni* (Plate 11) is a fine illustration of the words that Byron had so recently written and published, and it has its own contrast, on a minor scale, between the torment of the waters and the serenity of the rainbow. But the 1839 *Campo Vaccino* (Plate 174) takes a vast subject for its theme — the beauty of fallen greatness — and it leaves the spectator torn between enchantment and melancholy, rapture and heartbreak.

By the time that canto IV of *Childe Harold's Pilgrimage* was published in April 1818, Turner was already busy producing his series of twenty watercolours for engraving in James Hakewill's *Picturesque Tour of Italy*.[49] Part I of Hakewill's book was issued in May 1818 and Turner was paid 200 guineas for his first ten drawings by its publisher John Murray on 15 June.[50] James Hakewill (1778-1843) belonged to a London family of architects, painters and decorators and was himself an architect. He was also a good topographical draughtsman and in 1813 he published *The History of Windsor, and its Neighbourhood*, a large and handsome volume with twenty-one plates and fourteen vignettes engraved after his own drawings. Turner and he moved in the same circles and probably knew each other by 1816.[51] In the spring of that year he travelled with his wife to Italy, returning in the summer of 1817 with over three hundred pencil sketches from nature and the idea of producing another book.[52] *A Picturesque Tour of Italy* was to consist of high-quality engravings based on Hakewill's own drawings, accompanied by a small amount of letterpress derived from the best authorities on Italy.[53] The book was a typical product of its time, as can be seen from the fact that a rival publishing firm, Rodwell & Martin, published a very similar part-work — Elizabeth Batty's *Italian Scenery* — during exactly the same period, 1818-20. Their subject matter reflected the renewed interest felt in Italy now that English travellers could once again visit the Continent and they were

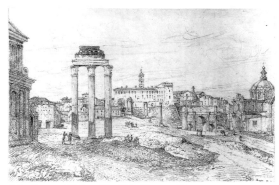

12. James Hakewill, *The Forum Romanum*, 1816/17, pencil, $5\frac{1}{2} \times 8\frac{1}{2}$ in., private collection

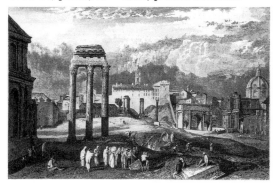

13. George Hollis and J. Mitan after Turner, *The Forum Romanum*, 1820 (R, 149), engraving, $5\frac{3}{4} \times 8\frac{3}{4}$ in.

specifically aimed at the new middle-class reading public. These readers liked illustrated books with a text consisting solely of extended captions and they also preferred subscribing to part-works paid for by instalments.

The extraordinary publication history of Hakewill's *Picturesque Tour of Italy* has already been described in some detail elsewhere.[54] What is important here is the role played by both Hakewill himself and his book in preparing Turner for his first visit to Italy. Transforming twenty of Hakewill's very detailed and meticulous pencil sketches into book illustrations with a life and character of their own (compare Plates 12 and 13) was something entirely different from copying J. R. Cozens's airy drawings for Dr Monro by candlelight or studying the grand etchings of Piranesi in Sir Richard Colt Hoare's library. Through his work for Hakewill Turner learnt Italy by heart and its famous sights became dear to him (Plates 14 and 15). Again and again on his journeys through Italy in 1819 he made a point of standing on the same spot as Hakewill and making rough pencil sketches of the very views that he himself had already completed in watercolours or that he had enjoyed in Hakewill's portfolios (see Plates 88 to 91). There can be little doubt that during 1818 and the first half of 1819 Turner had long conversations about Italy with Hakewill, and his 1819 sketches reflect his appreciation of parts of the book with which he was not personally involved, such as the views of museum interiors which Hakewill claimed had never before been illustrated in a book on Italy. As Turner became ever keener to visit Italy himself, Hakewill filled a small notebook with helpful information for the projected journey, which Turner later labelled *Route to Rome*. He provided a detailed itinerary based on his own tour (which Turner in fact chose to ignore) and copious advice on hotels and sightseeing. He also entrusted him with small personal commissions, such as the buying of cameos and a mosaic, which one hopes that Turner remembered to fulfil. Turner certainly seems to have consulted the notebook fairly frequently in Italy and used it for notes and sketches for many weeks.

For all their wonderful detail, Turner's scenes in the *Tour of Italy* seem today a little hesitant (see Colour Plate 16). It is, as Ruskin wrote in the 1870s, 'a series which expresses the mind of Turner in its consummate power, but not yet in its widest range'.[55] However, the views were greatly admired in their own time. Examples of both the watercolours and the engravings appeared in public exhibitions in the 1820s and 1830s not only in London but also in the provinces.[56] Six were pirated and re-engraved in Josiah Conder's popular pocket guidebook *Italy* of 1831.[57] Some of Turner's own colleagues made drawings for engraving which are so close to Turner's that they are almost copies — the J. D. Harding and Samuel Prout views of the Cascade at Terni for instance.[58] On one occasion there was an angry episode at the Royal Academy when Turner actually accused another artist of plagiarising his work.[59] In 1878 Ruskin included seven *Tour of Italy* scenes in the exhibition of his collection of Turner watercolours, and he wrote about them at length in the catalogue, stressing the excellence of their drawing, their truth to nature and their poetical atmosphere. It is hard to escape this conclusion: that just as Hakewill himself had helped introduce Turner to the glories of Italy, so too Turner's illustrations for his book led countless other Britons to Italy and made them love the self-same sights.

Meanwhile, in 1819, Italy itself brought Turner's art to the mind of his friend Sir Thomas Lawrence. Early in May Lawrence had left Vienna, where he had been painting several of the leaders of the Allies for the Waterloo Chamber series of portraits, and went to Rome. There he painted Pope Pius VII and Cardinal Consalvi, but he also found time to explore the riches of Rome and its environs. In June he visited Tivoli and was reminded of Turner's art so strongly that he wrote to the antiquary Samuel Lysons:[60]

in Mr. Turner, it is injustice to his fame and to his country, to let the finest period of his genius pass away, . . . without visiting those scenes which, if possible, would suggest still nobler images of grandeur and of beauty than his pencil has yet given us, and excite him to still greater efforts than those which have already proved him the foremost genius of his time.

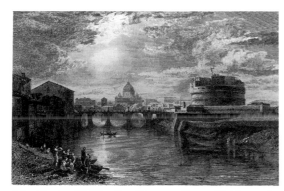

14. George Hollis after Turner, *Rome. Bridge and Castle of St Angelo on the Tyber*, 1818 (R, 147), engraving, $5\frac{1}{2} \times 8\frac{5}{8}$ in.

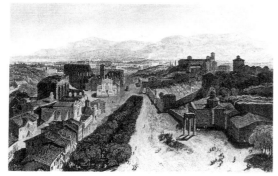

15. George Cooke after Turner, *The Roman Forum, from the Tower of the Capitol*, 1818 (R, 148), engraving, $5\frac{1}{2} \times 8\frac{3}{4}$ in.

On 2 July Lawrence wrote a similar letter to Joseph Farington, RA:[61]

> Turner should come to Rome. His Genius would here be supplied with new Materials, and entirely congenial with it. It is one proof of its influence on my mind, that enchanted as I constantly am whenever I go out, with the beauty of the Hues & forms of the Buildings — with the Grandeur of some, and variety of the Picturesque in the masses of the ordinary Buildings of this City, I am perpetually reminded of his Pencil; and feel the sincerest regret that his Powers should not be excited to their utmost force. He has an Elegance and often a Greatness of Invention, that wants a scene like this for its free expansion; whilst the subtle harmony of this Atmosphere that wraps every thing in its own Milky sweetness (for it is colourless compared with the skies of France & England and more like the small Claude of Mr Angerstein's and Lord Egremont's) tho' the latter has a slight tendency has it not to heaviness? this blending I say of Earth & Heaven, can only be rendered according to my belief, by the beauty of his Tones. I must already have written the substance of this to you as I have to Lysons; but my dwelling on the subject arises from no affectation or assumed Feeling. It is a fact, that the Country and scenes around me, *do* thus impress themselves upon me, and that Turner is always associated with them. Claude, tho' frequently not so often, and Gaspar Poussin still less.

Did these letters contribute to Turner's decision to leave for Italy? Lysons died two days after receiving his, so he can hardly have pressed Lawrence's case with Turner. Farington may well have encouraged Turner to set out for Rome, but the time between his receipt of Lawrence's letter and Turner's actual departure is far too short for his advice to have been crucial. Turner himself had already decided to make 1819 the year in which he visited Italy, and Lawrence's presence in Rome was merely an additional inducement to go. Reports of the welcome that Lawrence was accorded wherever he went made Rome seem a particularly hospitable place at just this moment, and two other Royal Academicians also chose to visit the city that summer. These were Turner's close friend Francis Chantrey, the most outstanding British sculptor of his day, and John Jackson, a fashionable portrait painter.

It has sometimes been suggested that once Turner arrived in Rome, Lawrence was not very interested in seeing him.[62] This was not the case: Lawrence certainly did see Turner and tried to draw him into the glamorous English circle around Elizabeth Duchess of Devonshire in which he himself moved.[63] Eastlake also made him welcome, as did the great Canova who had visited Turner's gallery on his visit to London in 1815.[64] But Turner's social contacts in Italy were chiefly with English people, since although he was well prepared for his visit in many other respects, he was unable to speak Italian. Charts of foreign words in several of his sketchbooks show his desire to learn foreign languages but he obviously found this very difficult. He had to rely on tourists' phrases copied into his notebooks, help from acquaintances and, at any rate later on, a pocket phrasebook.[65] In January 1829 a chance travelling companion noted that Turner spoke 'but a few words of Italian, about as much of French, which two languages he jumbles together most amusingly'.[66] Turner's Italo-franglais may have sounded odd, but it took him all over Europe.

Chapter 2

THE PATH TO ROME, 1819

Turner set off for Rome on 31 July 1819.[1] He crossed from Dover to Calais by the packet boat and then travelled through France on the most direct route to the Alps, which took him through Paris, Sens, Auxerre, Châlon-sur-Saone, Lyons, Chambéry and Lanslebourg to the Mont Cenis pass. This part of his journey, recorded in the *Paris, France, Savoy 2* sketchbook,[2] probably took him two to three weeks, so that he at last savoured his first sight of Italy around the middle of August. The present book is concerned only with Turner's experiences of central and southern Italy, and not with the time he spent in the north, so it will discuss only part of his journey to Rome. However, it must be noted that he spent about three or four weeks crossing northern Italy and looking at Turin, Milan, the lakes and Venice. During that period he filled three or four sketchbooks with drawings, usually working in pencil, but also occasionally in watercolour.[3]

He left London alone and apparently without a passport. His Royal Academy friends Chantrey and Jackson set off for Italy about three weeks later, both with passports issued by the Foreign Office in London,[4] but there is no record of the Foreign Office providing one for Turner. This is not as strange as it seems, for it was quite common in the early nineteenth century for British travellers to the Continent to obtain their passports either from the French Embassy in London or from the British Embassy in Paris.[5] Turner must have followed one or other of these practices. Another artist bound for Rome who acquired his passport in Paris was William Etty. His experience in 1816 of being passed from official to official, 'bandied from hand to hand like a bad shilling', was far from uncommon at this time and may well have been shared by Turner.[6] It is less clear why Turner avoided the company of Chantrey and Jackson on his journey. He may have been unwilling to wait for them, especially since he was planning a tour of Italy that was both longer and more complex than theirs; and having already been twice to the Continent, in 1802 and in 1817, he would have realised that he could easily manage on his own.[7]

There is very little written evidence concerning Turner's journey to Rome. He abandoned his attempt at a diary almost immediately and if he wrote any letters they have not survived. The one supposedly eye-witness account of Turner *en route* for Rome will be shown, in the course of this chapter, to be of very dubious authenticity. However, the shortage of verbal evidence is not important when Turner's own sketches of his journey are so plentiful. As his Scottish friend 'Grecian' Williams declared, sketches made while travelling 'may impart a pretty accurate general idea of any scene' and 'will aid the imagination more than any verbal description'.[8] Turner's Italian sketches show, as clearly as any diary or letters, where he went, what he looked at, what he was interested in. They also reveal his entire attitude to travelling and sketching, and the seriousness with which he took this particular tour. Nearly all of the sketchbooks he used in Italy (if not actually all) were bought beforehand in England.[9] They are very varied in external appearance, size, paper and weight and were clearly intended for different purposes. Whilst actually travelling Turner consistently used the largest size of sketchbook that would fit into his pocket (about $4\frac{1}{2}$ by $7\frac{1}{2}$ inches, close to the size of today's paperbacks). Each contained about ninety pages of white paper, and nearly all were bound in boards, with leather only on the spine, which means they weigh less than a completely leather-bound book. Turner filled

ten of these nearly identical sketchbooks during his months in Italy, using them chiefly for sketches but also now and again for brief notes.[10] Sometimes these relate to his sketches, sometimes they are independent memoranda: notes on the countryside or costumes, names and addresses, useful Italian phrases, financial calculations.

In these pocket-sized sketchbooks Turner nearly always used pencil. There are no sketches in watercolour, which he employed only in the larger sketchbooks brought out when he was staying for a while in one place — in Venice, Rome, Tivoli and Naples. Even so, there is still the considerable variety in technique that is so frequent in Turner's small sketchbooks. Now he indicates the spread of a landscape with long loose strokes of a softly applied, fairly blunt pencil across two pages of the sketchbook at once. Now he draws a highly composed view of a town square as seen from a carefully selected vantage point near one of its corners, his hard pencil newly sharpened and crisply manipulated (Plate 21). When travelling through hilly country with ever-changing views he quickly divides up the pages into four or five rectangles so as to make as many sketches as possible, just as he had often crammed half-a-dozen views of the Rhine on to one page in 1817 (Plate 22). Certain overall consistencies may nevertheless be perceived. There are few notes on colour. Light and shade are only rarely indicated by hatching; generally the outlines alone of a landscape or a building are indicated. He almost invariably avoided sketching in detail the obvious and repetitious (he did not draw fourteen identical windows on a façade: he drew one or two carefully and wrote '14' next to them) but he swooped on interesting points of detail such as unusual triglyphs or a heraldic decoration. There are also few occasions on which he studied the sky. On his travels Turner was concerned to record and memorise unchanging essentials rather than the transient and variable. One transitory sight, however, never ceased to interest him: he was always ready to include the human element. Wherever Turner went in Italy he observed its people closely and he drew richly on his own observations in many later paintings. The *contadina* in *Lake Albano*, for instance, is wearing a brilliantly coloured bodice and skirt appropriate to that area (see Colour Plate 25), while *Forum Romanum* (Colour Plate 22) has a Catholic procession at its heart, both formally and metaphorically.[11]

Turner's journey to Rome could not have been more different from that of the modern tourist. First, he would have travelled through France by the huge public vehicles known as *diligences*, booking ahead in stages as he arrived in each large town: in Paris for Lyons, in Lyons for Chambéry, in Chambéry for the passage over the Alps.[12] In one town he sketched a group of travellers waiting beside the *diligence* (Plate 16), a sight with which he must have been all-too-familiar. The *diligence* which took him from Calais to Paris held, according to his own notes, '2 Frenchmen and 2 English[, in the] Cab[riolet] 3 Engl[ish]' and he listened to the general conversation about the state of Europe with interest.[13] He must often have enjoyed casual contact of this sort with his fellow-passengers.

In Italy the public transport system had an entirely different basis from that in France. Owners of suitable *vetture* (vehicles) made their own arrangements with travellers to take them an agreed distance.[14] There can be little doubt that Turner travelled by this method since there were only two other possibilities.[15] One was to buy or hire a private carriage, an expensive form of transport which the notoriously frugal Turner is unlikely to have used. The other was to travel with the courier who took the mail which involved driving through the night; Turner's myriad sketches show that he did not do this. By the very nature of the Italian system, *vetture* were of no fixed design, type or size (some held four people, others eight or more), while the number of horses, mules or even, in hilly country, oxen that were needed to draw them was also highly variable.[16]

The pattern of travelling, however, was quite consistent. The carriage set out very early in the morning and the same horses took it the whole day's journey which was therefore interrupted by a long rest in the middle. In November 1837 Hannah Palmer described her journey to Rome with her husband Samuel: 'We get to an Inn to luncheon at 12 and to dinner at 7 - we rise at 5 in the morning and sleep in a fresh Inn every night.'[17] Other accounts show that it was not uncommon to begin the day at 3 a.m.[18] Such a timetable —

16. Travellers waiting by a *diligence* (*PFS2*, 32a), pencil, 4½ × 7 in.

for days or weeks on end — may nowadays appear gruelling but travellers seldom complained. Hannah Palmer became 'so perfectly used to riding that I can ride from 5 in the morning until 6 at night with ease' and when the railway made travelling in Italy easier, British visitors were sad that it had 'utterly destroyed the picturesque delights of "travelling *vetturino*," with its necessity of sunrise and sunset scenes and the midday siesta'.[19]

Progress on the road was very slow and only about thirty to thirty-five miles were covered in a day.[20] The route and stopping places were agreed in advance with the driver, or *vetturino*, and guidebooks advised travellers to settle their terms before starting out but not to pay more than half until their safe arrival at their destination.[21] The *vetturino* arranged both food and accommodation *en route*, a great boon for travellers who could not speak Italian and dreaded the thought of complicated financial transactions.[22] They also dreaded, but could rarely avoid, the invariably indifferent food, the cold and dirty rooms and (perhaps worst of all) the fleas.[23] Another perennial cause for complaint was the excessive zeal with which carriages would be stopped, searched and delayed at every customs house and frontier post, of which there were a vast number before the unification of Italy.[24]

The slow pace of the *vettura* encouraged a variety of activities. Travellers could simply enjoy the scenery. They could read novels or guidebooks or famous works of Italian literature.[25] They could stroll beside the horses, as Eastlake often did on his journey to Rome in 1816. He later wrote that unless he actually stopped walking in order to make sketches, he was sure to arrive at any town long before the carriage.[26] The traveller might also make sketches and notes from the *vettura* itself. The practice of drawing 'carriage sketches' — in small sketchbooks and in pencil, it is barely necessary to add — was widely recommended in travel books, with the proviso that the sketches should be 'revised, while the recollection of the originals is yet tolerably fresh', and it was followed by many artists, both amateur and professional.[27] Ruskin described in *Praeterita* how, at the age of fourteen, he fell into this 'bad habit, yet not without its discipline, of making scrawls as the carriage went along, and working them up "out of my head" in the evening'; and in many artists' sketchbooks one can actually see that the rambling lines of carriage sketches have been strengthened after the traveller's arrival at his destination.[28] This, however, was not the practice of Turner: on arriving in a new town he was more concerned to study something new than to improve on the memoranda of the day. It is very likely that in the summer of 1819 he often chose to sit outside in the cabriolet in order to sketch more easily, while a letter written by a fellow-traveller from Rome to Bologna in the freezing January of 1829 tells how Turner was 'continually popping his head out of [the] window to sketch whatever strikes his fancy, and became quite angry because the conductor would not wait for him whilst he took a sunrise view of Macerata. "Damn the fellow!" says he. "He has no feeling"'.[29] The writer's use of the word 'continually' is hardly an exaggeration, since there must have been many days on Turner's journeys when he drew dozens of little sketches (see Plate 22). However, his constant glancing out of the window would not have been simply in order to sketch, but to be sure of not missing anything.

Turner very rarely dated his Italian sketches. It is hardly ever possible to say exactly when he was at a given spot, unlike many other artists — such as J. R. Cozens — whose movements in Italy can be followed on a day-to-day basis.[30] However, he often labelled his sketches with the names of towns or churches, rivers or streets, not only in the case of places he actually passed through but also when he sketched a distant mountain or a town picturesquely situated far away on a hill, places whose names he could only have discovered from the *vetturino* or his fellow-passengers.[31] Turner's sketches show that in the late summer of 1819 he travelled from Venice to Bologna and then to the Adriatic at Rimini. He followed the coast down to Ancona and then went south-west to Rome through Macerata, Tolentino, Foligno, Spoleto and Narni.[32] Turner's route was well used by travellers of this date for it was the easiest and quickest way to Rome: the mountainous part of the journey was 'less, both in quantity and difficulty' than on the more direct road through Florence.[33]

22

Turner's own sketches of his journey from Venice to Rome show clearly the route he followed during a period of about three weeks in September–October 1819. They therefore make one look critically at the story of the 23-year-old Irish medical student Robert James Graves who claimed to have travelled for several months with Turner in 1819 from the Alps to Rome, via a stay in Florence.[34] This story entered the literature on Turner in 1902 in the pages of Sir William Armstrong who was at that time Director of the National Gallery of Ireland and knew members of Graves's family,[35] and its description of Turner at work has been accepted without question in nearly all subsequent discussions of the artist's sketching habits. Unfortunately, however, apart from Armstrong himself, who admitted to some doubts about the story, modern authors invariably quote small extracts divorced from their context and they also fail to mention that the entire account was written neither contemporaneously nor by Graves himself, but by his colleague William Stokes, in a posthumous biographical notice of 1863.[36] The discrepancies between the route and time-scale of Graves's journey and that of Turner have already been noted. The reader should now consider Stokes's description as a whole, for it is only by so doing that the full extent of its oddity becomes apparent.

Graves was travelling by diligence, when, in one of the post stations on the northern side of the Alps, a person took a seat beside him, whose appearance was that of the mate of a trading vessel. At first, no conversation took place between them, but Graves' curiosity was soon awakened by seeing his fellow-traveller take from his pocket a notebook, across the pages of which his hand, from time to time, passed with the rapidity of lightning. Overcome at length by curiosity, and under the impression that his companion was perhaps insane, Graves watched him more attentively, and discovered that this untiring hand had been faithfully noting down the forms of the clouds which crossed the sky as they drove along, and concluded that the stranger was no common man. Shortly afterwards, the travellers entered into conversation, and the acquaintance thus formed soon became more intimate. They journeyed together, remaining for some time in Florence, and then proceeding to Rome. Graves was himself possessed of no mean artistic powers, and his sketches from nature are full of vigour and truth. He was one of the few men in whose company Turner is known to have worked. The writer has heard him describe how, having fixed on a point of view, he and his companion sat down, side by side to their work. 'I used to work away,' he said, 'for an hour or more, and put down as well as I could every object in the scene before me, copying form and colour, perhaps as faithfully as was possible in the time. When our work was done, and we compared drawings, the difference was strange; I assure you there was not a single stroke in Turner's drawing that I could see like nature; not a line nor an object, and yet my work was worthless in comparison with his. The whole glory of the scene was there.' The tone and fire with which Graves uttered these last few words, spoke volumes for his sympathy with, and his admiration of the great painter of nature.

At times, however, when they had fixed upon a point of view, to which they returned day after day, Turner would often content himself on the first day with making one careful outline of the scene. And then, while Graves worked on, Turner would remain apparently doing nothing, till at some particular moment, perhaps on the third day, he would exclaim, 'There it is!' and seizing his colours, work rapidly till he had noted down the peculiar effect he wished to fix in his memory. It is a curious fact, that these two remarkable men lived and travelled together for months, without either of them inquiring the name of his comrade, and it was not till they reached Rome, that Graves learned that his companion was the great artist.

The story is bizarre from beginning to end. If Graves was indeed an amateur artist, he could not possibly have failed to realise that his fellow-traveller was engaged in the perfectly normal practice of making carriage sketches. Turner hardly ever made sketches of the sky when actually travelling and on the road to Rome there was no question of returning day after day to the same spot to sketch (let alone contemplate without

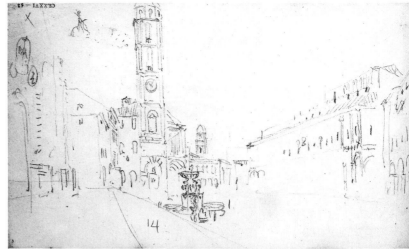

17. Cesena: the Rocca Malatestiana, Fontana Masini and Piazza del Popolo from the first floor of the Albergo Leon d'Oro (*V to A*, 47), pencil, $4\frac{3}{8} \times 7\frac{3}{8}$ in.

18. Faenza: the cathedral, clock tower, fountain and town hall (*V to A*, 43), pencil, $4\frac{3}{8} \times 7\frac{3}{8}$ in.

sketching). Finally there is Graves's extraordinary statement that 'there was not a single stroke in Turner's drawing that I could see like nature; not a line nor an object'. This is instantly refuted by a glance at Turner's 1819 sketchbooks themselves.

Turner's sketching habits are a source of eternal fascination for lovers of his art; Stokes's account has been accepted largely because there are so few eye-witness reports of Turner sketching that any such account tends to be regarded as valuable evidence. But it is worth remembering that by the date of Stokes's memoir both Turner and Graves himself were dead and there was no one to deny the stories that were circulating in Dublin and losing nothing in their repeated retelling. An earlier memoir of Graves's life had appeared in 1842. When its author, W. R. W. Wilde, asked Graves to authenticate 'some anecdotes of his boyish days' that he had heard, Graves requested him to make no reference to these things.[37] Wilde's account makes no mention of Turner, nor does it give any hint that Graves had the slightest interest in art.

* * * *

Turner left Venice on 12 or 13 September and travelled to Bologna across the plain of the Adige and Po.[38] This is one of the few parts of Italy barely recorded in his sketches but, although the countryside itself did not spur him into activity, he nevertheless occasionally recorded bridges or houses, animals, peasants or 'Boats on the Po'.[39] At Bologna, however, he found a city whose buildings were both picturesque and varied. Its streets were, as Hazlitt said, 'a perpetual feast to the eye and the imagination' and Turner recommended sketching with as much intensity as in Venice.[40] But he did not spend long there. Soon he was on his way to the coast at Rimini, a journey of very little interest to a landscape painter since the Apennines are just too far away to be felt with any immediacy. Between Bologna and Rimini Turner made most of his sketches in the towns through which he passed — Imola, Faenza, Cesena — recording their chief features, whether a fountain in a piazza, a bridge, or a Roman arch.[41] It is hard to tell at which places he stayed overnight, but it is clear that the *vettura* made a short halt at nearly every town, giving Turner a chance to make sketches whilst stationary. Sometimes he did not even have to choose between sketching and refreshment. His sketch of Cesena (Plate 17) was made from a first-floor balcony of an inn.

It would be wrong to over-emphasise the eclecticism of Turner's artistic tastes as displayed in sketches such as these. In a small town it was not so much a question of choosing what to sketch amidst a multiplicity of attractions as of seeing the two or three items of interest to which every visitor's attention would be directed. Occasionally such assistance was itself superfluous. The Rome-bound traveller necessarily arrived at Rimini by crossing the Roman bridge and departed by passing the Roman arch: Turner did not have to go out of his way to see them.[42] But what his sketches do display is an eagerness to look at and record the buildings of each town, whatever they were, as opposed to merely

24

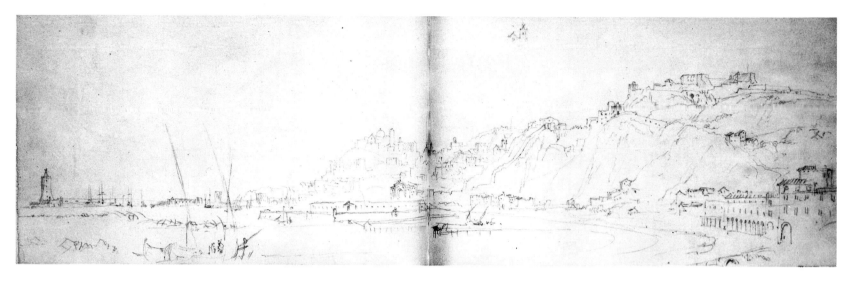

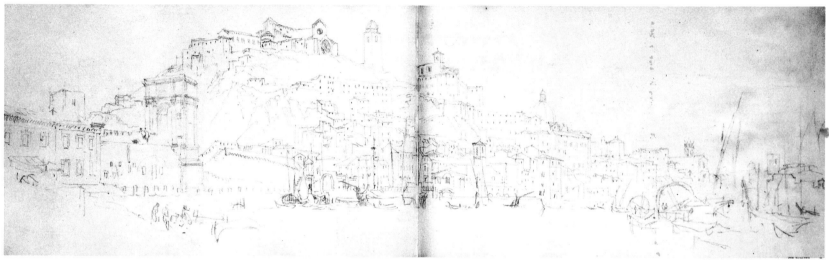

19. Ancona from the coast road to the north (*V to A*, 68a-9), pencil, each page 4⅜ × 7⅜ in.

20. Ancona from the sea (*V to A*, 73a-4), pencil, each page 4⅜ × 7⅜ in.

seeing them *en passant*. Of the thousands of travellers that have journeyed towards Rome, how many, one might ask, have, like Turner, bothered to count the number of steps leading up to the cathedral at Faenza or the bays of its town hall (Plate 18)? Turner's sketching habits have been likened to those of the modern tourist with a camera who is keen to accumulate all the photographs he can.[43] He may also be compared to the ordinary tourists of his own time and it is often more profitable to draw comparisons between Turner's Italian sketches and the letters and journals of contemporary tourists than to compare them with the sketches and reactions of other artists whose focus was sometimes very narrow. Nothing could be further from Turner's responses than David Wilkie's comment at Terni that 'one [waterfall] is much like another . . . they seldom differ much in effect' or that Paestum could be 'perfectly conceived without being seen' and 'presented . . . scarcely a new idea'.[44] On the other hand, Turner's sketches and the tourists' writings both embrace the same profusion of experiences, from the sight of quaintly dressed peasants and scruffy pedlars, white oxen ploughing and Catholic processions to the enjoyment of a great diversity of landscapes and the study of Italy's artistic heritage.

The straight, flat coastal road south of Rimini provided as little material for sketching as that from Bologna to Rimini, but Turner was clearly excited by Ancona: the magnificent curve of the bay, the huge triumphal arches and the bustle of a flourishing port.[45] At Bologna he had enjoyed looking at the city from a distance — from the Madonna di S. Luca to the west and from the Montagnola gardens to the north.[46] At a coastal town, however, the landscape artist can depict many totally different aspects of his subject, approximating, as it were, to the full-face view, profile and so forth of the portrait painter. Turner studied Ancona from nearby villages along the coast (Plate 19), from the sea (Plate 20) and from

25

Colour Plate 3. The Arches of Constantine and Titus, the Meta Sudans and the Temple of Venus and Rome, 1819 (*RCSt*, 40), pencil, watercolour and bodycolour on white paper prepared with a grey wash, 9 × 14½ in.

Colour Plate 4. The Basilica of Constantine, 1819 (*RCSt*, 38), pencil, watercolour and bodycolour with pen and brown ink, 9 × 14½ in.

21. Ancona: Piazza di S. Domenico (now Piazza del Plebiscito) (*V to A*, 68), pencil, 4⅜ × 7⅜ in.

22. 'Carriage sketches' made near Otricoli (*A to R*, 71a), pencil, 7⅜ × 4⅜ in.

high up inland so that the spread of the city around the bay formed his foreground and the sea his distance. He was to sketch a similar variety of views when he reached Naples later in the year. Turner's concentration on the sea front at Ancona was a natural result of his own love of the sea and of harbours which led to a similar reaction to Naples. However, it also finds a parallel in contemporary accounts of Ancona which contrast the 'bella apparenza' of the town when seen from the sea with the 'aspetto sordido' of its interior. Or, as Eustace's *Tour through Italy* put it, 'Seated on the side of a hill, forming a semicircular bay, . . . open only to the breezes of the west, . . . surrounded by fields of inexhaustible fertility, Ancona seems formed for the abode of mirth and luxury. . . . The general appearance of Ancona, though beautiful at a distance, is, within, dark and gloomy, in consequence of the narrowness of the streets, and want of squares and great public buildings.'[47] Where Turner was unusual was that he looked as well at parts of Ancona behind its seafront. He made a detailed sketch of the curious stepped piazza of S. Domenico, characteristically placing himself close to one of the corners of the square so as to have a record of three sides of it (Plate 21). An interesting aspect of this sketch is the care with which Turner drew the very fine fifteenth-century gateway on the left of the page, the entrance to Francesco di Giorgio's Palazzo della Prefettura. He had not sketched the Tempio Malatestiano at Rimini, but this was almost certainly because his perambulations happened not to have taken him past it and guidebooks did not direct the tourist's attention towards it. His sketch at Ancona proves that Early Renaissance architecture could hold as much fascination for Turner as that of any other period. A striking building or monument was always likely to attract his eye.

Turner's journey from Venice to Rome is chiefly recorded in two sketchbooks, *Venice to Ancona* and *Ancona to Rome*, and there is a certain felicity in the chance that he needed to begin a new sketchbook at Ancona. At this point there is a new impetus in his sketches which may be attributed to two causes. South of Ancona, the road to Rome turns inland and for the first time enters hilly country, winding its way past one town after another and constantly revealing new silhouettes and vistas. In *Ancona to Rome* Turner often made several small sketches in quick succession, hastily dividing the page into roughly drawn compartments in order to keep up with the changes in the passing scene (Plate 22).[48] This situation had not arisen in *Venice to Ancona* when the progress of the *vettura* would probably have been much faster on the flat and easy road.

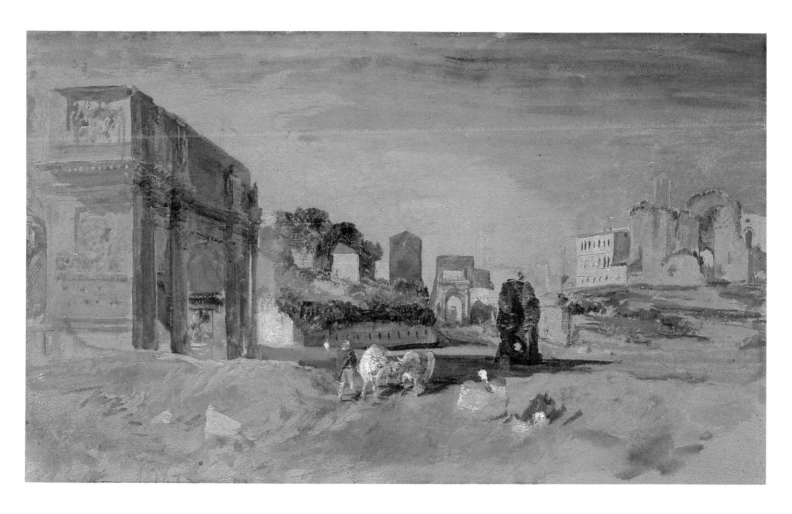

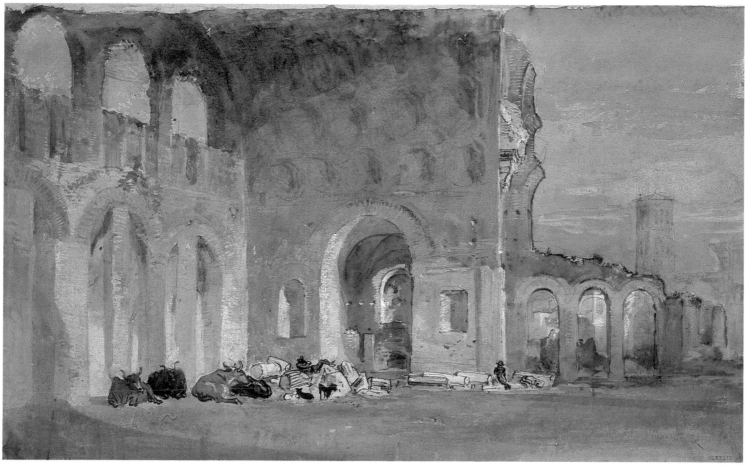

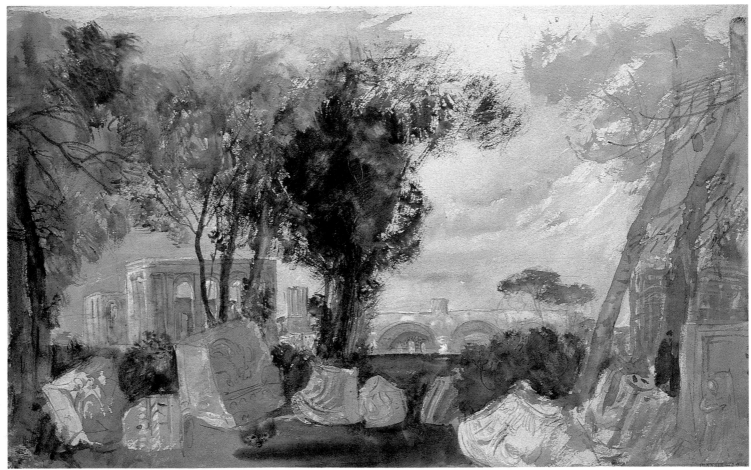

Colour Plate 5. The Campagna, with Monte Velino in the distance, 1819 (*NRCSt*, 42), pencil and watercolour, 10 × 16 in.

CLXXVII — 6

23. 'The first bit of Claude' (*A to R*, 6), pencil, 4⅜ × 7⅜ in.

South of Ancona, too, Turner felt that he had at last reached the land of Claude and Wilson. On one occasion he specified the exact location that reminded him of the earlier painters, beginning a long note on the colours of the scenery, 'Loretto to Recanata. color of the Hill Wilson Claude'.[49] A second reference — 'very like Ld Eg Claude' — appears on a quick little sketch, drawn while travelling, which shows range upon range of hills comparable to those that form the distance in the *Jacob and Laban* at Petworth (Plate 5).[50] The subject of this sketch is hard to recognise but that of the sketch which Turner himself triumphantly labelled 'The first bit of Claude' (Plate 23) can be conclusively identified with the view of Osimo that the traveller sees when approaching it from Ancona (Plate 24). On the horizon Turner indicates clearly the castellated tower of the Palazzo Comunale and the pointed one of the cathedral. Below the town the tree-dotted hillside descends gently into fertile rolling fields, in a view that is very characteristic of this ravishingly beautiful area of Italy (compare Plate 25) and may indeed remind the spectator of the middle distance of *Jacob and Laban* or the *Landscape with the Father of Psyche sacrificing to Apollo*

24. 'The first bit of Claude' today: Osimo from the Ancona road

Colour Plate 6. View from the Palatine, 1819 (*RCSt*, 30), pencil, watercolour and bodycolour on white paper prepared with a grey wash, 9 × 14½ in.

25. General view of Osimo today

(Plate 4). The beauty of the scene sketched by Turner may be felt even today, when it has been considerably altered by the addition of modern buildings (the stark, square water-tower on the right of Plate 24 is a post-war construction). In Turner's day the whole of this area was admired and loved by British and Italians alike. Eustace's *Tour through Italy* advised readers to explore it thoroughly and commended it for being 'both beautiful and classical', and Lady Morgan's *Italy* extolled the 'rich [and] lovely hill and valley scenery' around Macerata and 'the most enchanting views of natural fertility improved by cultivation'.[51] In the spring of 1819 the young Leopardi wrote his poem 'L'Infinito' on a nearby hill in his native town of Recanati:[52]

> Sempre caro mi fu quest'ermo colle,
> E questa siepe, che da tanta parte
> Dell'ultimo orizzonte il guardo esclude.
> Ma sedendo e mirando, interminati
> Spazi di là da quella, e sovrumani
> Silenzi, e profondissima quiete
> Io nel pensier mi fingo; ove per poco
> Il cor non si spaura . . .

It is perhaps not over-fanciful to envisage Turner, too, savouring the 'interminati spazi', 'sovrumani silenzi' and 'profondissima quiete' of this area, and finding in the countryside not only formal reminders of Claude's art but also a metaphysical resemblance to it as well.

The English traveller to Italy at this date expected to be reminded of Claude and Wilson when he saw the central Italian countryside — and particularly so if he happened to be a painter. In August 1838, after ten months in Italy, Samuel Palmer was to write discontentedly to the Linnells, 'I have been surprised to find hitherto nothing resembling Claude's compositions either of landscapes or sea ports,'[53] However, most artists found

30

that their expectations were fulfilled. Andrew Geddes wrote in 1829 that 'one cannot sufficiently appreciate the works of R. Wilson till they come to Italy. Everything puts you in mind of him', while in 1837 William Collins declared to David Wilkie that 'since the time of Claude, justice has not been done to the sublime features, and especially to the tones of colour, peculiar to this region of creation [i.e. the Roman Campagna]. In this remark, however, I ought not to include poor Richard Wilson, whose characteristic pencil I am here continually reminded of'.[54] Turner's comment, 'The first bit of Claude', shows that he had shared his contemporaries' expectations. That these were fulfilled can be deduced from the number of times Claude's and Wilson's names appear in his 1819 sketchbooks, chiefly in the Roman Campagna with which they had been so closely associated but also in the area south of Ancona. Here he was reminded of Claude both generally and specifically: at one point the countryside struck him as Claudian in an overall way, on another occasion a range of hills reminded him of a particular painting. More importantly, Turner's references also show that Italian scenery recalled Claude's paintings to his mind both by its 'sublime features' and by its 'tones of colour'. The sketches labelled 'very like Ld Eg Claude' and 'The first bit of Claude' capture profiles of hills and buildings that are characteristically Claudian, while his notes on the countryside between Loreto and Recanati were exclusively concerned with colours:

> color of the Hill Wilson Claude the olives the light of these when the Sun shone grey [turn?]ing the Ground redish green Gray now [apt?] to Purple the Sea quite Blue, under the Sun a Warm Vapour from the Sun Blue relieving the Shadows of the Olive Tree dark while the foliage Light or the whole when in shadow a quiet Grey. Beautifull dark Green yet warm. the middle Trees get Bluish in parts for distance. the aquaduct redish the foreground Light grey in Shadow.

Turner had made no colour sketches or notes since Venice, and his subsequent colour notes in Italy are no more than occasional records of local colours — 'Red', 'Green', and so on. Near Loreto, however, he describes the colours of trees, sea and ground at specific moments, contrasting their appearance 'when the Sun shone' with that 'when in shadow'. The ground appears now 'redish green Gray . . . Purple', now 'Light grey'. A month or two later he commented on the Barberini Claude, *Pastoral Landscape with a View of Lake Albano and Castel Gandolfo* (Plate 136), 'the tone generally more warm than usually his grey pictures are', implying a mental division between Claude's brighter and not so bright works.[55] Turner's notes near Loreto suggest that at the very point in his journey where he first began to be reminded of Claude's art, he was struck also by the power of the Italian sun to transform the face of nature. He now saw for himself how it was that Claude had depicted Italy now in cool silvery tones, now in warm golden ones.

Special mention should be made here of Turner's visit to Loreto which is well documented by notes and sketches (e.g. Plate 26).[56] The Holy House at Loreto was at this

26. Loreto: Piazza della Madonna (*A to R*, 13a 14), pencil, each page 4⅜ × 7⅜ in.

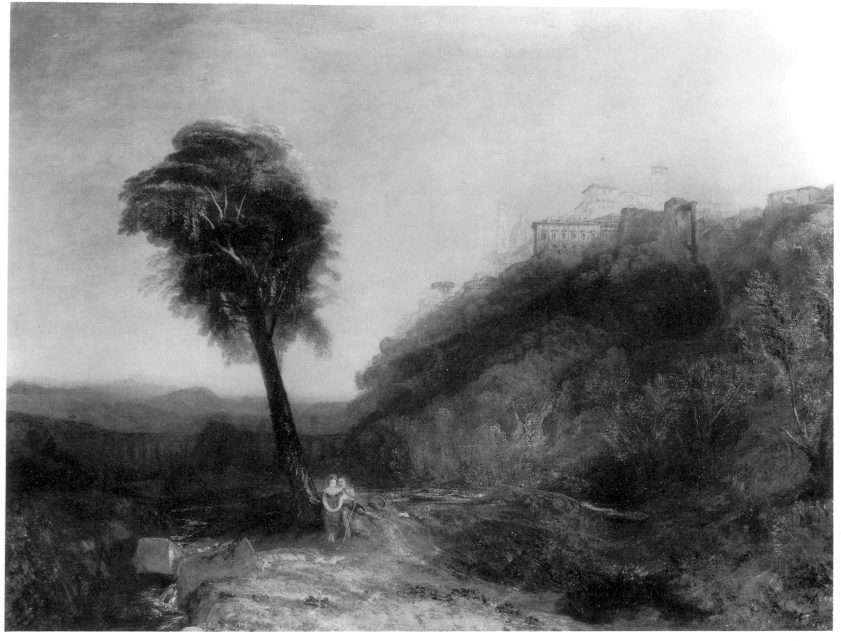

27. *The Loretto Necklace*, 1829 (B & J, 331), oil on canvas, 51½ × 68⅞ in., Tate Gallery, London

date 'the most noted shrine of the Christian world, after St. Peter's and Jerusalem'[57] and the thoroughness of Turner's sightseeing there is an early indication of his fascination with the practices of Catholicism which is reflected in several of his Italian paintings. Furthermore, the town and its hill occupy a prominent position in *The Loretto Necklace* (Plate 27), a painting which has few admirers today because of its sad discoloration but was once a work of extreme beauty.[58] The presence of this painting at the 1829 Royal Academy has led to the widespread supposition that it was produced in a great hurry in the spring of 1829 when the canvases painted in Rome in 1828 failed to arrive in London in time for the exhibition. (He himself depicted his frenzied activity in March 1829 in a delightful drawing.)[59] However, there is nothing to show that *The Loretto Necklace* was newly begun in 1829 and there can be little doubt that *Ulysses deriding Polyphemus*, that great 'central picture' in Turner's career, would have occupied the forefront of his mind in the spring of 1829. It may be suggested, on a number of counts, that *The Loretto Necklace* was begun early in the 1820s and was hastily finished for exhibition when the necessity arose in 1829.

To begin with, one of Turner's 1819 sketches (Plate 28) corresponds closely to the view of the town shown in the painting, whereas his 1829 sketch of the same subject (Plate 29) is curiously inaccurate. Second, Turner's view depicts Loreto as it is seen by the traveller on the Ancona road and this very impressive sight would have had far more impact on Turner

32

28. Loreto from the river at Villa Musone, 1819 (*A to R*, 10), pencil, $4\frac{3}{8} \times 7\frac{3}{8}$ in.

coming south in 1819 than travelling north in January 1829 and leaving the town behind him.[60] Finally, Turner's painting also includes the aqueduct near Loreto which he had sketched again and again in 1819 (but not in 1829), and it once displayed an extravagance and gorgeousness of colour and a virtuosity in effects of light and shade that recall the 1819 notes quoted above.[61] In short, *The Loretto Necklace* can be related so closely to Turner's sketches, notes and experiences of 1819 that it appears to embody a recollection of his first enjoyment of Loreto exactly as the *View of Orvieto* was to commemorate his first view of that city in 1828.

Examination of *The Loretto Necklace* itself lends support to the idea that it was not painted all at the same time, for the tree dominating the foreground has more than once been the subject of technical criticism. The *Athenaeum* reviewer of 1829 noted its inappropriate tonality ('were the tree in the foreground less gorgeous, the rest of the picture might be allowed to pass without any qualification to the highest eulogium') and its drawing was strongly criticised by Ruskin in the 1850s: 'A very noble work, spoiled curiously by an alteration of the principal tree. It has evidently been once a graceful stone pine, of which the spreading head is still traceable at the top of the heavy mass: the lower foliage has been added subsequently, to the entire destruction of the composition.'[62] Both its colouristic imbalance and its design changes suggest that Turner worked on *The Loretto Necklace* over an extended period of time. Since it was only exhibited once and never left his possession, the occasion which necessitated the alterations must surely have been the Royal Academy of 1829.[63]

The *Athenaeum*'s reviewer was also bothered by the subject matter of *The Loretto Necklace*. The importance to Catholics of rosaries bought and blessed at Loreto was well known to Protestant visitors to Italy, and the reviewer chided Turner for confusing them with mere ornaments: 'never did we dream, that, under the very walls which encircle the treasure of Catholic Christendom, a Loretto Necklace would plead with any great effect the cause of an innamorato. . . . we are . . . ignorant . . . of the meaning of the Loretto Necklace. . . . Mr. Turner should certainly have told his story more explicitly' (and so forth, at some length). The reviewer was, however, unnecessarily critical, for the Italian attitude to such necklaces was nothing if not broad-minded, as Turner, as a tourist, could have seen for himself. Lady Morgan visited Loreto shortly after Turner and described how the inn-keeper pressed a number of rosaries upon her: 'They were all sparkling and pretty; and I told our host that I regretted my heresy rendered me unworthy of becoming a purchaser. He said quickly, "Non importa, Signora mia, se non per devozione, compratene per la *toletta*!" I took the hint, and purchased a dozen very smart necklaces, if not very

29. Loreto from the Ancona road, 1829 (*Ro to Ri*, 32a-3), pencil, each page $3\frac{7}{8} \times 5\frac{1}{4}$ in.

CLXXVIII — 33

efficacious talismans.'[64] An Italian viewer of Turner's painting would not have been at all troubled by its content.

The road south of Loreto took Turner through cultivated countryside famous for its luxuriance, through wide empty plains and uninhabited tree-clad mountains to Foligno where it met the main road to Rome from Florence via Arezzo and Perugia.[65] In his notes in Turner's *Route to Rome* sketchbook Hakewill had advised 'travelling gently to Rome, as Perugia, Spoleto, Terni, Narni, Civita Castellana should all be stopped at' but he was assuming that Turner would be travelling to Rome via Florence.[66] Coming from Loreto, Turner did not pass through Perugia, but he paused to sketch at all the other places Hakewill had suggested. With many of them he was already familiar at second hand (see Plate 10). At Spoleto he drew a number of sketches of the town: some from the north, just across the river Tessino; some from the south, on the road to Rome; and one from the north-east.[67] This last sketch, which shows a tower perched above the valley spanned by the aqueduct, is similar in its overall composition to one of Turner's very late unfinished and unexhibited oil paintings which for the last twenty years has been known as *The Ponte delle Torri, Spoleto*.[68] More recent research, however, has demonstrated the very close links between this painting and *The Bridge and Goats*, an imaginary scene which Turner issued as a *Liber Studiorum* plate in 1812.[69] These links are so fundamental that it is now highly questionable whether there is really any connection at all between Turner's painting of the 1840s and his very skimpy sketch of Spoleto. It is more likely that in 1819 he was gratified to find a real Italian scene that closely paralleled one that he had previously invented as an illustration of the 'Elevated Pastoral' in painting, and he therefore made himself a very quick sketch as a reminder.

In southern Umbria Turner visited all the famous beauty spots that were within reach of the main road and also made a detour of a few miles up the river Velino from Terni to visit the lake of Piediluco.[70] His deep interest in this area may be contrasted with its relative neglect by eighteenth-century artists in favour of Latium and Tivoli,[71] and was due to a variety of influences. The countryside itself was spectacularly beautiful and had inspired some fine descriptions in canto IV of *Childe Harold's Pilgrimage*. Moreover, Turner himself had quite recently depicted both the Cascata delle Marmore near Terni and the bridge of Augustus at Narni for Hakewill's *Picturesque Tour of Italy* (see Plates 11 and 30), and he may well have known the large watercolours of the same views by A.-L. Ducros which formed part of Sir Richard Colt Hoare's collection at Stourhead.[72]

A number of eighteenth-century artists, including J. R. Cozens and Thomas Patch, had sketched or painted the Cascata delle Marmore but their scenes are usually timid affairs compared to the force and grandeur, brilliance and sparkle which characterise Turner's watercolour. In his accompanying letterpress of 1820 Hakewill quoted parts of two of Byron's stanzas on the Cascata but Turner's scene reflects a whole host of phrases from Byron's long section on the falls: there can be little doubt that Turner's vision of them was very much that of the poet. The post-1818 traveller came to the Cascata with *Childe Harold* in his mind, if not actually in his hand,[73] and the fact that Turner's illustration for Hakewill was widely copied, as was noted in the last chapter, shows that the public regarded Turner's image as the complete pictorial realisation of Byron's verses.

In 1819 Turner himself studied the falls from both a high viewpoint (the small hut at the top right of his watercolour) and the lower one used by Hakewill on the Ferentillo road.[74] His contemporaries did exactly the same and modern tourists follow their example.[75] The quantity of Turner's sketches reveals his interest in visiting a site he had already painted but not seen, but their lack of detail indicates a certain indifference towards the minutiae of the scene compared to the overwhelming impression of the whole. There was no need for him to make a detailed sketch of the Cascata from the same viewpoint as Hakewill: his watercolour was already finished and the engraving published. What is interesting is that, under exactly the same circumstances, Turner placed himself on the medieval bridge at Narni to draw a careful sketch of the Roman bridge just as it appears in his illustration for Hakewill (Plates 30 and 31). The two bridges standing side by side offered a pleasing

34

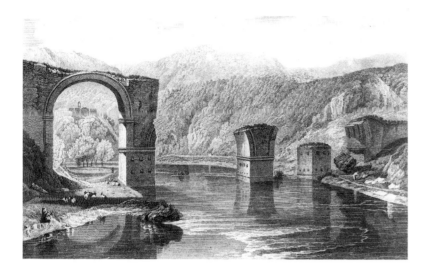

30. S. Middiman after Turner, *Bridge at Narni*, 1819 (R, 146), engraving, $5\frac{1}{2} \times 8\frac{5}{8}$ in.

31. Narni: the bridge of Augustus (*A to R*, 62), pencil, $4\frac{3}{8} \times 7\frac{3}{8}$ in. Turner sketched the rest of the bridge on f.63

subject for an artist: in the 1780s J. R. Cozens had shown them thus from both upstream and downstream and Turner in 1819 made many similar sketches.[76] Hakewill, however, under the classical influence of Eustace, had concentrated on the massive ruins of the Augustan bridge, using its one remaining arch to frame a small convent whose situation he described as 'one of the most romantic that can be imagined . . . on an eminence rising abruptly from the river bank, encircled by a lofty amphitheatre of rocks clothed from top to bottom with cypress, laurel, olive, and ilex'.[77] Turner's choice of precisely the same view in 1819 shows that he found it equally charming.

After Narni and Civita Castellana Turner's route must have left the Via Flaminia and joined the new road from Siena.[78] From this, in a short while, the traveller could catch his first, longed-for, glimpse of Rome. On the heights above Baccano the *vettura* would stop and the driver would point to a far distant but just visible sight: the dome of St Peter's. All readers of Eustace's *Tour* would have been waiting for this moment, artists were ready to record their first view of Rome, and few travellers were unaffected by the emotion of the moment.[79] Turner's sketch is hasty and its annotations ('Roma' and 'Primero V of Roma') are laconic compared to other travellers' outpourings of feeling but excited he must have been.[80] His goal was in sight, his ambition at last about to be fulfilled. The date of Turner's arrival in Rome is not known but he was certainly there by 6 October when Lawrence reported to Farington: 'he feels the beauty of the Atmosphere and Scenery as I knew he would — Even you would be satisfied with his genuine & high Respect for Wilson, and the pleasure he feels at so often seeing him, in and round the Campagna of Rome'.[81] If Turner was by now already exploring the Roman Campagna, he may have reached Rome before the end of September.

Turner's journey to Rome in 1819 has previously been glossed over in a handful of sentences by all writers on the artist notwithstanding the fact that the importance of his first visit to Italy is universally acknowledged. But it must be stressed that in the early nineteenth century Rome was not reached in a day. Among the many journeys that Turner undertook throughout his life, Rome was his most distant destination; in artistic terms, it was his most significant goal. The sketches he drew in the late summer of 1819 are not remotely equalled in quantity, quality or interest either by those of his return journey in January 1820 or by those of his 1828-9 visit to Italy. They are rivalled only by the sketches which he continued to make in Rome, Naples and Florence during the remainder of 1819.

Chapter 3

'TURNER'S VISIONS OF ROME'

Turner's sketches of Rome have always attracted admiration and interest. Ruskin was full of praise for the larger, more finished drawings and put a number of them on display soon after Turner's death; in 1925 one of the first Directors of the British School at Rome, Thomas Ashby, made them the subject of a short monograph, *Turner's Visions of Rome*.[1] However, the aims of both Ruskin and Ashby were comparatively limited. Ruskin was only interested in the more careful sketches that showed Turner at his best. He dismissed large quantities of the Italian sketches as 'careless' and 'inferior', and probably never studied them in detail.[2] Ashby, on the other hand, was chiefly concerned with the relationship of the sketches to the topography of Rome, a subject which he was uniquely qualified to consider. Today any discussion of Turner's sketches has to have a much broader basis than this and, at the same time, to analyse the works themselves far more closely.

The documentary value of Turner's Roman sketches is easily appreciated. He kept no journal there and his one surviving letter is short and uninformative.[3] His friends were rarely concerned to record his activities (there was, in any case, an overlap of only a few days between Turner's sojourn in Rome and Chantrey and Jackson's); and it is not even known where he stayed.[4] The eight sketchbooks he used in Rome thus constitute virtually the entire evidence of how he spent his time.[5] However, it is impossible to follow Turner's exploration of Rome by means of his sketches. Only two of the sketchbooks contain dates (in November and December) while the others can be connected with specific periods only by circumstantial evidence.[6] The same subject may appear in different guises here and

32. The Portico of Octavia (*St P's*, 50), pencil, $7\frac{1}{2} \times 4\frac{1}{2}$ in.

CLXXXVIII – 50

33. The Colosseum and the Arch of Constantine (*ANR*, 53), pencil, from a page $4\frac{3}{8} \times 7\frac{1}{2}$ in.

34. The Temple of Mars Ultor and the Arco dei Pantani (*St P's*, 14a), pencil, $7\frac{1}{2} \times 4\frac{1}{2}$ in.

there in three or four separate sketchbooks, while a single sketchbook may include sketches of distant places in every geographical direction in no discernible order.[7] All that is clear is that sketching was Turner's primary occupation. He would certainly have agreed with Goethe that 'wherever one goes . . . the eye is at once struck with some landscape — . . . palaces, ruins, gardens and statuary, distant views of villas, cottages and stables, triumphal arches and columns', so that 'here you *must* become an artist, you get fuller and fuller every day, and it [is] . . . a necessity for you to deliver yourself of something'.[8]

How did Turner decide what to sketch among this wealth of views? He was well prepared for his first sight of Rome — from conversations with Hakewill and Colt Hoare, from his reading of Eustace, from works of art by Claude, J. R. Cozens, Wilson and Piranesi; he had his notes on what to visit and his guidebook, Reichard's *Itinerary of Italy*. He would also have been able to see the standard views of the city in print shop windows. It was thus inevitable that he should seek out and study all the chief antiquities: the Forum, the Colosseum, the Pantheon, the triumphal arches, the ruins of the Palatine. But his search for good views did not stop here. His walks and drives also took him to less famous or less central sites as well: the Theatre of Marcellus, the Pyramid of Cestius, the city gates and walls. He looked at the Renaissance and baroque buildings of 'modern' Rome — St Peter's, the Campidoglio, the Fontana di Trevi, Piazza del Popolo. He made numerous sketches along the Tiber, sometimes within the city, near the Ripa Grande, the Isola Tiberina and the Ponte Rotto, sometimes in the adjacent Campagna. Like so many artists who had preceded him to Rome he surveyed the townscape as a whole from the hills which provide superb vantage points, the Aventine, the Pincio, Monte Mario, the Janiculum.[9] In the city itself there were scenes which appealed to many of his interests at once. This was especially true of the Forum, where trees and grass, peasants, cattle and carts provided a pastoral setting for the ancient ruins, but also of many other parts of Rome including the Portico of Octavia which in Turner's day housed the city's fish market (Plate 32).

In Rome Turner was almost exclusively concerned with recording what he saw rather than making studies for paintings. This was a cause of great disappointment to his biographer A. J. Finberg who regarded the Roman sketches as works in which 'the spirit of curiosity and of cold and accurate observation is predominant'; he described Turner in 1819 as 'a mere common tourist with a kind of accidental knack of making rapid and wonderfully beautiful pictorial memoranda. It is as though the creative artist had said to his familiar daemon, "We are now in fair Italy. Sleep thou, and take a well-earned rest. The business of note-taking will go on automatically without thee"'.[10] Today Finberg's criticism seems strangely lacking in appreciation of Turner's working methods. As a perceptive art critic, P. G. Hamerton, had written in the 1870s, 'Turner's system of study from nature was from the first adapted to the habits of a tourist who never remained long in one place. . . . He was always a painter from memoranda.'[11] What is more, although Turner undoubtedly worked very rapidly, there was nothing automatic about his sketches. A later part of this chapter will examine the multiplicity of his techniques. It is also clear that even in the smallest sketches he was constantly making choices — precisely where to stand to get the best view, how much to include in his composition, whether to make one sketch or several. It is Turner's skill in such matters that makes his sketches so interesting.

One of the ways in which Turner combined efficient fact-gathering and effective composition can be seen in a small sketch of the Colosseum and the Arch of Constantine (Plate 33). His initial concern was with the overall view, but his eager eye for detail made it inevitable that he looked carefully at each storey of the Colosseum in turn, and made a definitive record of each type of bay, profile and capital. In larger compositions it was possible to include details in their proper places. Turner's sketch of Piazza del Popolo from the Pincio (Plate 35) shows all that he could see from a well-chosen viewpoint. Some of these large sketches were worked up in colour (where and how this was done will be considered later), and for this a clear and informative structure of pencil was essential. The coloured view of St Peter's from the grounds of the Villa Barberini (Plate 36), for instance, would have been painted over a drawing similar to — though possibly not as careful as —

35. Piazza del Popolo from the Pincio (*RCSt*, 52), pencil on white paper prepared with a grey wash, 9 × 14½ in.

36. St Peter's from the grounds of the Villa Barberini (*RCSt*, 21), pencil, watercolour and bodycolour on white paper prepared with a grey wash, 9 × 14½ in.

37. St Peter's from the grounds of the Villa Barberini (*RCSt*, 7), pencil on white paper prepared with a grey wash, 9 × 14½ in.

that in Plate 37. In the smaller sketchbooks, Turner might execute one part of a sketch in great detail while leaving the rest ill-defined (see Plate 34). He had evidently enjoyed the picturesque sight of modern life amid the ancient ruins of the Temple of Mars Ultor and the Arco dei Pantani and he composed his scene so as to include both elements; but it was only the upper part of the temple that he was concerned to record precisely.

This sketch also manages to convey all the grandeur and magnificence of ancient Rome on a page measuring only 4½ by 7½ inches and, like a number of other sketches from 1819, it shows clearly the influence of Piranesi's etchings in the *Vedute di Roma*. In Rome Turner often employed Piranesi's methods of composition: massive buildings are placed diagonally to the picture plane so that they reach up to the corner of the page or are cut off by it; vistas down side streets and smaller buildings are placed at the edge of a composition (see Plates 33 and 34). Occasionally, too, Turner's sketches echo the *Vedute* directly. His drawing of the Fontana di Trevi, for instance, is very similar to one of Piranesi's treatments of this subject (Plates 38 and 39). His sketch of the Arch of Constantine (Plate 40) echoes the design of the large watercolour of the arch by A.-L. Ducros, which Turner could have seen at Stourhead (Plate 41). This, in its turn, had copied an etching in the *Vedute di Roma* showing the Arch of Septimius Severus very close to the spectator and at a diagonal angle on the left-hand side of the page.

The influence of the *Vedute di Roma* on Turner's 1819 sketches is very striking and demonstrates the power which the art of the past was able to exert over him even in his mature years. However, the mere fact that his Roman sketches show views that had been drawn by other artists does not in itself mean that Turner knew their work or was influenced by them. Many of the ruins and buildings of Rome form naturally picturesque

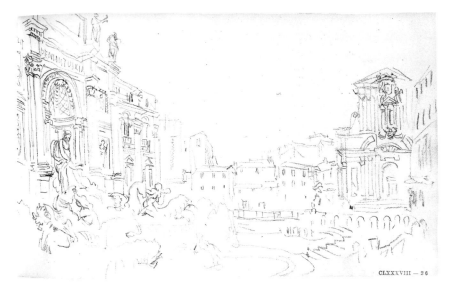

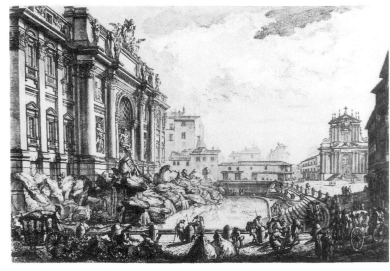

38. The Fontana di Trevi (*St P's*, 26), pencil,
4½ × 7½ in.

39. G. B. Piranesi, *The Fontana di Trevi*, from the
Vedute di Roma (1748-78), etching, 15½ × 21¾ in.

40. The Arch of Constantine and the Colosseum
(*RCSt*, 29), pencil on white paper prepared with a
grey wash, 9 × 14½ in.

41. A.-L. Ducros, *The Arch of Constantine and the
Colosseum*, c. 1790, watercolour and bodycolour,
30¾ × 43¼ in. The National Trust, Stourhead

ensembles which have appealed to countless artists, whether professional or amateur, both before Turner and after.[12] There must have been many occasions when he discovered good viewpoints for himself, others when he deliberately stood where earlier artists had stood before him, and yet others when he was guided in his choice by friends such as Lawrence or Eastlake who knew the city well. One sketch in particular suggests this last possibility. It shows a narrow lane tucked away behind the Barberini palace where the church of S. Caio, a tall stone-pine, and a statue of Apollo then formed a delightfully picturesque group (Plate 42). Turner might have come across this spot by accident, but it is far more likely that his attention was directed to it by a fellow-artist. Several other northerners found it equally enjoyable (Plate 43).[13]

Some views in Rome presented themselves ready-made to his gaze. On other occasions, he had to pay great attention to composition in order to achieve a satisfactory sketch. Consider, for example, his sketches of the *Jonah* designed by Raphael in S. Maria del Popolo (Plate 44). The aspect of the statue seen by the visitor on entering the Chigi chapel is by no means its best one: the figure seems uncomfortably posed, neither active nor passive, and the legs are foreshortened in an ugly manner. Turner searched for the viewpoint which gave the statue the vigour and grace expected of Raphael: he found it by squeezing himself up against the altar, by the foot of the pendant statue, *Elijah*. When sketching a very different figure in the Capitoline, the *Faun* of Praxiteles, Turner's concern was to emphasise the statue's sensuous qualities. He therefore stood well to the left of the *Faun* where its sinuous curve is seen to the best effect and the Faun appears at his most elegant and languid (Plate 59).

42. Statue of Apollo in the gardens of Palazzo Barberini and the church of S. Caio (*ANR*, 69a), pencil, 7½ × 4⅜ in.

43. Ettore Roesler Franz, *Vicolo Sterrato*, 1876, oil on canvas, Museo di Roma, Rome

44. Sketches of Raphael's *Jonah*, Chigi chapel, S. Maria del Popolo (*St P's*, 47), pencil, 7½ × 4½ in.

45. The interior of St Peter's, sketched from the south-west corner of the pier of St Helena (*St P's*, 84a), pencil, 4½ × 7½ in.

46. The interior of St Peter's, with Canova's *Monument to the Last of the Stuarts* (*St P's*, 83a), pencil, 4½ × 7½ in.

At other times Turner selected a particular viewpoint so as to record the maximum amount of material. In the outdoor sketches his angle of vision was usually well over 90 degrees and in his sketch of the Quattro Fontane crossroads he increased it to about 180 degrees so that all four statues are shown.[14] Meanwhile, he made half a dozen sketches inside St Peter's which show complicated views across the nave or the crossing into the transepts and side-chapels (Plates 45 and 46). These are very different from contemporary topographical prints and paintings of the subject which look more or less straight down the nave (a view Turner himself was later to depict in a finished watercolour). Instead they vividly record the experience of being in the huge, interlocking spaces of a vast building. He always enjoyed finding the most exciting places to stand wherever he went. In S. Stefano Rotondo he sketched standing in the one place from which he could include every feature that interrupts the church's repetitive and plain interior: the entrance, the grille window, the altar, the only recessed chapel, an unblocked window in the roof.[15] For his only sketch

inside the Pantheon he chose a viewpoint similar to one of Piranesi's: he stood in one of the apses so that the view is bisected by a huge column (Plate 47). This serves as a *repoussoir* to give an awesome sense of the size and height of the building and the distance between the spectator and the far side.

Turner's divergent reactions to the Pantheon and St Peter's call to mind Addison's opinion of these two buildings which every visitor to Rome naturally compared: 'I must confess the Eye is better fill'd at first entering the *Rotund*, and takes in the whole Beauty and Magnificence of the Temple at one view. But such as are built in the Form of a Cross, give us a greater Variety of Noble Prospects.'[16] Exteriors of buildings also presented a variety of aspects and Turner often sketched them from several viewpoints. His record of his journey to Rome had included many sketches made as the carriage was winding its way slowly through hilly country and the features of the landscape were forever regrouping themselves into slightly different ensembles. In Rome he himself often moved round his subjects. He was frequently at work near or within the Forum, surveying it from the tower of the Capitol, the Clivus Capitolinus, the Mamertine prison, the church of SS. Cosmas and Damian, the Arch of Titus, the Palatine and many other viewpoints. The temples of Vespasian, Castor and Pollux, and Saturn are shown from every angle, appearing now in the foreground as screens in front of the Forum (Plates 48 and 49), now as less important features in the background.[17] This search for a comprehensive grasp of his subject is also

47. The interior of the Pantheon (*St P's*, 64a), pencil, $7\frac{1}{2} \times 4\frac{1}{2}$ in.

48. The north end of the Forum (*ANR*, 57), pencil, $4\frac{3}{8} \times 7\frac{1}{2}$ in.

49. The Forum, looking south (*ANR*, 65a-6), pencil, each page $4\frac{3}{8} \times 7\frac{1}{2}$ in.

found in Turner's sketches of sculpture. In the Vatican, for example, he sketched several statues from two or even three different angles (Plate 50).

Turner was a keen observer and a careful recorder but this does not mean that his sketches are always completely, literally, truthful. He frequently shifted his position while making a single sketch with the result that it depicts a composite view. He began drawing the façade of the Pantheon standing slightly to the left of centre so that the obelisk interrupts the pediment just after the word 'FECIT' (Plate 51). He subsequently moved both to the right and to the left and his sketch shows the drum of the Pantheon on both sides of its façade, a view which is physically impossible. His sketch of the Campidoglio (Plate 52) has clearly been drawn from several different places. The rooflines of the palaces appear more continuous and harmonious than they really are and the whole area seems less congested. Turner's sketches of antique statues sometimes show the same amalgamation of views for artistic effect: his winged *Psyche* combines features from both oblique and

50. Sketches in the Vatican Museums, including two views of a seated female statue and three views of a seated nymph and satyr (*V Fr*, 45), pencil, 6¼ × 4 in.

51. The façade of the Pantheon (*St P's*, 28), pencil, 4½ × 7½ in.

52. The Campidoglio and S. Maria in Aracoeli (*ANR*, 56a), pencil, 4⅜ × 7½ in.

frontal views so as to emphasise her gracefulness.[18] Sometimes, too, he would use artistic licence in composition without actually changing his viewpoint. His large sketch of Rome from Raphael's loggia in the Vatican was drawn leaning on the window ledge of the bay nearest to St Peter's Square (Plate 123). From here one can still see the cluster of towers and domes in Trastevere that Turner sketched, but the visitor to the loggia will discover that the obelisk and colonnade are not so close to the churches as Turner has made them. The sketch is neater and more picturesque than reality. Finally, he did sometimes simply make errors. In copying inscriptions he sometimes jumbled up the unfamiliar Latin words and in sketching sculpture he now and again misrepresented figures or architectural details.[19]

It is easy to talk about 'Turner's Roman sketches' as if they formed a homogeneous group, but technically they were far from this. Since his earliest sketching tours in Britain he had habitually worked simultaneously on both a small scale and a large, and in Rome he used sketchbooks ranging from $4\frac{1}{2}$ by $3\frac{1}{2}$ inches to 16 by 10 inches. Most often he drew in pencil on white paper, usually in books measuring *c.* $4\frac{1}{2}$ by $7\frac{1}{2}$ inches, almost identical with those used on his journey to Rome, but also in the 16 by 10 inch *Naples: Rome. C. Studies* which includes work in watercolour. At other times he drew in pencil in two books whose pages are prepared on one side with a wash of grey: *Rome: C. Studies* ($14\frac{1}{2}$ by 9 inches) and *Small Roman C. Studies* ($5\frac{1}{4}$ by $10\frac{1}{8}$ inches). On some of the grey pages he also worked in watercolour, bodycolour, brown ink and ink wash while on the white pages he occasionally used black or red chalk. These three sketchbook titles are Turner's own and it is often thought that he intended 'C.' as a reminder that the books contained coloured studies. However, that is not the only possibility. It will be seen again and again in Chapter 8 that Turner's Italian watercolours and oils of the 1820s took their compositions more or less directly from the highly structured sketches in the *C. Studies* sketchbooks. The sketches in these books are rarely concerned with the collection of data — they are, above all, *compositions*. And it must be pointed out that Turner's most celebrated (and freest) coloured sketches of 1819 — those depicting Venice — occur in a sketchbook to which Turner did not award a 'C.'[20]

Turner's range of media is not in itself extraordinary. Since the Renaissance it has been common for artists to employ a variety of media in their different sketches and British artists have been no exception. When Joseph Wright of Derby was in Italy in 1774-5 he used pencil, chalk, different coloured inks and washes, watercolour and bodycolour, not only on white paper but on light blue, green and yellow papers. There is no less diversity in the work of Maria Graham, an amateur artist whom Turner met in Rome in 1819 and who later married Augustus Wall Callcott RA. She worked on paper of several colours using pencil, chalk and coloured inks, and also made oil sketches on paper.[21] What is interesting about Turner's practice in Rome is the way he used the different media. He employed red chalk very occasionally and in a purely naturalistic way, confining its use to the depiction of Roman brickwork.[22] On the other hand, his one excursion into the atmospheric effects of dark brown wash combined with white bodycolour was probably prompted by associational reasons. This sketch (Plate 53) is the nearest he came in Rome to drawing in the style of Claude, and it may be no coincidence that it shows the north end of the Forum, including, on the left, the three columns of the Temple of Castor and Pollux. Samuel Palmer was later to refer to these as 'Claude's three columns', from the frequency with which they feature in that artist's work.[23]

Turner's use of bodycolour and watercolour in Rome looks back to his 1817 Rhine drawings in these media but he may well have been stimulated by other artists to make the much more brilliantly coloured drawings of 1819. The work of eighteenth-century *vedutisti* such as Charles-Louis Clérisseau, Carlo Labruzzi, Antonio Zucchi and Giovanni Volpato could easily have shown him the potential of the bright effects of bodycolour.[24] However, he could also have been influenced by the more straightforwardly topographical work of the painters working in Italy in 1819. The Austrian landscape painter Joseph Rebell (1787-1828), for instance, whose name Turner noted in a sketchbook and who was

Colour Plate 7. The entrance to the Via della Sagrestia, 1819 (*RCSt*, 6), pencil and watercolour with bodycolour on white paper prepared with a grey wash, $14\frac{1}{2} \times 9$ in.

44

Colour Plate 8. The 'Temple of Minerva Medica' and the Aurelian wall (*RCSt*, 35), pencil, watercolour and bodycolour on white paper prepared with a grey wash, 9 × 14½ in.

53. The north end of the Forum (*SRCSt*, 3), dark brown wash and white bodycolour over pencil on white paper prepared with a grey wash, 5¼ × 10⅛ in.

elected a member of the Roman Academy of St Luke on the same day as himself,[25] worked in bright ochres, pale salmony browns and clear blues that resemble Turner's own during his months in Italy. Turner could well have seen Rebell's work in Rome or in Naples. Turner's pencil drawings on grey prepared paper, on the other hand, are similar in size and technique (and frequently in angles of vision and tricks of composition also) to those made by Wilson for the 2nd Earl of Dartmouth in Rome in 1754 (Plate 54). These were very much admired by artists and connoisseurs in the early nineteenth century.[26] Many of the

54. Richard Wilson, *The Palatine Mount*, 1754, black chalk and stump, heightened with white, on grey paper, $10\frac{7}{8} \times 16\frac{3}{8}$ in., Cecil Higgins Art Gallery, Bedford

55. Trajan's Column and Forum (*St P's*, 48), pencil, $4\frac{1}{2} \times 7\frac{1}{2}$ in.

56. Rome from the Janiculum (*RCSt*, 12), pencil on white paper prepared with a grey wash, with lights rubbed and scratched out, 9 × 14½ in.

drawings in *Rome: C. Studies* — such as Plates 35, 36 and 37 — show the influence of Wilson just as clearly as others show that of Piranesi: the earlier masters taught Turner not only how to see Rome but also how to draw it.

Turner's inconsistent practice in producing finished drawings was recorded by Farington in 1799: 'He told me He has no systematic process for making Drawings. He avoids any particular mode that he may not fall into manner'; 'He reprobated the mechanically, systematic process of drawing.'[27] The Roman sketches show that Turner also avoided falling into a routine when it came to sketching. He kept a variety of sketchbooks and media at his disposal to choose between; he also made use of the same medium in different ways on different occasions. Among the small sketches on white paper, some have been roughly drawn all over first, individual areas being worked over later in more detail, with the pencil being more firmly applied (Plate 51). Others apparently have no underlying preliminary framework: fine and delicate pencil work has been embarked on straightaway (Plate 55). Often the pencil is almost blunt and is smoothly handled; elsewhere it is sharpened to the finest possible point; sometimes the side of the pencil is used, providing an almost chalk-like appearance. When Turner sketched on grey-washed paper he varied his effects in many ways. First, he could choose a darker or lighter page to suit the individual day and view. On the light pages his pencil work varies from the finest, most precise touches to areas that are roughly hatched, almost scribbled. When he wished to create highlights on the darker pages he sometimes sponged or rubbed out the grey wash, he sometimes scratched the paper away to its original white surface, and he sometimes used white bodycolour. Each method produced not only a different shade of white but also a different textural effect. Sponging out was most suitable for soft expanses of sky or the smooth pale surface of the Tiber meandering through the Campagna;

48

57. The Basilica of Constantine, S. Francesca Romana, the Arch of Titus and the Colosseum (*RCSt*, 20), pencil, watercolour and bodycolour on white paper prepared with a grey wash, 9 × 14½ in.

scraping out exactly captured the glint of sunlight on the rough bark of a tree, distant snowy mountains or the crumbling side of a ruined building; white bodycolour recreated the gleaming flank of a triumphal arch. In one and the same sketch Turner might well need to employ two or even three methods of achieving chiaroscuro effects, in close proximity to each other (Plates 56 and 133).

The coloured sketches show even more complex variations in Turner's practice. Some pages consist of an overall colour treatment including small areas brought to a more advanced stage (Colour Plate 3). In others there are sections painted with great care together with large areas left completely untouched by colour (Plate 57). Where the whole page is covered with colour it is often impossible to see the underlying pencil framework, but there can be no doubt that beneath all the coloured sketches there lay a preliminary drawing similar to that seen in the half-completed watercolours; visible pencil lines may sometimes have been rubbed out afterwards. In *Rome: C. Studies* watercolour and bodycolour are frequently juxtaposed or bodycolour is superimposed on areas already covered by watercolour: white and pale lemon bodycolour float over the red watercolour in the drawing of the Colosseum by moonlight on dark grey paper (Colour Plate 2). Outlines are sometimes added in brown ink. In the sketch of the Basilica of Constantine (Colour Plate 4), the ink harmonises with the bright golden and reddish brown watercolour used for the brickwork, while in the view of Rome from the Villa Barberini it contrasts with the blue watercolour used to give aerial perspective to the distance (Plate 126). Meanwhile the sketches of the Roman Campagna on the white pages of *Naples: Rome C. Studies* achieve an equal variety of effects using only watercolour. There are delicate areas of very liquid paint, scumbled passages created with a nearly dry brush, foregrounds with a textured finish made by fingerprints, and marvellous flurries of wet paint which have been agitated

49

by a finger or the end of the brush to produce the effect of rough grassy hillocks (Colour Plate 5 and Plate 164).

It is very tempting to believe that some of Turner's coloured sketches of Rome (e.g. Colour Plate 6) were painted in the open air,[28] but this is by no means certain. A number of them could not possibly have been coloured in front of the motif — those depicting showers or rainbows or moonlight. It is also intrinsically unlikely that he sat colouring in the more frequented parts of Rome: he would hardly have sat in front of St Peter's colouring his brilliantly light-filled sketch of the entrance to the Via della Sagrestia (Colour Plate 7). On many occasions his colours deliberately or accidentally contradict his pencil work, which is far more likely to happen if the colouring is done later, away from the motif. He ignores pencilled trees and paints a foreground right across the page; he changes the shape of a building; he misinterprets his sketch of the brick arcading in the Aurelian wall near the 'Temple of Minerva Medica' and depicts the arches as voids as though the wall was an aqueduct (Colour Plate 8).[29] Furthermore, reliable accounts of Turner's sketching practice stress the fact that he preferred to sketch in pencil on the spot and finish his work in colour quietly from memory at home or at an inn afterwards. This routine was recorded by H. A. J. Munro when he visited the Alps with Turner in 1836.[30] Over twenty years earlier, some of Turner's friends persuaded him to colour in the open air in Devon by the ruse of fitting up a portable painting-box and producing it at a favourable moment; however, the whole point of the story of this incident is that Turner was inveigled into totally uncharacteristic behaviour.[31]

The idea that Turner coloured some of his Italian sketches in the open air originated with Ruskin. The spontaneity and vigorous execution of the two sketches of the 'Temple of Minerva Medica' — what Ruskin regarded as their carelessness — led him to make the suggestion in Turner's defence. But what Ruskin really believed was that Turner 'hardly ever sketched a colour effect except from memory' because he knew 'that before the deliberate processes necessary to secure the true colours could be got through, the effect would have changed twenty times over. He therefore almost always wrote the colours down in words, and laid in the effect at home'.[32] There were other reasons, too, for not colouring out of doors. John Soane's elder son, who was travelling in Italy in 1819, related to his father that when 'a sucking blade of the brush made the request of going out with pig Turner to colour — he grunted for answer that it would take up too much time to colour in the open-air, he could make 15 or 16 pencil sketches to one colored & then grunted his way home'.[33] Turner's reticence must also have been due to a wish to protect his reputation. He was famous for his highly accomplished and complex watercolours and anyone who expected him to produce such work on a sketching expedition would have been sorely disappointed. The gulf between his rough pencil work out of doors and his detailed colouring is well illustrated by the 1819 drawing of Vesuvius (Colour Plate 14). The poetic vision of the bay soars above the prosaic foreground, miraculous colour over functional pencil. The young Soane records that when 'the Fashionables' caught sight of Turner's 'rough pencil sketches', they were astonished and wondered 'of what use these rough draughts can be'. It was precisely such an ignorant reaction that made him unwilling to go out colouring in company.[34]

Chapter 4

STUDY AND USE OF THE ANTIQUE

Turner studied the art treasures of Rome just as intently as the city itself. It may seem surprising to discuss his study of sculpture before that of painting, but there is good reason for according it pride of place. In Turner's day classical sculpture enjoyed a reputation unequalled by that of any other form of fine art in Europe and many of the statues in Rome were particularly renowned: their physical beauty, emotional expression and superb quality of execution, combined with their sheer antiquity and historical connections, had won them widespread fame and unprecedented influence during the previous three centuries.[1] Admiration for the very different beauties of the Elgin Marbles, which had led to their belated acceptance by the British government in 1816, did not, as might be expected, produce an instant disparagement of the Grand Tourists' pantheon of marble sculptures in Rome.[2] Equally, their reputation was as yet unaffected by the growing realisation that most of them were not original works of art but Hellenistic or Roman copies of Greek bronzes.[3]

Furthermore, the 1819 sketchbooks abound in sketches of antique sculpture which were evidently drawn 'with intense delight'.[4] When Turner visited the Louvre in 1802, he seems to have confined his attention to paintings, filling the *Studies in the Louvre* sketchbook with notes and sketches but making no studies of sculpture, either those from the former French royal collection or those taken from Rome as booty by Napoleon. In Rome itself, the situation was virtually reversed. He made tantalisingly few records of paintings but he filled nearly an entire sketchbook, *Vatican Fragments* (c. $6\frac{1}{4}$ by 4 inches), with studies of the classical sculptures in the museums: Chantrey described him as 'much occupied in the *Vatican* in drawing Capitals &c., . . . very industrious'.[5] The large number of these sketches and their sometimes rather random ordering suggest that Turner visited the Vatican Museums on several occasions.[6] The smaller collection in the Capitoline Museum, on the other hand, was all studied on a single visit: his room-by-room progress can be followed in twelve pages of sketches.[7] He also made a careful examination of the reliefs and decorations of nearly all the most celebrated buildings and monuments of Rome,[8] and classical sculptures often caught his eye in picture galleries or gardens.[9] On his journey home he studied some of the famous antiquities in the Uffizi, making sketches of the Medici Vase and the *Hermaphrodite*; and it was perhaps in Florence that he sketched one of the restored versions of the *Pasquino*, even though his accompanying note, 'Pasquinati', refers to the epigrams attached to the battered version near the Piazza Navona.[10]

Turner's keen interest in classical sculpture at this stage in his career is reflected in the fact that his first visit to Rome was immediately followed by his first appointment as Inspector of the Royal Academy's cast collection. However, it should not be imagined that his concerns were exclusively formal. On the contrary, his interests were as wide-ranging as ever, as the example of the *Pasquino* sketch makes clear. They were also closely related to his own work. His pictorial priorities often dictated which sculptures he chose to sketch, and some of the works he studied in 1819 were later transformed to play important roles in his paintings. But above all, the study of antiquity was central to Turner's conception of himself as an artist, making him very different from those of his British predecessors in

58. Capital and funerary monuments in the Vatican Museums (*V Fr*, 10a-11), pencil, each page 6¼ × 4 in. F. 11 records various aspects of the freestanding 'cutlers' tomb' which commemorates L. Cornelius Atimetus and L. Cornelius Epaphra. By contrast, the monument on f. 10a to T. Fluvius Iulius is sketched much more straightforwardly.

Rome who had been exclusively landscape painters. The work of John 'Warwick' Smith, Thomas Jones, Francis Towne and J. R. Cozens, for instance, does not suggest that they spent much of their time in Italy in museums. But Turner saw himself as a painter not only of landscapes but also of historical and other subjects; and he was heir to the belief that to succeed in the elevated genre of history painting the artist should steep himself in the great works of the past, including those of antiquity. He had accomplished the first stage in this process — studying casts of the most famous antique statues — during his training in the Royal Academy schools in the 1790s.[11] It was, in a sense, predictable that in 1819 he would make full use of the opportunity to continue these studies in front of the sculptures themselves, following the examples of the painters whose historical landscapes had already influenced his art — Claude, Poussin and Wilson. However, whilst Claude and Wilson had had a profound influence on Turner's vision of Italy and his way of depicting it, his study of the antique found no precedent in their practice. His pursuit of classical sculpture went far beyond that of Claude, in whose drawings depictions of antique statuary are notably uncommon, and it exceeded Wilson's in both extent and variety. On the other hand, Turner's study of antiquity had marked resemblances to that of Poussin, as will be seen shortly.

Some of the characteristics of Turner's sketches of sculpture have already been noted in the discussion of his sketches in Chapter 3: his care in selecting the most effective viewpoint, for instance, and his desire to record a figure or group from several different angles (Plates 44 and 50). The variety of his pencil technique is also worthy of comment. Intricately carved architectural fragments were recorded in sharp and crisp detail. The female nude occasioned the use of blurred hatching with the side of the pencil, which gives a sense of roundness and tangibility.[12] If an altar or sarcophagus included both high and low relief carving, he might distinguish between them simply by altering the pressure on his pencil (Plates 58 and 59). The subtle changes in Turner's responses which are inherent in these technical changes are particularly notable in view of the obvious haste with which he

59. Statues and reliefs in the Capitoline Museum (*V Fr*, 57-6a), pencil, each page 6¼ × 4 in. On f.57: the *Faun* of Praxiteles, *Cupid and Psyche*, *Antinous*; below these, decoration from three pieces used as statue bases in the same room of the museum; finally, a relief scene from a pedestal: a warrior galloping on a bull towards a seated figure of Tellus who supports an infant. On the facing page: the *Capitoline Venus* and a *Priestess holding a vessel*; a cinerarium and a circular altar dedicated to Hercules; finally, two relief scenes from the same pedestal as on f. 57: a winged Victory accompanied by a seated figure of Roma, and a sacrificial scene of two men with a bull.

was working. The sketches are often only an inch or two high and are crammed swiftly on to the page, filling every available space.

The minute size of Turner's museum sketches is in striking contrast to those made by two of his British predecessors in Rome, Wilson in 1754 and Wright of Derby in 1774-5.[13] Several of Wilson's sketches are in a sketchbook measuring over 11 by 8 inches while Wright used pages twice that size, and both artists usually drew only one statue on each page. Furthermore, while Wright concentrated mainly on famous statues like the *Barberini Faun* and the *Dying Gladiator*, Turner very rarely sketched the most renowned sculptures. He may have felt that he had studied them sufficiently in his youth, and in any case there were countless engravings available of them.[14] There is no evidence that any of Turner's 1819 sketches of sculpture was itself drawn from an engraving, as was the case with many of Poussin's drawings after the antique, or from casts or copies such as those in the French Academy drawn by Wright. On the contrary, Turner's sketches of statues occur *en masse*, documenting beyond doubt his visits to the museums. Occasionally, too, his sketches show views of entire rooms in the museums (Plate 60), after the fashion of some of the plates in Hakewill's *Tour of Italy*.[15] Having at last journeyed to Rome, he was only interested in sketching the real thing.

The *Vatican Fragments* sketchbook shows that Turner was fascinated by the whole range of ordinary Roman sculpture from ash-urns to candelabra, from statuette groups to altars. This breadth of interest was not in itself unusual. Wilson's Italian sketchbook in New Haven displays similar switches of attention from herms and animal sculptures to keystones and torsos.[16] But while Wilson had selected examples that were particularly admired in his own day — a relief that had been praised by Jonathan Richardson the Younger and scenes that were shortly to be included or adapted in works by Batoni, Panini, Stubbs or Piranesi — Turner's omnivorous appetite led him to draw numerous examples of each sculpture type, not just the best or the most celebrated. Turner's first biographer, Walter Thornbury, noted the variety of subjects included in *Vatican Fragments*: 'satyrs,

60. The Sala a Croce Greca in the Vatican,
looking towards the staircase (*V Fr*, 47a), pencil,
4 × 6¼ in.

61. *The Temple of Jupiter Panellenius restored*,
1816 (B & J, 133), oil on canvas, 46 × 70 in.,
Richard L. Feigen, Chicago, Illinois

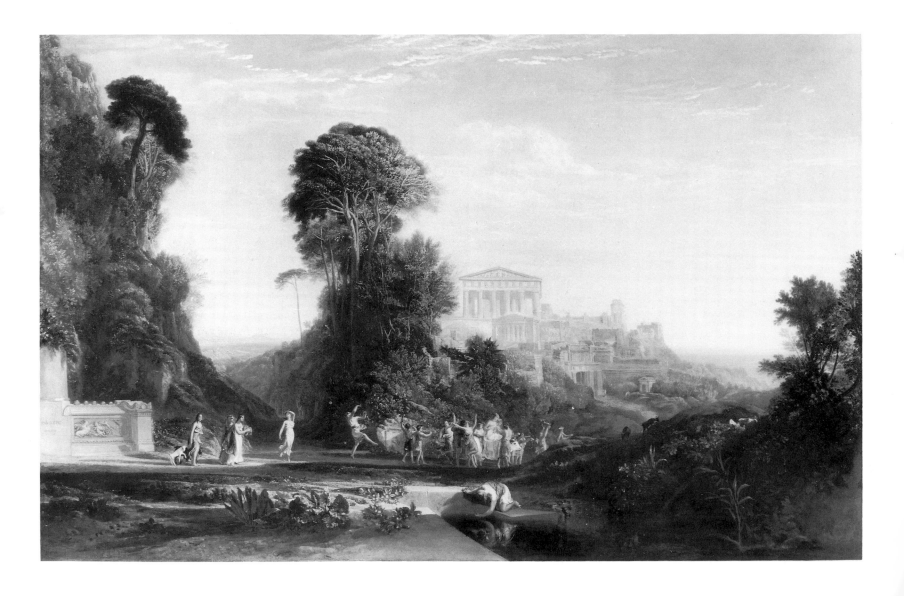

vases, griffins, Bacchantes, Cippi, tombs, masks, leafage, Apollino, Psyche, female heads', a list recalling the title of Piranesi's *Vasi, Candelabri, Cippi, Sarcofagi...* (1778), which had achieved an international reputation and could well have been known to Turner.[17] Apart from this, however, Thornbury's reference throws little light on Turner as a student of the antique. To understand the nature of his interests, it is necessary to analyse his sketchbook somewhat more closely.

One of the significant features to emerge is that Turner showed a distinct preference for reliefs over free-standing sculptures, even going so far as to sketch the reliefs on the base of a statue while ignoring the statue itself. This preference is not altogether surprising. Antique friezes and reliefs have commanded the attention of painters from the Renaissance onwards, partly because of the lack of extant examples of ancient painting, and partly because a relief is intrinsically similar to a two-dimensional painting in its organisation. The influence of altars and sarcophagi can be seen in the work of many artists whom Turner admired, particularly Poussin, and in that of the neo-classical painters of his own day such as Benjamin West. Occasionally Turner himself disposed his figures in the style of a relief. In 1816, the year in which the controversy over the Elgin Marbles reached its finale, he exhibited two paintings with Greek subject matter, *The Temple of Jupiter Panellenius restored* (Plate 61) and *View of the Temple of Jupiter Panellenius....* In these he deliberately arranged his principal figure groups just as they might have appeared in an antique frieze.[18]

On the more personal level, it is self-evident that a mature artist brings to his study of the art of the past his own pictorial concerns. Both his choice of subjects and the features he elects to emphasise may reflect his personal tastes and priorities. Thus Rubens chose to sketch the most dynamic and powerful free-standing statues in Rome — *Laocoon*, the *Belvedere Torso*, the *Farnese Hercules* — and he showed expressive faces, firm flesh and bodies alert with potential movement.[19] When Flaxman sketched paintings or sculptured panels from the Renaissance, he suppressed their architectural backgrounds and eliminated their indications of perspective so that they were flattened like the classical bas-reliefs whose linear rhythms he admired.[20] Wright of Derby's Roman sketchbook in the British Museum contains studies from the antique, from life, from models posed after antique statues, and from the memory of both life and the antique, demonstrating clearly that he sketched statues as part and parcel of his study of the human body, not through an interest in the antique *per se*.[21] The fact that Turner consistently drew complex relief scenes rather than single free-standing figures suggests a preoccupation with composition and a concern for ensembles rather than individual human forms. Similarly, his lack of interest in depicting facial physiognomy in his paintings is mirrored in his disinclination to sketch the portrait busts in Roman museums. Other visitors there in his day were responsive to the 'freshness of truth and nature' in Roman portraiture while the work of sculptors like Chantrey and writers like Hazlitt and Charles Lamb show a noticeable interest in the portrait bust as such.[22] However, Turner's concern in the Sala degli Imperatori and the Sala dei Filosofi in the Capitoline Museum was exclusively with the reliefs high up on the walls, and not with the serried ranks of marvellously characterised faces much nearer to hand.

One type of Roman sculpture that particularly attracted Turner was the private funerary monument, which usually took the form of a small grave altar or a container for ashes.[23] In sketching these, he frequently did not sketch the piece as a whole but adopted instead an approach that was both economical and analytical: a sketchbook page of 'Bacchantes... tombs... leafage... inscriptions' may well constitute a record of all the separate parts of only one or two monuments (Plate 62). Because of Turner's method of sketching it is easy to overlook the nature of the works in which he was interested, so their complexity should be emphasised. They form a characteristic type in which relief scenes and inscriptions are enclosed in a decorative architectural setting making, as it were, an art form embracing several of the arts. Despite his poor Latin, Turner copied out many of the long inscriptions on these monuments, and it seems very likely that he attributed to them

62. A typical double-page spread of 'Vatican fragments' (*V Fr*, 8a-9), pencil, each page 6¼ × 4 in. The top half of f. 9 records the cinerarium of T. Flavius Eucharistus. The lower half shows the different ingredients of the monument seen at the top right of f. 8a. The monument sketched at top left of f. 8a stands adjacent to it in the museum as in the sketch.

63. Nicolas Poussin, Reliefs and sculptures in Rome, *c.* 1640, pen and brown wash, 12¼ × 8 in., Witt collection, Courtauld Institute Galleries.

poetical qualities they in fact do not have. He may even have seen in the Roman juxtaposition of inscription and narrative relief scene a precedent for his own practice of accompanying his paintings with verses.

Turner's contemporaries scarcely glanced at these altars and funerary urns, but they had attracted the eye of several earlier artists. Their appeal for Renaissance artists needs no underlining here, and would have been clear to Turner from works such as Raphael's *Sacrifice at Lystra*. Out of Poussin's seventy or so drawings from the antique about a dozen pages represent richly decorated altars and urns of exactly the type that later caught Turner's attention (Plate 63).[24] Since Turner's early historical paintings had been strongly influenced by Poussin, their similarities as copyists of the antique are of the greatest interest. Both were concerned not only to study what was famous but also to gather a personal repertory of forms and motifs. Both were intrigued by the strange and curious — for example the reliefs of symbolic and sacrificial instruments in the Capitoline Museum.[25] Neither was interested in making the very detailed or measured drawings that were necessary for antiquarian researches; their sketches were for themselves alone.

* * * *

Turner's studies of sculpture had two quite different potential uses, both of which must have been in his mind in 1819: the faithful rendering of famous monumental sculptures in topographical scenes, and the imaginative adaptation of museum statues for his own artistic purposes. He would almost certainly have envisaged painting the Roman Forum, which he had already depicted in watercolour for Hakewill's *Picturesque Tour of Italy* (Plate 13), and it would have been partly with an eye to such future works that he recorded the three triumphal arches. In the event, however, the Arch of Titus was the only one to be shown in any detail, in *Forum Romanum* (1826; Colour Plates 22 and 24), and Turner had great difficulty in reproducing it from his sketches. He misspelt the Latin inscription on the arch (it was carelessly copied in the original sketch) and the painting's prospective owner, John Soane, had to ask for it to be corrected.[26] Furthermore the wrong relief appears on the inside left face of the arch. When sketching these reliefs — as isolated scenes rather than *in*

56

situ [27] — Turner did not record where each scene appeared, and in *Forum Romanum* he painted the chariot and horses of the emperor's triumph instead of the procession with the spoils of Jerusalem that properly belongs on this side of the arch. This too must have caused Soane some irritation. The small and badly preserved sacrificial frieze over the arch was sketched very hastily and in a way that suggests that Turner was unable to make out its subject matter.[20] In the painting it became vaguer still, to the point of unintelligibility. There were other occasions, too, when Turner's system of record-making could have been a hindrance to the later production of accurate paintings. A single sketchbook page contains a general sketch of the Arch of Janus and a more detailed one of sculptured reliefs — not, as might be assumed, from that same arch, but from the nearby Arcus Argentariorum (Plate 64). Elsewhere the friezes of the Colonnacce are recorded partially *in situ*, partially on their own, making it difficult to envisage the relationship of the parts to the whole later on.[29]

Turner's records of the Arch of Constantine, on the other hand, were very methodical. A large pencil study of the south side, complete with all its sculptures (Plate 40), established the architectural position of each of the types of ornament on the arch. Thus for the north side it was sufficient merely to record the reliefs as isolated scenes, in order from top to bottom.[30] However, Turner made no immediate use of his many detailed pencil studies of this arch and it seems doubtful if he consulted them when producing his 1830s oil painting which shows it only as a gleaming shape catching the evening sun (Colour Plate 39). In the 1819 colour sketch which forms the closest parallel to the painting, no individual reliefs are depicted but the whole arch is broken up into an articulated surface of golden-brown lights and shadows.[31] In the painting, the free-standing statues of the attic storey and the medallion reliefs are discernible as such, but this is the most that can be said of them and the monument lacks even the overall encrusted look of the sketch.

Whereas Turner's study of Rome's triumphal arches did not lead to successful depictions of these famous monuments complete with their sculptures, his museum sketching had important repercussions on his work. In his historical and mythological paintings after 1820 he increasingly included sculptural fragments that were relevant to his scene, as he had begun doing in earlier paintings such as the 1814-15 *Lake Avernus: Aeneas and the Cumaean Sibyl* (Colour Plate 1). The inclusion of fragments of architecture or sculpture was not, of course, an innovation of Turner's. Northern artists who had studied in Rome had been introducing classical statuary and monuments into their paintings, both to indicate a topographical setting and to carry symbolic meanings, ever since the days of Elsheimer and Breenbergh. Such staffage had been one of the essential ingredients of the 'ideal' classical landscapes of Claude. However, in introducing symbolic statues or reliefs into his paintings Turner was really following not Claude himself but Wilson. In Claude's paintings statuary tends to be unobtrusively integrated into an architectural ensemble rather than a compositional element in its own right. When he does introduce classical staffage into a foreground it is usually an architectural fragment rather than figurative sculpture. In Wilson's paintings, however, statues are often very prominent and are intended to be closely read.[32] Precisely how closely must remain an open question, but his repertory of motifs was decidedly narrow, the same statue reappearing in several different paintings.[33] Turner soon learnt to be far more inventive than Wilson (compare the 1798 and 1814-15 versions of his *Lake Avernus*, Plate 2 and Colour Plate 1). Sometimes he insists upon the spectator's close attention by painting a relief scene very clearly. Sometimes he prefers to make a more generalised reference by depicting a characteristic sculptural type. Sometimes he avoids any specific symbolism altogether and merely shows fragments of fallen masonry.

The relief on the right of Turner's 1814-15 *Lake Avernus* shows a god or hero overcoming Cerberus, the three-headed guardian of Hades: a very suitable motif in a picture dealing with the descent of Aeneas to the Underworld and his return, aided by the golden bough, which Virgil had described in *Aeneid* VI. The stone slab on which this completely self-contained scene is presented is clearly a metope from the frieze of a Doric

64. The Arch of Janus and the reliefs on the Arcus Argentariorum (*ANR*, 45), pencil, 7½ × 4⅜ in.

temple; this fact, together with the style of the very high relief figures themselves, shows that Turner had been studying the Parthenon metopes which had started arriving in London in 1802 and of which he later acquired some casts.[34] At this stage, before his visit to Italy, Turner was perhaps unaware of the inappropriateness of such overtly Greek sculpture in an Italian landscape. However, after 1819 his staffage in Italian paintings became strictly canonical: architectural fragments are of the Corinthian order, while sculpture is based on the prototypes he had sketched in the Roman museums. In *The Golden Bough* (1834), for instance, the piled-up debris on the right consists entirely of sarcophagi, round or triangular pedimented tombs, and containers for ashes, some of which display the popular motif of paired cupids supporting a medallion for an inscription or portrait (Colour Plate 9).[35] This analysis reveals Turner's purpose in introducing the staffage at all: it is not decorative, but symbolic of death, and originally the three fates were shown seated among it (the present *two* figures were a later modification of Turner's).[36] Another pedimented tomb occupies the left foreground of *Ancient Italy — Ovid banished from Rome* (1838; Plate 171), one of the paintings in which Turner is concerned with the decline of ancient Rome. Here the tomb serves to make a striking contrast with the monuments of greatness high in the city behind: the winged Victory on her orb; the rostral column celebrating Rome's naval successes; the equestrian statue denoting her imperial might and military strength.

In *The Golden Bough* it is the monuments themselves that are significant rather than their decoration. By contrast, in the *View of Orvieto* (1828; Colour Plate 26), the frieze on the fountain at which the women are washing clothes and drawing water is reasonably legible and depicts, very suitably, an aquatic subject. In *The Bay of Baiae* (1823; Colour Plate 10) the ruined building behind the Sibyl bears a surprisingly well-preserved frieze with a series of unmistakably martial scenes symbolising the destruction of Baiae between its heyday and its ruined present. As Eustace's *Tour through Italy* had put it, '*Baiae* and its retreats ... were doomed to devastation; and earthquakes, war and pestilence were employed in succession to waste its fields, and depopulate its shores.'[37] To emphasise these events, Turner made his frieze serve simultaneously as a visual link between the foreground and the middle distance and as a temporal link between Baiae's prime and Baiae's ruin. The friezes in both these paintings have legible and precise subject matter, but neither is a copy of an actual relief Turner had sketched. Characteristically, he drew on his experiences of authentic works in order to create his own imaginary examples.

In devising the figure of Apollo in *The Bay of Baiae* it is very likely that Turner made use of his 1819 sketch of the statue of that god in the gardens of the Barberini palace in Rome (Plate 42). On the other hand, in *What You Will!* (1822) he made much bolder use than usual of his sketches of classical sculpture, transforming the three graces and the cupids which he had sketched on low reliefs on sarcophagi into large-scale, free-standing variants on these themes (Colour Plate 11).[38] Here the setting is not classical but, as Turner's punning title shows, a fairy-tale amalgam of the Illyria of *Twelfth Night or What You Will* and a Watteau garden. The sculpture is appropriate to both these settings through its subject matter of loves and graces but particularly so in a painting relating to French eighteenth-century art. The gardens of French châteaux abound in classical sculpture, while Watteau's own *fêtes galantes* frequently include statues which, far from being merely decorative, appear as silent spectators of the scene. This is precisely the role assigned to the stone maiden half-hidden in the trees on the left of *What You Will!* Meanwhile, the statue in the painting nearest to the spectator is a veiled double herm which Turner has invented out of those he had seen.[39] This brilliantly sums up the disguises and intrigues and complicated relationships around which Shakespeare's play revolves.

What You Will! was bought at the Royal Academy by Chantrey and must surely have been painted expressly for him. In November 1819 Chantrey had been aware of Turner's diligent work in the *Vatican Fragments* sketchbook; either then or later the two friends could hardly fail to have discussed the Vatican sculptures themselves. The painting is not only unusually small for Turner, it is unusually light-hearted. If Turner and Chantrey shared many serious concerns — particularly evident in their devotion to the Academy and

their respective bequests to the nation — they also shared the same sense of fun. Their long and intimate friendship was punctuated by practical jokes, puns and playful insults. High art and comedy went hand in hand exactly as in *What You Will!*

It is occasionally possible to link the subject matter of Turner's later paintings with his study of antique sculpture in 1819. One example of this concerns *Phryne going to the Public Baths as Venus — Demosthenes taunted by Aeschines* (1838; Plate 65). As a tourist in the Uffizi Turner could well have heard the story that connected the *Medici Venus* with Praxiteles' mistress and model, 'the famous Phryne, the courtezan of Athens, who, at the celebration of the Eleusinian games, exhibited herself coming out of the bath, naked, to the eyes of the whole Athenian people'.[40] Had he later turned to Lemprière's *Classical Dictionary*, he would have found a further story centring upon the charms of Phryne and featuring a distinguished fourth-century Attic orator — not, however, Demosthenes or Aeschines, but Hyperides.[41] The historical foundations of Turner's *Phryne* are both obscure and shaky. However, the starting-point for his imagination could well have been provided by the *Medici Venus*, while the painting itself contains echoes of some of the female sculpture which he had drawn in 1819: the *Wounded Amazon* with her raised arm, a woman carrying a box, friezes of Bacchantes and other dancing figures.[42]

Sometimes, too, the sculpture which Turner sketched may have been iconographically suggestive. In his sketch of the celebrated 'dawn' medallion on the side of the Arch of Constantine, he shows clearly the horse-drawn chariot emerging from the water, driven by Aurora, who bears in her hand a torch-carrying child, her son Phosphorus, the personification of the morning star.[43] In another famous Roman representation of the dawn, Guido Reni's *Aurora* (on which he wrote the longest notes he devoted to a single painting in Rome),[44] the horses of the morning are similarly accompanied by the morning star, personified by a boy carrying a torch (see Plate 69).[45] The horses rising from the sea in Turner's *Ulysses deriding Polyphemus* (1829; Plate 66) have traditionally, and rightly, been seen as those of Apollo; adaptations — perhaps at second hand — from those on the east pediment of the Parthenon.[46] However, one element in *Ulysses* may have crept there from the representations of the dawn which Turner had studied in Rome. It has been convincingly shown that the nereids in the foreground personify the then recently investigated and scientifically observed phenomenon of phosphorescence.[47] It may also be suggested that Turner was aware of the artistic tradition whereby Phosphorus was depicted accompanying the dawn. With his ability to work simultaneously from multiple sources and his own imagination, and with his well-known love of puns, both just demonstrated in *What You Will!*, he would have enjoyed up-dating a traditional motif in a modern scientific way by adding these phosphorescent nereids, each with her own twinkling little star.

The infant Phosphorus sketched in the Arch of Constantine relief stands on a ball in the left hand of Aurora. This is also the pose of the winged Victory held by one of the statues in the Vatican which Turner sketched[48] and, in due course, of another winged Victory, extended towards St Peter's Square by the reclining statue in his painting *Rome, from the Vatican* (1820; Colour Plate 12). This figure is a variation on the large classical personifications of the Nile and the Tiber in the Roman museums and it must be interpreted as representing the Tiber. Turner's statue, taken as a whole, personifies victorious Rome gazing out over its possessions. However, his message does not end there, for two sculptured infants have tumbled from the lap of Father Tiber and lie cold and neglected. These must be none other than Romulus and Remus, the legendary children of ancient Rome, and their fall illustrates the fall of the pagan world. To stress this point, Turner has placed an antithetical group immediately next to them. In Raphael's *Madonna della Sedia* the Virgin Mary clasps the infant Jesus tenderly to her bosom, under the adoring gaze of St John the Baptist. Here, at the exact centre of the foreground, is the Holy Child who now dominates modern Rome.

* * * *

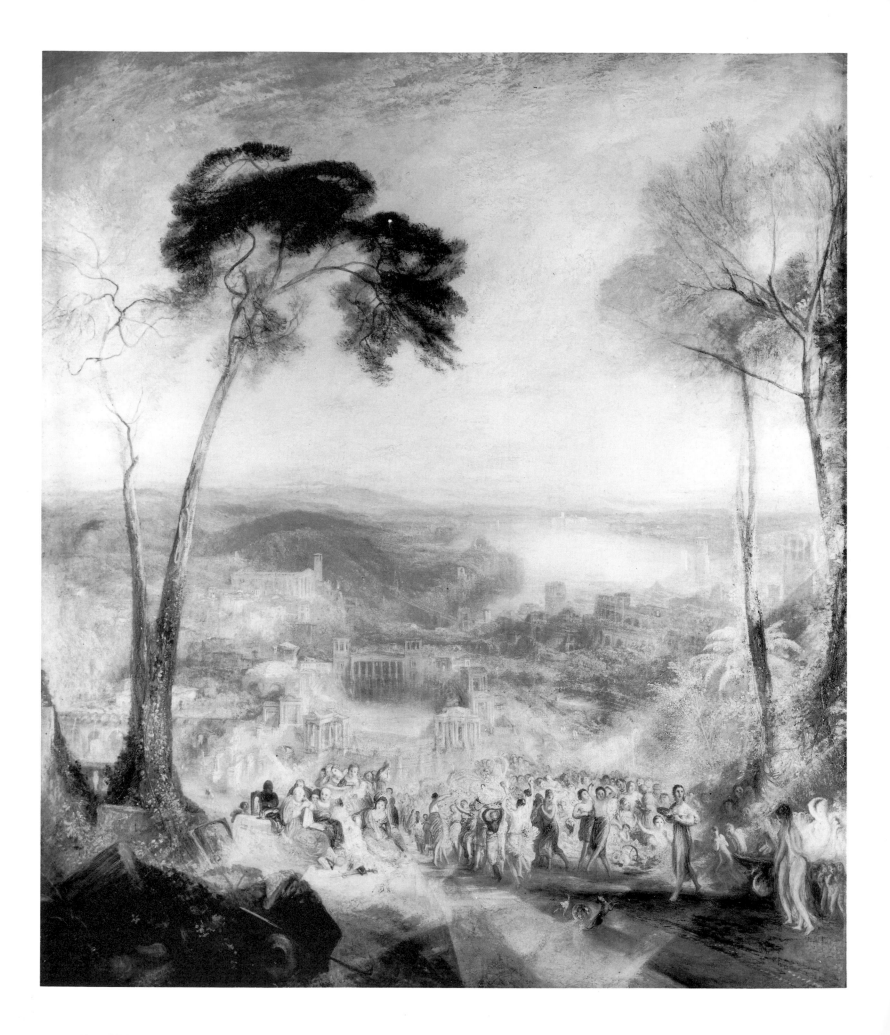

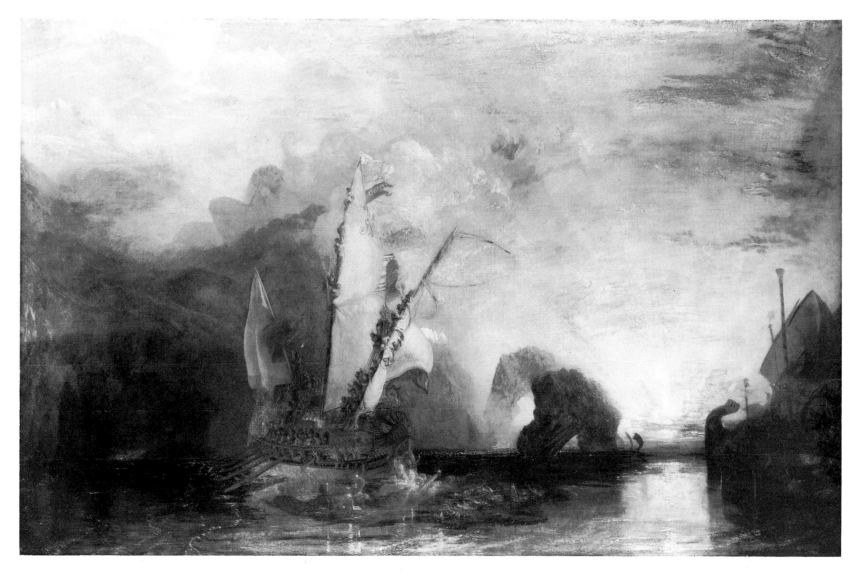

66. *Ulysses deriding Polyphemus*, 1829 (B & J, 330), oil on canvas, 52¼ × 80 in., National Gallery, London

65. *Phryne going to the Public Baths as Venus — Demosthenes taunted by Aeschines*, 1838 (B & J, 373), oil on canvas, 76 × 65 in., Tate Gallery, London

Before ending this chapter it should be noted that not all the sculpture Turner looked at in Rome was classical. He probably visited the studio of the Danish neo-classical sculptor Thorwaldsen, while it is inconceivable that he did not see that of Canova.[49] He was almost certainly taken by Canova to see his *Pauline Borghese as Venus Victrix* by candlelight, a favour that few were accorded,[50] and he also studied Canova's recently completed *Monument to the Last of the Stuarts* in St Peter's, on this occasion making a sketch (Plate 46). He may perhaps have heard from the sculptor himself of his current battle with the papal authorities concerning the nudity of the angels on this tomb,[51] for the only other monument Turner sketched in St Peter's was famous in the early nineteenth century for having been the centre of a similar charge of indecency.[52] This was the monument to Pope Paul III Farnese, executed by Guglielmo della Porta to the designs of Michelangelo. Of course, he may have been genuinely impressed by the earlier tomb or attracted by the famous name attached to it. It was almost certainly the latter reason that led him to the church of S. Agnese fuori le Mura where he made two sketches of a marble head of Christ which was greatly admired as being the work of Michelangelo.[53] He also sketched Raphael's *Jonah* in S. Maria del Popolo, as was noted in Chapter 3 (Plate 44): this was celebrated for being one of the 'only specimens in the world of Raphael's skill in statuary', and was still admired although many were aware that it had been executed by a pupil of Raphael's and not by the master himself.[54]

Shortly before Turner's visit to Rome, a portrait bust of Raphael had been placed in the loggia in the Vatican containing his frescoes of biblical subjects.[55] It was the work of the promising young sculptor Alessandro d'Este (1787-1826) whose father was the Director of

61

Colour Plate 9. Detail of *The Golden Bough*
(Colour Plate 34)

Colour Plate 10. Detail of *The Bay of Baiae*
(Colour Plate 20)

67. Sketches of the bust of Raphael by Alessandro
d'Este (1787-1826), Vatican loggia, Rome (*T and
R*, 24), pencil, 4⅜ × 7⅜ in.

the Vatican Museums. Turner showed this bust in its architectural context in his large
drawing of the loggia, *Rome: C. Studies*, 41 (Plate 123), but he also made two detailed
sketches of it on f. 24 of the *Tivoli and Rome* sketchbook (Plate 67). These sketches follow
close on his studies of the loggia itself (ff. 13a-21) and precede his musings on the theme of
an artist among his pictures (ff. 25a, 26; Plate 128). One can hardly escape the conclusion
that this image of Raphael, surrounded by his own decorations (see Plate 127), provided
the germ of Turner's choice of subject for his 1820 painting *Rome, from the Vatican*. He
certainly made use of the bust as a source for Raphael's features. However, because he had
introduced the painter himself into the scene, he could not include the bust as well, and he
had to close his view down the loggia rather anti-climactically with an empty pedestal.

Apart from these works connected with Michelangelo and Raphael, Turner seems to
have had little concern with Roman sculpture after the period of antiquity. This is not to
say, however, that he did not look at Italian sculpture of other periods, when he was in
towns other than Rome. He showed a marked interest in Giambologna in both Bologna
and Florence, for instance, while his studies in Florence also embraced both Donatello and
the neo-classical sculptor Stefano Ricci.[56] It was simply that in Rome itself most other
sculpture paled into insignificance in comparison to that of antiquity. He was attracted by
the formal beauty and historical interest of classical sculpture, its variety and complexity.
He was stimulated to adapt and transform what he saw so as to rival the sculptors of
antiquity in invention, in exactly the same way as he set himself to compete against the
landscape painters of the past whom he admired. No other class of sculpture in Italy
presented him with such an attractive challenge.

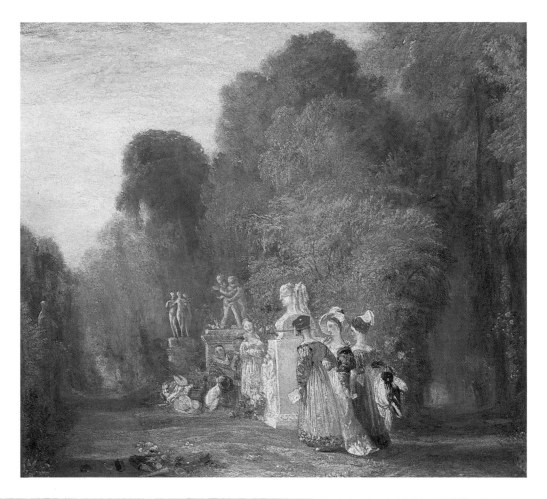

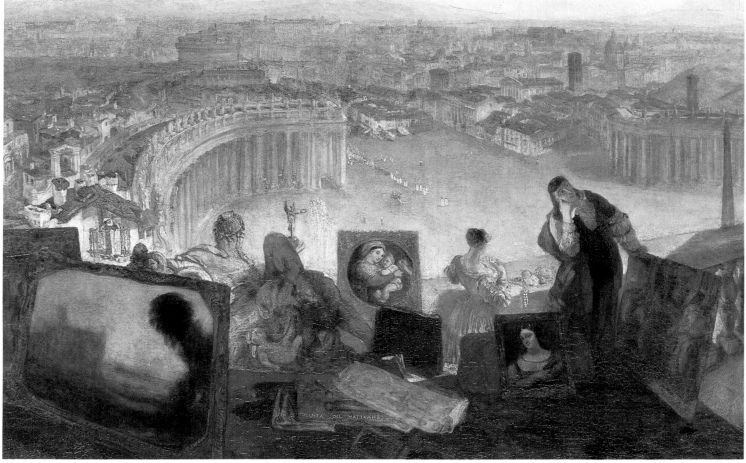

Chapter 5

STUDYING THE OLD MASTERS

In Rome Turner also looked at a great many paintings. He visited the celebrated collections of families like the Barberini, Borghese and Doria. He studied famous decorative cycles such as the Carracci ceiling in Palazzo Farnese and Raphael's frescoes in Villa Farnesina. He made a careful study of Raphael's loggia in the Vatican with its fresco cycle of biblical subjects.[1] However, he does not appear to have been an unusually avid student of paintings by early nineteenth-century standards. In the autumn of 1819 the poet Tom Moore visited sixteen collections, some of them several times, in a mere three weeks, while David Wilkie's Italian letters and journal constantly bear out his claim that his 'great pursuit' there was pictures.[2] Turner's Roman sketchbooks suggest quite the opposite, that the Old Masters were only one interest among many.

Turner often used his sketchbooks unsystematically, opening them at random and not attending to chronological continuity. However, he did try to be methodical in recording works of art. Antique sculpture is chiefly depicted in *Vatican Fragments*, as was seen in the last chapter. His sketches and comments on the Roman picture collections occur in only two types of sketchbook: the small lightweight ones he had prepared beforehand and carried round as guidebooks, *Route to Rome* and the *Italian guide book* sketchbook; and the leather-covered books with groups of pages prepared with a wash of grey, *Vatican Fragments* and *Remarks*. In their virgin state these last two would have formed the closest parallel among the 1819 sketchbooks to the one he had used in 1802, *Studies in the Louvre*, and he must have intended them as Roman equivalents to the earlier book. However, their contents are very different from those of *Studies in the Louvre*, for his visit to Rome inspired neither the coloured copies nor the discursive notes which he had made in Paris. The grey-washed pages in *Vatican Fragments* are virtually unused (in marked contrast to the rest of that book), as is the major part of *Remarks*.

His notes themselves are sparse and summary. The Palazzo Farnese decorations are described in little more than a string of names — 'Apollo Hyacinth bad Galethea Carraci Annible fine' — while the famous Borghese paintings elicited such brief remarks as 'Domenichino Chase beautiful'.[3] It is hard to tell which paintings he liked best, since he sometimes employed his own shorthand way of 'starring' them in lists of this kind, using symbols whose values remain obscure.[4] Occasionally, however, the notes are slightly fuller and show a variety of responses which reveal Turner the spectator as well as Turner the practising artist. Sometimes he was concerned only with matters for the eye: he made memoranda of colours using the letters Y(ellow), R(ed), B(lue) and so on; he commented on the notoriously unpleasant changes undergone by some of the pigments in Raphael's *Galatea*; he noted Titian's use of a white ground; he assessed draughtsmanship and facture — 'elegant' and 'beautiful' 'lines of the figure'; 'exquisitely findish' (i.e. finished).[5] Sometimes subject and sentiment were noted. His comment on Salvator Rosa's gigantic and gruesome depiction of the disembowelled Prometheus in the Corsini collection — 'horrible' — is not really surprising, since Turner himself always avoided the direct depiction of physical agony.[6] He noted three other expressive paintings of suffering in the Corsini collection, the heads of Christ crowned with thorns by Carlo Dolci, Guido Reni and Guercino.[7] The powerfully characterised look of anguish in the Guercino reminded him of

Colour Plate 11. *What You Will!*, 1822 (B & J, 229), oil on canvas, 19 × 20½ in., Sir Michael Sobell

Colour Plate 12. Detail of *Rome, from the Vatican* (Colour Plate 19)

a profoundly moving work back home in England, Annibale Carracci's *Dead Christ Mourned*, now in the National Gallery in London.[8]

Turner's sketches of Roman paintings are as disappointing as his notes. He made no full-page copies of whole paintings and none in colour. There are only tiny memoranda of compositions or rough sketches of single figures or groups, often without any identification or comment.

The reasons for this situation may be easily imagined. Turner would usually have visited private collections with friends like Eastlake or Canova, who had helped him gain access, or with other tourists. He would therefore have made his notes and sketches hastily, perhaps surreptitiously, or even from memory afterwards. Only in the comparative anonymity of the public museums — the Capitoline and the Vatican — did he devote both time and care to his sketches. Then there were the restrictions imposed by some galleries themselves. The need to obtain permission before copying or sketching was a perennial source of irritation to visitors to Italy, and sometimes even sketching was forbidden. In 1845 Ruskin complained of the Pitti: 'they don't give leave to make notes [with] a book in one's hand of forms or shades, which is just what one wants to do, but one must *name* a picture, and go in regularly & copy it'.[9] Lastly, it is possible that Turner was simply not impressed by what he saw. He would not have been alone in this feeling. After the excitement of Hazlitt's 1802-3 trip to Paris, he approached Rome in 1825 with high expectations which were dashed to the ground: 'This is not the Rome I expected. . . . the Vatican falls short of the Louvre. . . . I thought that here were works immoveable, immortal, inimitable on earth, and lifting the soul half way to heaven. I find them not'.[10] Hazlitt was equally unimpressed by the Borghese and Corsini pictures, while in 1819 Chantrey thought most of the Doria collection 'very bad'.[11] Perhaps Turner experienced similar feelings in these famous galleries. Comparison between the treasures of Paris and those of Rome was inevitable and Turner himself was in the habit of measuring the unfamiliar against the known. In 1802 he compared the buildings of Lyons with those of Edinburgh, the falls and precipices of Switzerland with those of Wales and Scotland.[12] There is no escaping the fact that his *Studies in the Louvre* sketchbook breathes an excitement, intensity and interest which most of the 1819 notes and sketches of paintings are conspicuously lacking.

By and large, Turner noticed the paintings which were traditionally accorded high praise by visitors to Rome, such as Titian's *Sacred and Profane Love* in the Borghese collection or Raphael's *Three Graces* spandrel in Villa Farnesina. His notes on less famous works may nowadays appear to indicate an unusually eclectic taste but they frequently reflect the preferences of his age and can be linked to eulogistic entries in contemporary guidebooks. For example, the four large circular mythologies by Francesco Albani noted by Turner in the Borghese collection were rated as highly as the works there by Domenichino and Titian in the guides by Mrs Eaton and Mariana Starke.[13] When Turner comments on a painting that might pass almost unnoticed today, there is often a simple explanation: inventories of his day attributed it to Michelangelo, Titian or another master and it was pointed out to the visitor by the *custode*. In a list of the artists on whose work (or supposed work) Turner concentrated, there are no surprises: Raphael and Michelangelo, Titian, the Carracci, Domenichino, Guercino and Guido Reni. He had already studied works by several of these painters in the Louvre, and in 1819, as in 1802, he was interested in studying historical, classical or biblical subject paintings with landscape backgrounds.

Although Turner's selection of artists is predictable, there are notable omissions from his notes and sketches. They provide no evidence that he studied the Sistine Chapel and although he devoted a lot of attention to sketching Raphael's loggia he made no sketches of the stanze, the *Transfiguration* or the *Deposition*. However, he was already well acquainted with all these works, through engravings of the frescoes and study of the easel pictures in Paris in 1802 (by 1819 he had used the *Transfiguration* as an example in one of his Perspective Lectures).[14] It was typical of his economical nature not to spend time

68. Marcello Venusti (1512-79), *The Annunciation*, oil on panel, 17¾ × 11¾ in. (formerly Palazzo Corsini), Palazzo Barberini, Rome

69. Guido Reni, *Aurora*, 1613-14, fresco, 110 × 275 in., Casino Rospigliosi-Pallavicini, Rome

sketching works that were already familiar. The result is the curious situation that Turner's only references to Michelangelo in 1819 concern work which today is no longer attributed to him: two large paintings of saints in the Borghese collection, now seen as the work of a follower, and two tiny scenes in the Corsini palace, *The Holy Family* and *The Annunciation*, now regarded as the work of Marcello Venusti (Plate 68).[15] In the field of sculpture, too, he accepted attribution to Michelangelo when he was presented with it: his sketches of the *Head of Christ* in S. Agnese fuori le Mura were mentioned in Chapter 4. Although these works are now excluded from Michelangelo's *oeuvre*, all are very close to it in style (the Corsini paintings are based on Michelangelo's own drawings), so Turner can hardly be castigated for lack of connoisseurship. He must certainly have studied genuine works by Michelangelo as well. A previous inspection of the Sistine Chapel is implicit in his 1828 comment in a letter to Sir Thomas Lawrence that the 'Sybils and Prophets of the ceiling are as grand magnificent and overwhelming to contemplating as ever'.[16]

Turner's longest notes discuss Guido Reni's *Aurora* on the ceiling of the Rospigliosi Casino, a work which enjoyed universal esteem for uniting 'the truth of Raphael and the colouring of Titian with the taste and divine spirit of the painter himself' (Plate 69).[17] Turner had long known this work, too, from its engraving, but the experience of seeing the ravishing and wonderfully preserved colouring of the fresco itself was a complete revelation.[18] He was fascinated by the way the colours were arranged to balance the lights and the darks and how this affected the perspective in the painting, matters of the utmost significance for a Professor of Perspective who also painted hundreds of watercolours for engraving. Of the central figure he wrote, 'the dark figure with golden Hair and light Blue drapery is beautiful as to form color and design[.] the drapery is the lightest color in the picture. the greenish robe of the next figure second[,] the next a lilia robe and light drapery. the Apollo red Lake and comes off whole in half tone from the Sky'.

Although these notes are chiefly analytical, they also contain a note of criticism, that the sky is 'perhaps . . . too solid' and 'rather Yellow'. Its bright uniformity is certainly in marked contrast to the subtle gradations of tones and interplay of colours in Turner's own painted skies and to his records of the real skies he saw in Italy. He made a direct comparison between the Italy depicted in a painting and his own experience of it in his notes on the small Claude in the Barberini collection, *Pastoral Landscape with a View of Lake Albano and Castel Gandolfo* (Plate 136). One of his comments, 'The Trees on the left and Centre dark, the right tree warm yellow leaves and brown Stem, tho' in light yet darker than the Sky; like the French Academy as to effect last night', measures Claude's ideal landscape against his own observations in the gardens of the Villa Medici and provides a counterpart to the occasions in 1819 when he wrote 'Claude' or 'Wilson' on his sketches when a view reminded him of their work. But he was less concerned with absolute truthfulness to nature than with the effective manipulation of nature into art, and he commented on the Sciarra collection's *Landscape with the Port of Santa Marinella* (Plate 70), painted as a pendant to the *Lake Albano*, 'The Sun in the Centre and Sky full of Clouds rather spotted and too strong for the whole. The upper part of the Sky Blue and the water

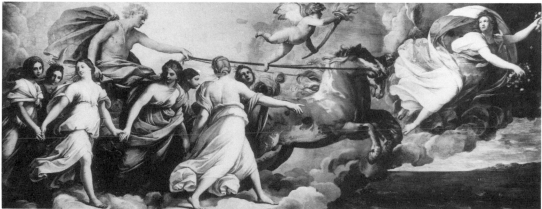

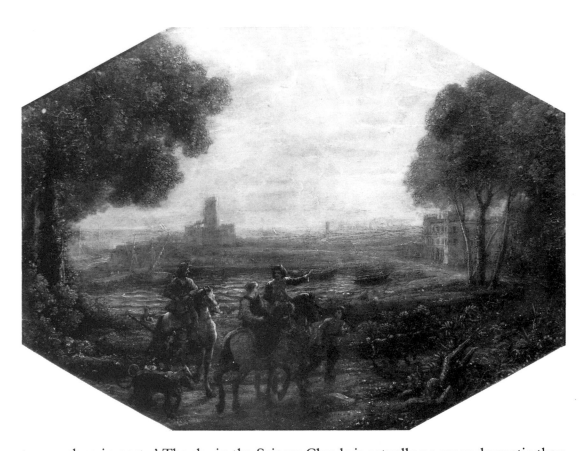

70. Claude Lorrain, *Landscape with the Port of Santa Marinella*, 1639, oil on copper, 11¾ × 14½ in. (formerly Sciarra collection), Musée du Petit Palais, Paris

71. Sketches of the Barberini and Sciarra Claudes (*Remarks*, 80), pencil, 4½ × 3 in.

too much so in parts.' The sky in the Sciarra Claude is actually no more dramatic than some of the Italian skies seen and recorded by Turner himself in pencil sketches and colour notes,[19] but for such a small painting he felt that nature's brilliant colours and abrupt transitions should have been modified.

Turner's close attention to Claude's paintings in Italy in 1819 contrasts markedly with his lack of interest in those in the Louvre in 1802. It can be explained partly by his increased interest in Claude generally, partly by the superiority of the paintings in Italy to the examples in Paris, but above all by the fact that he was now experiencing for himself the land which Claude had painted. Memories of Claude's paintings came to his mind as he looked at the Italian countryside and he studied the paintings in Rome in the light of his own new-found knowledge of the country they depict. This comparison between nature and art extended from his sketches near Loreto in September to his study of the Uffizi *Seaport* in December and its importance to Turner is shown by his own sketches: he recorded Claude's paintings in Rome far more systematically than the other pictures he saw there. Besides the Barberini and Sciarra paintings (Plate 71), he made a quick memorandum of the composition of seven others (Plate 72).[20] The four paintings on the left-hand page were all in the Doria palace (the top one, marked 'Molina', is a version of the Angerstein '*Mill*' now in the National Gallery in London: Plate 160). The three on the facing page were probably all seen in the Pallavicini collection. The middle one, the *Landscape with Bacchus at the Palace of King Staphylus,* had reached that family quite recently from the Colonna collection and the Pallavicini also owned a copy of its pendant, the *Landscape with the Nymph Egeria* (then, as now, in Naples) which is recorded in the sketch above it.

But what was it about the other paintings Turner studied that captured his attention? Was he attracted by works that seemed to share his own priorities and was he influenced by what he saw? It is tempting to believe that he was. One painting he noticed in the Borghese collection was Barocci's *Aeneas fleeing from Troy* which forcefully evokes a heroic moment of struggle and turmoil (Plate 73). Aeneas and his family stumble through the rubble of the burning city, the slowness of their progress emphasised by their path from right to left across the canvas. Barocci also transfers the idea of heat very vividly from the inanimate

72. Sketches after Claude (*Remarks*, 80a-1),
pencil, each page 4½ × 3 in.

city to the human beings who can feel it in every pore of their skins and must flee or be burnt
alive. Their flapping garments are painted in reds and yellows and appear like tongues of
flame, their flesh is already pink and shiny. At an earlier date Turner had been highly
critical of Poussin's *Deluge* in the Louvre because the bright and cheerful colours of the
garments of the victims ill-accorded with the grey light and sombre mood of the whole.[21]
Barocci's colouring, on the other hand, is entirely appropriate: it is neither naturalistic nor
decorative but suggestive, a ploy which would definitely have appealed to Turner.

He also noted occasions when the Old Masters handled colours in the way he liked to do
himself, especially their juxtapositions of yellow, red and blue. In Raphael's *Galatea* he
noted 'one of the Cupids exquisite colord' — doubtless referring to the topmost boy with
the flaxen hair, beautifully painted flesh and a wing where yellow melts gradually into a

73. Federico Barocci, *Aeneas fleeing from Troy*,
1598, oil on canvas, 70 × 100 in., Villa Borghese,
Rome

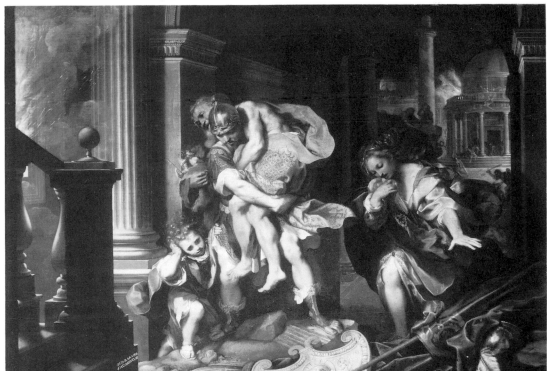

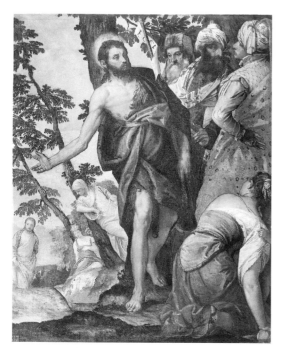

74. Veronese, *The Preaching of St John the Baptist*, c. 1562, oil on canvas, 82 × 55 in., Villa Borghese, Rome

blue that blushes tenderly into red. He again concentrated on the three primaries in his notes on the two Corsini paintings which he believed to be by Michelangelo. In particular he praised the angel in *The Annunciation* whose red and blue wings are extended against a blaze of yellow (Plate 68). This was no fortuitous colour arrangement, and Turner's use of the term 'The Glory' shows his appreciation that heavenly radiance accompanied the heavenly messenger.

Sometimes he was drawn to a painting by its composition. In the Borghese collection he sketched St John and the kneeling woman from Veronese's painting, *The Preaching of St John the Baptist* (Plate 74); an echo of the woman's pose may be felt in the woman whom Turner later placed at the centre of *Forum Romanum* (Colour Plates 22 and 24). *The Preaching of St John the Baptist* is also a good example of an element of composition which Ruskin believed that Turner imitated from Veronese, Tintoretto and Titian: the sustaining of one vertical mass by another.[22] Turner had recently employed this device in his watercolour *Turin, from the Superga* for Hakewill's *Picturesque Tour of Italy* and he was soon to use it again for the grouping of the people and the statues in *What You Will!* (1822; Colour Plate 11). His composition study *Italian Landscape with Tower, Trees and Figures*, painted in Rome in 1828, probably depicts an oration or a sermon.[23] Here the importance of the small central figure is emphasised by his position immediately below the tower on the horizon and he commands the attention of the spectator just as urgently as he does that of the ghostly crowd around him.

But Turner learnt more from Venetian art than how to arrange his materials. It was noted in the last chapter that when he was working in the same genre as Claude and Wilson — the ideal, classical landscape — his intellectual references were both more varied and more specific than theirs. His symbolic language was in fact closer to that of Titian. When Turner studied the *Sacred and Profane Love* in 1819 he would have found a host of meaningful ingredients juxtaposed to build up a painting rich in allusions and he would have appreciated the symbolism of the sarcophagus and water, the church and the castle, the sheep and the rabbit. His historical paintings of the 1820s and 1830s became increasingly full of such symbolism — note, for example, the white rabbit in *The Bay of Baiae* (1823; Colour Plate 21) and the sarcophagi in *The Golden Bough* (1834; Colour Plate 9). It is clear that his natural inclination to fill his work with allusions received strong encouragement from Renaissance painting.

The sheer immensity of the Venetians' achievement also left its mark on Turner. Back in England, Chantrey asked him which of all the painters whose work he had seen in Italy he would most wish to have been. The reply was 'Tintoretto'.[24] The scale of Tintoretto's work, his inventiveness, his superhuman energy, his power to create drama, his dynamic control of light and dark, his brilliance of touch, his mastery of drawing: Turner must have envied them all.

Turner's interest in painting was never confined to the art of the past and certainly not so in Italy. In the *Remarks* sketchbook he listed the names of some twenty European painters then practising in Rome whose work he probably examined in their studios.[25] He made another such list in his guidebook, sometimes adding brief comments such as 'draws well'.[26] However, by and large, he thought little of the art of his foreign contemporaries in Italy and later declared 'that he considered the art at Rome at the lowest ebb'.[27] In Florence, he had a careful look at a recent history painting in the neo-classical style by the head of the Florentine Academy, Pietro Benvenuti, whom Wilkie described shortly afterwards as 'a man of knowledge and power in drawing, but lost, according to our notion, from being a disciple of the French school, while the great masters of his own country are forgotten'.[28] Turner may well have shared Wilkie's views.

He also visited two Roman academies of art and must certainly have enjoyed seeing how their students were trained. This excursion was recorded by Tom Moore in his diary for 15 November 1819:[29]

Went at half past five with Canova, Sir T. Lawrence, Chantrey, Jackson, and Turner (four Royal Academicians), to the Venetian Academy of Painting (where Canova first

studied when he came to Rome), and saw the naked model, — a very noble figure of a man, who threw himself into the attitudes of the various ancient statues with striking effect. From thence we all went to the Academy of St Luke's, where there were near a hundred students, drawing and modelling from another naked figure, not quite so good as the former.

Turner's own academy sketches of *c.* 1800-4 show the model taking up the poses of famous antique statues in just this way and he was strongly in favour of prolonged study of the nude.[30] He acted as Visitor to the Life Class at the Royal Academy for a total of eight years between 1812 and 1838.[31] With his passionate involvement with the Royal Academy, he would have been greatly interested to see other academies at work, and to find that teaching methods in Rome were similar to those in London.

The English artists' visit to the Academy of St Luke had another significance apart from this, which is not mentioned by Tom Moore. Through the good offices of Canova, Perpetual President of the Academy, Turner, Chantrey and Jackson were all proposed and elected honorary Academicians. On 15 November Canova wrote to the Secretary asking for the immediate issue of the diplomas for Chantrey and Jackson who were about to leave Rome.[32] Turner himself was elected Accademico di Onore at the Congregation of 21 November, writing to Canova on 27 November to thank him for his recommendation.[33] Membership of the Academy of St Luke afforded Turner much satisfaction and he described himself grandly in the Royal Academy catalogue as 'Professor of Perspective, Member of the Roman Academy of St Luke' when he exhibited *Rome, from the Vatican* in 1820. He may then have been indulging in a piece of friendly rivalry with Lawrence who was by now the President of the Royal Academy and consequently appended a whole string of titles to his name in the catalogue;[34] but he also described himself as 'Membro dell'Accademia Reale di Londra e di quella di S. Luca in Roma' in the advertisements for his own exhibition in Rome in 1828.[35] However, although Turner quite rightly regarded himself as a member of the Academy of St Luke, he was only an honorary Academician and not an Accademico di Merito like Benjamin West, Flaxman or Lawrence.[36] This was entirely due to the circumstances of the Academy itself which already had its full complement of Accademici di Merito.[37] Turner's visit to Rome unfortunately coincided with a period when many artists could only be honorary members of their own academy, a category of membership which at other times was bestowed on heads of church or state or patrons of the arts.

As a foreigner only briefly resident in Rome Turner was unable to participate much in its artistic life in 1819. The return of British artists to the city after Waterloo had only just begun: Eastlake had arrived in 1816, Seymour Kirkup and J. B. Lane by 1817 and the Irish painter James Atkins in 1819. It was not until the early 1820s that the number of British artists living there swelled to the fifteen or so who met regularly and, resentful of the cultural pre-eminence of the Villa Medici and irritated at having to attend foreign classes for study, formed the British Academy of Arts in Rome (1823).[38] In 1819, there was no core of British artists to which Turner could have attached himself, and apart from Canova and Eastlake, the people with whom he had contact were visitors like himself. But Eastlake's rooms at 12 Piazza Mignanelli, a tall house on the southern flank of the Spanish Steps, were filled with activity. Captain Thomas Graham, RN and his wife Maria, whom Eastlake had met in Malta in 1818, were also living in the house and Lawrence began a portrait of Maria in Eastlake's studio.[39] Turner himself was to live and work at 12 Piazza Mignanelli on his second visit to Rome in 1828. His evenings there in 1819 must have provided him with an agreeable foretaste of its charms.

Chapter 6

THE LANDSCAPE OF ANTIQUITY: TIVOLI, NAPLES, THE ALBAN HILLS

All foreign visitors to Italy were eager to explore its countryside. Two excursions were particularly *de rigueur* — to Tivoli, in the mountains east of Rome, and the longer journey south to Naples through the Alban hills. All these areas had by now influenced several generations of artists and were to affect Turner no less profoundly.

Naturally enough, he was frequently occupied in studying Roman antiquities — the outward and visible signs that he was indeed on classic ground. He also looked closely at the countryside, and must have shared the feeling of the Welsh artist Thomas Jones that both Tivoli and Latium seem 'formed in a peculiar manner by Nature for the Study of the Landscape-Painter'.[1] As Jones had observed in the 1770s, 'the characters of both are perfectly distinct and in a manner Opposite':[2]

> About Frescati, Albano, Castello, L'aricci, Gensano &c are to be seen Groves & Walks of the finest and most luxuriant forest Trees imaginable — The Ilex, Chessnut, Plane, Oak & Wallnut grow to an Amazing Size, to which we may add the Noble Pines & Cypresses which are planted in the Gardens & Vineyards. — The Waters of the two Lakes, still & transparent — reflect as in a mirrour, the verdure of their shady Margins — The hills gently swelling — Turrets and Cupolas are seen emerging from their tufted Summits — and the prospect terminated either by a vast expanse of Sea, the flat *Campagna,* losing its horizon in the Atmosphere — or the rugged *Appenines* whose lofty Summits are covered with Snow — At Tivoli — the foaming Torrents rush down the Precipices into the deep Abyss with a fearful Noise and horrid Grandeur — The immense Masses of Stone rise abrupt — luxuriantly fringed with Shrubs, and crowned with antique towers and Temples — Where the perpendicular & hanging Sides admit of no vegetation, & you discover the naked Rock — the Eye is charmed with the most beautiful variegated Tints. . . . But here is wanting the large Umbrageous Tree — to deck the foreground — The Plantations being chiefly Olive, which growing Thin & stragling, cast not the Venerable Shade of the Forest — though, in the distance — they have a good Effect — In short — Gasper Poussin seems to have form'd his Style from this Country, and Claude Lorraine, from the Other.

Turner's sketches around Tivoli and Albano record and celebrate all these features and show his own sensitivity to the differences between the two areas. Although he himself had 'form'd his Style' through study of Claude rather than Gaspar Dughet, it was the chiaroscuro of the more exciting and varied Tivoli landscape that really captured his interest in 1819 (Plates 75 and 76), not the placid beauty of the Alban hills. He may have spent the same amount of time in each area, but he sketched much more intensively at Tivoli and seems to have fallen completely under its spell.

Nearly forty years after Thomas Jones's visit to Tivoli, Samuel Rogers saw it rather differently — with the poet's all-embracing eye rather than the landscape painter's more specialised one: 'How rich in associations is Tivoli. Horace & Catullus, Claude & Poussin have given it a lustre not its own, yet in itself it is a gem of the first order . . . the most classically beautiful, the most romantic, the gayest scene in the world!'[3] The unique appeal of Tivoli lay in its combination of natural beauty and wide historical connections: its

75. Tivoli (*T*, 2), pencil on white paper prepared with a grey wash, with lights rubbed out, 8 × 10 in.

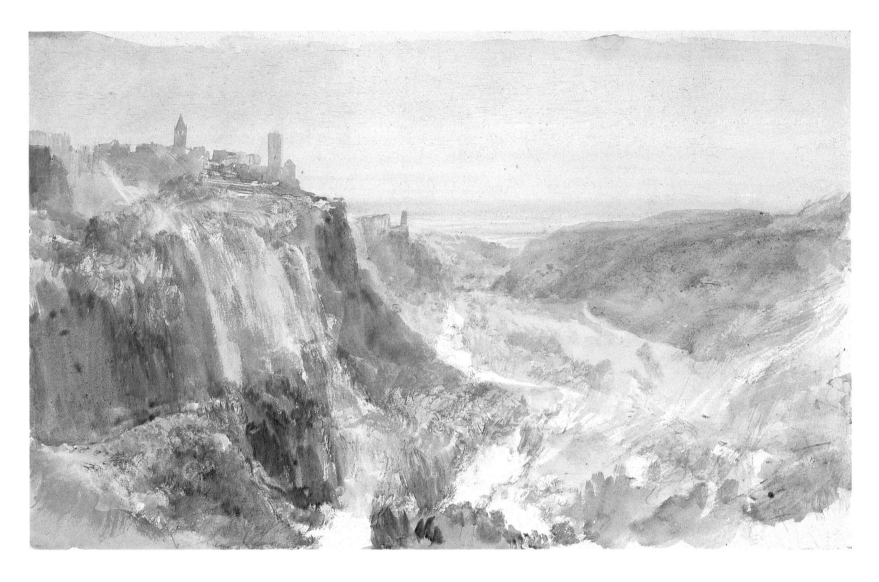

Colour Plate 13. Tivoli,
1819 (*NRCSt*, 32), pencil
and watercolour, 10 × 16 in.

76. Tivoli (*NRCSt*, 28),
pencil and watercolour,
10 × 16 in.

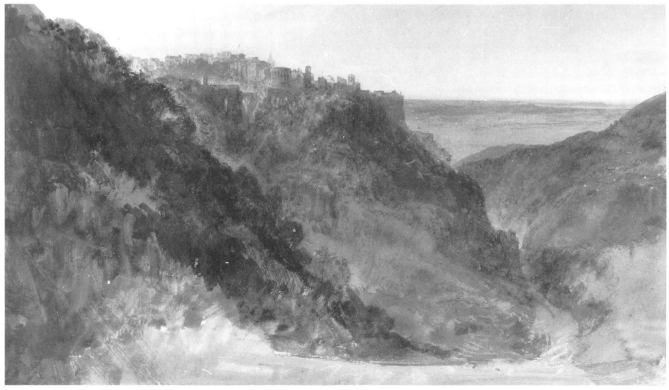

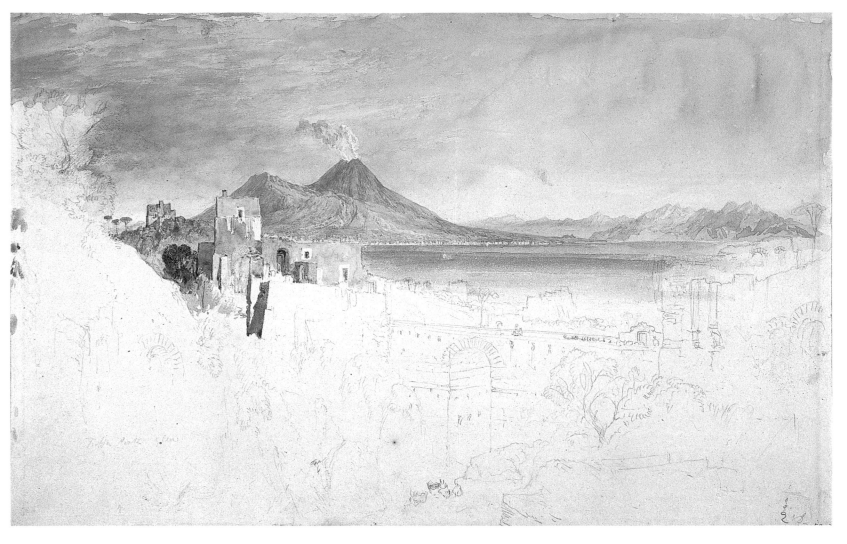

Colour Plate 14. Vesuvius, 1819 (*NRCSt*, 18), pencil, partly finished in watercolour, 10 × 16 in.

mountains and cascades had been commemorated by some of the most revered of the Latin poets and were familiar through the works of the greatest seventeenth-century landscape painters. In the eighteenth century the site continued to be very popular with foreign artists and inspired many scenes by British painters such as J. R. Cozens, Jonathan Skelton and Francis Towne.[4] None, however, was quite so captivated by Tivoli as Turner; none was so concerned with all its aspects. The number of sketches he made there — almost two complete sketchbooks — testifies to his delight in its beauty; his annotation of his sketches with the names of Claude and Gaspar Dughet shows his recollection of them at the very spots they had painted;[5] and if he did not call to mind the verses of Horace and Catullus, his sketches of the Temple of Vesta and his survey of Hadrian's Villa show his abiding concern with the classical past.

If Turner expressed his pleasure at Tivoli to Lawrence when he returned to Rome, it would have come as no surprise to the older painter. It was at Tivoli, in June 1819, that Lawrence had been so much reminded of Turner's work, and so determined that Turner should come to Italy himself, that he wrote home:[6]

Such a union of the highly and varied picturesque, the beautiful, grand, and sublime, in scenery and effect, I hardly imagined could exist ... it is infinitely beyond every conception I had formed of it, although so many fine pictures, by Gaspar and others, have been painted from it. The only person who, comparatively, could do it justice would be Turner, who *(I write the true impression on my eye and on my mind)* approaches, in the *highest* BEAUTIES of his noble works, nearer to the fine lines of composition, to the effects, and exquisite combinations of colour, in the country through which I have passed, and that is now before me, than even Claude himself. I now speak the clear

74

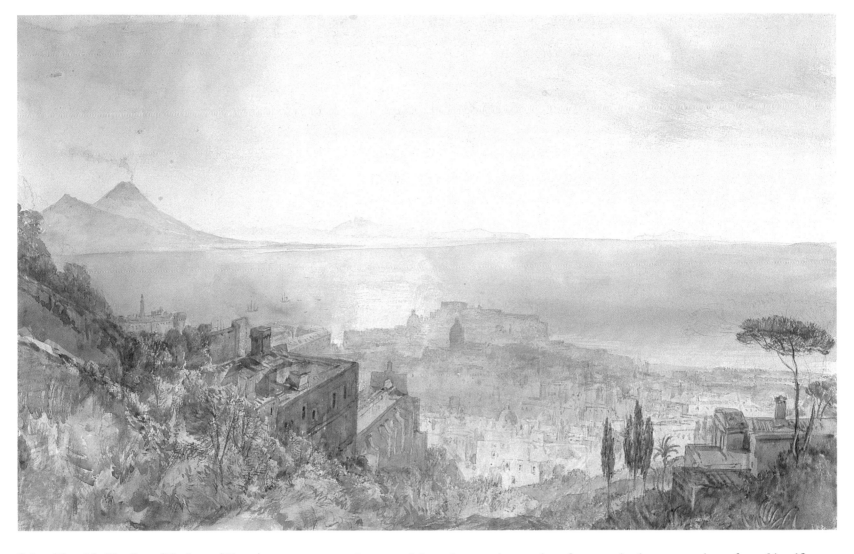

Colour Plate 15. The Bay of Naples and Vesuvius, 1819 (*NRCSt*, 13), pencil and watercolour, 10 × 16 in.

remembrance of those impressions, when frequently the comparison *forced* itself upon me.

Lawrence may well have been reminded of Turner at Tivoli because the latter had very recently exhibited the large watercolour *Landscape: Composition of Tivoli* (RA, 1818) which uses the famous motifs of the Temple of Vesta and the cascades in an imaginary romantic setting.[7] But this watercolour was not Turner's only depiction of Tivoli before his visit: many years earlier, probably around 1798, he had made a copy of one of Wilson's paintings of the site.[8] Turner's prolific sketches in 1819 would certainly have made possible a further painting of Tivoli such as Lawrence hoped for. As in Rome, he traversed the terrain thoroughly, studying Tivoli from near and far in every direction. He sketched the town's antiquities, studying architectural details and pacing out dimensions; he walked or drove to the best viewpoints nearby like the sanctuary of Quintiliolo opposite the Villa of Maecenas. He explored the grounds of the Villa d'Este; he descended into the grottoes of the Villa Gregoriana. As in Rome, he collected rough sketches in a small sketchbook with white pages *(Tivoli and Rome)* and made more composed studies in a larger sketchbook with grey-washed pages *(Tivoli)*. He also used eight of the large pages in *Naples: Rome. C. Studies*. However, Lawrence's hopes that Turner would paint Tivoli were not realised. Perhaps Turner, like Samuel Rogers, felt that 'the many falls, & the many turns of this magnificent glen[,] presenting a thousand pictures, have been so often painted, why add more?'[9]

Turner's excursion probably took place early in October.[10] It began with several hours' drive through a flat and desolate area of the Campagna and he only began sketching just before Tivoli itself, at the Ponte Lucano and the Tomb of the Plautii. Here the carriage

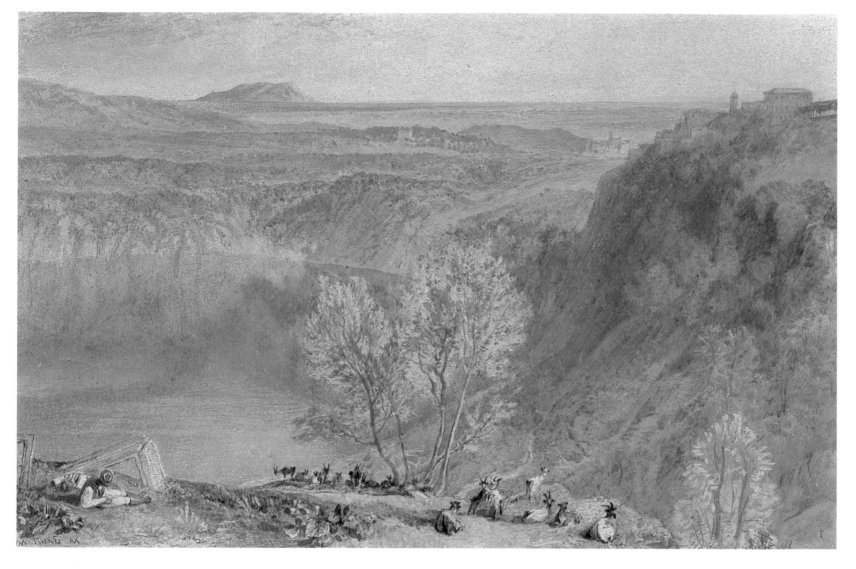

Colour Plate 16. *Lake Nemi, c.* 1818 (W, 711),
watercolour, $5\frac{1}{2} \times 8\frac{1}{2}$ in., private collection

stopped and he was able to make a number of careful sketches of this very picturesque
ensemble as well as those he had made in the carriage from the moment the bridge first
came into sight.[11] At this point he could have gone directly to Tivoli, but instead he took the
road to Hadrian's Villa where he continued sketching avidly, though rather hastily. He
managed to sketch all the most impressive buildings and to explore as far as the Serapeum
at the southern end of the Canopus.[12] These sketches are only very quick memoranda,
literally flung on to the page, but they manifest many characteristic features. Choosing the
most extensive and imposing of the ruins — the Large Baths and the adjacent Praetorium
— he made sketch after sketch from slightly different angles. Other sketches show the
Greek Library towering over the complicated forms of the Maritime Theatre, so that the
ruins appear precariously piled up for the spectator's gaze.[13] Turner's sketches of
Hadrian's Villa contain little detail, but they express very clearly his response to its drama
and monumental grandeur. When, a few weeks later, he sketched the well-preserved
symmetrical temples at Paestum, he chose ingenious viewpoints for himself in order to
increase the interest and scope of his sketches. At Hadrian's Villa, however, he was
stimulated by the picturesquely irregular patterns made by the ruins as they stood, and he
enjoyed combining and recombining them into different groups.

When Turner reached Tivoli itself, he visited the sixteenth-century Villa d'Este, but he
spared hardly a glance for its rather severe exterior (then regarded as architecturally
unattractive); he concentrated his attention on the superb views from the grounds and on
the gardens themselves.[14] However, all these subjects were of only passing interest, for
there was so much else on which to feast his eyes: the olive-clad hills and stony cliffs, the

sparkling cascades and dark grottoes, the town perched high above the falls, the silhouettes of buildings seen against the sky, the low sweep of the Campagna to the west. The small sketches record the 'Foam illuminated by sunshine' noted by Rogers — one sketch bears the words 'Spray in Light' — and they capture the 'cypresses, rock, foam, catching lights & brown shadows' by means of looping outlines, diagonal hatching, long vertical scribbled lines and shading with the side of the pencil (Plate 77).[15] They also record *contrejour* effects of the hillside against the 'orange' sky of the sunset.[16] Apart from sun and sky, however, brightness is not a characteristic feature of the Tivoli landscape with its grey mountains, softly coloured olive trees and dusky cypresses. The entire scene is often veiled in haze or mist that tints mountains, buildings and trees alike with countless tones of grey. This phenomenon may well have stimulated Turner to make good use of his large *Tivoli* sketchbook, where he achieved a great subtlety of chiaroscuro effects on its grey-prepared pages. Here he varied not only his handling of the pencil but also his lifting of the grey tint: he removed it in broad sweeps for clouds or a foaming cascade; in diagonal zigzags for a rocky hillside; with flickering touches for the light on a distant building (Plates 75 and 78).[17] He rarely used the scratching out found in the grey Roman sketches, but this technique is not missed in the *Tivoli* sketchbook with its wide-ranging effects from water white as snow to the blackness of the grottoes.

77. Tivoli (*T and R*, 49a), pencil, 4⅜ × 7⅜ in.

78. Tivoli (*T*, 6), pencil on white paper prepared with a grey wash, with lights rubbed out, 8 × 10 in.

Unlike Eastlake, who made a number of oil sketches at Tivoli earlier in 1819, Turner only made two coloured sketches there, using watercolour over pencil on white paper. These sketches, like many of the coloured Roman views, concentrate on light and shade and are rich in textural effects through their vigorous handling of paint and the use of fingerprints (Colour Plate 13 and Plate 76). However, they are unlike most of the coloured sketches of Rome in using white paper and pure watercolour. In Rome Turner consistently varied his tools to suit his subject, choosing mixed media on grey-prepared paper for the city and buildings, and watercolour on white paper for the adjacent countryside: he obviously felt that the more substantial subjects called for rich and dense treatment, while the landscape and atmosphere of the Campagna needed a subtler, lighter touch. Following the same principle, his coloured studies at both Tivoli and Naples were drawn on white paper in pure watercolour.

Turner's delight at Tivoli led him to mention it when talking to friends on his return home,[18] but his sketches did not lead to a painting. In 1826-7 he illustrated the Temple of Vesta in a minute vignette for Rogers's *Italy*, which includes only a fraction of all the data he had collected in 1819.[19] In the 1830s he used Tivoli material in two oil paintings, the unfinished *Tivoli: Tobias and the Angel* (c. 1835?; Colour Plate 38) and *Modern Italy—the Pifferari* (RA, 1838; Plate 172). By now, however, he was no longer very interested in topographical painting, and he did not make direct use of his earlier sketches. The themes of the two pictures go far beyond the world of 'Horace & Catullus, Claude & Poussin' which had neatly summed up Tivoli for Rogers; classical antiquity is barely discernible and one tree alone retains a Claudian profile. These are typical late Turner paintings, imaginative not descriptive, visions of Italy rather than views. Ruskin wrote disparagingly of *Modern Italy — the Pifferari*: 'it is composed from Tivoli material, enriched and arranged most dexterously, but it has the look of a rich arrangement, and not the virtue of the real thing'. The judgment is subjective; the analysis quite correct.[20]

★　　★　　★　　★

Although Turner's second visit to Italy in 1828 took him back to Tivoli,[21] there is nothing to suggest that he returned to Naples. His exploration of that region belongs entirely to 1819, when it played a very important role in his tour since Naples and its environs provided countless delights for both the eye and the imagination. Visiting the submerged and overgrown ruins at Baiae, the tomb of Virgil overlooking the Bay of Naples, the bosky shores of Lake Avernus where Aeneas had descended into the Underworld, or the recently rediscovered silent streets of Pompeii beneath the slopes of Vesuvius, the modern traveller could feel that he was well and truly 'surrounded by memorials of the rulers of the world; . . . as much among Romans as we should be if we were at Rome itself'.[22] Such an unparalleled and intoxicating mixture of natural beauty and history was a great inducement to foreigners to spend a long time exploring southern Italy. Many, like J. R. Cozens and William Beckford in 1782, stayed for months; some stayed for years. Turner himself spent just over a month enjoying Italy south of Rome. On 6 October Lawrence wrote to Farington that Turner 'is going immediately to Naples' — a plan which is confirmed by '12 Oct' scribbled on one of his sketches of Terracina; the final part of his return journey to Rome included 9-11 November when he made dated sketches near Albano.[23] It is easy to imagine how this month was spent: travelling itself would have occupied the best part of two weeks — four days from Rome to Naples, from Naples to Paestum a couple more[24] — while the number of Turner's sketches in and near Naples suggests a stay there of at least a fortnight.

A general idea of Turner's journeys in southern Italy is provided by his pencil sketches in the four sketchbooks *Gandolfo to Naples*; *Pompeii, Amalfi, Sorrento and Herculaneum*; *Naples, Paestum, and Rome* and *Albano, Nemi, Rome*, all measuring c. 4½ by 7½ inches like many of the others used in 1819. These sketches indicate his route down to Paestum and back fairly clearly, but it is not so easy to establish the minor details of his tour and his movements around Naples. It seems reasonable to believe that he labelled his second

sketchbook *Pompeii, Amalfi, Sorrento and Herculaneum* because it recorded a clockwise tour in which he visited these places in this particular order, but it is not clear whether such a tour took place before or after (or was even part of) the visit to Paestum.[25] Similarly, the numerous sketches of the beauty spots west of Naples may perhaps represent a single tour of that area, though Turner, like many other tourists in Naples, could equally well have made separate day excursions to all the different attractions.[26] Nor is it known where in Naples Turner stayed.[27] What is clear, however, is the more important fact that he visited and studied virtually everything that the region had to offer.

Turner's sketches between Rome and Naples show that he took the shortest, best and most frequented road. These were important considerations for this journey was still regarded as the most dangerous in the country for robbery and brigandage, as it had been for centuries past.[28] His journey began by providing him with a first glimpse of the lakes of Albano and Nemi, though few opportunities for sketching.[29] Soon afterwards a long, straight, tree-lined road took him through the Pontine marshes to the coast at Terracina. This road offered little of interest to sketch,[30] but after the marshes there were many attractive subjects. At Terracina, he sketched the dramatic cliffs and rock at the water's edge and climbed 800 feet to draw the ancient arcades perched high above the sea and the extensive view of the coast and Monte Circeo.[31] Then the road took him inland again, through Fondi, with its huge medieval castle, and past the precipitous hilltown of Itri with its steeply ascending walls and its castle; soon the road rejoined the coastline, providing beautiful views of the Gulf of Gaeta.[32] There were antiquities such as Cicero's tomb near Formia and the aqueduct of Minturnus; often, too, there were gaily clad country people riding ponies or carrying bundles on their heads.[33] As usual, Turner made many of his sketches from the moving carriage, but he did not neglect the opportunities for more ambitious sketching when the carriage halted at a town such as Capua.[34]

In spite of its title (given to it by Turner himself), the *Gandolfo to Naples* sketchbook is largely devoted not to his journey but to his exploration of Naples and its environs. He visited Cumae and Lake Avernus, Pozzuoli with its Temple of Serapis and the remains of Caligula's mole, the Bay of Baiae with its ruined villas and so-called 'temples' (which are more probably baths); he made the ascent of Vesuvius, where a shower of hot ash spattered some of his sketches of Baiae, and he surveyed the Bay of Naples from its heights. Like many a northerner visiting this area for the first time, he was delighted by its unfamiliar flora and he filled a page with sketches of plants and flowers; he studied many of the impressive buildings of Naples (Plate 79) and its picturesque sea front.[35] Many of these scenes he already knew very well at second hand, for around 1814-15 he had produced an oil painting of Lake Avernus with Aeneas and the Sibyl (a theme he had first treated in 1798: see Colour Plate 1 and Plate 2); and a few years later he had painted a watercolour of Naples from the mole for Hakewill's *Picturesque Tour of Italy* and his three finished watercolours of Vesuvius.[36] Turner's sketches of all these subjects in 1819 display his keen interest and pleasure in at last seeing them for himself. He made numerous rough sketches of precisely the view of Lake Avernus looking south to Baiae and Cape Misenum that he had already shown so beautifully in his two oil paintings: its balancing rhythms of hills and promontory, lake and sea formed a most satisfying composition.[37]

Of Turner's three watercolours of Vesuvius, those in New Haven (dated 1817) and Birkenhead (1817-18; Plate 80) depict the volcano in eruption and celebrate the infinite energy of nature in a dazzling display of red and gold. As will appear shortly, the Birkenhead version was intended for engraving in a work on Pompeii: recent advances in the excavations there, together with the fact that Vesuvius passed through an extended phase of volcanic activity during 1817-19, made it (or rather, should have made it) the perfect moment for such a publishing venture. Like Wright of Derby in 1774, Turner must eagerly have hoped that he would witness an eruption of Vesuvius while he was in southern Italy, but he was less lucky than Wright had been. The main eruption of autumn 1819 occurred late in November after he had gone back to Rome, and there is no evidence in his sketchbooks to suggest that he saw any spectacular volcanic effects.[38] The 1819 sketches of

79. Castelnuovo and the Arco del Trionfo, Naples (*G to N*, 63a), pencil, from a page 4¾ × 7¾ in.

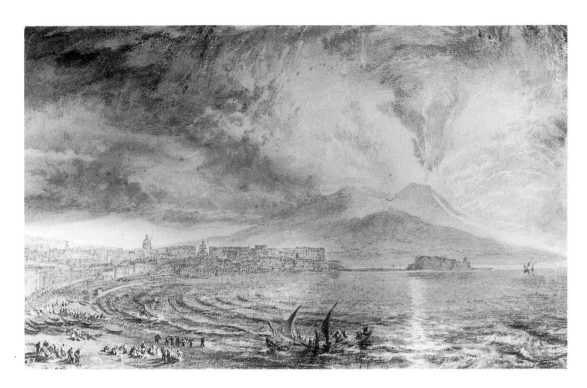

80. *Bay of Naples (Vesuvius angry)*, 1817-18 (W, 698), watercolour, 7 × 11¼ in., Williamson Art Gallery & Museum, Birkenhead

Vesuvius, like his third finished watercolour, show the mountain as a gentle giant, powerful but slumbering. It appears thus in one of a handful of large sketches in watercolour on white paper made in and around Naples (Colour Plate 14).[39] Here, as in Tivoli, Turner used pure watercolour rather than the mixed media he favoured in Rome, and his coloured sketches of the Neapolitan sea, sky and coastline have a transparent brilliance wholly suited to the pure and sparkling atmosphere of the region (Colour Plate 15). However, his sketching practice in Naples was similar to that in Rome in one respect. Here again there are sketches that are roughly coloured all over with small areas of detail here and there; other sketches contain detailed passages in watercolour, while the rest of the page has not been coloured at all. In Colour Plate 14 a silken veil of colour has been cast over part of a rough pencil sketch. Shabby, forlorn-looking houses are transformed into golden dwellings. Vesuvius is serenely poised between sea and sky, emitting soft puffs of smoke to merge with the clouds, and every fissure in its rocky side is clearly defined by light and shade. But Turner has entirely lost interest in the foreground.

When this drawing was exhibited at the National Gallery in 1881 it was described by Ruskin as a 'beginning of a finished drawing' and although this is not very likely, it is easy to see why he thought so.[40] Vesuvius is a much more finished piece of painting than anything else Turner depicted in 1819. The watercolour also provides an illustration of Turner's use of colour which may be considered in relation to one of Ruskin's claims in the first volume of *Modern Painters*:[41]

> In the whole range of Turner's works . . . you will not find an instance of anything near enough to have details visible, painted in sky blue. Wherever Turner gives blue, there he gives atmosphere: it is air, not object. Blue he gives to his sea; so does nature; — blue he gives, sapphire-deep, to his extreme distance; so does nature; — blue he gives to the misty shadows and hollows of his hills; so does nature; but blue he gives *not*, where detail and illumined surface are visible.

This passage, too, contains a Ruskinian misconception — understandably so, since in 1843 his knowledge of Turner's work was still fairly limited. The sketches in *Naples: Rome. C. Studies* show that Turner's use of blue for his distances was extremely varied and it did, in fact, embrace both air and objects.

Turner himself made the long, laborious and hazardous ascent of Vesuvius with two other travellers, one of whom was the young architect Thomas Leverton Donaldson (1795-

1885).[42] He seems simply to have asked if he could join their party and it was probably now that he acquired the round snuff-box made from lava from Vesuvius which he reputedly used as a palette in Italy and subsequently gave to his friend James Holworthy.[43] Donaldson later recalled that in the course of their excursion Turner 'made a coloured sketch of the sky, which he did not show to his companions'. This sketch is not immediately identifiable in Turner's sketchbooks, and it is just possible that Donaldson merely saw Turner making one of the pencil sketches of the Bay of Naples from Vesuvius which feature in the *Gandolfo to Naples* sketchbook.[44] However, it has recently been suggested that a sketchbook almost entirely devoted to sky studies and independently datable to the years between 1818 and 1822 — the *Skies* sketchbook — was probably used in Italy in 1819.[45] Its richly coloured, boldly painted studies of clouds and sunsets are certainly close in style to those sketched in the *Small Roman C. Studies* sketchbook, which makes it very tempting to believe that it was used by Turner on Vesuvius and that Donaldson's recollections are trustworthy.

Turner also joined Donaldson in dining with the British Minister in Naples,[46] and he may well have met him again in Rome, for the architect wrote his Roman address into one of Turner's sketchbooks.[47] There is a further link, too, between them, for both were connected, in very different ways, with a contemporary book on Pompeii. This may conveniently be considered here.

* * * *

The history of 'DELINEATIONS of the celebrated CITY OF POMPEII; consisting of Forty Picturesque Views, on a large scale, from accurate Drawings made in the Year 1817. By MAJOR COCKBURN, of the Royal Artillery'[48] has several points in common with that of Hakewill's *Picturesque Tour of Italy*. James Pattison Cockburn (1779?-1847) was an ex-pupil of Paul Sandby at the Royal Military Academy at Woolwich who became an accomplished artist, publishing several books of Italian and Swiss views in the 1820s.[49] *Delineations of Pompeii* was issued by John Murray as a part-work, but it fell into serious trouble, for after Parts I and II had been published, probably in March and December 1819, it ceased publication.[50] Murray withdrew from the scheme and it was announced in February 1820 that future parts would be published jointly by Rodwell & Martin, J. & A. Arch and W. B. Cooke.[51] However, Parts III and IV never appeared, and nor did the 'highly finished engraving of Mount Vesuvius, in a state of Eruption, from a powerful Drawing by J. M. W. Turner, R.A.' (Plate 80) which had been promised for Part III.[52] In February 1822, Turner's watercolour was exhibited by W. B. Cooke at his Soho Square gallery, together with its pendant *Bay of Naples, with Vesuvius; Morning,*[53] and in the exhibition catalogue Cooke indulged in a long piece of advance publicity for the conclusion of the *Delineations*, mentioning that Turner's scene would form its frontispiece. All the same, it was not until the summer of 1827 that the project was completed and a folio book published: Cooke complained to John Murray that 'all my other works . . . have not *altogether* cost me half the trouble and exertion as that of Pompeii'.[54] The new book, which incorporated material from Parts I and II, included letterpress written by T. L. Donaldson, who was too young to have figured in its earlier history (it is conceivable that Turner introduced Donaldson to Cooke), but it did not contain Turner's long-awaited depiction of Vesuvius. Instead, the frontispiece was an engraving after a drawing by John Martin of an eruption of Vesuvius in 1822. Martin had recently enjoyed a great success with his huge oil painting, *The Destruction of Pompeii and Herculaneum* (1822), exhibited that same year at the Egyptian Hall, Piccadilly, and Cooke's move to replace Turner's frontispiece with one by John Martin was undoubtedly a piece of shrewd opportunism.

Turner's drawing was nevertheless published very soon afterwards, in Smith & Elder's *Friendship's Offering for 1830.*[55] Many years later it was acquired by Ruskin who took particular pleasure in owning it 'because the engraving from it was the first piece of Turner I ever saw . . . when I was a mere boy'.[56] If Ruskin's enjoyment of the engraving dated from

its first publication, for the Christmas of 1829, the seeds of his appreciation of Turner were really sown over two years before he received Rogers's *Italy* on his thirteenth birthday in February 1832, a gift which is generally regarded as the inspiration of his interest.[57] However, his own remarks show that he loved the Vesuvius engraving at a more childish level of understanding than the Rogers scenes. 'What between my love of volcanoes, and geology, . . . I used to feast on that engraving every evening for months, and return to it again and again for years, before I knew anything either about drawing, or Turner, or myself.' By contrast, 'I had no sooner cast eyes on the Rogers vignettes than I took them for my only masters, and set myself to imitate them as far as I possibly could by fine pen shading.'[58] It could well have been the young Ruskin's attachment to the single Turner image in *Friendship's Offering* that led his father's friend to give him a book with further illustrations by the same artist. If this is so, it was a happy chance indeed that rescued Turner's *Vesuvius* from a grand and rather specialised volume on Pompeii and gave it to the general public in the small and popular pages of *Friendship's Offering*.[59]

<div style="text-align:center">★ ★ ★ ★</div>

Turner's own visit to Pompeii in 1819 is recorded in about thirty pages of sketches, some no more than quick memoranda, some very detailed and featuring lengthy Latin inscriptions and intricate architectural mouldings.[60] At Pompeii, as elsewhere, he often focused his attention closely on one small area, making sketches of it from many different directions; and he would often stand at the edge of the road or near the corner of a building to gain an asymmetrical composition. This was the case in the Street of the Tombs, for example, where he looked up towards the Herculaneum Gate from both verges, across the street in both directions, and down the street. The same tombs appear again and again, now in detail, now in rapid outline (Plate 81). Equally characteristic was the way in which he climbed among the ruins to get more extensive views of his subject.[61] Turner did not label any of his sketches of Pompeii, which suggests that he did not have a companion or the benefit of a guide. He nevertheless explored the site with his usual thoroughness, from the Street of the Tombs at the west to the amphitheatre at the east, and recorded not only the remains of mighty buildings but also the pathetic groups of abandoned domestic utensils: as Stendhal remarked, 'no other sight on earth can furnish such *understanding* of antiquity'.[62]

Whereas Pompeii had been extensively excavated by 1819 (notably by the French in 1799-1815), there was still not much to see at Herculaneum. Visitors could do little more than stumble down a flight of steps by torchlight and peer around a few half-excavated subterranean passages.[63] Turner's sketchbook records his visit in a handful of scribbled pages which look very much as if he was working in near-darkness and they amply confirm

81. Pompeii: the Street of the Tombs (*PASH*, 5a-6), pencil, each page 4½ × 7½ in.

his contemporaries' belief that there was little point in visiting the site.[64] But Turner was too compulsive a tourist to let any experience be neglected.

Baiae and Paestum, on the other hand, presented him with supremely picturesque and evocative scenes. At Baiae, the villas of the wealthy Romans lay crumbling and overgrown, the epitome of grandeur turned to ruin, of pride laid low; at Paestum, three of the most imposing of the temples of the ancient world stood firm between the mountains and the sea. The range of meanings embraced by Turner's 1823 oil painting *The Bay of Baiae* and its relationship to his on-the-spot sketches will be discussed in a later chapter of this book. However, it must be noted in the present chapter that Turner paid considerable attention to Baiae in 1819: this may well indicate that he was already intending to paint it.[65] The bay itself had attracted many earlier artists including Claude and Wilson, while the tree-clad hills enclosing it in a natural theatre provided a perfect setting for historical subject matter. Turner had read Eustace's *Tour through Italy* in 1818-19, while preparing for his own visit. Since he had only recently painted the second of his two Carthaginian 'rise and fall' pictures, *Dido building Carthage* (1815) and *The Decline of the Carthaginian Empire* (1817), he must surely have noticed Eustace's long and eloquent passage on a parallel theme:[66]

> *Baiae* became the receptacle of profligacy and effeminacy, of lust and cruelty, as far beyond the bounds of nature as the power of the imperial monsters was above human control. The beauties of nature were tarnished by the foulness of vice, and the virtuous man turned away from scenes which he could not behold without disgust and horror . . . *Baiae* and its retreats, defiled by obscenity, and stained with blood, were doomed to devastation; and earthquakes, war and pestilence were employed in succession to waste its fields, and depopulate its shores. Its pompous villas were gradually levelled in the dust; its wanton alcoves swallowed up in the sea; its salubrious waters were turned into pools of infection; and its gales that once breathed health and perfume, now wafted poison and death. The towns forsaken by the inhabitants, gradually sunk to ruin, and the most delicious region the sun beholds in his course, is now a desert, and seems destined to expiate in ages of silence and desolation the crimes of the last degenerate Romans.

Turner's sketches of the bay, the castle and the ruins by the shore may well reflect a desire to match Eustace's prose with his own *tour de force* in paint.

Paestum was the most remote historical site in southern Italy that Turner studied. Here three fifth-century Greek Doric temples had been rediscovered in the mid-eighteenth century so that Paestum, like Pompeii and Herculaneum, became the subject of great archaeological and architectural interest, but it was far less commonly visited owing to its greater distance from Naples. However, Turner was indefatigable as a traveller and there were, in any case, many inducements for him to press on. There was the dramatically sheer and rugged coastline of the Sorrento peninsula which he would already have known from the drawings of J. R. Cozens: Turner drew pages of tiny sketches of this spectacular scenery when he returned from Paestum to Naples by boat (Plate 82).[67] The temples themselves were familiar to him both from Cozens's drawings and from the series of fifteen late Piranesi drawings owned by John Soane (Plate 83).[68] Turner himself had already used an illustration of the Temple of Neptune in his Perspective Lectures.[69] Furthermore, Hakewill had included Paestum in his Italian tour and recommended Turner to do likewise.[70]

Turner can hardly have been disappointed when he reached Paestum. He made sketches of the temples standing majestically in the middle of the plain, with mountains closing the vista in three directions; he studied them individually both outside and inside.[71] A less ambitious artist would have been content simply to sketch the wonderfully preserved exteriors, as Hakewill had done: many such views of the temple group were produced as topographical prints, paintings and souvenirs. Turner, however, like Piranesi in the 1770s, chose several times to sketch inside a temple and record the experience of being surrounded by a dense forest of columns. Standing inside the Temple of Neptune — at a corner or close to one — and casting his gaze round 120 degrees or so, he sketched large parts of both its

82. The coastline of the Sorrento peninsula (*PASH*, 36), pencil, $7\frac{1}{2} \times 4\frac{1}{2}$ in.

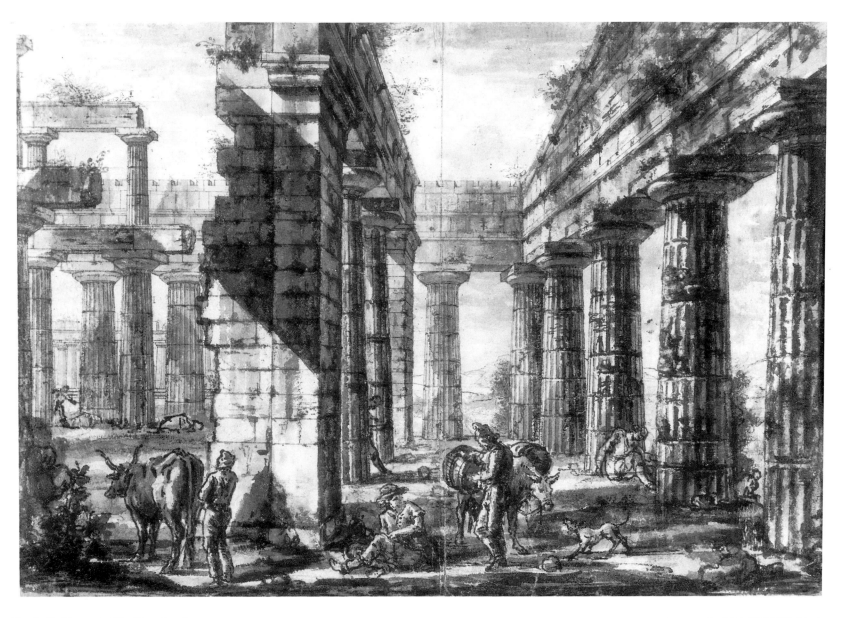

83. G. B. Piranesi, *The Temple of Neptune at Paestum*, 1778, pen and ink and wash, $18\frac{3}{4} \times 26$ in., Sir John Soane's Museum, London

84. Paestum: the Temple of Neptune with the Basilica seen in the distance (*NPR*, 43), pencil, $4\frac{1}{2} \times 7\frac{1}{2}$ in.

inner and outer colonnades, and caught a glimpse of the columns of the adjacent Basilica as well (Plate 84). In the Basilica he made a similar sketch looking towards the Temple of Neptune. Turner's fondness for a corner viewpoint and his inclusion of the maximum amount of material are familiar features in his Italian sketches. So, too, is his recollection of Piranesi's work whilst visiting the very sites that Piranesi had imprinted on his mind.

Turner collected a good deal of information at Paestum. He recorded the number of columns on each temple and noted that those of the Basilica are cigar-shaped rather than straight-sided. Curiously, however, he did not make use of his material when the opportunity arose. Eight years later, when he drew the Paestum vignette for Rogers's *Italy*, he depicted the Temple of Neptune not as he had seen it but in a restored and complete state (Plate 85). He even forgot that it was a Greek Doric temple with the unusual proportions of six by fourteen columns, and drew it as a regular Roman Doric temple with six columns on the façade and eleven along the side. This lapse of memory is a further demonstration of the influence of Piranesi's depictions of Paestum upon Turner. He would have known very well that Piranesi had constantly sought to illustrate the superiority of Roman architecture over Greek, and he must have failed to realise that Piranesi's last series of drawings was actually of Greek temples. When these drawings were published, after Piranesi's death, both text and captions played down the Hellenic origins of the temples as far as they could, emphasising that they stood on Italian soil and reflected Italian creative genius.[72]

Besides making his excursions to Vesuvius and Pompeii, Baiae and Paestum, Turner also enjoyed Naples itself and its world-famous setting. In his *Naples: Rome. C. Studies* sketchbook, which measures *c.* 16 by 10 inches, he painted a small number of watercolour sketches which capture the breath-taking beauty of sea and sky (Colour Plates 14 and 15). He also drew some of his finest and most careful pencil sketches. Sometimes he studied Naples from inland, ascending to a vantage point on the edge of the city so that its great mass was spread beneath him; sometimes he took a boat and viewed the city from the sea, as just one part of a land, sea and sky ensemble (Plates 86 and 87).[73] In Naples itself he

85. *Paestum, c.* 1827 (W, 1173), pencil and watercolour, $3\frac{1}{2} \times 6\frac{3}{4}$ in. (TB CCLXXX, 148)

86. Naples from inland (*NRCSt*, 22), pencil, 16 × 10 in.

seems to have given little thought to the classical past which was so dominant in the surrounding countryside, but devoted most of his attention to the modern city. He spared only a cursory glance for the *Farnese Bull*, which was splendidly sited on the sea front,[74] and if he visited the Museo degli Studi at all he did not sketch its masterpieces. He rarely drew the back streets of Naples, which held little attraction for visitors,[75] but both the large sketches and many of the smaller ones display his interest in the quays, waterfront and mole — Neapolitan subjects which have always attracted artists, whether Italian or foreign — and his curiosity about the boats and all the activities of the people.[76] Turner's enjoyment of every type of subject matter that presented itself to his gaze has already been

87. Naples from the sea (*NPR*, 4a-5), pencil, each page 4½ × 7½ in.

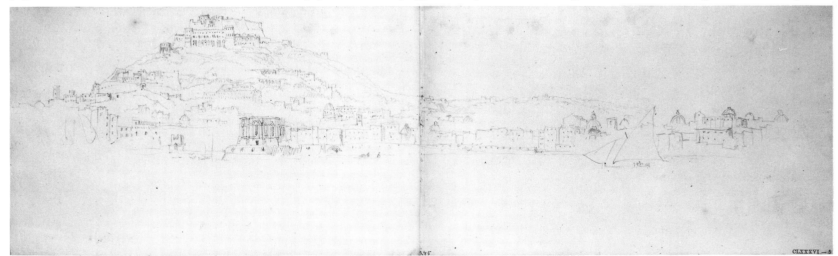

88. James Fittler after James Hakewill, *Frascati*, 1820 (from *A Picturesque Tour of Italy*), engraving, 5⅝ × 8½ in.

89. Frascati from the Villa Aldobrandini (*ANR*, 30a-1), pencil, each page 4⅜ × 7⅜ in.

noted in Chapter 2. However, the sketches discussed there were only quick records made on a journey. When he had leisure to choose his subjects, as in Rome or Naples, two characteristic interests are often to the fore: the realisation of a grand vision and a concern with the down-to-earth. One moment he is describing Neapolitan games and dances with the care of a novelist or a genre painter, the next he is drawing the entire city planted between sky and sea.[77] Whatever their topographical setting, Turner's finished paintings in both oils and watercolours often amalgamate these two interests which sprang from

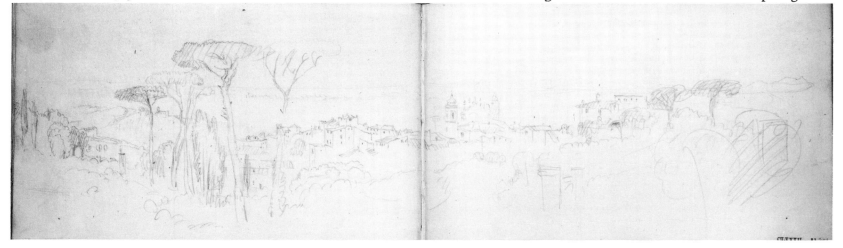

different sides of his many-faceted personality and are found separately in his sketches. One Italian example would be *Childe Harold's Pilgrimage — Italy* (1832; Colour Plate 35), in which modern-day *contadine* unconcernedly pursue their pastimes against a stunning setting of thickly overgrown hills and ruined buildings. Turner here achieves a perfect balance between his diverse ingredients. His superb rendering of the Italian countryside deliberately evokes antitheses between 'rise' and 'fall', past and present, the brevity of human life and the perennial resurgence of nature, but he rescues his painting from excessive vagueness and unreality by the inclusion of the humble everyday motifs in the foreground. The latter are, by their setting, elevated from the mundane and acquire universal significance.

On his return journey from Naples to Rome, which followed the same route as his outward one, Turner spent several days exploring Frascati and Tusculum, Ariccia, Genzano and the lakes of Albano and Nemi.[78] All these places were already familiar to him through the paintings of earlier artists including Claude, Wilson and J. R. Cozens and, even more directly, through his own copies after Cozens (e.g. Plate 1) and his watercolours of Lake Nemi (Colour Plate 16) and Ariccia for the *Picturesque Tour of Italy*. Hakewill's sketches of this area in 1816-17 show that he had found it particularly interesting and he may well have encouraged Turner to linger here. At any rate, Turner chose to sketch many of the same subjects as Hakewill, sometimes placing himself in practically the identical spot. This was the case with his panoramic view of Frascati from the terrace of the Villa Aldobrandini (Plates 88 and 89). At Ariccia, Turner sketched the Chigi Palace and Bernini's S. Maria dell'Assunzione from a spot well-loved by artists in the valley below and thus repeated the view of his own watercolour for the *Tour of Italy* (Plates 90 and 91).

On one occasion in the Alban hills, at Marino, Turner was reminded again of 'Lord Egremont's Claude', the *Jacob and Laban* at Petworth, but he seems to have been reminded far more strongly of Wilson. He annotated his sketches several times with that artist's name or comments such as 'Wilson Brown Campagna'; on seeing the site of ancient Tusculum in the distance from Frascati, he recalled Wilson's painting of Cicero and his friends at his villa, and asked himself 'where is Wilson's Picture taken from'.[79] Turner's reactions were those of many a British visitor familiar with Wilson's work. When Thomas Jones visited this area in 1776, he wrote, 'Every scene seemed anticipated in some dream — It appeared Magick land — In fact I had copied so many Studies of that Great Man, & My

91. John Pye after Turner, *La Riccia*, 1819 (R, 154), engraving, $5\frac{5}{8} \times 8\frac{3}{4}$ in.

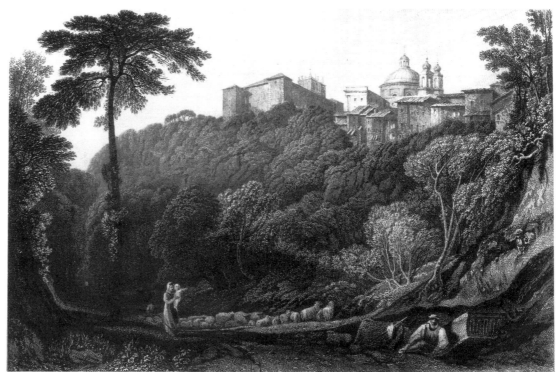

90. Ariccia: Palazzo Chigi and S. Maria dell'Assunzione (*ANR*, 82a), pencil, $4\frac{3}{4} \times 7\frac{3}{8}$ in.

CLXXXII — 10

92. Lake Albano (*ANR*, 10),
pencil, $4\frac{3}{8} \times 7\frac{3}{8}$ in.

Old Master, Richard Wilson, which he had made here as in Other parts of Italy, that I insensibly became familiarized with Italian Scenes, and enamoured of Italian forms.'[80] What is surprising is the rather small number of Turner's sketches of the Alban hills, compared to those of Tivoli, and their lack of detail. One explanation is that Turner probably spent much of his time exploring the hills on foot, an activity which was very common among artists in this neighbourhood, but never stayed long in any one place. He used dozens of viewpoints round Albano and Nemi to make quick records of the varying aspects of the lakes and configurations of the hills.[81] Moreover, he was here confronted not by the complex chiaroscuro of nature to be found at Tivoli but by a much more placid scene — smooth lakes, rolling hills and rounded masses of trees. Though beautiful, these scenes were much less compelling than others he had enjoyed on his southern tour and he sketched them very swiftly and schematically, using bold loops and rippling lines for the hillsides, rocky outcrops and bushy fringes of the lakes (Plate 92). His sketches of the Alban hills are really only memoranda and, unlike the grey Tivoli sketches, are not works of art in themselves.

This does not mean, however, that Turner did not appreciate the beauty of this part of Italy; his subsequent comments and paintings are clear proof that he did. On his return to England in 1820 he talked to Farington about his Italian tour and the latter recorded the most memorable part of their conversation in his diary: 'Tivoli, Nemi, Albano — Terni — fine'.[82] Turner celebrated the loveliness of southern Italy with splendour and brilliance in a large watercolour of Lake Albano (*c.* 1828), which looks back to Claude's painting of this subject then in the Barberini collection in Rome. He evoked it in an oil painting, *Cicero at his Villa* (1839), which predictably looks back to Wilson. At about the same date he created a glorious poetic vision of Lake Nemi in watercolour. All these works, which are discussed in the later chapters of this book, show that Turner did far more than merely take sketches of this region back home with him in his sketchbooks; his mind feasted on it for over twenty years.

Chapter 7

FAIR FLORENCE

Turner was back in Rome by the middle of November. He spent the next month sightseeing, studying and sketching until it was time to leave for home.[1] At this period the British traveller in Italy usually made a circular tour, choosing one route going southwards and another for his return, in order to enjoy as many of the famous sights as possible. Following this convention, Turner now went north to Florence, using the better of the two roads, that through Perugia and Arezzo.[2] His homeward journey, like his outward one, was made alone, for Chantrey, Jackson and Tom Moore had all started home in mid-November. Lawrence, however, left Rome at about the same time as Turner and they almost certainly met again in Florence.[3]

Turner's five- or six-day journey from Rome to Florence is recorded in the $4\frac{1}{2}$ by $7\frac{1}{2}$ inch *Rome and Florence* sketchbook. Even in mid-December he was keen to follow the changing silhouettes of the hilly landscape, to identify the places he glimpsed, to record the colours made by the sun on the mountains.[4] These sketches, however, are among the roughest and most disjointed of his entire visit and afford little scope for study. Far more important are the sketches of Florence itself which Turner made during the fortnight or so that he spent there. They contain a wealth of material which provides insights both into his earlier depictions of the city for Hakewill's *Picturesque Tour of Italy* and into his later watercolours and oil paintings.

By Turner's day Florence had been attracting the British for a long time: it had constituted an essential part of the eighteenth-century Grand Tour, for both artistic and social reasons. However, English attitudes towards the city itself were ambivalent. On the one hand, the prospect of Florence, viewed from a distance, was regarded as utterly delightful (Plate 93); on the other hand, tourists derived no enjoyment at all from walking around among the buildings of the city. In 1813 Eustace described the Tuscan style of architecture as 'dull and heavy' with a 'sullen appearance better adapted to monasteries or even prisons than to palaces' and the same sentiments were voiced by numerous travellers who followed in his footsteps.[5] On his ill-fated trip to Italy in 1816 the painter William Etty was overcome by its 'character of gloom'. After four days, he turned homewards, abandoning all thoughts of Rome.[6] In 1825 Hazlitt even went so far as to say that Florence felt like a besieged town where the plague might still be lurking.[7] It was a rare visitor who recognised that, if only the streets had been wider, people might have enjoyed the splendour of the buildings,[8] and the palaces of Florence were rarely illustrated in British literature on the city even though they played an important role in continental publications such as Zocchi's *Scelta di XXIV Vedute . . . di Firenze* (1744).

Zocchi had presented his magnificent portraits of palaces with a certain amount of artistic licence. He concentrated first and foremost on the building itself, and then added the subsidiary vistas at a suitable distance, so that streets and squares seemed broader than they really are. Of course, Turner himself was perfectly capable of such licence either when painting or when standing in the street sketching, but in Florence he sketched the palaces so rarely that he must have shared his fellow-countrymen's dislike of them. The only ones he drew were those that could be studied at a convenient distance: Palazzo Vecchio, the Pitti, and Palazzo Uguccioni on the north side of Piazza della Signoria.[9] This last building

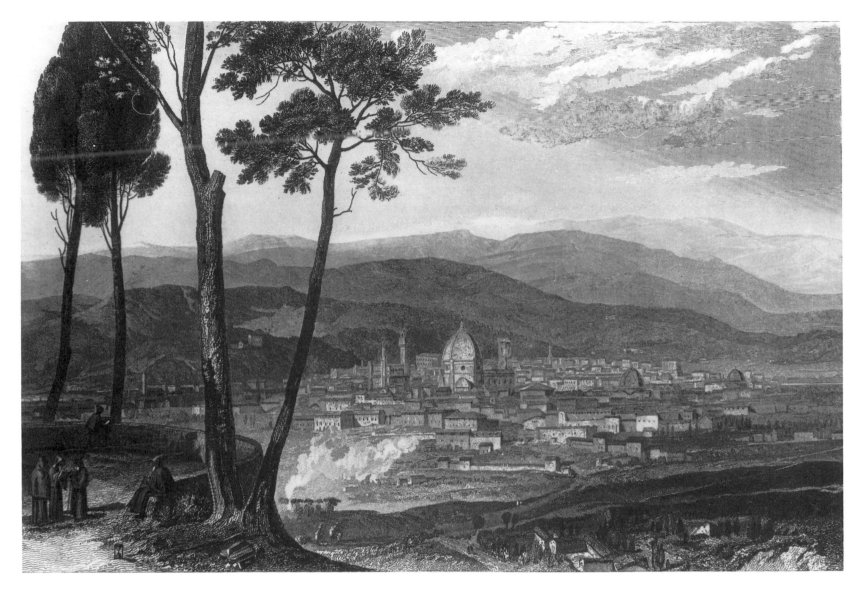

93. W. R. Smith after Turner, *Florence, from Fiesole*, 1819 (R, 159), engraving, $5\frac{5}{8} \times 8\frac{3}{4}$ in.

may seem a curious choice of subject, but Turner was probably attracted by its conspicuously Roman High Renaissance style. By now his eyes were well attuned to Roman architecture and he would have found its design more congenial than the unfamiliar Tuscan style of the other buildings round him. In addition, he probably believed that it was designed by Raphael or Michelangelo, as conflicting traditions then maintained.[10]

English visitors to Florence also disliked its cathedral. In 1819 Tom Moore and Chantrey found it tasteless and Samuel Palmer later described it as 'semi-barbarous'.[11] Turner's sketch of its bare and lofty interior is a perfunctory affair (Plate 94), and he derived more enjoyment from the ornate courtyard of Palazzo Vecchio which William Beckford had found romantic and exotic some forty years earlier (Plate 95).[12] For this last sketch, Turner chose a particularly good viewpoint: he used one column as a *repoussoir* and placed himself exactly where he could see Cellini's *Perseus* through the open doorway of the palace. Turner studied the exterior of very few churches in Florence. These, like the palaces, were not appreciated by English visitors — understandably, since many still lacked their marble facings and could truthfully be described as 'a rude pile of brick', as one guidebook wrote of S. Croce.[13] However, Turner's lack of interest in the buildings which had already been completed in marble — the campanile and the baptistery, for instance — may well have been due to feelings such as those voiced by Chantrey: 'The great object of architecture is to produce, by its different forms and projections, different pleasing effects of light and shadow: but an almost flat surface . . . which substitutes variety of colour for variety of light and shadow . . . can be only considered a large and beautiful toy.'[14]

94. The interior of Florence cathedral (*R and F*, 46), pencil, $4\frac{3}{8} \times 7\frac{1}{2}$ in.

95. The courtyard of Palazzo Vecchio (*R and F*, 69a), pencil, $4\frac{3}{8} \times 7\frac{1}{2}$ in.

Turner's 1819 sketches of the buildings of Rome were undoubtedly influenced by his knowledge of Piranesi. By contrast, he seems to have been quite unaware of Zocchi's engravings of Florence, although they could have come to his notice both in England and in Italy.[15] If Turner had known Zocchi's engraving of Vasari's long Uffizi courtyard as seen from the lungarno, for instance, one feels sure that he would have drawn that splendid perspective view for himself. As it was, he sketched the Uffizi and the Signoria from little further back than the modern entrance door to the galleries.[16]

English travellers to Florence unanimously revelled in the beauty of the city when they saw it from afar. Hazlitt's evocative description which appeared in the *Morning Chronicle* in 1825 must have echoed the feelings of countless tourists and inspired many more to visit Florence:[17]

> we came to the brow of the hill overlooking Florence, which lay under us, a scene of enchantment, a city planted in a garden, and resembling a rich and varied suburb. The whole presented a brilliant amphitheatre of hill and vale, of buildings, groves, and terraces. The circling heights were crowned with sparkling villas; the varying landscape, above or below, waved in an endless succession of olive-grounds. . . . In the midst, the Duomo and other churches raised their heads; vineyards and olive-grounds climbed the hills opposite till they joined a snowy ridge of Apennines . . .; one plantation or row of trees after another fringed the ground, like rich lace; though you saw it not, there flowed the Arno; every thing was on the noblest scale, yet finished in the minutest part — the perfection of nature and of art, populous, splendid, full of life, yet simple, airy, embowered. . . . the view . . . is, indeed, quite delicious.

This wonder and delight was a far cry from the fear and *Angst* which English tourists experienced in the city itself, and it is easy to understand why British books on Italy depicted Florence almost exclusively in panoramic views. Turner's watercolours for Hakewill's *Picturesque Tour of Italy* had included three of Florence, two of them showing the city from a distance — from the 'Chiesa al Monte' in the south-east, and further away, from Fiesole in the north-east (Plates 96 and 93). The rival publication, Elizabeth Batty's *Italian Scenery* (1818-20), also depicted Florence as 'a city planted in a garden', as, too, did Josiah Conder's *Italy* of 1831. Conder's illustration was a pirated version of the Turner-Hakewill engraving of Florence from Fiesole, which is a clear indication of its popularity.

Turner spent much of his time in Florence in 1819 sketching from a large number of vantage points outside the city. He made sketches from the north-east, the east, the south-east, the south-west and the west.[18] However, he seems not to have drawn the city from the north. The absence of a sketch from this direction — from the convent at Montughi, for example, which afforded Zocchi an excellent prospect — again suggests an ignorance of that artist's work.

96. George Cooke after Turner, *Florence, from the Chiesa al Monte*, 1820 (R, 158), engraving, $5\frac{1}{2} \times 8\frac{5}{8}$ in.

Turner's studies of Florence range from thumb-nail sketches only an inch or two high to ones that occupy an entire double-page spread 15 inches across. Their handling displays a predictable variety: some consist of only a few soft sweeping lines while others are characterised by tiny strokes of a hard pencil that describe each villa and olive tree. Some employ an unusual amount of blurred hatching to obtain strong chiaroscuro effects, which suggests that they were made at dawn or sunset when the distant city appears particularly lovely.[19] Turner made no studies of Florence in the large sketchbooks he had been using in recent months for coloured sketches, although one would have expected this after his practice in Rome, Tivoli and Naples, and there are minimal colour notes on the pencil sketches.[20] The absence of large or coloured sketches is explained quite simply. It was by now late December and probably too cold to make detailed drawings in a large sketchbook out of doors — in pencil, let alone in colours. He may also have seen little point in recording the wintry light and colours that he saw; were he to paint Florence later he would almost certainly realise his conception of the city in summer rather than his memories of winter. Indeed this is precisely what happened. When Turner came to depict Florence in 1827-8, he showed the city basking in gleaming sunshine while its inhabitants recline in the foreground amid fruit and flowers (Colour Plates 17 and 18).

This watercolour was very popular with the English public and Turner painted four versions, probably all around the same time.[21] All are nowadays described as *Florence, from San Miniato*, but it must be pointed out that S. Miniato was not really Turner's viewpoint, and when one of the watercolours was engraved in the *Keepsake for 1828* it bore the simple title *Florence*.[22] From nowhere in the grounds of S. Miniato is it in fact possible to look

97. Samuel Rawle after Turner, *Florence, from the Ponte alla Carraia*, 1818 (R, 157), engraving, 5⅝ ×8⅝ in.

westward and see the Arno and its bridges as Turner has shown them, because the church lies much too far to the south. The bridges can, however, be seen in just such a way from half a mile to the north of S. Miniato, a spot nowadays on the western side of Piazzale Michelangelo.

Turner made a number of sketches from around here in 1819,[23] but his earliest depiction of the view was his watercolour for Hakewill's *Picturesque Tour of Italy* (Plate 96).[24] In this he shows the procession of *Frati della Misericordia* just outside the city walls, i.e. just inside the grounds of S. Salvatore al Monte. The 1827-8 versions of the scene depart significantly from the Hakewill one and become topographically much less accurate. Turner now makes his characters occupy an imaginary cliff even further to the north, which projects right over the Arno: this enables him to preserve from the Hakewill scene the wonderful vision of the parallel bridges over the river. But what Turner has really done is manipulate Florence and the Arno into a Claudian composition close to that which he had used in *The Festival upon the Opening of the Vintage of Macon* (1803) and *Thomson's Aeolian Harp* (1809). He shows centrally placed trees, a group of people beneath them, the river sweeping in a curve towards the spectator and, with its bridges, occupying a very dominant role in the picture: a much more dominant role than the Arno ever possesses when seen from this direction.[25]

The river Arno is also the central feature of Turner's third watercolour for Hakewill, entitled *Florence, from the Ponte alla Carraia* (Plate 97). The lungarni were the only streets in central Florence along which English visitors liked walking, and Turner clearly enjoyed them too, extending his walks far along the river banks to both west and east.[26] The

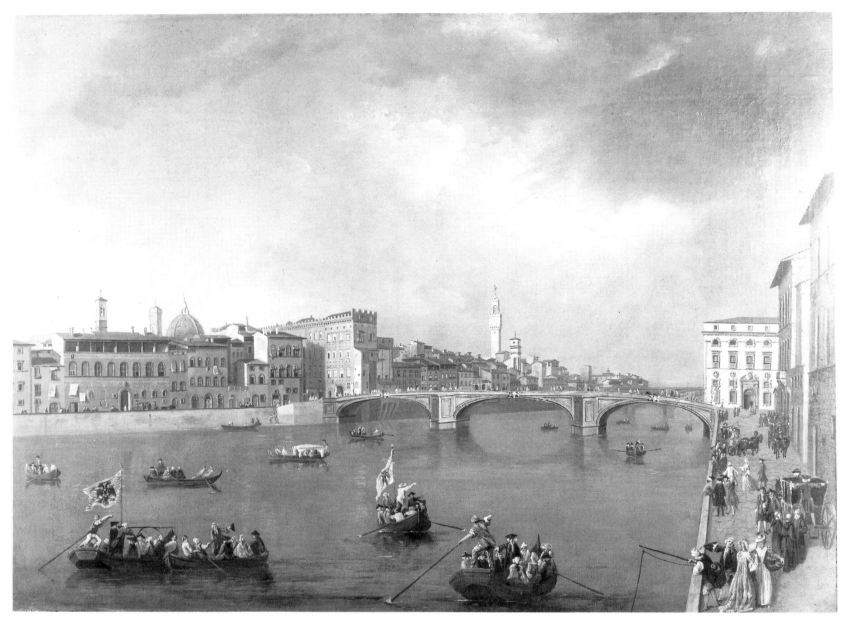

98. Thomas Patch, *View of the Arno and Ponte S. Trinita, c.* 1760, oil on canvas, 34½ × 47 in., private collection

Hakewill illustration depicts the bridges at the very heart of Florence, contrasting the picturesque disorder of the historic Ponte Vecchio with the serene elegance of Ponte S. Trinita, then unanimously regarded as one of the most beautiful bridges in the world.[27] This nicely balanced view can be traced back to the early eighteenth century, when Zocchi had included it in his *Scelta di XXIV Vedute.* Thomas Patch, who poked fun at many a Grand Tourist in his caricatures, produced several oil paintings of the same scene shortly afterwards (Plate 98) and a very similar engraving to the Turner-Hakewill one was published exactly two months earlier, in Batty's *Italian Scenery.*

The reason for the special popularity of this view with British lovers of Italy is revealed by Elizabeth Batty's caption. It was not only a delightful view in itself; it was what the traveller saw from Schneider's Hotel on the lungarno Guiccardini, an expensive but reliable establishment much patronised by the British. 'A room with a view' was what British visitors to Florence had been demanding for well over a century before Lucy Honeychurch arrived there in the pages of E. M. Forster's novel. A number of Turner's friends and acquaintances stayed at Schneider's, including Samuel Rogers and Tom Moore, and Hakewill recommended it in the *Route to Rome* sketchbook.[28] Even if Turner did not in fact stay here in 1819, he certainly sought out the view to enjoy it for himself, and he sketched the two bridges from a spot that was very close to the viewpoint of his watercolour.[29]

99. Simone Martini and Lippo Memmi, *Annunciation and Two Saints*, 1333, tempera on panel, 105 × 120 in., Uffizi, Florence

100. Alesso Baldovinetti, *Madonna and Child with Saints*, c. 1453, tempera on panel, 69 × 65 in., Uffizi, Florence

Turner must also have spent part of his time in Florence studying the works of art in her palaces and churches, though his notes and sketches afford only a glimpse of what he must have looked at. In the Uffizi, he noted down a number of artists' names in his guidebook: Memmi, Baldovinetti, Raffaelino del Garbo, Piero di Cosimo, Dürer and Pontormo.[30] The list reflects Turner's well-known interest in a variety of styles and periods and invites speculation about which paintings he studied and why. The Memmi he looked at was definitely the *Annunciation and Two Saints* by Simone Martini and Lippo Memmi while the Baldovinetti was the *Madonna and Child with Saints* from Cafaggiolo (Plates 99 and 100).[31] These may initially have attracted Turner's eye by the brilliance and richness of their colouring and their sumptuous intermingling of gold, white, red and blue. However, he took the trouble to note down dates for both paintings, and, since they were hanging within a few paces of each other, it is tempting to imagine that he reflected on the developments in Italian art in the century between them.[32] He would undoubtedly have been interested in the change from a decorative gold background to a more realistic setting; his concern with perspective might well have led him to ponder on the development from Simone Martini's use of separate niches and a single plane for his figures to Baldovinetti's attempt to integrate his figures around the Virgin and thereby to unite the front and back planes.[33]

Although many visitors to Florence at this date still tended to concentrate on the artists of the High Renaissance — Raphael, Leonardo, Andrea del Sarto, Correggio, Titian — this was by no means the whole story. The Early Renaissance was now attracting an increasing amount of interest among British artists and art-lovers and this development exactly coincided with Turner's lifetime. While Turner was growing up, Flaxman had sketched part of Duccio's *Maestà* in Siena, Uccello's *Deluge* in S. Maria Novella and part of *The Triumph of Death* in the Campo Santo at Pisa. By the early nineteenth century the Brancacci chapel was firmly on the tourist map and Samuel Rogers was not alone in enjoying the works of Giotto and Cimabue.[34] Turner's interest in Simone Martini and Baldovinetti cannot be exactly matched in the records left by his contemporaries but it forms part of a general change in taste at this period. An increasing number of visitors to the Uffizi no longer went exclusively to the Tribuna, but were attracted and interested by the early paintings in other rooms in the gallery. It was completely characteristic of Turner both to be aware of a new focus of interest and to look closely at everything that came within his reach.

In Florence, as in Rome, however, Turner made few sketches of the paintings he studied and only the briefest of notes. The largest and most detailed of all these sketches depicts Claude's *Seaport with the Villa Medici* in the Uffizi; it was the only painting he sketched there (Plates 101 and 102). Turner's interest in the Claudes he saw in Italy has been discussed in earlier chapters and needs no further comment. However, it is worth noting that he may have been prepared for his first sight of this particular one by a friend. H. W. Williams studied the *Seaport* in 1816 and could well have talked to Turner about it when they met in Scotland in 1818.[35] His published description of the painting suggests what he would have said:[36]

This exquisite and perfect picture represents the SUN RISING among buildings, shipping, and figures; and, in point of composition, is equal to any of the finest of Claude's paintings to be seen in England. Indeed, it is impossible to conceive any work of art, in which more consummate skill, or a more intimate knowledge of nature, can be displayed. The sun absolutely appears to shine and sparkle upon the various objects, which are so judiciously arranged, as to give effect and sentiment combined. No *positive* outline appears among the buildings; the objects are so sweetly blended into each other, that nothing individually intrudes itself through the illuminated misty air, though, when curiously examined, innumerable interesting details develope themselves in the most captivating manner. On the fore-ground, the connecting figures, colours, shadows, and touches of brilliancy on silver vases and musical instruments, unite with the whole subject, exciting altogether the happy feelings connected with a lovely morning. It is in

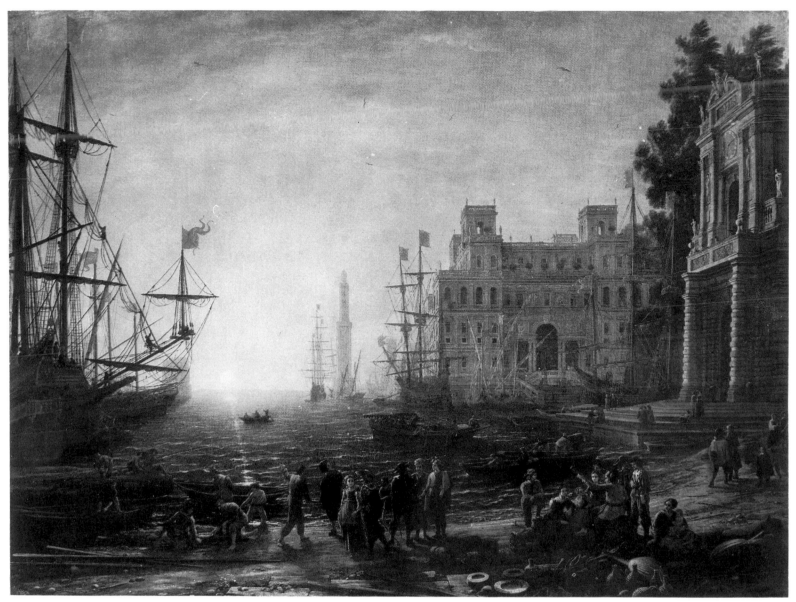

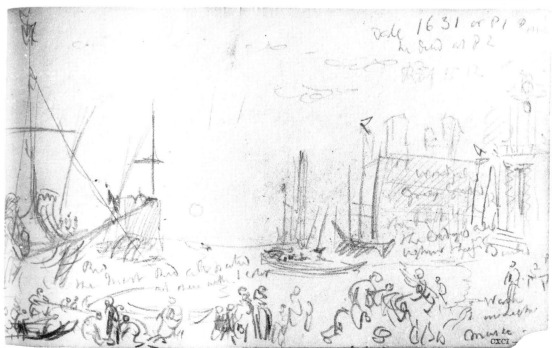

101. Claude Lorrain, *Seaport with the Villa Medici*,
1637, oil on canvas, 40 × 49⅜ in., Uffizi, Florence

102. Sketch of Claude's *Seaport with the Villa
Medici* (*R and F*, 60), pencil, 4⅜ × 7½ in.

103. Notes on S. Croce and sketches of frescoes in SS. Annunziata (*R and F*, 35a and 36), pencil, each page $7\frac{1}{2} \times 4\frac{3}{8}$ in.

104. Andrea del Sarto, *Birth of the Virgin*, 1514, fresco, detail, SS. Annunziata, Florence

105. Pontormo, *The Visitation*, 1514-16, fresco, SS. Annunziata, Florence

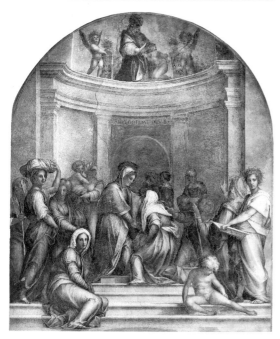

such effects that the inimitable Claude, like the glorious sun which he represents, appears to shine. He does not aim at mere effect, nor combinations of objects for trifling purposes, but to excite sentiment and feeling, to remind us of past joys, and impart new delight.

Intimate knowledge of nature, effect and sentiment were all essential ingredients in a painting for Turner. His own notes remarked on the warmth of Claude's light and he, too, noticed the musical instruments in the foreground; but he was also concerned with practical details such as the way the red mast on the left was 'all painted at once with 1 color' and, here again, with the date of the painting.[37] Williams's analysis of Claude's achievement — superbly beautiful general effect strengthened by meaningful details — would have surprised Ruskin who believed that Turner alone could produce such a combination and that Claude's details are merely ornamental.[38] But Turner himself never underestimated the complexity of Claude's art and he was to pay tribute to the Uffizi *Seaport* in a highly complex painting of his own, *Regulus*, which was painted and exhibited in Rome in 1828.[39]

French writers of Turner's day enjoyed maintaining the claim of Claude's early biographers that he was 'le Raphaël des païsagistes',[40] so it is not inappropriate that Turner's sketch of the *Seaport* happens to contain the tiny memorandum 'Raf 1512'. In 1819 a supposed portrait of Raphael's mistress, 'La Fornarina', dated 1512, was hanging in the Tribuna where it was still admired by visitors, although its authenticity as a Raphael was already under question.[41] Turner was evidently untroubled by such doubts — in 1820 he included this portrait in his celebration of Raphael's art, *Rome, from the Vatican* (Colour Plate 19). In 1819, however, he sketched neither of the famous Florentine paintings included in *Rome, from the Vatican*, the *Fornarina* itself and the *Madonna della Sedia*. Prints and copies of both works rendered on-the-spot sketching unnecessary.

The same, however, was not always true of frescoes, and Turner made sketches of a number of those at SS. Annunziata (Plate 103). In the entrance courtyard he sketched several figures from Andrea del Sarto's *Birth of the Virgin* and Pontormo's *Visitation* (compare Plate 103 and Plates 104 and 105). In the Cloister of the Dead he first sketched

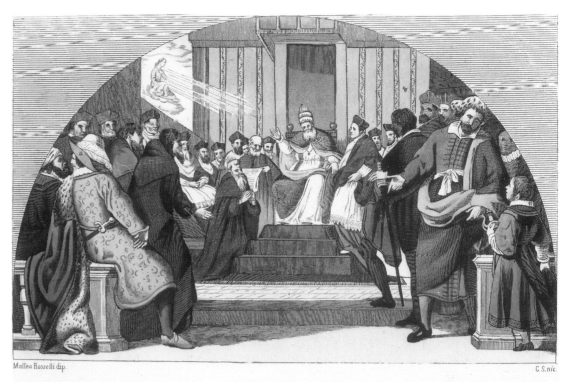

Matteo Rosselli dip.

G.S.inc.

Alessandro IIII inspirato dalla B. Vergine approvando l'ordine de' Servi concede potersi dal B. Buonfigliuolo Generale fabbricar luoghi di questa Religi-

one per tutto l'universo la Bolla di tutto ciò a favore di quest' ordine fu data in Napoli alli XXV di Gennaio MCCLV.

106. Engraving of Matteo Rosselli (1578-1650), *Alessandro IIII approvando l'ordine de' Servi*, SS. Annunziata, Florence

107. Engraving of Bernardino Poccetti (1548-1612), *Il Beato Buonagiunta Manetti Generale predetta . . . la sua vicina morte*, SS. Annunziata, Florence. Plates 106 and 107 are both from [Florence: SS. Annunziata] (1864)

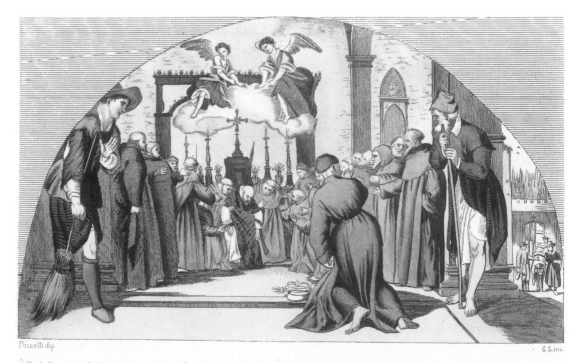

Poccetti dip.

G.S.inc.

Il Beato Buonagiunta Manetti Generale predetta prima a tutti la sua vicina morte nel ragionare dopo la messa co' Frati all'Altare della passione di N.S. venuto a quelle parole In manus tuas commendo spiritum meum con le braccia distese come nel Crocifisso trasformatosi muore in Monte.

sonaria l'anno MCCLXI

Andrea del Sarto's *Madonna del Sacco* which was noted for its exquisite colouring and, as every nineteenth-century visitor knew, had been admired by both Michelangelo and Titian.[42] He then sketched some of the early seventeenth-century frescoes by Bernardino Poccetti and Matteo Rosselli which illustrate the history of the Servites. Today this cycle is no longer completely extant and barely gets a glance from tourists, but in Turner's day the frescoes were held in high esteem. Reynolds had sketched several figures from them in the 1750s and in 1825 one visitor described them as[43]

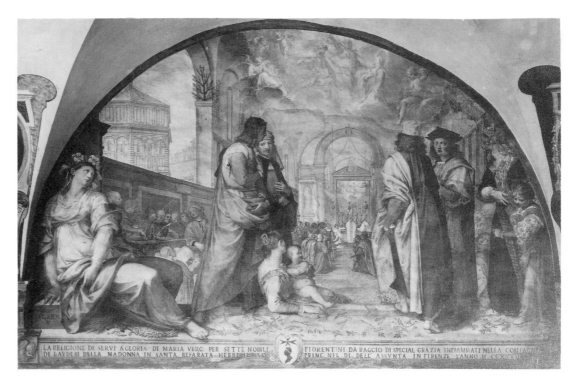

108. Bernardino Poccetti, *La Religione de Servi...
hebbe il suo princ° ... MCCXXXIII*, fresco,
SS. Annunziata, Florence

109. Bernardino Poccetti, *Il Beato Filippo Benizi
... ridusse ... due cattive Donne a religiosa vita*,
fresco, SS. Annunziata, Florence

worthy of the attention of the first masters. The compositions are in general fine, ... the colouring exquisitely rich, ... The invention displayed in the designs — the varied beauty of the female forms — the gentle bendings and fine roundings of the limbs — with the richness and fulness of the draperies, are truly astonishing.

Turner's eye missed none of this: he recorded colours and he studied poses. However, his two aims were not neatly separated, for in virtually every case it was the most colourful figures that he chose to sketch. Frescoes depicting the history of the Servites inevitably contain many sombre scenes dominated by the black and white habits of that order. These parts of the cycle Turner ignored. Instead he extracted figures from here and there around the cloister exactly as Reynolds had done: a nobleman in richly coloured attire and a broad-

Colour Plate 17. *Florence, c.* 1827 (W, 728), watercolour and bodycolour, $11\frac{1}{4} \times 16\frac{1}{2}$ in., British Museum, London (Lloyd Bequest)

110. Stefano Ricci, *Philosophy*, on the tomb of P.G. Signorini da Mulazzo, died 1812, S. Croce, Florence

brimmed 'Red Hat w feathers' and two gaily clad peasants. All these figures act as framing devices for the lunettes and introduce notes of colour into their scenes (see Plates 106 and 107). He also drew a quick sketch of one of the more lively frescocs as a whole (Plate 108) and recorded the bright figures of the 'due cattive Donne' who have embraced the religious life (Plate 109). These two penitents are clothed in complementary colours (green and red for one, orange and blue for the other), and one is shown in a pose made famous in *The Expulsion of Heliodorus* and, in reverse, in the *Transfiguration*. Turner would certainly have recognised the quotation from Raphael and his colour notes — 'Gr', 'R' and 'OR', 'BL' — suggest that he was taking note of the juxtaposition of complementary colours which he himself avoided.

A very different but equally expressive depiction of a woman caught Turner's eye in S. Croce (compare Plate 103, line 4, and Plate 110). This was a very recent work, the 'beautiful recumbent figure of Philosophy, whose countenance expresses deep sorrow' on the tomb of P. G. Signorini da Mulazzo (died 1812) by the Florentine Academician Stefano Ricci.[44] Turner's notes on S. Croce range from 'Giotu' and 'donatello Christ in Wood' — further examples of his interest in the Early Renaissance — to neo-classical works such as that by Ricci and Canova's monument to Alfieri, unveiled in 1810.[45] At this period S. Croce was chiefly noted as the resting-place of Michelangelo, Galileo and Machiavelli, whose monuments inspired memorable lines in *Childe Harold's Pilgrimage* and led visitors to call the church the 'Pantheon of Florence';[46] many of the now-famous

101

111. The Niccolini chapel, S. Croce, Florence

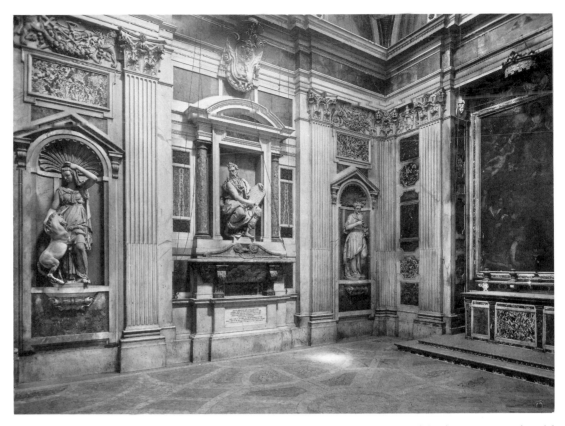

frescoes were still covered by later overpainting. While it was inevitable that Turner should here concentrate on tombs and sculpture, his repeated mention of the names of Volterrano, Allori and Francavilla suggests that he was also very interested in the Niccolini chapel (Plate 111). Its classical vocabulary and rich decoration of gilding and coloured marbles, paintings and sculptures were a welcome sight to English eyes after the rigours of Tuscan Gothic and some visitors regarded it as 'the most striking thing' in the entire church. Stendhal claimed that Volterrano's Sibyls on its cupola had given him 'the profoundest experience of ecstasy' that he had ever encountered through painting.[47]

No other visits to churches in Florence are recorded in the *Rome and Florence* sketchbook and a number of its pages are blank. The shortness of Turner's visit, together with the fact that it took place at Christmas, may well have curtailed his sightseeing; and he was probably drawn into the festivities and social life of the English community through the fact that Lawrence was by now staying with the British Minister, Lord Burghersh. He later reported that Lawrence's paintings were much admired in Florence.[48] Turner left the city early in January 1820 to travel through Bologna, Milan and Turin to the Mont Cenis pass, a journey which probably took him about ten days.[49] Freak weather conditions then led to an exciting crossing of the Alps which he later enjoyed recounting:[50]

> We were capsized on the top. Very lucky it was so; and the carriage door so completely frozen that we were obliged to get out at the window — the guide and Cantonier began to fight, and the driver was by a process verbal put into prison, so doing while we had to march or rather flounder up to our knees nothing less in snow all the way down to Lancesbyburgh [i.e. Lanslebourg].

Nevertheless, Turner was back in London on 1 February 1820, having 'been absent 6 months to a day', and he resumed his London life, attending a Royal Academy Club dinner on the following day. Farington sat next to him and they talked of Turner's recent experiences but, alas, Farington's record could hardly be briefer.[51] Turner's uncommunicative disposition had worried Chantrey in Rome in the previous autumn.[52] His silence was maintained on his return to England and neither then nor later does he seem to have made any significant remarks about his first visit to Italy.[53] To see what he gained from his experiences it is necessary to turn to his paintings.

Colour Plate 18. Detail of *Florence* (Colour Plate 17)

Chapter 8

POETRY AND PROSE: TURNER'S ITALY IN THE 1820s

The paintings of Italy that followed Turner's 1819 visit fall naturally into clearly defined groups. First come his watercolours for Walter Fawkes. Then there are the large oil paintings, *Rome, from the Vatican* (1820), *The Bay of Baiae* (1823) and *Forum Romanum* (1826). These were followed by two further sets of watercolours which date from around 1826-8: those intended for engraving in Charles Heath's *Picturesque Views in Italy* and those actually engraved as vignettes in Samuel Rogers's *Italy*. None of these works is merely a depiction of Italy; each grew out of Turner's own experiences and attitudes and is, in effect, a manifesto.

Walter Fawkes was probably Turner's dearest friend and most constant patron from the first decade of the century until his death in 1825, and he collected the fruits of Turner's foreign tours particularly keenly. Between 1803 and 1810 he bought about twenty of Turner's watercolours of Switzerland and it was for Fawkes that Turner painted his fifty-one Rhine subjects in 1817.[1] It was thus entirely natural that in 1820 Turner should embark upon some further watercolours for him that related to his most recent foreign travels, his months in Italy.[2] The previous few years had, moreover, seen the relationship between artist and patron reaching its closest. Fawkes bought Turner's large oil painting the *Dort* from the 1818 Royal Academy; he started commissioning Turner to paint about fifty watercolours relating to his Yorkshire home, Farnley Hall, and its surroundings; and between April and June 1819 he exhibited some sixty or seventy of his best Turner drawings at his London house, 45 Grosvenor Square.[3] Fawkes's dedication to Turner in the exhibition catalogue, though conventionally worded, shows clearly the warmth of his feelings towards him,[4] while the degree to which Turner felt part of the family at Farnley Hall is extremely well known and requires no underlining.

The eight new watercolours were not all of identical dimensions or proportions, but they can nevertheless be regarded as constituting a series: their subjects seem carefully chosen to show a cross-section of the attractions of Italy. Two depict views of Venice. *Snowstorm, Mont Cenis* and *Bay of Naples, with Vesuvius — Morning* balance each other nicely both as a north/south pair and as works in which the forces of nature are celebrated either in action or in repose. Finally there are four Roman subjects — two city views (from Monte Mario and from S. Pietro in Montorio) and two studies of single buildings, representing Rome's great achievements in ancient and in modern times, the Colosseum and St Peter's. Turner began on these scenes soon after his arrival home. Three are dated 1820, two 1821, and the rest may safely be assigned to these years. He probably charged Fawkes for *The Colosseum* and *Rome, from Monte Mario* in 1820, for all the remaining subjects except one appear in some financial calculations in his *Paris, Seine, and Dieppe* sketchbook, used in 1821.[5] Turner spent Christmas 1821 at Farnley Hall and this page may well contain a draft of his end-of-the-year accounts.[6] On the same page he also listed Milan, Florence, Simplon and a fourth, illegible, word, which suggests that he was considering painting even more watercolours for Fawkes than just eight (such lists of potential subjects occur frequently in Turner's sketchbooks). These further views seem never to have been executed.

The four watercolours depicting Rome are closely related both to the 1819 sketches and

112. *Rome, from Monte Mario*, 1820 (W, 719), watercolour and scraping out, 11¼ × 16 in., private collection

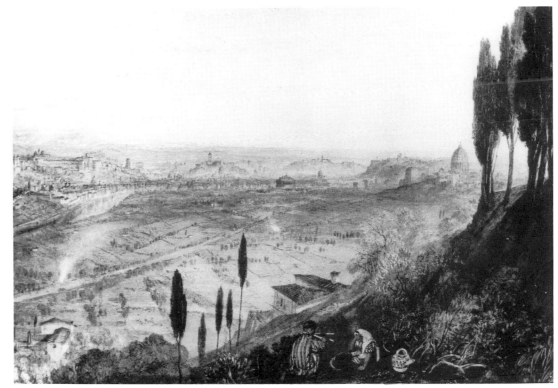

113. Rome from Monte Mario (*RCSt*, 31), pencil on white paper prepared with a grey wash, with lights rubbed out, 9 × 14½ in.

to the works of art which had shaped Turner's attitudes to Rome before his own visit. *Rome, from Monte Mario* and *Rome, from S. Pietro in Montorio* (Plates 112 and 114) belong to a long tradition of views looking across Rome which go back to the earliest representations of that city, a tradition which grew up largely because of Rome's geographical situation on its seven hills and the fact that it could also be conveniently surveyed from two other hills nearby to the west, Monte Mario and the Janiculum. The artist wishing to depict the city from one of these vantage points could choose between two quite different approaches to his subject. He might concentrate on a single prospect with a span of 90 degrees or so, recording it in great detail from the far horizon to the ground at his feet, perhaps using a camera lucida or obscura. This was what Hakewill had done in his

114. *Rome, from S. Pietro in Montorio, c.* 1820-1 (W, 720), watercolour, 11¼ × 16½ in., private collection

115. Rome from S.Pietro in Montorio (*RCSt*, 2) pencil on white paper prepared with a grey wash, with lights scratched out, 9 × 14½ in.

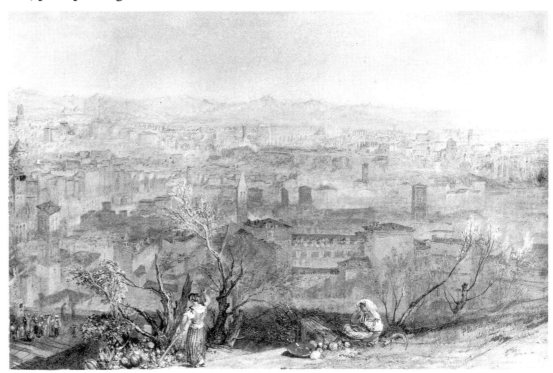

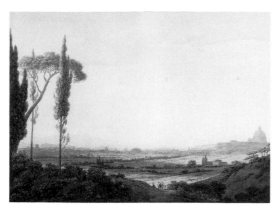

116. J. R. Cozens, *Rome from the Villa Mellini, c.*
1783-8, pencil and watercolour, $17\frac{1}{4} \times 23\frac{1}{2}$ in.
Fitzwilliam Museum, Cambridge

pencil sketches from the tower of the Capitol and Monte Mario, from which Turner had produced his watercolours of *c*. 1818 (Plate 15). This was the approach, too, of many works by eighteenth-century artists such as J. R. Cozens's *Rome from the Villa Mellini* (Plate 116) and Richard Wilson's paintings of Rome from the Villa Madama and from the Janiculum (Plate 6). On the other hand, the artist might take a panoramic approach and, like Addison, cast his 'ravish'd eyes' all around him. There was a longer history behind this second method of depicting Rome than might be thought. In the sixteenth century, Marten van Heemskerck, Anton van den Wyngaerde and their followers produced a number of views taken from one of the hills of Rome, each consisting of a long, strip-like view that provided a 180-degree or 360-degree record of the buildings of Rome.[7] In 1765 Piranesi's master, Giuseppe Vasi, published an etching on twelve sheets of paper showing a 180-degree view from the Janiculum. However, the idea of the panorama was reborn (and, indeed, the word itself invented by Robert Barker) when Turner was a boy, and the years from 1790 onwards saw the production of numerous panoramas of famous cities and battles and their display in circular rooms. Rome was an ideal subject for the new invention and many examples of Roman panoramas are known from the period of Turner's two visits. He himself probably saw some of them. A grand panorama of Rome from the tower of the Capitol was exhibited at Barker and Burford's gallery in the Strand in 1817; in 1824 L. Caracciolo produced his painted panorama of Rome as seen from the Palatine, now in a circular room in the Victoria & Albert Museum; in 1825 Thomas Sutherland and Thomas Shew produced an engraving of a 180-degree view, also taken from the Palatine; and in 1827 Luigi Rossini published his series of engravings of the 360-degree view from the tower of S. Francesca Romana in the Forum.[8]

Turner's 1819 sketchbooks show that he, like his predecessors and contemporaries, frequently surveyed Rome from the most famous viewpoints. What is more, he utilised both the above methods of representation. In the large sketchbook *Rome: C. Studies* there are sketches both in pencil and in colours which concentrate on a segment of the city and explore every detail from the grass and bushes close at hand to the distant mountains seen against the sky (Plates 113 and 115).[9] In the small sketchbooks, however, there are groups of pages where rough sketches demonstrate that Turner rotated his gaze fairly quickly through 180 or 360 degrees. One such sequence, in the *St Peter's* sketchbook, shows that he stood at the northern end of the Janiculum and looked first north-west, north and north-east and then turned to look east, south-east and south: his eyes swept right round from St Peter's to S. Pietro in Montorio.[10] Elsewhere he sketched a 180-degree view of the Forum, perhaps from the Torre dei Conti. A further sequence of pages (including Plate 117) gives a 360-degree view from one of the best viewpoints of all, the top of the tower of the Capitol.[11] Tom Moore later described Turner's anger when he was disturbed by another tourist on the tower of the Capitol: if he was trying to make a series of panoramic sketches at just that moment, his annoyance was quite understandable.[12] Turner never developed his rough panoramas of 1819 into a finished painting but he did make use of later sketches of this type. In 1828 he drew a series of very detailed sketches from the Aventine which occupy two double-page spreads of a small sketchbook and continue on to a fifth page (Plate 158). What is interesting in the present context is that when he came to use these sketches for a painting in 1836 he did not simply use them for a background, producing the long horizontal view of the panorama painter or draughtsman. *Rome, from Mount Aventine* (Plate 159) condenses the sketchbook material horizontally and at the same time expands it vertically; and does this with such control of perspective that one could easily imagine the painting to have been based on a single sketch with similar proportions to itself.

Rome, from Monte Mario and *Rome, from S. Pietro in Montorio* belong to the eighteenth-century tradition which liked to see the city of Rome integrated into a landscape composition rather than to the panoramic style that was popular at the time of Turner's own visit. Their viewpoints, too, were undoubtedly influenced by tradition. Wilson and J. R. Cozens had both painted Rome from Monte Mario, while *Rome, from S. Pietro in Montorio* views the city from the equally popular heights of the Janiculum. These

CLXXXVIII — 77

117. Panoramic view from the Capitol: the Esquiline to the Aventine (*St P's*, 76a-7), pencil, each page 4½ × 7½ in. The view of the Forum on f.76a may be compared with that in Plate 15

superb viewpoints were, of course, no less fashionable in Turner's own day than they had been in earlier centuries.[13] Yet it is surely no accident that although he had made sketches of Rome from numerous other fine viewpoints whilst he was there, for his two finished watercolours he chose the two viewpoints that had been most popular among earlier artists. Similarly both *The Colosseum* and *The Interior of St Peter's* (Plates 118 and 120) are strongly influenced by eighteenth-century models. The Colosseum in Turner's watercolour wears a very different face from the homely building portrayed in contemporary paintings by Eastlake. It towers over the spectator, just as it does in Piranesi's etchings. Turner even outclasses Piranesi here, for he avoids the problems of perspective that had weakened his predecessor's image: he makes his amphitheatre so vast that it thrusts itself right out of the picture space in a terrifying burst of energy. Meanwhile it is impossible to look at Turner's *Interior of St Peter's* without being reminded of Panini's monumental depictions of the identical subject which were widely disseminated during Turner's lifetime — oil paintings by Panini himself, studio versions or mere copies.

In both these watercolours Turner's theme is a traditional one, the grandeur of Rome. His choice of the interior of the one building and the exterior of the other also reflects traditional and popular taste. Many visitors to Rome found the outside of St Peter's disappointing and difficult to see properly and Turner's own notes on the building, though sometimes illegible and a little rambling, are certainly critical of its exterior.[14] On the other hand, the vast scale of the interior, combined with the perfect proportions of its decorative details, has always been a feature which impresses the visitor.[15] With the Colosseum, however, it was the exterior that called forth wonder and awe. 'Vastness; Solidity; & masonry grand & simple', wrote Samuel Rogers in 1814. 'Thousands of years hence will some of its stones be found, one upon another. Its masses are like so much rock.' Eleven years later Hazlitt observed: 'As you pass under it, it seems to raise itself above you, and mingle with the sky in its majestic simplicity.'[16]

Turner's watercolours for Walter Fawkes grew out of his 1819 sketches in a variety of ways. *Snowstorm, Mont Cenis,* which recreates his eventful crossing of the Alps on 15 January 1820, does not exactly follow any of the hasty sketches in the *Return from Italy* sketchbook, and it cannot be said to represent any particular given spot. It does, however, include a motif from one of these tiny sketches: the dramatic effect of a dark house seen against a backdrop of white snow.[17] *The Colosseum,* on the other hand, follows a sketch pretty faithfully — for obvious reasons (Plate 119). This sketch is in pencil only, so that Turner had to devise a suitable colour scheme from his memory and imagination and his 1819 colour sketches. He made two other important changes when he transformed his sketch into a watercolour. He turned the lounging cattle into sprightly goats, in order to introduce a note of picturesque contrast and vivacity into his scene; and he changed the position of the Colosseum within the picture space so that it becomes much more

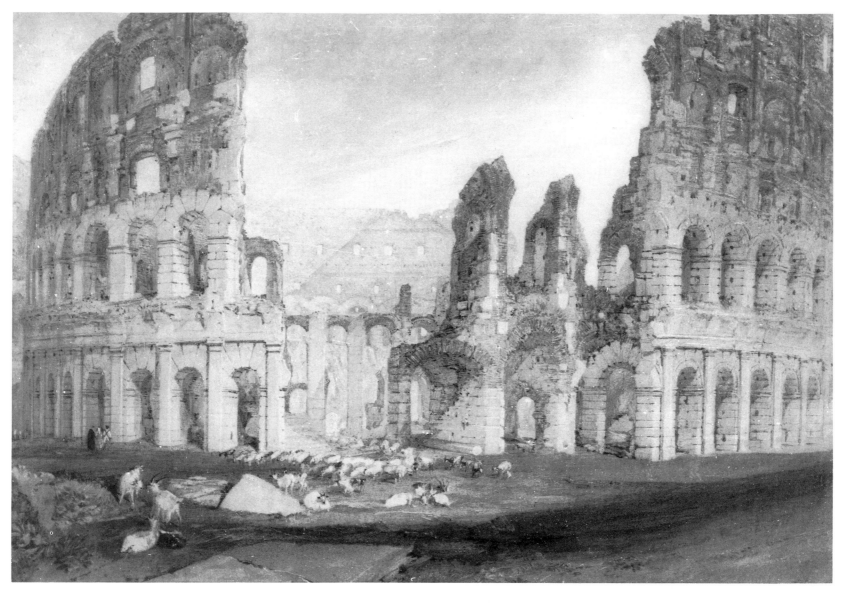

118. *The Colosseum*, 1820 (W, 723), watercolour, 11 × 15½ in., British Museum, London (Lloyd Bequest)

119. The Colosseum (*RCSt*, 23), pencil on white paper prepared with a grey wash, with lights rubbed out, 9 × 14½ in.

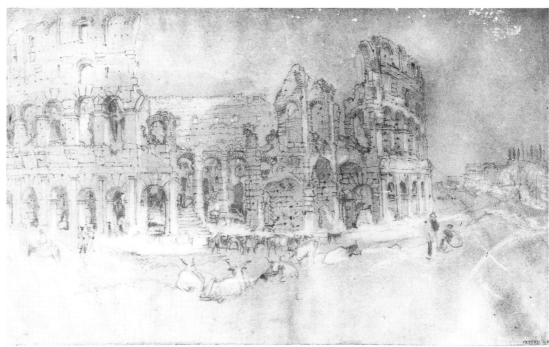

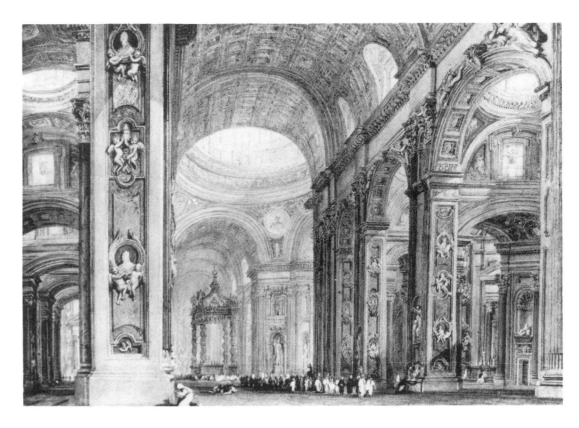

120. *The Interior of St Peter's*, 1821 (W, 724), watercolour, $11\frac{1}{2} \times 16\frac{1}{4}$ in., private collection

121. G. P. Panini, *The Interior of St Peter's*, 1755, oil on canvas, Niedersächsisches Landesmuseum Hannover

122. G. B. Piranesi, *The Interior of St Peter's*, from the *Vedute di Roma* (1748-78), etching, $16 \times 23\frac{1}{2}$ in.

dominant. In the sketch, the Colosseum is cut off by the edge of the paper on the left and a sizeable vista extends beyond it on the right. In the finished watercolour, only a fraction of the world beyond the Colosseum can be glimpsed and it now appears to the left of the building. On the right, where the spectator's eye tends naturally to rest, the Colosseum occupies the entire picture space and is cut off by the edges of the paper. The relationship between sketch and finished watercolour is even closer in the two Roman views. *Rome, from Monte Mario* and *Rome, from S. Pietro in Montorio* derive from very detailed large pencil sketches in *Rome: C. Studies* (Plates 113 and 115). For these watercolours Turner needed merely to copy all the necessary ingredients from his sketches and then create his colour effects.

The Interior of St Peter's (Plate 120) has an altogether more complex history. All Turner's 1819 sketches of the interior of St Peter's are rough and ready affairs in a sketchbook measuring $4\frac{1}{2}$ by $7\frac{1}{2}$ inches (Plates 45 and 46); none provided him with the vast amount of detailed information that has gone into his $11\frac{1}{2}$ by $16\frac{1}{4}$ inch watercolour. What is more, Turner's view is a highly composed and artificial one: St Peter's itself is so huge that it is impossible to look simultaneously down the left aisle, the nave and the right aisle, as Turner would have the spectator believe. He most probably based his watercolour on one of the Panini oil paintings of which it is so reminiscent (Plate 121), and at the same time he may also have consulted Piranesi's etching of this subject for points of detail (Plate 122). Naturally, he adapted his models to create his own vision: he draws the spectator much closer into St Peter's than Panini does, and he makes him feel smaller in comparison to the building, by the deliberate exclusion of much of the ceiling and pavement. This was just an artistic manipulation of topographical material similar to that in *The Colosseum*. Turner would have enjoyed emulating two such celebrated eighteenth-century scenes as Panini's and Piranesi's, and he would particularly have enjoyed doing so in the modern British medium of watercolour.[18]

This series of watercolours was once described as 'the work of a traveller who relates with immense gusto and with touches of pardonable exaggeration what he has just seen'.[19] The above discussion has, however, shown just the opposite: there is very little exaggeration in the watercolours. In their basic outlines, they are as faithful to Turner's own sketches — or other sources — as his earlier watercolours of Italy had been to Hakewill's sketches; and

they are really quite different from 'tourists' pictures' or 'picturesque views'. With the obvious exception of *Snowstorm, Mont Cenis,* they have less emphasis on picturesque incident than the watercolours for Hakewill, and depict the sights of Italy in a relatively straightforward way. A key factor in dictating their mood was obviously their intended destination — in the private collection of a patron who was also a close friend, rather than as engravings to please the public.

* * * *

The oil paintings of Italy which Turner exhibited to the London public in 1820-6 were, however, rich in content and incident, poetry and sentiment. The first was *Rome, from the Vatican. Raffaelle, accompanied by La Fornarina, preparing his Pictures for the Decoration of the Loggia* (Colour Plate 19). Since he had only arrived back in London on 31 January or 1 February 1820 and the Academy exhibition opened in April, it is worth noting its sheer size, nearly six feet by eleven, which makes it the third largest canvas he ever exhibited. He must have worked on it more or less non-stop during February and March in order to get it finished, and it is not surprising that it was his only exhibit. He probably began a second Italian subject, *The Rialto, Venice,* simultaneously, intending it as a pendant.[20] However, work on *The Rialto* did not progress very far. Turner soon realised that he could never finish two such large paintings in two months and he had a particular reason for wanting to exhibit *Rome, from the Vatican* at the 1820 Royal Academy as will soon be apparent.

Rome, from the Vatican has always had its critics and raised problems for commentators. These criticisms and difficulties cannot be ignored and must be mentioned, if not resolved, straightaway. Many spectators are disconcerted by the fictitious nature of the foreground incident — Raphael and the Fornarina standing in the loggia as if it were a corner of his studio — and the anachronistic view of Rome at the centre of the painting. Raphael is surrounded by his architectural plans for the Vatican; some famous pictures either by him (the *Madonna della Sedia*) or usually attributed to him in Turner's day (*La Fornarina*); and canvases containing scenes which he actually painted as frescoes (the biblical ones) or is not known to have executed at all (a landscape labelled 'Casa di Raffaello').[21] He himself gazes up at his Bible frescoes on the ceiling of the loggia, but his mistress is quite oblivious of all the works of art that surround her: she is apparently engrossed in trying on her jewellery. Behind this complicated imaginary scene appears the city of Rome — as it was in Turner's day, not Raphael's, and including Bernini's elliptical colonnades in front of St Peter's which were built nearly a century and a half after Raphael's death. There is no escaping that historical fact, but it may be suggested, in Turner's defence, that he introduced the colonnades simply because they were now there, he had seen and sketched them from Raphael's loggia, and there was no means of depicting the view as it would have been in Raphael's own times.[22] If Bernini's colonnades were not actually there in Raphael's day, then for Turner's present artistic purposes, they should have been. It may also be argued that the palpably fictitious foreground scene and the anachronistic background lend a poetic legitimacy to each other. If the background were prosaically and historically correct, the foreground incident would appear more outrageous than it in fact does, and vice versa.

The second disturbing aspect of *Rome, from the Vatican* is its uncomfortable organisation of space, which Ruskin described as 'a general challenge to every known law of perspective to hold its own'.[23] As another Victorian critic remarked, 'the floor of the loggia slopes like the floor of a ship's cabin in a storm' and 'the arch through which we get the view of Rome . . . goes over our heads like the Milky Way, and looks so prodigious in comparison with its next neighbour that few would imagine the two to be really of the same size'.[24] One may also wonder about a number of other compositional puzzles: what, for instance, has happened on the left to the balustrade which is seen to the right of Raphael, exactly where (and on what) is he standing, why is he so large and the Fornarina so tiny?

Turner may perhaps have been experimenting with an original system of perspective that did not succeed. He may have been trying to lead the spectator's eye in two different directions at once, as he had already done in *Châteaux de St Michael, Bonneville, Savoy*

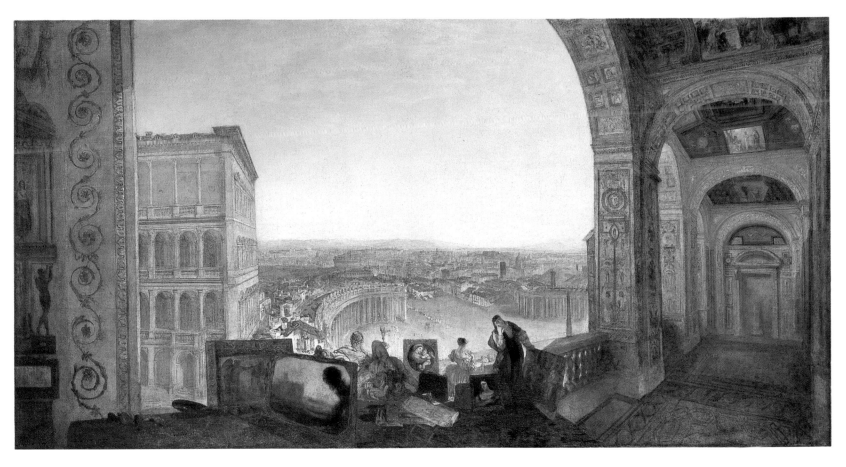

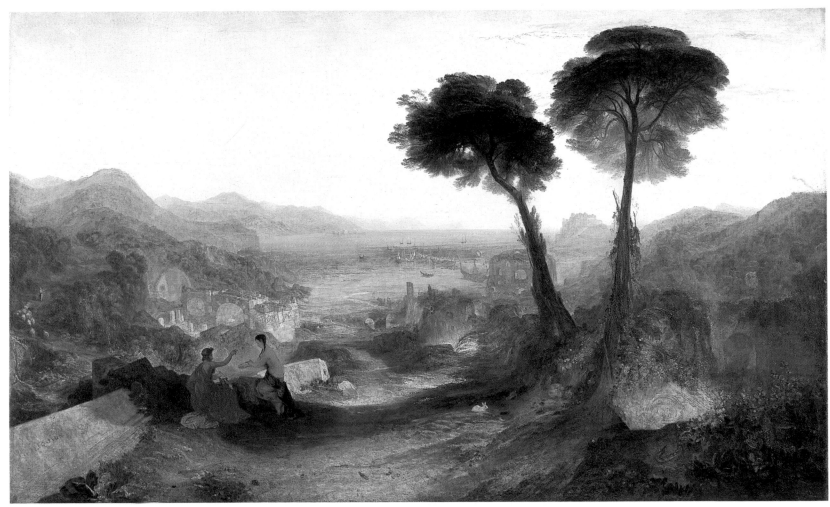

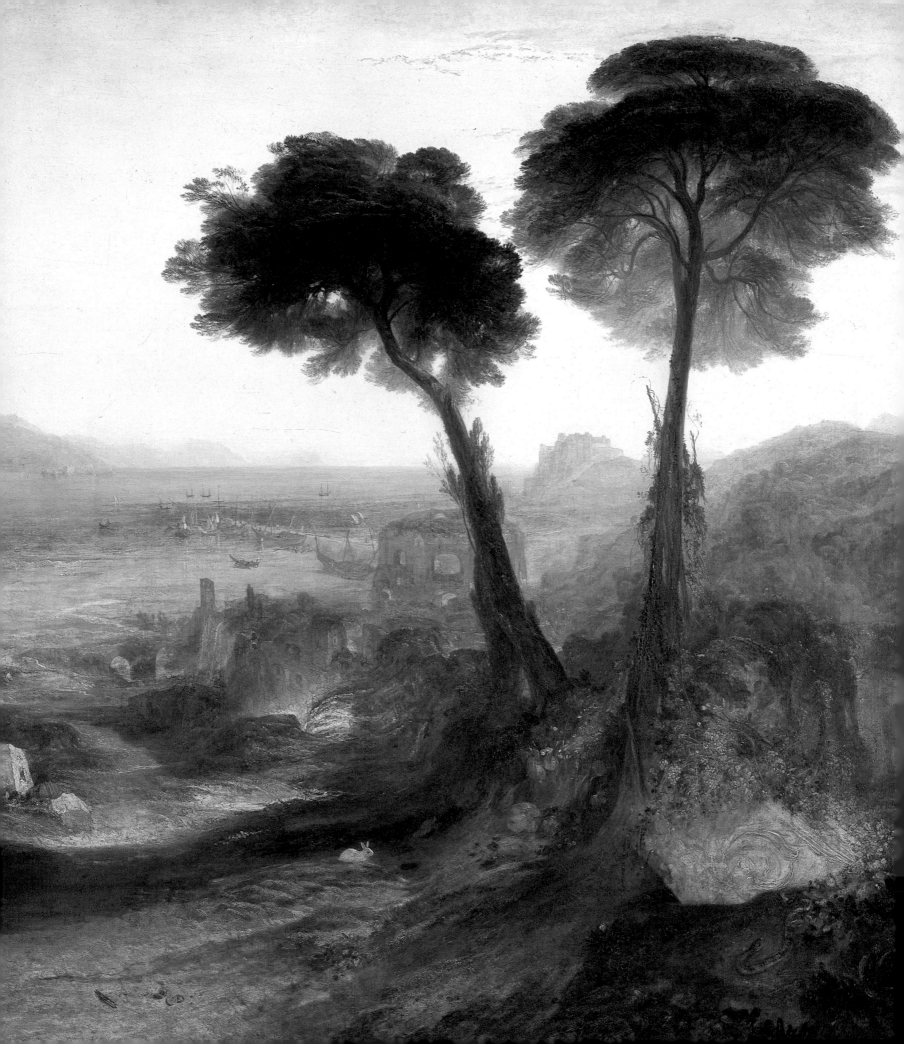

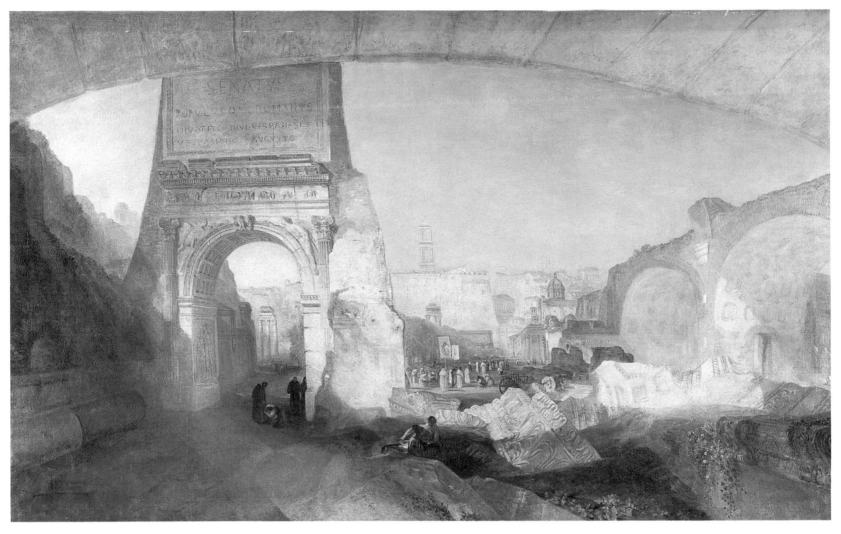

Colour Plate 22. *Forum Romanum, for Mr Soane's Museum*, 1826 (B & J 233), oil on canvas, 57⅜ × 93 in., Tate Gallery, London

(RA, 1803) and *Frosty Morning* (RA, 1813).[25] But one reason behind the spatial peculiarities of *Rome, from the Vatican* could well be that it was executed at great speed: Turner constructed it from information contained in sketches which had been drawn from entirely different viewpoints and he made no attempt to reconcile these with one another (Plates 123 and 124). In order to draw the view in Plate 123, he must have leant on the window sill of the last bay of the loggia, i.e. that nearest to the bust on the pedestal (note, on the right, the sliver of the *outside* of the Vatican which is sketched between the obelisk and the decorated pilaster). Turner used the view of Rome in this sketch virtually unchanged for the painting itself, there combining it with a view looking down the loggia which he copied from another sketch (Plate 124). In order to draw the latter, however, he must have stood right up against the *inside* wall of the loggia, and at the end of the fourth bay away from the statue. In *Rome, from the Vatican* the spectator is made to feel that he is close to the inside wall of the third bay, not the fourth, but from either position it is impossible to see St Peter's Square at all, since one is too far away from the window. And one certainly cannot see the outside of the Vatican (still visible, in the painting, between the obelisk and the pilaster!).

None of the sketches on which *Rome, from the Vatican* was based was in colour. Despite this, the painting is notable for its wonderful colour effects which were widely commented on in 1820, sometimes critically, sometimes with approbation.[26] The overall scheme of blue, gold and red — described as 'gaudy', 'obtrusive' and 'the display of colours for the sake of colours' by one critic — is worth a brief analysis, since, although as a whole it may appear to be a typical product of Turner's imagination, many parts were based on nature or convention. The sky reaches its bluest at the zenith, as it so often does in the works of Claude but as it also does in nature itself. The golden hue cast over the stonework was a

Colour Plate 21. Detail of *The Bay of Baiae* (Colour Plate 20)

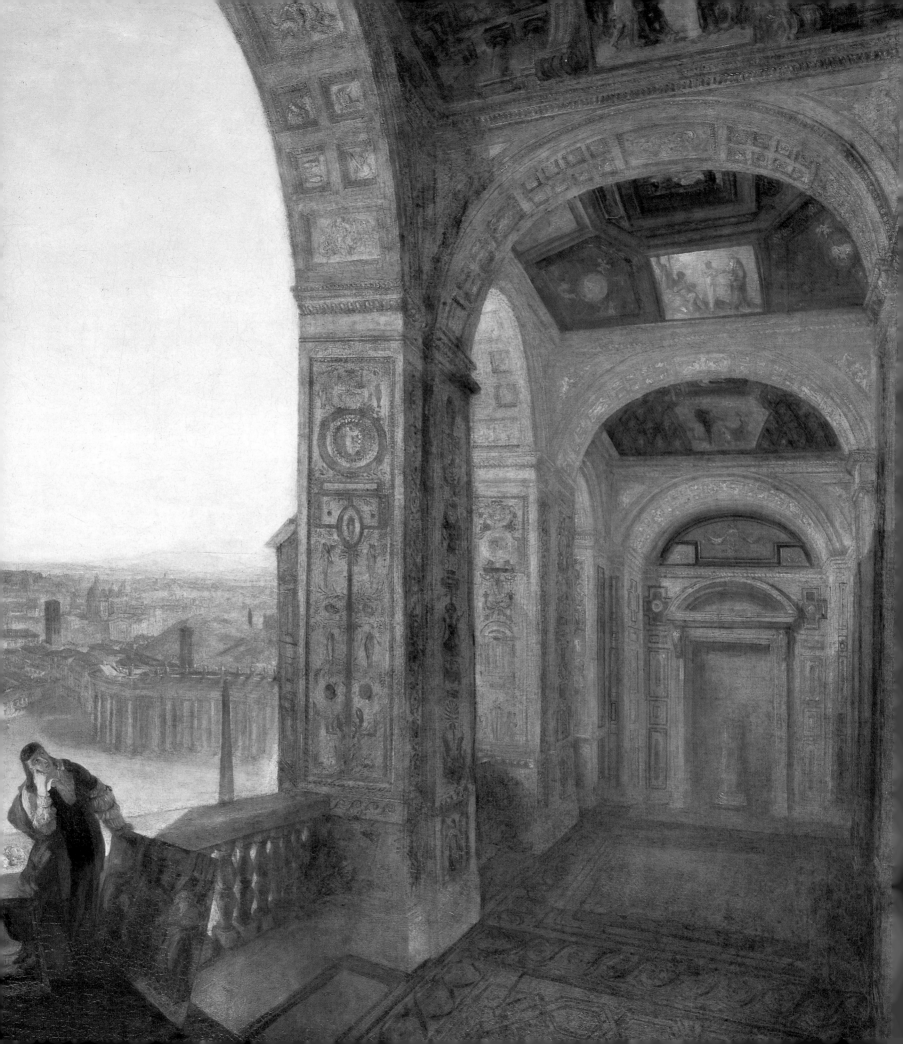

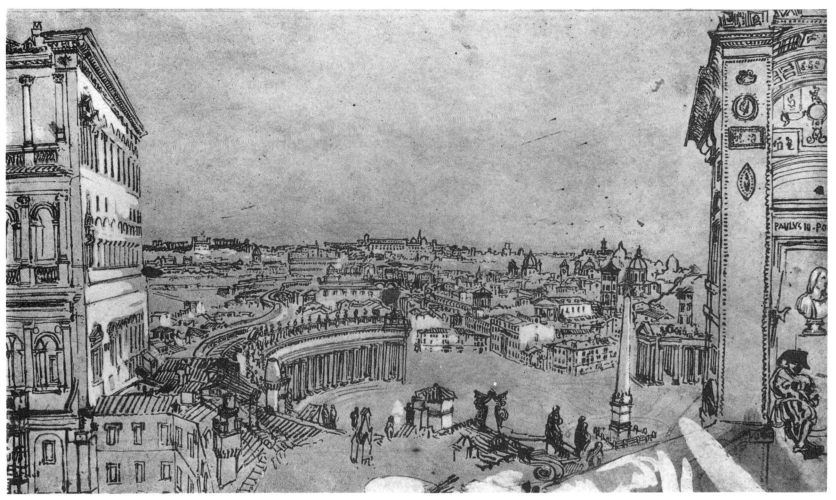

123. Rome from the Vatican loggia, (*RCSt*, 41), pencil, pen and ink, and white bodycolour on white paper prepared with a grey wash, 9 × 14½ in.

124. The structure of the Vatican loggia (*T and R*, 13a), pencil, 4⅜ × 7⅛ in.

Colour Plate 23. Detail of *Rome from the Vatican* (Colour Plate 19)

piece of well-established poetic licence. Turner's numerous and very detailed pencil sketches of Raphael's ceiling frescoes, stucco decorations and floor patterns included many colour notes which must have been consulted for the oil painting (Plate 125). As far as the colours of the distant city are concerned, Turner would have been helped by his own coloured sketches, such as that drawn near the Villa Barberini, just across the Tiber from

125. The decoration of the Vatican loggia (*T and R*, 14), pencil, $4\frac{3}{8} \times 7\frac{3}{8}$ in

S. Giovanni dei Fiorentini (Plate 126). This evokes just the same effects as the distant view in *Rome, from the Vatican*: reddish-brown roofs, white buildings and the blue mist that hovers over the city creating a natural aerial perspective. Thus in the final painting the only part of Turner's colour scheme to be pure invention was the warm rich red of the foreground.

Why did Turner make so many sketches relating to the Vatican loggia? This question is easily answered, since Raphael's decorations in the Vatican were extremely celebrated in the early nineteenth century as they have been ever since they were painted. A visit to the loggia (Colour Plate 23 and Plate 127) then formed part of every tourist's itinerary and the view from it was greatly admired in its own right. In 1814, Samuel Rogers described the prospect shown by Turner as 'perhaps the richest view of a Metropolis in the World' and it inspired him to quote lines celebrating the glories of Rome from *Paradise Regained*.[27] Another factor was that by the time of Turner's visit the decorations of the open loggia were in a very precarious state, owing to their having been exposed to the weather for close on three hundred years. In 1814 one British tourist described the arabesques as 'in many places quite effaced, everywhere greatly injured', and in that same year the French administration were so appalled at the state of the frescoes that they began glazing in the loggia under the direction of Canova.[28] In May 1819 Lawrence described himself as 'not sufficiently prepared for the ravages of Neglect & Time' in the Raphael rooms in the Vatican: 'all . . . is Ruin and Decay'; at about the same moment the British scientist Sir Humphry Davy was trying 'to ascertain if anything can be done to preserve the frescoes of Raphael in the Vatican'.[29] In short, in 1819 the condition of Raphael's work in the Vatican was a subject of international concern. Turner must surely have been aware of this (he was in touch with both Canova and Lawrence in Rome, and possibly also with Davy as well, since the last was a close friend of Chantrey's)[30] and he may well have wanted to make a careful study of the loggia, and his own personal records of its splendours, before it decayed even further.

Concern about the loggia itself may have contributed to Turner's prolific sketching in 1819, but his reason for wanting to exhibit a painting about Raphael at the 1820 Royal Academy was a celebratory and historical one: 6 April 1820 was the tercentenary of Raphael's death. (This took place, incidentally, in his house in Piazza Rusticucci, the tiny square visible just next to Raphael's head in *Rome, from the Vatican*, which may well account for Turner placing him in that precise spot in the painting).[31] It has already been

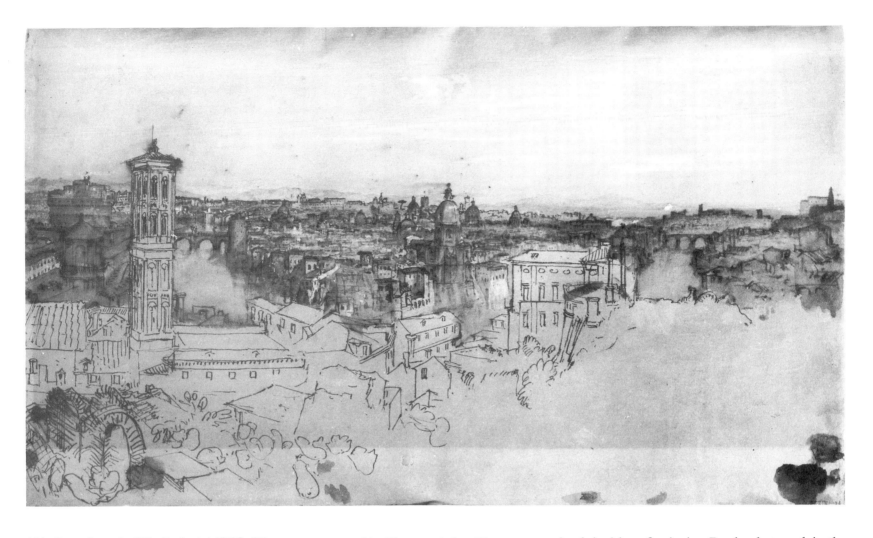

126. Rome from the Villa Barberini (*RCSt*, 34), pen and ink, watercolour and white bodycolour on white paper prepared with a grey wash, 9 × 14½ in.

127. The loggia of Raphael, Vatican, Rome

suggested in Chapter 4 that Turner conceived the idea of painting Raphael at work in the loggia whilst he himself was actually sketching there in 1819. First he recorded the loggia itself (Plates 124 and 125); then he sketched the portrait bust of Raphael at the far end of the loggia (Plate 67); finally he made composition studies on the theme of an artist at work (Plate 128). It is not surprising that such an idea occurred to Turner while he was in Rome, since interest in Raphael was extremely high there at this moment, particularly among foreigners.[32] One group of artists, for example, was reported to be collecting together all Raphael's letters and manuscripts to be published for the tercentenary.[33] Turner may well have seen Ingres's picture of Raphael and the Fornarina, painted in Rome in 1813 and existing in several versions; he may also have recalled H. J. Fradelle's painting of a similar subject, exhibited in London in 1817.[34] But Turner's concern — unlike Ingres's — was to show Raphael as a great artist. His selection of Raphael's paintings — real, invented and transformed — relates to the contemporary and new-found interest in Raphael as master of all the genres, of easel paintings as well as of frescoes. The architectural plans illustrate his important work as an architect; the statuary recalls his achievement as a sculptor. Nevertheless, Raphael's chief claim to fame was still, as always, the frescoes which adorn the Vatican, and his pose in Turner's painting brilliantly reminds British art-lovers of the inscription in London's mightiest classical building, 'Si monumentum requiris, circumspice.'

Turner's second Italian subject of the 1820s, *The Bay of Baiae, with Apollo and the Sybil* (RA, 1823; Colour Plate 20), was very different from his first. After an urban, architectural scene he chose a coastal landscape with only a few distant and ruined buildings; after Rome, the busy 'caput mundi', he chose the relaxing luxuriance of southern Italy; and after a Renaissance subject he chose a theme from the world of classical mythology. Such conspicuously different subject matter suggests that Turner felt a strong

128. An artist at work in a vaulted room (*T and R*, 26), pencil, 4⅜ × 7⅜ in.

desire to demonstrate publicly the diversity of his responses to Italy; but his knowledge of the art of the past may well have helped to lead him towards his particular choice of theme. Wilson had made about a dozen paintings of the Bay of Baiae and Claude had painted Apollo and the Sibyl in a setting which is in part recognisably based on the Bay of Baiae.[35] It is tempting to suppose that Turner chose his theme in his usual spirit of rivalry with these masters; he certainly produced a treatment of Baiae that is not only larger and grander than theirs but also vastly more complex.

In *The Bay of Baiae*, as in his earlier paintings of Aeneas and the Sibyl, Turner's protagonists are depicted in the most appropriate landscape setting. Apollo is shown conversing with the Sibyl of Cumae which lies only a few miles distant from the Bay of Baiae itself. But there is more to Turner's choice of setting than topographical suitability. The Bay of Baiae, to the west of Naples, had been particularly admired for its beauty in ancient times. Here the wealthy Romans had built luxurious country villas with magnificent seaside gardens in order to enjoy their winter leisure among the warm and gentle coastal breezes. By the eighteenth century, however, the area was completely ruined, its villas deserted, crumbling and overgrown with wild vegetation — a perfect example of beauty that had passed away. The comments of early nineteenth-century visitors were consistently on this theme. Thus Samuel Rogers in 1815: 'Perhaps the Forum Romanum alone affects you more with its vestiges of antient splendour'; Henry Sass in 1818: 'Nothing demonstrates more the vicissitudes and fragility of human affairs than the sight of these shores, covered with ruins, and actually deserted'; Henry Matthews in 1820: 'all is fairy ground. — Here you may wander about, with Virgil and Horace in your hand, and moralize over the changes that time has produced. — How are the mighty fallen!'[36] The subject of Turner's painting comes from that treasure-trove of stories relating to change, Ovid's *Metamorphoses*, and it, too, is concerned with the passing of time and the fading of beauty. The Cumaean Sibyl was loved by the god Apollo who promised to grant her whatever she asked. She took a handful of earth and asked to live as many years as there were grains of dust in her hand, a request which was granted. Apollo would also have given her perpetual youth in return for her love, but this she denied him, so she wasted away till only her voice remained. Thus, while the beauty of the landscape in *The Bay of Baiae* is only a whisper of what it once had been, the Sibyl herself is, as Ruskin put it, 'the type of the ruined beauty of Italy'.[37]

But Turner's message is even more complex than this, for a stone in the left foreground

bears a quotation from Horace's Ode to Calliope, 'Liquidae placuere Baiae'.[38] The phrase itself refers to the poet's delight in the sparkling air of Baiae but the poem as a whole has a more serious message. As Robert Anderson pointed out in his *Complete Edition of the Poets of Great Britain*, a book owned by Turner, the ode is 'wholly consecrated to piety. The first ten strophes shew the happiness of those, who live in a constant submission to the gods, and the last ten propose the rigorous chastinement of those who violate that submission'.[39] The appropriateness of Horace's ode to the story of the Sibyl who rejected Apollo's love would have struck many educated spectators of Turner's day. Meanwhile, a number of poets and travel writers had interpreted the decline of Baiae as a punishment for the profligacy and degeneration into which it had fallen.[40] The purple passage which Baiae inspired in Eustace's *Tour through Italy* has already been quoted in Chapter 6, and Turner's painting itself makes a specific reference to Baiae's fall from virtue by the introduction of a snake into its foreground.

The Bay of Baiae is closely related to other paintings by Turner on the subject of glory and decline, both looking back to the Carthage pictures of 1815-17 and looking forward to the 'ancient' and 'modern' Italian pairs of 1838-9. It differs from all these, however, in that heyday and fall are not separated into two paintings; it shows a conflation of time. The Sibyl is still young and beautiful and, as Ruskin observed, both Apollo and the Sibyl seem unaware of the decay that surrounds them.[41] In juxtaposing contrasting and incompatible moments which are supposedly centuries apart, Turner's painting is far closer to poetry than to traditional history painting. Equally poetical is its use of landscape as an allegorical extension of its story. (Keats had recently done exactly this in 'La Belle Dame Sans Merci' where the mood of the knight-at-arms, 'Alone and palely loitering' is mirrored in his surroundings where 'The sedge is wither'd from the lake, And no birds sing.)[42] *The Bay of Baiae* shelters its own fragment of poetry among its other classical fragments, the 'Liquidae placuere Baiae' already mentioned, which holds another significance still, besides that of useful topographical signpost and advocate of morality. The typical eighteenth-century visitor to Italy was always very conscious of ancient history and literature and there were many who, like Addison, had matched quotations to locations with unflagging zeal. Turner's quotation from Horace is reminiscent not only of Addison's practice but also of the vogue for placing classical nature inscriptions in English eighteenth-century gardens. One of the most famous of these, Shenstone's The Leastowes, had benches inscribed with passages from Virgil.[43] Meanwhile, Turner's own line in the Royal Academy catalogue, 'Waft me to sunny Baiae's shore', embodies a recollection of the words of Addison himself in his celebrated 'Letter from Italy' of 1701: 'Bear me, some god, to Baia's gentle seats'. Turner's line could well have made spectators recall Addison's whole passage on Baiae, which itself was concerned with the conflation of time:[44]

> Ev'n the rough rocks with tender myrtle bloom,
> And trodden weeds send out a rich perfume. . . .
> And all the seasons lavish all their pride:
> Blossoms, and fruits, and flowers together rise,
> And the whole year in gay confusion lies.

The Bay of Baiae is also redolent of earlier visions of Italy through its Claudian composition. Turner provides a wide foreground, softly curving hills at either side and tall trees with light filtering through their transparent leaves; he creates a sense of space through gently flowing diagonal lines and the use of streams and paths to lead the eye back to the far horizon. The chief difference between *The Bay of Baiae* and a painting by Claude is, of course, its colouring, in particular the browns and yellows in the foreground. Turner here confines his use of green to individual plants and leaves which are isolated against the brownish yellow earth; foliage and fruits elsewhere are orange-brown or copperish-brown, while the shadows are a darker brown. Turner's choice of colouring probably has some basis, at least, in naturalism. He had visited Baiae in October or November and he may well have savoured southern Italian views 'shining with autumnal color like burnished gold in

the morning sun' as Samuel Palmer was to do in October 1838.[45] But it is hard to avoid reading Turner's colours metaphorically. His painting is, after all, centred on the grains of sand which the Sibyl is displaying to Apollo, and the spectator is invited to ponder on the fading and withering away of her beauty into an endless autumn.

The landscape setting of *The Bay of Baiae* (Colour Plate 21) also has both a naturalistic and an imaginative dimension: its background was keenly observed from nature, while its middle distance and foreground are purely artificial.[46] All the 1819 sketches of Baiae in the *Gandolfo to Naples* sketchbook take for their subject the area included in the top half of the painting — the mountains round the bay, the concave roof of the Temple of Diana, the shoreline and pier, the octagonal Temple of Venus and the castle on the promontory (Plate 129).[47] The same ingredients are studied again and again from slightly different viewpoints, with Turner always standing somewhere fairly close to the shore so that the buildings are near enough to be precisely observed. In 1823, however, he was not content merely to show the Bay of Baiae as he had seen it; he wanted to paint a subject picture. The foreground he produced contains nothing that he had seen and sketched, for the simple reason that no such gradual slope as he depicts actually exists at Baiae — a very short way inland Baiae is closed in by hills which form a natural theatre round the bay. Since Turner had invented his foreground, he now had to invent all its features, which it was easy to do from his imagination and his existing repertory. Apart from specific items like the snake, rabbit and inscription, all of Turner's staffage — plants, flowers, creepers, fruit and architectural fragments — can be found in the foregrounds of earlier paintings.[48]

The reaction of Turner's friend the painter George Jones to *The Bay of Baiae* was thus, in a sense, inevitable:[49]

> One day Mr. G. Jones, having discussed Turner's picture of the 'Bay of Baiae' with a traveller who had recently been there, was surprised to find that half the scene was Turner's sheer invention; upon which, in fun, Mr. Jones wrote on the frame,
> 'SPLENDIDA [sic] MENDAX.'
> Turner saw it, and laughed. His friend told him that where he had planted some hills with vineyards, there was nothing in reality but a few dry sticks. Turner smiled, and said it was all there, and that all poets were liars. The inscription remained on the frame of the picture for many years; Turner never removed it.

In view of Turner's retort, it is worth noting that the Bay of Baiae features in three contemporary poems by Shelley: the 'Ode to the West Wind' (1819, published 1820), 'The Sensitive Plant' (1820, published 1820) and the 'Ode to Naples' (1820, published 1824). Comparisons between Turner and Shelley have been made ever since the 1830s and it is generally agreed that Turner's late paintings of Venice have much in common with Shelley's verses about that city.[50] One reviewer of his poetry in 1839 noted the similarity between Shelley and Turner in their love and study of 'the flat sandy beach, the wild seaside marsh which fringes the coast of the sluggish Mediterranean' rather than 'only the ordinary poetical store of rocks, breakers, storms, and so forth'.[51] He must almost certainly have been thinking of *The Bay of Baiae* and these lines from the 'Ode to the West Wind':

> Thou who didst waken from his summer dreams
> The blue Mediterranean, where he lay,
> Lulled by the coil of his crystalline streams,
>
> Beside a pumice isle in Baiae's bay,
> And saw in sleep old palaces and towers
> Quivering within the wave's intenser day,
>
> All overgrown with azure moss and flowers
> So sweet, the sense faints picturing them![52]

It is easy to regard Turner's sea as lulled into sleep, like Shelley's, while the contrast in the painting between the deep blue sea and the much lighter sky is exactly parallel to the poet's

129. The Bay of Baiae, with the Temple of Venus and the castle (*G to N*, 82a-3), pencil, each page 4¾ × 7¾ in.

reference to 'the wave's intenser day'. Shelley enjoyed the experience of southern Italy in very much the same ways as Turner, combining a sensuous delight in the sea and coast and atmosphere with a personal response to the traditional associations of the south, familiar to him through his reading of classical literature. He described the effect of the scenery as 'inexpressibly delightful. The colours of the water & the air breathe over all things here the radiance of their own beauty'.[53]

But it is not only on the descriptive level that Shelley's poetry matches *The Bay of Baiae*. Two of his poems mentioning Baiae are fundamentally about the passing of time and the changing of the seasons, the very themes which lie at the core of Turner's picture. The 'Ode to the West Wind', conceived and written on an autumn day in Florence, takes the reader through all the seasons in retrospect or in prospect, using Baiae to evoke the past days of a beautiful summer, now dispelled by the autumnal winds. In 'The Sensitive Plant', the spirit of summer tends a fair garden; it then suddenly dies and the garden is plunged into the harshness of winter and decay. For Shelley, Turner and their contemporaries, the ruined beauty of Baiae was a highly moving illustration of the passing of time and the fragility of life. Both are known to have read Eustace's *Tour through Italy* with its strongly worded passage on this theme.[54] Both had thoroughly digested the commonplaces of their age on the history of Baiae and each created his own personal poetry out of the theme: Shelley referred to Baiae whilst elaborating upon the contrasts of the natural world, Turner emphasised the vicissitudes of human affairs while using the landscape itself to point the same moral. Later visitors to Baiae seem to have been less intensely concerned with such historical and metaphysical reflections. In 1838 Samuel Palmer described Baiae on an exclusively visual level as 'an epitome of all that is beautiful. Every point I have seen affords the finest lines of capes — reaches — and islands — and a months stay would furnish distances for life'; his wife called it 'a place of enchantment' and neither made any comment at all on its associations.[55] In 1846 Dickens barely gave the place a mention in his *Pictures from Italy*.[56] It was upon the classically educated but romantically minded generation of Turner and Shelley that Baiae's ruined beauty exercised its fascination most potently.

Three years after *The Bay of Baiae*, Turner exhibited the third of his large oil paintings based on his experiences of 1819. This was *Forum Romanum*, in which he returned to Rome itself and the very heart of the ancient city (Colour Plate 22). Its full title at the 1826 Royal Academy, *Forum Romanum, for Mr Soane's Museum*, makes it virtually certain that the painting was a commission from the architect John Soane. This is in no way surprising. Soane commissioned paintings from many of his friends and colleagues from about 1814 onwards, including Thomas Stothard, Eastlake, Callcott, George Jones, Henry Howard and John Jackson.[57] He was also passionately interested in classical architecture. He had travelled in Italy in 1778-80, he had been Professor of Architecture at the Royal Academy

130. The Dome of Sir John Soane's Museum, London, as it was in 1813, watercolour by J. M. Gandy, $49\frac{1}{2} \times 28\frac{1}{4}$ in., Sir John Soane's Museum, London

131. The Arch of Titus and the Basilica of Constantine (*SRCSt*, 1), pencil on white paper prepared with a grey wash, with lights rubbed out, $5\frac{1}{4} \times 10\frac{1}{8}$ in.

since 1806, he was the designer of buildings in the classical style and an avid collector of antiquities. The commission to Turner embraced both of Soane's principal interests, the encouragement of British art and the development of his own museum.

Soane's museum — at 12-14 Lincoln's Inn Fields — was technically created by the private Act of Parliament of 20 April 1833 which settled and preserved his library and works of art for the benefit of the public.[58] However, he had been assembling his collection for the previous quarter of a century and the word 'museum' was used of it long before the date of Turner's painting.[59] Initially begun at Pitzhanger Manor, and with an eye to the artistic education of Soane's two sons, its aims soon became much broader. In 1834 it was described as 'a commencement . . . towards supplying that desideratum, a national architectural academy. The Soanean Museum . . . cannot fail of proving highly beneficial to the student in architecture, and more particularly to those persons of ardent and keenly inquisitive dispositions, who can neither afford time nor money to travel and examine the ancient edifices of distant countries'.[60] In the museum the student could examine antique fragments, scale models of entire classical buildings, casts of famous sculptures and thousands of architectural prints and drawings from the fifteenth century to the present day.

Turner's *Forum Romanum* would have been an eminently suitable addition to this collection and it must be surmised that Soane had specified its subject matter. It also seems highly likely that Soane gave his commission to Turner as a direct result of his rebuilding of 14 Lincoln's Inn Fields in 1824 and the creation of the new Picture Room at the rear (the room which now houses the Hogarths).[61] As every visitor to the Soane Museum is immediately aware, space there is extremely restricted; even the Picture Room is only about thirteen feet square. However, its north and south walls have hinged folding leaves which carry paintings on their inside and outside planes while yet further paintings are hung in the recesses behind them. Because of this arrangement the room can hold as many pictures as a gallery twenty feet broad by forty-five feet long and this thought seems to have encouraged Soane to commission new works. Eastlake's *Una delivering the Red Cross Knight from the Cave of Despair* (1830) was commissioned in 1824-5; *The Passage Point* by Callcott, also acquired in 1830, was probably commissioned about 1827.[62] However, Soane's correspondence with Eastlake and Callcott shows that he was extremely dictatorial regarding the size and shape of their pictures, even down to the measurements of their frames, so that the paintings would fit into their appointed places. His insistence was quite understandable, for it was in just this respect that his arrangement with Turner had broken down in 1826. Turner's correspondence with Soane indicates that the painter had made *Forum Romanum* 'over-size' compared to what had been specified; Soane 'was not perfectly satisfied with it' and 'the picture did not suit the place or the place the picture'.[63] He therefore did not accept it, for there was nowhere else in the house to hang a painting measuring some five feet by eight. But his new Picture Room would have been a wonderful setting for *Forum Romanum*. The experience of strolling from the Dome, crowded with antiquities (Plate 130), through the Corridor, with its casts, copies and fragments from the Roman Forum, and then coming face to face with Turner's painting, surrounded by works by Clérisseau and Piranesi, would have been like treading on classic ground itself.

Forum Romanum is directly based on a remarkably large number of sketches, scattered through four different sketchbooks.[64] The grand shape of the Arch of Titus and the smaller mass of the Basilica of Constantine had formed a composition in *Small Roman C. Studies* (Plate 131). More specific details of the arch, such as its inscription and the exterior and interior friezes, were recorded in *Rome: C. Studies* and *St Peter's*, while the basilica shown in *Forum Romanum* is an amalgam of several sketches in *St Peter's* which even include the rugged fragments of fallen masonry and coffering later found in the painting itself (Plate 132). The buildings at the north end of the Forum, which the painting shows between the arch and the basilica, derive from sketches in *Rome: C. Studies* (Plate 133), *Small Roman C. Studies* and *St. Peter's*. Finally, the three columns of the Temple of Castor and Pollux

122

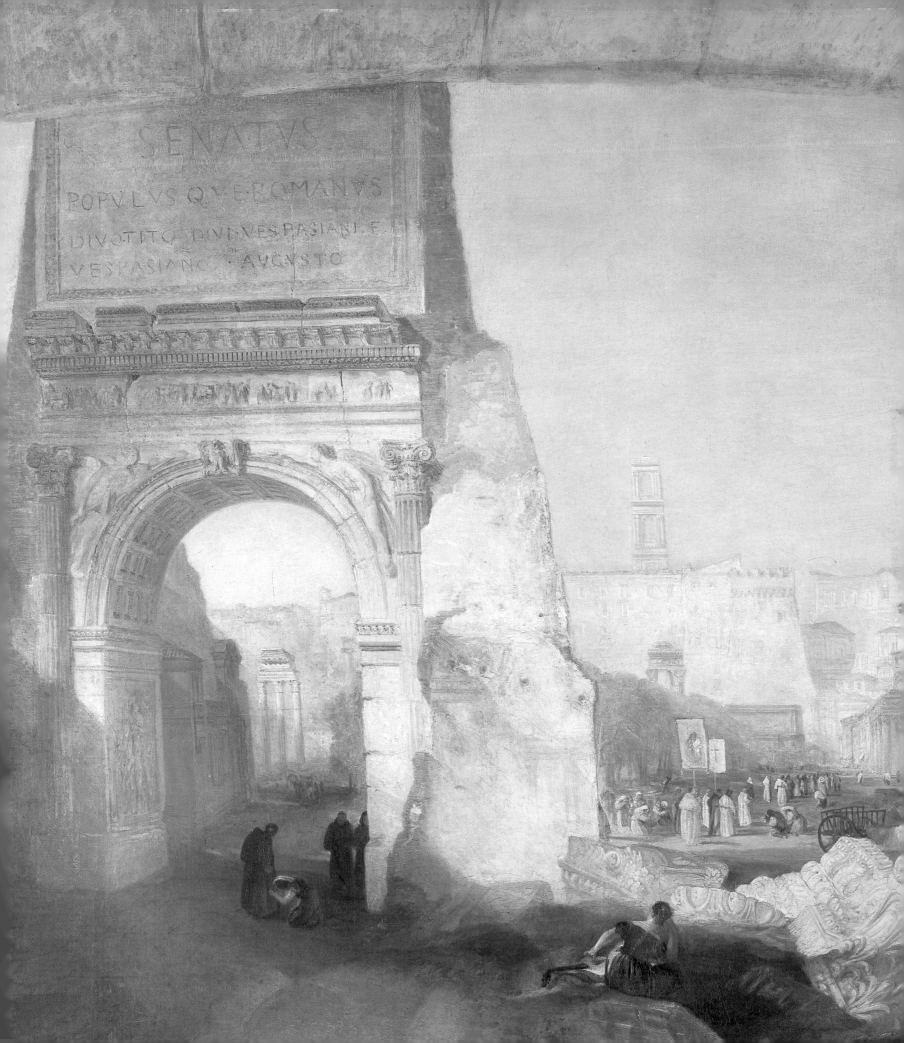

132. The Basilica of Constantine (*St P's*, 58), pencil, $4\frac{1}{2} \times 7\frac{1}{2}$ in.

133. The view looking towards the north end of the Forum (*RCSt*, 25), pencil on white paper prepared with a grey wash, with lights rubbed and scratched out and some white bodycolour, $9 \times 14\frac{1}{2}$ in.

134. A.-L. Ducros, *The Arch of Titus, Rome, c.* 1790, watercolour over outline etching, $28\frac{3}{4} \times 20$ in., The National Trust, Stourhead

Colour Plate 25. Detail of *Lake Albano* (Plate 135)

(seen through the Arch of Titus in the painting) had been the subject of a detailed pencil sketch in *Albano, Nemi, Rome* and a coloured sketch in *Rome: C. Studies.* Many other sketches of the same buildings from different angles can be found in three of the same sketchbooks, but probably contributed little to the painting.[65]

Turner used these sketches with considerable licence. If Plate 131 is compared with the finished painting (Colour Plate 23) it is seen that in 1826 he tidied up the unsightly accretions on the right of the Arch of Titus (which were in fact demolished in the early 1820s). In their place he neatly inserts a view looking straight down towards the Tabularium and the tower of the Capitol, features which are not visible to the right of the Arch of Titus so long as the Temple of Castor and Pollux is kept in sight through its archway. Inevitably, the relationships between individual buildings in Turner's painting become topographically incorrect. The Temple of Saturn (just visible through the Arch of Titus) is now widely separated from the Temple of Vespasian (immediately below the tower of the Capitol). It is almost as if Turner felt that every famous monument in the Forum must be slotted in somewhere to make a token appearance, lest he be accused of omitting them.

Forum Romanum takes liberties with its subject but it does so very successfully, breathing new life into a much-depicted view. Artists have sketched and painted the Forum constantly and from every angle since the Renaissance, and although the northern end has perhaps attracted more attention through the variety of its subjects, the southern end has also inspired many works of art; a glimpse of the Forum framed by the Arch of Titus forms a naturally picturesque subject. Prints of such a view by Marten van Heemskerck were already in circulation in the early sixteenth century and it was very popular in the eighteenth century, when it was painted by Vanvitelli and by Canaletto. Piranesi's *Vedute di Roma* included a close-up view of the Arch of Titus framing the Basilica of Constantine, while a further eighteenth-century representation that Turner would have known was the large watercolour at Stourhead by A.-L. Ducros (Plate 134). Visitors to the 1826 Royal Academy would thus have found the left-hand part of Turner's painting quite conventional as far as the subject was concerned, and they might well have regarded the foreground clutter of antiquities and foliage as acceptably Piranesian. Those with a good knowledge of Piranesi's work might also have found Turner's huge stone arch framing the smaller arch below it somewhat familiar; in the *Archi Trionfali* of 1748 Piranesi had shown the Arch of Constantine in a similar fashion, as if entirely framed by one of the ground-floor arches of the Colosseum.

With his imaginary framing arch, Turner's debts to the past end. Veering characteristically towards excess, he avoided making the traditional view of the Forum through the Arch of Titus the whole subject of his picture. Instead he relegated it to one side, filling the rest of the canvas with enough material for several different pictures of Roman antiquities. Where the viewer might expect clarity, Turner's scene is vague and swathed in the overlapping veils of shifting mist that were later to float around his *Ancient Rome* and *Modern Rome* of 1839. Even the most monumental buildings are not presented as awesome: the Basilica of Constantine seems soft and insubstantial rather than gaunt and massive. The painting was criticised in 1826 for being too colourful and not having enough chiaroscuro;[66] one may read between the lines that the critics thought that Turner had treated his subject without the necessary — and indeed traditional — dignity and gravity. What he was actually doing, however, was remembering the light and colour effects that he had seen in Italy: 'wide arches, which the reflected radiance makes lighter than the sky'.[67]

The scenes from modern life in *Forum Romanum* also derive directly from Turner's own experiences. In Turner's day British travellers in Italy were fascinated by the complex and unfamiliar Catholic practices which could be seen daily not only in churches but also in public places. Intellectual reactions were varied: some were envious of congregations where people of different classes apparently worshipped together like members of a family; others were outraged at what was seen as cant and imposture, superstition and

mummery.[68] None the less, most found the sheer spectacle of Catholic ceremonial highly attractive, and even a man like Hazlitt, who condemned Catholicism wholeheartedly, had to admit that 'The Priests talking together in St. Peter's, or the common people kneeling at the altars, make groups that shame all art.'[69] The eyes of British tourists were riveted by the sight of Italians genuflecting in the street; by processions of clergy with crucifixes, banners and torches; by masked fraternities collecting money for the souls of condemned criminals; by pilgrims with staffs and shells; by hooded friars; by the groups of bagpipers known as *pifferari* who played in front of images of the Madonna during the Christmas season; and by the ceremonies of the church services themselves.[70]

Religious processions in the Forum were a very frequent sight, since there were several churches both in and around it,[71] but Turner has provided rather more than just a piece of convincing and relevant staffage. In the early nineteenth century the British tourist in Italy commonly regarded Catholicism as an adaptation of the ancient pagan religion of the Romans. This idea lay behind the Rev. J. J. Blunt's *Vestiges of Ancient Manners and Customs, discoverable in Modern Italy and Sicily* (1823), a book owned by Turner which was mentioned in Chapter 1, and the travel literature on Italy is rich in references to the matter. The Italians venerated a host of saints who were the equivalent of the pagan gods and goddesses; they worshipped in Roman temples which had been converted into Christian churches; their festivals, prayers, images, offerings, processions and superstitions were all adaptations from the pagan world.[72] In other words, the past was not dead and gone; it lived on in modern Italy for all to see. Against this background of thought, Turner's choice of figure subjects in *Forum Romanum* (and — equally important — their placing in the picture) looks very like a deliberate attempt to express his own sense of the continuity of Italian life, the unity of past and present. For what does he actually show? Under the arch dedicated to the Roman emperor Titus, 'divine Titus, son of divine Vespasian' as he is styled in the inscription upon it, a woman kneels before one of the holy men of the present, a Catholic monk (Colour Plate 24). The ruined wall adjoining the arch has been transformed into part of a church with a fresco of a Madonna and Child adored by an angel; the pose of this angel echoes that of the winged figures in the spandrels of the arch, again making a juxtaposition of pagan and Christian. On the ceremonial route for the sacrificial processions of pagan Rome, the Via Sacra, there comes a group of monks carrying a banner and crucifixes and the Host under a canopy. Their destination is undoubtedly the church of S. Lorenzo in Miranda which had been constructed out of the pagan temple dedicated to Antoninus and Faustina. Finally Turner crowns the entire picture with an all-embracing imaginary arch as if to bring home his whole message: that the same city shelters ancient and modern, dead and living, pagan and Christian.

The average twentieth-century gallery-goer does not instantly appreciate all these nice juxtapositions in *Forum Romanum* and it is easy to regard it merely as a topographical view enlivened by touches of modernity. However, the spectators of Turner's own day would have read the painting rather differently: it did not simply depict the visible; it spoke of a belief in a continuous historical process.

* * * *

Forum Romanum was Turner's last oil painting of Italy before he returned there in 1828, but he produced a number of watercolours of Italy around 1826-8. On the one hand, there were the tiny vignettes to illustrate a new edition of Samuel Rogers's poetic cycle *Italy*. Turner also began work for the print publisher Charles Heath on a group of large watercolour views of Italy (*c.* 11 by 16 inches). These were for reproduction in a work which was intended to follow the pattern of Heath's *Picturesque Views in England and Wales*, on which Turner had begun working in 1825, and would probably have been called *Picturesque Views in Italy.* Turner completed three subjects — *Florence, Lago Maggiore* and *Lake Albano* — which were exhibited in June-July 1829 by Charles Heath and Robert Jennings at the Large Gallery of the Egyptian Hall, Piccadilly, alongside thirty-eight of his

watercolours for *England and Wales*.[73] At this stage *Picturesque Views in Italy* was scheduled for publication in the spring of 1830 but it never in fact materialised, presumably because of Charles Heath's financial difficulties. Turner stopped working on the project but his three finished watercolours had by now all been engraved on a small scale and published in one of the annuals which Heath owned, the *Keepsake*. *Florence* was engraved by Edward Goodall for the *Keepsake for 1828*, while *Lake Albano* and *Lago Maggiore* both appeared in the *Keepsake for 1829*, engraved by Robert Wallis and W. R. Smith respectively.[74] These annuals were published in the preceding autumn to catch the market for Christmas and New Year presents, so that *Florence* must have been engraved in the summer of 1827, *Lake Albano* and *Lago Maggiore* in the summer of 1828.

The subject and viewpoint of *Florence* have already been considered in Chapter 7, within the context of Turner's 1819 visit to that city, but *Lake Albano* (Plate 135) demands attention on many different levels. Turner had passed Lake Albano twice on his tour of southern Italy in the autumn of 1819 and had made many small sketches from around the lake, especially of the view shown in his watercolour, that looking towards Castel Gandolfo. These rough pencil outlines were not the only source for his 1828 watercolour, however; in 1819 he had also studied an exquisite little painting by Claude, the *Pastoral Landscape with a View of Lake Albano and Castel Gandolfo*, then in Palazzo Barberini in Rome (Plate 136). One of Turner's comments on this painting has already been mentioned in Chapter 5, but both the painting itself and the comments deserve a closer look.[75] When Turner's *Lake Albano* is compared with Claude's *Pastoral Landscape* it is immediately obvious that the Turner embodies a recollection of the Claude. Even the details of Turner's scene have their counterpart in his own notes of nine years earlier. After mentioning that Claude's picture was 'warm, brilliant and clear', Turner had noted the subtle contrasts within it: 'The Trees on the left and Center dark, the right tree warm yellow leaves and brown Stem, tho' in the light yet darker than the Sky'; he had described the peasant woman leaning on her staff as 'The figure in blue yellow kerchief and pink petticoat clear all and keeps the Eye to the Center'; and he had observed that in the foreground 'a few flowers are painted very sharp'. In Turner's *Lake Albano* dark green and light brown are disposed among the trees in exactly the same way as in Claude's painting; the tonal relationship between the right-hand tree and the sky is also based on Claude's scheme. He has placed his figure group exactly where Claude had placed his, keeping 'the Eye to the Center', and has even dressed his *contadina* in a brilliant blue that rivals Claude's.[76] Finally, he has sprinkled his own foreground with crisply painted little flowers and touches of crimson, sky blue, turquoise, mauve and gold so that it resembles a richly coloured floral tapestry. Here, however, the similarities between the two paintings end, for they record the light and colour of Italy in a totally different way. Claude's scene has the bright clarity of a finely painted miniature but Turner's glows like an opulent jewel. His iridescent, primrose-tinted sunlight blurs the forms of lake, hillside, distant trees and buildings in a dazzling array of tiny strokes of mauve, light turquoise and pale gold (Colour Plate 25). Taken as a whole, this painting recalls neither the Barberini Claude nor the Lake Albano which Turner had seen on a November day in 1819. It conjures up the very essence of sunlight itself.

When Turner's *Lake Albano* was reproduced in the *Keepsake* it accompanied a short story entitled 'The Sisters of Albano, by the Author of Frankenstein', in other words Mary Shelley, the widow of the poet, whom Shelley's relations would not allow to use his name. Her magnificent description of Lake Albano corresponds exactly to Turner's scene and is therefore worth quoting in full:

As the sun descended, it poured a tide of light into the valley of the lake, deluging the deep bank formed by the mountain with liquid gold. The domes and turrets of the far town flashed and gleamed, the trees were dyed in splendour; two or three slight clouds, which had drunk the radiance till it became their essence, floated golden islets in the lustrous empyrean. The waters, reflecting the brilliancy of the sky and the fire-tinted banks, beamed a second heaven, a second irradiated earth, at our feet. The

135. *Lake Albano, c.* 1828 (W, 731), watercolour, $11\frac{1}{2} \times 16\frac{1}{2}$ in., private collection

Mediterranean gazing on the sun — as the eyes of a mortal bride fail and are dimmed when reflecting her lover's glance — was lost, mixed in his light, till it had become one with him. — Long (our souls, like the sea, the hills, and lake, drinking in the supreme loveliness) we gazed, till the too full cup overflowed, and we turned away with a sigh.

At our feet there was a knoll of ground, that formed the foreground of our picture; two trees lay basking against the sky, glittering with the golden light, which like dew seemed to hang amid their branches — a rock closed the prospect on the other side, twined round by creepers, and redolent with blooming myrtle — a brook crossed by huge stones gushed through the turf, and on the fragments of rock that lay about, sat two or three persons, peasants, who attracted our attention. One was a hunter, as his gun, lying on a bank not far off, demonstrated, yet he was a tiller of the soil; his rough straw hat, and his picturesque but coarse dress, belonged to that class. The other was some contadina, in the costume of her country, returning, her basket on her arm, from the village to her cottage home. They were regarding the stores of a pedlar, who with doffed hat stood near; some of these consisted of pictures and prints — views of the country, and portraits of the Madonna. Our peasants regarded these with pleased attention.

The casual reader might suppose that the drawing had been made to illustrate the story, but this is most unlikely. Mary Shelley's description is not part of her main narrative, but occurs in a long prologue which sets the scene and stimulates one of the characters to tell a story — 'The Sisters of Albano' itself. The sequence of events must have been this: Charles

128

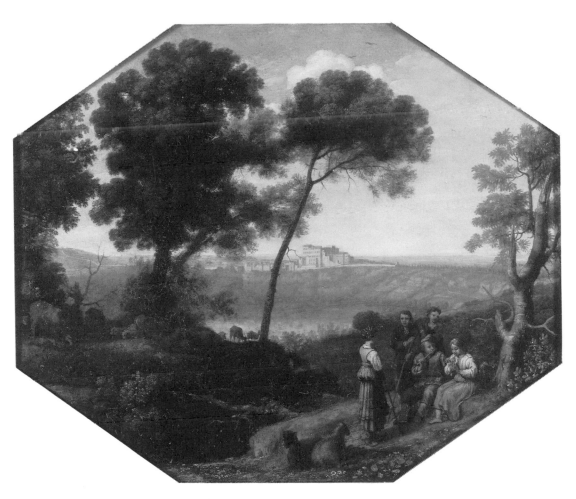

136. Claude Lorrain, *Pastoral Landscape with a View of Lake Albano and Castel Gandolfo*, 1639, oil on copper, 12 × 14¾ in. (formerly Barberini collection), Fitzwilliam Museum, Cambridge

Heath decided to include *Lake Albano* in the *Keepsake* and commissioned an accompanying story. Mary Shelley wanted to write a more dramatic and romantic story than Turner's image suggested and she therefore devised a prologue into which she could incorporate her description.[77]

To effect her transition between prologue and story, Mary Shelley writes:

'One might easily make out a story for that pair,' I said: 'his gun is a help to the imagination, and we may fancy him a bandit with his contadina love, the terror of all the neighbourhood, except of her, the most defenceless being in it.'

Indeed, not only the gun but the man's complete attire proclaim him to be a bandit. The tall hat with wide brim and banded crown, the elaborately decorated suit, the stockings bound around with leather thongs — all were unmistakable.[78] Brigandage had been rife in the countryside near Rome for centuries, causing terror among generations of travellers and periodically necessitating stern measures on the part of the papal government. In the seventeenth century Pope Urban VIII had demolished acres of forest in an attempt to reduce brigandage; woods were still being burnt down for the same purpose in 1822.[79] Just at the time of Turner's first visit to Italy the papal government took drastic steps against some of the bandits' principal strongholds, destroying the entire village of Sonnino, in the mountains north of Terracina, and dispersing its inhabitants.[80] The road from Rome to Naples was regarded as the most dangerous of any in Italy and there were many travellers of Turner's generation who were deterred from exploring Italy thoroughly, for fear of being robbed, held to ransom or murdered.[81] Hazlitt referred jokingly to his own fear that he would find 'a thief concealed behind each bush, or a Salvator Rosa face scowling from a ruined hovel, or peeping from a jutting crag at every turn' as he travelled round Italy, but he never brought himself to venture any further south than Rome.[82]

Back in the safety of their own homes, however, Grand Tourists had greatly enjoyed the picturesque subject matter of Salvator Rosa's *banditti* paintings, and the later eighteenth

century saw Wilson, de Loutherbourg, John Hamilton Mortimer and Wright of Derby all painting bandit subjects reminiscent of Rosa's. Turner's theme in *Lake Albano* does not stem directly from this tradition but belongs instead to a revival of interest in *banditti* which occurred in the 1820s and 1830s. This was partly a natural result of travellers returning to Italy after the Napoleonic Wars. The British now saw for themselves the extent of the bandit problem and took a certain pleasure in observing how badly governed Italy was. Their interest was also encouraged by the publication of Maria Graham's *Three Months Passed in the Mountains East of Rome, during the year 1819* (1820), an unusual and authoritative book which combined a detailed first-hand description of the rural economy of the village of Poli, near Palestrina, with a full account of the activities and customs of the bandits who had fled from Sonnino to that part of Italy. The book was illustrated by six aquatints, some of which showed life among the *banditti*, after drawings by Eastlake who had accompanied Captain and Mrs Graham on their visit to Poli in June to September 1819. Eastlake soon received a number of commissions for bandit pictures which he usually sent home for exhibition at the British Institution.[83] Many of his paintings simply showed a bandit and *contadina* rather than the scenes of action and terror which had been painted in earlier centuries, and Turner's couple in *Lake Albano* are clearly influenced by popular works by Eastlake such as his 1823 *Sonnino Woman and Brigand* (Plate 137). Turner had been in contact with the Grahams and Eastlake in Rome in 1819 and their visit to Poli had taken place immediately before his arrival. He would undoubtedly have heard vivid accounts of it at first hand. There is nothing to suggest that Turner himself was involved in any adventures with Italian bandits, but horror stories had inevitably circulated among his British friends in Rome in 1819 — Chantrey, Jackson and Tom Moore — and Turner was reputed to have taken an umbrella with a swordstick handle on all his travels in Italy as a defence against brigands.[84]

Eastlake's success with bandit subjects encouraged many other British artists in Italy to attempt the same theme. Thomas Uwins, for instance, painted *The Brigand's Wife* for a commission in 1825 and 'an English child in the hands of the brigands' a few years later.[85] From the early 1820s to the 1830s there were nearly always a handful of *banditti* paintings at the Royal Academy every year, some with such thrilling titles as *English travellers attacked by banditti, on the road to Rome, between Gaeta and Terracina* and *Bandit chief destroying his child, fearing that its cries might lead to a discovery of his place of retreat*.[86] But interest in *banditti* was not confined to the walls of the Royal Academy and the British Institution. The year 1824 saw the publication of Lady Morgan's *Life and Times of Salvator Rosa*, with its account of the famous, if legendary, episode in that painter's youth when he was captured and held by Neapolitan bandits. Eastlake's bandit pictures became so popular that most of them were engraved and when J. R. Planché's play *The Brigand* was performed in London in 1829, three of Eastlake's paintings were 'realised' as stage tableaux. Theatrical print-makers then issued their own engravings, thus repeating the same scenes at a further remove, while paintings at the Royal Academy also showed scenes from brigandage on stage.[87] The general public's demand for bandit subject matter seems to have been almost insatiable. In November 1829, Mary Shelley's short story was itself dramatised and was performed at the Adelphi Theatre, London, under the title of *The Sisters, or the Brigands of Albano*. More importantly, January 1830 saw the first performance, in Paris, of Auber's celebrated comic opera *Fra Diavolo* which was very soon delighting audiences not only there but in London, St Petersburg, New York and a dozen other major cities.[88] Turner's *Lake Albano* can only be properly understood within this historical context. It was painted — and widely disseminated through the popular pages of the *Keepsake* — at precisely the period when bandit scenes were the very height of fashion. As at every other moment of his life, Turner was fully aware of all that was going on around him, and he was keen to participate as much as he could.

But what does his watercolour actually depict? According to Mary Shelley, the bandit and *contadina* 'were regarding the stores of a pedlar . . . pictures and prints — views of the country, and portraits of the Madonna'. There can be little doubt that the second of these

137. William Humphrys after C. L. Eastlake, *Sonnino Woman and Brigand*, BI 1823, engraving

suggestions is the right one, for the piety of the bandits was an extremely well-known, if puzzling, aspect of their lives: the paradox is implicit in the very title of *Fra Diavolo* itself. Maria Graham related that, 'Every robber had a silver heart, containing a picture of the Madonna and Child, suspended by a red ribbon to his neck.'[89] In Eastlake's *Contadina Family, Prisoners with Banditti* (RA, 1830), an image of the Madonna and Child hangs on the tree behind his swarthy brigand and 'AVE MARIA' is conspicuously carved upon its trunk. Guidebooks told of murders committed by 'a pious ruffian, who held a pistol in his right hand and a rosary in his left'; one such fearsome character wore a necklace with 'a crucifix of black ebony and the figure of Christ in gold'.[90]

Maria Graham also noted how the Italian peasants, 'never having seen heretics before, except struggling in flames in a picture, questioned us very minutely as to our faith; and when we acknowledged our want of belief in the Virgin and saints, and our disregard of images and pictures, they shrunk involuntarily, and earnestly entreated us to be of their church'.[91] The curiosity and concern of the Italian peasants was more than matched by the fascination of the British with Catholicism, which has already been mentioned in the discussion of *Forum Romanum*, and paintings about Catholicism were even more common than *banditti* pictures at London exhibitions in the 1820s and 1830s. Such an interest in England at this particular time is quite understandable, since this was the period of the battle for Roman Catholic emancipation. The Test Act of 1683, which had required all holders of public office to be practising members of the Anglican church, was repealed in 1828, and in 1829 the Roman Catholic Emancipation Act was passed, despite intense opposition from the Tories. These years saw the painting of Eastlake's *Italian Scene in the Anno Santo, Pilgrims Arriving in Sight of Rome and St Peter's: Evening* (RA, 1828), David Wilkie's *Washing the Pilgrims' Feet* (RA, 1829), Thomas Uwins's *A Neapolitan Saint Manufactory* (RA, 1832), Penry Williams's *Festa of the Madonna dell'Arco, Naples* (RA, 1837); and there were dozens of other paintings on similar themes, by both famous and minor British artists in Italy in the late 1820s and 1830s.[92] Turner's *Lake Albano*, like his *Forum Romanum*, clearly forms part of this genre and it is not simply because his bandit and *contadina* are gazing at religious images. Turner has placed his pious couple right in front of the papal palace at Castel Gandolfo, the Pope's summer residence outside Rome. Just as the gun in the foreground leads the spectator's eye to a puff of smoke in the distance, so too the strongly coloured figure which 'keeps the Eye to the Center' directs attention to the dome crowning the far horizon: the symbol of the Pope and of the dominance over Italy of the Roman Catholic church.

★　★　★　★

John Soane refused to accept *Forum Romanum* and the painting remained in Turner's studio for the rest of his life; Charles Heath's *Picturesque Views in Italy* was never published. Turner's other Italian commission of this period, however, was a resounding success: his series of vignettes for the new edition of Samuel Rogers's *Italy*.[93] Rogers had won a considerable reputation as a poet between 1790 and 1810 and, belonging as he did to a banking family, he was extremely well-off (Plate 138). His name has already occurred a number of times in this book for he was also a great lover of Italy and a collector and connoisseur of Italian art. He had travelled in Italy for several months in 1814-15 and kept a detailed journal which records many of the experiences later celebrated in the poems which make up his *Italy*.[94]

The publication history of Rogers's *Italy* between 1821 and 1830 is a complicated and often confusing saga, and it has, in any case, already been recounted elsewhere.[95] The story of the 1830 edition, on the other hand, is a straightforward story of vision and success. Rogers commissioned twenty-five landscape illustrations from Turner, nineteen figure studies from Thomas Stothard and a few other scenes from elsewhere. He employed thirteen different steel-engravers to make plates from these designs, and the illustrations were printed on the same pages that carried the poems themselves. It was a very expensive business to combine relief-printed letterpress and intaglio illustrations on the same page,

131

for every such page had to pass through the press twice. But Rogers was unconcerned. He paid for the printing of the new edition entirely by himself and spent over £7,000 in publishing 10,000 copies.

It is easy to understand why Rogers chose Turner as one of his illustrators. Turner was the best landscape artist in the country and Rogers could afford the best. Rogers's own *Table-Talk* includes only one — slightly grudging — pronouncement on Turner as a painter: 'We have now in England a greater number of tolerably good painters than ever existed here together at any former period: but, alas, we have no Hogarth, and no Reynolds! I must not, however, forget that we have Turner, — a man of first-rate genius in his line.'[96] A great talker and sharp-tongued socialite himself, Rogers amused his friends by poking fun at Turner's reclusive behaviour and laconic temperament. He commented on a fine table in Turner's house and added, 'how much more wonderful it would be to see any of his friends sitting round it'.[97] His own bookshelves at 22 St James's Place contained a row of wooden books with witty titles like 'Nebuchadnezzar on Grasses' and 'Logbook of the Ark'; the lead title was 'Turner's obiter dicta'.[98] Despite such jests, the two men got on extremely well together and shortly after the publication of the 1830 *Italy* Turner made Rogers one of the executors of his second will.[99]

Rogers was twelve years older than Turner and they shared many of the same tastes, particularly their attitude towards Italy which was very much that of an educated

138. Charles Mottram, *A Breakfast Party at Samuel Rogers's House, 1815, c.* 1830?, mezzotint, 26½ × 35¾ in., Victoria & Albert Museum, London. This composite scene with facsimile signatures includes many of the famous men who, over the years, attended parties at Rogers's house. He himself is seated in the centre with Byron on his right; other literary celebrities sit facing them: (from left) Sheridan, Tom Moore, Wordsworth, Southey and Coleridge. Stothard, Lawrence, Turner and Campbell are standing on the right studying a painting.

eighteenth-century traveller. Both Rogers's journal and his verses are full of historical allusions and he often mused on events and personalities, wars and leaders, poets and artists. He made every effort to visit places like Tasso's prison at Ferrara and Gibbon's house at Lausanne.[100] He wrote home ecstatically from Venice, 'Oh if you knew what it was to look upon a Lake which Virgil has mentioned & Catullus has sailed upon, to see a house in which Petrarch has lived.'[101] It was in just the same reverential spirit that Turner thought about Claude and Wilson at Tivoli and Albano, sketched scenes he already knew from the *Select Views in Italy*, and stood on the identical ground to Piranesi. In the preface to *Italy* Rogers offers his poem to 'those who have learnt to live in Past Times as well as Present, and whose minds are familiar with the Events and the People that have rendered Italy so illustrious'. Turner must have found this approach very congenial and his vignettes, too, take the reader right back into Italy's past. The silent wastes of the Alps led Rogers's thoughts to Hannibal, so Turner illustrates the Carthaginians battling their way into Italy.[102] Elsewhere Rogers tells how his Alpine guide had recalled meeting the cloaked figure of Napoleon on horseback: Turner depicts Napoleon crossing the Alps with his cloak swirling around him, as in Jacques-Louis David's famous portrait, and surrounded by troops and towering mountains.[103] Rogers's verses continually talk of the past so vividly that it comes as no surprise that one of Turner's vignettes shows Galileo's scientific instruments arrayed on his lawn, as if the astronomer himself were about to make use of them, or that Venice is seen crowded for a feast-day, with the Bucentaur outside the Ducal Palace as in the days of her greatness.[104]

Although Rogers was very conscious of Italy's history and heritage, he was not very good at describing landscape. Turner's vignettes often repaired this deficiency, bringing alive the settings that Rogers's verses took for granted — the Alps or the Campagna, the hills around Florence or the coast of Naples. Rogers's 'Florence', for example, concentrates entirely on works of art like the *Medici Venus*, the Brancacci chapel, Michelangelo's *Day* and *Night* and *Lorenzo*.[105] Of the city itself, he merely remarks,

> Of all the fairest Cities of the Earth
> None is so fair as FLORENCE. 'Tis a gem
> Of purest ray. . . .

139. *Florence, c.* 1827 (W, 1163), pencil and watercolour, $4\frac{7}{8} \times 6\frac{3}{4}$ in. (TB CCLXXX, 156). Engraved as a vignette $2\frac{3}{8} \times 3\frac{1}{2}$ in.

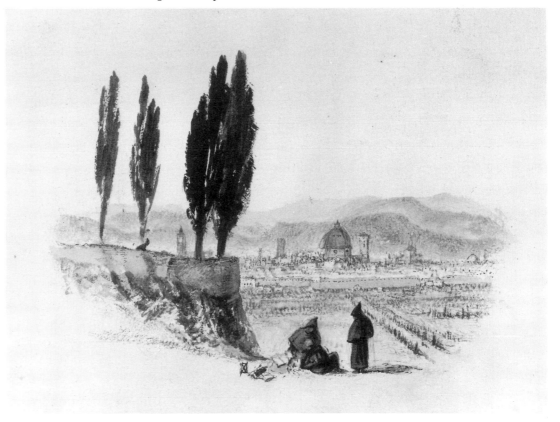

140. *Florence, c.* 1827, watercolour, $4\frac{1}{2} \times 5\frac{1}{2}$ in. (TB CCLXXX, 95)

He then goes on to say,

> Search within,
> Without; all is enchantment!

but it will be recalled from Chapter 7 that English visitors to Florence of Rogers's day did not really feel this. They enjoyed seeing the city from a distance, gracefully situated among the trees, but they found its streets very oppressive. Turner's vignette (Plate 139) shows Florence seen from Fiesole and it reflects contemporary taste exactly as his watercolours for Hakewill's *Picturesque Tour of Italy* had done; but it also adds a completely new dimension to Rogers's 'Florence'. Thanks to Turner's illustration, the reader can enjoy all the riches of Florence: both the vision of the fair city set in a garden *and* Rogers's musings on history and art. The nice balance of *Italy*'s presentation of Florence is especially interesting because the Turner Bequest includes several studies for vignettes which are different from those ultimately used.[106] Turner's abandoned depiction of Florence shows the centre of the city, with the Ponte Vecchio, the tower of the Signoria and the Uffizi (Plate 140). With its references to art and history this design would have matched Rogers's verses well, but it did not embody the contemporary ideal of Florence and it was therefore replaced.

Turner's vignette of Florence harks back to his earlier illustration for Hakewill's *Tour of Italy* (Plate 93), and the same is true of the vignette of St Peter's and Castel S. Angelo which accompanies Rogers's verses on the Renaissance popes (Plate 141; compare Plate 14). This is one of the most popular of all views of Rome: it has been drawn by numerous artists through the centuries and reproduced in countless prints including Piranesi's etching in the *Vedute di Roma*. Here again, Turner's vignette provides an appropriate accompaniment to Rogers's reflections, not an illustration of something he describes. It seems very likely that Rogers specifically requested a drawing of this famous and much-loved view.

But Turner's vignettes for Rogers's *Italy* are very different in flavour from his illustrations for Hakewill's *Tour*, for borderless vignettes are peculiarly suitable for the illustration of poetry.[107] In each the reader or viewer applies his mind and eye in brief concentration on an isolated and artificial fragment. Rogers offers his readers not his entire Italian experiences but tiny moments crystallised from his journal. Similarly, while

134

the Alps or the Campagna would themselves extend as far as the eye can see, Turner's depictions of them in his vignettes encapsulate profound truths in a small compass. Ruskin had little good to say about many of Turner's oil paintings of Italy, but he happily conceded that Turner 'caught her true spirit' in several of the Rogers vignettes, which were 'the beautiful concentration of all that is most characteristic of Italy'.[108] The vignettes were popular with generations of English travellers and Italy-lovers not only because of all the other qualities that so impressed Ruskin — their fidelity to nature in respect of chiaroscuro, clouds and mountains — or because of their topographical accuracy.[109] They were admired for capturing the very essence of Italy in the space of just a few inches.

The 'beautiful concentration' that is the great achievement of the *Italy* vignettes is in large measure due to the circumstances in which they were produced. Since Turner had himself visited Italy in 1819, he was able to use both the material collected in his sketchbooks and the memories stored in his mind, but he was also able to transform both by the power of his imagination. If the vignettes are compared with the 1819 sketches of the same scenes there are many differences in overall arrangement, details, composition or proportions. The ruined tomb in *The Campagna of Rome*, for instance, derives from, but is in several respects different from, that sketched in 1819; *Tivoli* is a careful rearrangement of a variety of ingredients in the *Tivoli and Rome* and *Tivoli* sketchbooks.[110] In viewpoint and proportions the vignette of Ponte and Castel S. Angelo and St Peter's and that of Florence from Fiesole both show marked differences from the sketches of the same subjects in *Small Roman C. Studies* and *Rome and Florence*.[111] Turner may have consulted all these sketches, but he certainly did not copy them. Another vignette must be compared not with an earlier sketch but with one of the oil paintings already discussed in the present chapter. In *The Forum* (Plate 142), Turner modified still further the view through the Arch of Titus that he had shown in *Forum Romanum* (Colour Plate 22): now, not only the Temples of Castor and Pollux and of Saturn but also that of Vespasian, the Arch of Severus and the Capitol can all be seen close together under the archway. He even condenses his perspective so that the Forum seems to be a small, compact area and the Temple of Castor and Pollux appears very near the Arch of Titus; he turns the Temple of Saturn through 90 degrees and also moves it to the left so that its six-columned façade can be seen through the columns of the Temple of Castor and Pollux. An equally free attitude towards topography and a

141. *Rome, Castle of St Angelo, c.* 1827 (W, 1166), pencil and watercolour, $3\frac{1}{2} \times 6\frac{1}{4}$ in. (TB CCLXXX, 160). Engraved as a vignette $2\frac{3}{8} \times 3\frac{5}{8}$ in.

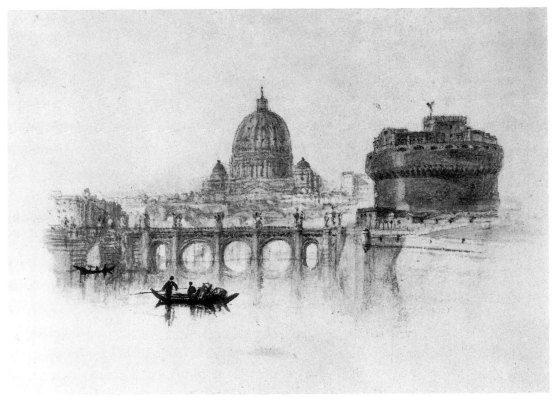

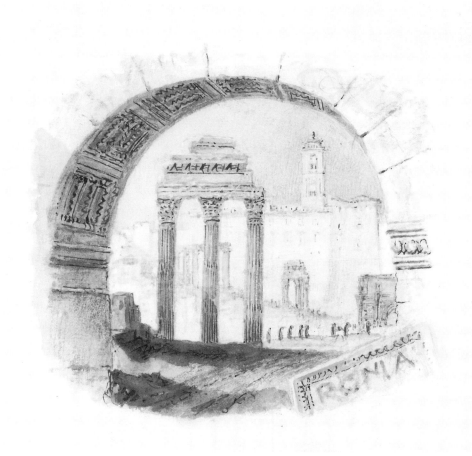

142. *The Forum, c.* 1827 (W, 1167), pencil and
watercolour, with pen and brown ink, $5\frac{1}{4} \times 5\frac{7}{8}$ in.
(TB CCLXXX, 158). Engraved as a vignette $3\frac{1}{8} \times 3\frac{3}{8}$ in.

similar concentration upon essentials are evident in the St Peter's and Castel S. Angelo vignette (Plate 141); this is particularly noticeable when it is compared with Turner's earlier illustration based on Hakewill's very accurate on-the-spot sketch (Plate 14). In the Rogers vignette Turner focuses his attention firmly on the buildings, not on the sky or the river. He moves St Peter's and Castel S. Angelo as close together as possible, doubles the size of the statues on the bridge and quadruples the size of the dome of St Peter's.

Turner is said to have promised that he would ensure that everyone read Rogers's poetry and that 'no lady's boudoir shall be complete without a copy'.[112] The de luxe edition of *Italy* was certainly an instant success. It sold 6,800 copies by May 1832 and, together with its sequel, Rogers's illustrated *Poems* (1834), it reached over 50,000 copies by 1847.[113] Lovers of the arts strove to acquire the finest proof impressions of the vignettes and raised a public outcry when they believed they were being fobbed-off with inferior ones.[114] But besides giving pleasure to thousands, the *Italy* illustrated by Turner also radically changed the course of nineteenth-century art criticism: Ruskin was later to claim that it was these vignettes that first aroused his interest in Turner's work and thus determined the whole course of his future career.[115] Rogers's biographer P. W. Clayden recalled in the 1880s exactly the sort of thrill that the thirteen-year-old Ruskin must have experienced. 'One of the most vivid recollections of my own boyhood is the wakening up of a new sense of an ideal world of beauty as I lingered over the lovely landscapes on these delightful pages. . . . there are many whose recollections of these two volumes harmonise with mine, to whom they were an education, and who learned from them to admire Turner before they had actually seen one of his paintings.'[116] Turner's vignettes to Rogers's *Italy* form his most substantial group of works depicting Italy and they were his first important illustrations to poetry; they were also the first inspiration of his most brilliant champion.

Chapter 9

RETURN TO ROME, 1828

Turner's work for Charles Heath and for Rogers's *Italy* filled his mind with thoughts of the south; it is easy to understand why, by the summer of 1828, he felt that he must return. But his second visit to Italy was very different from his first. He chose a new route for his journey and he spent his time in Rome itself quite differently. He led a far more sociable life there than he had in 1819 and wrote several letters to his friends back home which contain illuminating passages about his activities and interests. His sketchbooks, too, present a rather different kind of record of his visit, as a brief comparison will show. In 1819 he set out with a good supply of sketchbooks of various sizes, including some quite large ones. He filled twenty-three of them in six months, at times using watercolour and bodycolour as well as pencil. In 1828-9, on the other hand, he sketched only in pencil and used only ten sketchbooks in the whole six months. The books are not watermarked and come in a random mixture of sizes and types: he may perhaps have acquired them individually *en route* as he needed them. They are all smaller than those of 1819, several of them measuring less than 4 by 6 inches.[1] Eight of the ten sketchbooks were used on his outward journey: the sight of new areas of France and Italy and the sense of excitement at the beginning of a tour provided a strong incentive to sketch which virtually disappeared once he had reached his destination.

He probably left London in early August. A memorandum in a notebook suggests that he had reached Paris by 11 August and he was still there on the 23rd.[2] He was then still hesitating between the possible routes to Italy: 'I cannot say when I can arrive in Rome owing either to my passing by way of Turin to Genoa or by Antibes', but he soon made up his mind: 'I must see the South of France.'[3] From Paris he therefore went south to Orléans, then along the Loire and Allier valleys to Clermont-Ferrand. Here he went east to Lyons and then followed the Rhône valley south to Marseilles.[4] He later complained bitterly about the discomfort of this journey which 'almost knocked me up, the heat was so intense, particularly at Nismes and Avignon; and until I got a plunge into the sea at Marseilles, I felt so weak that nothing but the change of scene kept me onwards to my distant point'.[5] Travelling became easier and more enjoyable after Marseilles. Part of Turner's journey to Genoa was done by boat and he made many sketches of this dramatic coast, studying not only the inviting prospects before him but also the spectacular scenes he was leaving behind.

Turner's journey through France holds two special points of interest which may be briefly mentioned here. First, he was, as usual, very keen to see new places and embrace new experiences. His route from Paris onwards was as different as he could make it from that of 1819. It was much less direct and was clearly important in its own right — understandably so in view of his concern with France and its rivers during the 1820s, leading up to the three volumes of *Turner's Annual Tour* in 1833-5. Second, he was obviously very interested in the south of France for its own sake and it is worth noting that many travellers regarded the Roman remains there as superior even to those in Rome itself.[6] Turner's sketches at Nîmes show well his interest in its grand monuments. His sketch of the Maison Carrée, with details of mouldings and a capital interpolated into a corner of the page, is reminiscent of the 1819 sketches of Roman buildings. The same is

true of his sketches of the amphitheatre and the Jardin de la Fontaine: an archaeological site is viewed from above in order to capture its feel as a whole; at ground level, buildings are sketched both for themselves and as part of an architectural ensemble.[7]

Turner entered Italy shortly after Nice and continued along the coast past Genoa, La Spezia and Massa. He filled the pages of the *Coast of Genoa* sketchbook with quick studies of bays and headlands, lighthouses and harbours, precipitously placed towns and villages, and he later commented: 'Genoa, and all the sea-coast from Nice to Spezzia is remarkably rugged and fine; so is Massa.'[8] In Italy, as in France, he used routes that were new to him, visiting Carrara and Livorno on a coastal journey that was probably made, in part at least, by boat. He then went inland to Pisa and Florence, where he struck south, not by the Arezzo and Perugia road (which he had used in January 1820) but by the less popular Siena road.[9] After Siena he continued to Rome through S. Quirico d'Orcia, Radicofani, Aquapendente, Orvieto, Montefiascone, Viterbo and Nepi.

Despite its novelty, this journey to Rome is recorded far less carefully than that of 1819. The sketches in the four sketchbooks *Coast of Genoa*, *Genoa and Florence*, *Florence to Orvieto* and *Viterbo and Ronciglione* are sometimes no more than hasty scribbles or tiny memoranda. A few of Turner's sketches may even have been lost or discarded, for *Florence to Orvieto* appears to be only a fragment from a once-thicker sketchbook. Nevertheless, there is both variety and interest in Turner's brief records. They include sketches of towns and stretches of countryside made while travelling; careful drawings of architecture made when he stopped to rest; studies of skies and notes on colours; sketches of peasants at work and of his fellow-travellers.[10] Some sights he sketched again and again, as if obsessed by their appearance, as in the case of the aqueduct between Nepi and Civita Castellana.[11] One page in the *Viterbo and Ronciglione* sketchbook contains a type of sketch that is fairly common in Turner's oeuvre generally but not so on his visits to Italy: a group of six small studies for pictures (Plate 143). These sketches were probably drawn immediately after his arrival in Rome, for they all derive from what he had seen on the very last days of his journey, including the aqueduct just mentioned and castellated towers like those of the *rocca* at Nepi. The sketch at lower left is close to the *View of Orvieto* (Plate 149) while the

143. Studies for pictures (*V and R*, 25), pencil, $4\frac{7}{8} \times 6\frac{3}{4}$ in.

rest have pronounced affinities with other paintings begun in Rome, such as *Palestrina* (Plate 156).

The Italian towns which Turner sketched on his way to Rome appealed to many of his interests. Livorno was a thriving and busy port, second only to Genoa. As at Ancona and Naples in 1819, Turner's eye was caught by the buildings of the harbour and by the shipping, and he also sketched the massive fortifications, the lighthouse and the monument of Ferdinand I de' Medici proudly towering over his chained Moorish captives.[12] Pisa had a very different character. It had long fascinated British visitors, partly for the curious spectacle of its leaning tower, partly for its richly exotic style of architecture, partly for its extensive medieval frescoes in the Campo Santo.[13] Turner studied all these attractions. He made detailed sketches not only of the famous cluster of gems — the cathedral, baptistery and leaning tower — but also of the ornate little Gothic church of S. Maria della Spina on the lungarno.[14] In 1819 he had enjoyed looking at Early Renaissance paintings in the Uffizi and shared contemporary British interest in tracing the origins of Italian art, so it is not surprising that in 1828 he studied the frescoes in the Campo Santo at Pisa with close attention.[15] The more legible of his notes include a mention of Orcagna and Buffalmacco, '4 Memmo' (a reference to the four upper scenes of the *Life of St Rainerus* attributed by Vasari to Simone Martini), Giotto's *Job*, Ghirlandaio's *Esther*, and the *Noah* of 'Godsolli'. Turner's interest in the Campo Santo may well have been encouraged by friends who had already been there (Henry Sass was a visitor in 1817, Samuel Rogers in 1821, A. W. Callcott and Maria Graham on their honeymoon in the spring of 1828);[16] while his list of artists' names suggests that he examined the frescoes with a guidebook, probably Mariana Starke's *Information and Directions for Travellers on the Continent* which was widely used by Turner's generation and later owned by Turner himself.[17]

The 1828 sketches of Florence display exactly the same attitude towards the city as Turner's earlier sketches and drawings. He hardly sketched its interior at all, but made many sketches from a distance, returning to favourite viewpoints just outside the city such as the grounds of S. Salvatore and the banks of the Arno. From these places he made many studies of views that he was obviously delighted to see again.[18] Siena, on the other hand, was entirely new to him. Although his stay there was only very brief, he explored a great deal of the city in the way he had studied Italian towns in 1819, making detailed and often complex sketches, such as those of the Campo and the Palazzo Pubblico; the baroque, brick-built church of S. Giuseppe; and the Spring of Fontebranda and S. Domenico (Plates 144 and 145).[19] As in 1819, he rarely drew individual buildings on their own, but chose instead groups of buildings that formed pleasing ensembles, and he often went to the very edge of the city to sketch panoramas that embraced both countryside and architecture. Some sketches contain an extraordinary amount of information (Plate 144): here, within 4

144. Siena: the Campo (*F to O*, 15), pencil, 4 × 5¾ in.

145. Siena: S. Domenico and the Spring of Fontebranda (*F to O*, 17), pencil, 4 × 5¾ in.

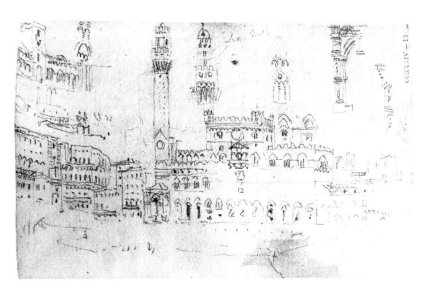

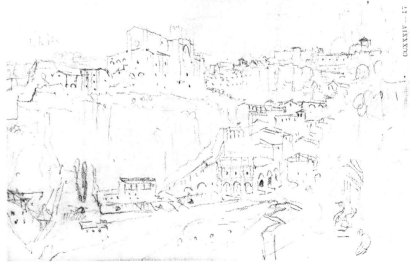

146. Turner's first view of Orvieto (*F to O*, 32a), pencil, from a page 5¾ × 4 in.

147. Viterbo: the interior of S. Francesco with Sebastiano del Piombo's *Pietà* of *c.* 1515 (*V and R*, 41), pencil, 4⅞ × 6¾ in.

by 6 inches Turner manages to represent, in detail, more than half the buildings that girdle a very spacious piazza.

But the sight that made the deepest impression on Turner as he travelled south to Rome was the hilltown of Orvieto perched on its precipitous crag in the plain near Bolsena. He noted on one sketch that it showed his first view of the city (Plate 146) and he later declared, with evident satisfaction, 'Orvieto I have seen'.[20] What is more, he made it the central feature of an oil painting very soon after he reached Rome. This painting and the sketches on which it was based will be discussed later in this chapter. Here it must simply be noted that, besides sketching the hilltown as a whole and its dramatically striking Gothic cathedral, Turner also studied its Signorelli frescoes of the Day of Judgment. His wish to see these is yet another manifestation of his interest in early Italian painting, but he was also aware, like other early nineteenth-century tourists, that Michelangelo had 'condescended to borrow largely' from these scenes for his own *Last Judgment*.[21] Turner later referred to Signorelli as 'shining preeminent, father of the rising of the Dead and Inferno'.[22] His interest in expressive figure studies was certainly well to the fore at this moment: a day or two later he sketched Sebastiano del Piombo's great *Pietà*, then still in its original setting in the church of S. Francesco at Viterbo (Plate 147). Although this sketch is rather rough and ready, there can be no doubt that Turner would have been impressed by the majesty of Sebastiano's painting, and it is very likely that he, like his contemporaries, knew of the tradition that associated Michelangelo with its design.[23]

After making the detour to Orvieto to look at its Quattrocento frescoes, Turner made another diversion to study a very different work of art, Vignola's Palazzo Farnese at Caprarola. By this date the palace was uninhabited and deserted but it was still much admired.[24] Its planning and execution evidently interested him a great deal for he drew himself a ground plan of it — a very rare occurrence on either of his Italian tours. He also drew several views of the whole or parts of the palace, and it is easy to imagine his fascination with the many exciting perspective effects which it offers.[25]

By now he was nearing his journey's end. He probably arrived in Rome shortly before 13 October when he wrote to George Jones, 'Two months nearly in getting to this Terra Pictura.'[26] After all the weeks of travelling and sketching, he now had a complete change: he settled down quietly for three months in Rome and did practically no sketching at all.

In planning his second visit to Rome Turner must have conceived it, from the start, as being wholly different from his first. In 1819 he had explored Rome so thoroughly and sketched it so intensively that he did not need or want to do the same again. Instead he was to paint pictures. This he did in a studio at 12 Piazza Mignanelli, the house by the Spanish Steps where Eastlake had been living since early in 1819 and with which Turner was thus already familiar. Eastlake had spent the spring of 1828 in England, returning to Italy in June-August.[27] Turner wrote to him from Paris in August asking him to get various things ready for his visit, including two eight-foot canvases: 'order me whatever may be [*tear*] to have got ready that you think right and plenty of the useful — but nothing of the ornamental — never mind Gim cracks of any kind even for the very Easel I care not'.[28] On 28 September Eastlake wrote to Thomas Uwins: 'Turner will be here in a few days and will perhaps occupy a spare study I have got; at any rate he will paint a large picture, perhaps two.'[29] Eastlake's predictions were more than fulfilled. In Turner's earliest letter from Rome, that of 13 October, he described himself as already '*at work*'.[30] On 23 October Eastlake wrote to his patron, Jeremiah Harman, that Turner had 'taken up his abode' in his house, was using the spare study and 'has begun two or three pictures'.[31] By 6 November Turner was reporting to Chantrey, 'having finished *one*, am about the second, and getting on with Lord E's, . . . but as the folk here talked that I would show them *not*, I finished a small three feet four to stop their gabbling'.[32] On 9 December Eastlake wrote to Lawrence that Turner 'had worked literally night and day' and 'has begun several pictures . . . and finished *three*'.[33] Later he was to talk of Turner having begun 'eight or ten pictures' in addition to the three that he completed.[34]

The three finished pictures mentioned by Turner and Eastlake were the *Vision of Medea* (on one of the eight-foot canvases), *Regulus* and the *View of Orvieto* (both three feet by four) (Colour Plates 27 and 28 and Plate 149): these were the works which formed the small exhibition held by Turner in the second half of December in the rooms to which he had moved near the Quattro Fontane.[35] Turner's phrase, 'the folk here talked that I would show them *not*', suggests that he had not originally intended to hold an exhibition at all but was persuaded to do so. There had, in fact, been great disappointment in Rome in 1819 that Turner had produced no finished paintings during his visit, a letter from Rome in the *London Magazine* of March 1820 lamenting that he 'did nothing for Rome. . . . His magic power would have confirmed the enchantment of the Italians [i.e. with British art]. He reserves himself for London'.[36] This article may have been written by Eastlake who contributed a number of pieces on Rome to the *London Magazine* around this time, and Eastlake would certainly have encouraged Turner to hold an exhibition in 1828, since he himself had exhibited a single painting, *Isadas*, in his Roman studio in 1826 and had enjoyed an enormous success.[37]

On 11 December, therefore, the *Notizie del Giorno* carried the following announcement:[38]

IL SIGNOR TURNER, Membro dell'Accademia Reale di Londra e di quella di S. Luca in Roma, esporrà due Paesaggi dipinti da lui, prima di mandarli in Inghilterra.

Questi Quadri saranno esposti nel Palazzo Trulli, via del Quirinale num. 49, per una settimana, principiando da lunedì 15 del presente mese, dalle ore 9 antimeridiane fino alle 4 pomeridiane.

The exhibition was, however, late in opening — on 17 December the *Diario di Roma* advised the public that it would open on 18 December[39] — and the exhibits were actually three in number, the *Vision of Medea*, *Regulus* and the *View of Orvieto*, rather than just 'due Paesaggi'. The delay in opening may perhaps have been caused by difficulties in getting the pictures framed. Eastlake reported: 'Turner's economy and ingenuity were apparent in his mode of framing. . . . He nailed a rope round the edges of each, and painted it with yellow ochre in tempera.'[40] Some years ago the *Vision of Medea* was reframed according to these specifications, and the ingenuity of Turner's design may still be admired today (see Colour Plate 28).

The three pictures were seen by more than a thousand visitors and aroused much controversy and astonishment among all who saw them.[41] Though one British painter could write that 'Turner's works here were like the doings of a poet who had taken to the brush', they did not appeal to the general public.[42] The sculptor Thomas Campbell took John Cam Hobhouse, statesman and intimate friend of Byron, to the exhibition on its opening day. 'An ignorant man like myself', wrote Hobhouse modestly, 'would find it difficult to believe them to be the production of the very first of living painters. The chief of these strange compositions, called the Vision of Medea, was a glaring, extravagant daub, which might be mistaken for a joke — and a bad joke too.'[43] Many artists in Rome disliked Turner's three paintings just as heartily as he had disliked theirs in 1819. 'You may imagine how astonished, enraged or delighted the different schools of artists were at seeing things with methods so new, inventions so daring, & excellences so unequivocal', wrote Eastlake to a friend in February 1829. 'The angry critics have I believe talked most & it is possible you may hear of general severity of judgment but many did justice & many more were fain to admire that [which] they confessed they dared not imitate.'[44] In March he wrote to Maria Callcott who was now back in England, 'The Romans have not yet done talking about the Paesista Inglese — *how* they talk would be worth relating if they knew anything of the matter. When you see his Vision of Medea, you may imagine with what astonishment the modern Italian school would look at it. . . . The one called "Regulus" is a beautiful specimen of his peculiar power, yet the wretches here dwelt more on the defects of the figures and its resemblance to Claude's compositions than on its exquisite gradation and the taste of the architecture. The latter was perfect for beauty of design, more Italian than Italy itself.'[45]

Eastlake's comment on *Regulus* underlines an important fact about the three paintings Turner exhibited in Rome: they all related very specifically to Italy and should thus have been accessible, on that level at least, to an Italian audience. In London, where he was extremely well known, Turner constantly sought to demonstrate his versatility by painting in every genre. In Rome, where he was known only by repute, he did exactly the same, showing a landscape, a harbour scene and a figure painting, but he also made a deliberate attempt to suit his audience's interests. The *View of Orvieto* celebrated the beauty of a glorious piece of Italian countryside, a famous sight in central Italy. *Regulus* paid tribute both to Claude and to Italian architecture by modelling itself on the *Seaport with the Villa*

148. Sketches of Orvieto (*F to O*, 34), pencil, 4 × 5¾ in.

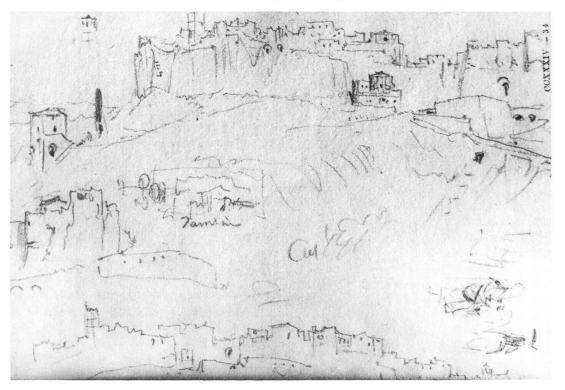

149. *View of Orvieto, painted in Rome*, 1828;
reworked 1830 (B & J, 292), 36 × 48½ in., Tate
Gallery, London

Medici in the Uffizi and it took its subject from Roman history. The *Vision of Medea* also
had classical subject matter and was, moreover, painted in a markedly Venetian style: both
its composition and its colouring reflect Turner's life-long study and love of Titian. But it
was also a very topical work, paying homage to the artistic achievements of modern Italy,
as this chapter will shortly reveal.

Turner's three paintings demand separate consideration, for each reflects his thoughts
and experiences in its own individual way. The most easily appreciated of the three is
certainly the *View of Orvieto* (Plate 149), a bright yet placid landscape with a genre scene in
the foreground. Peasant women wash clothes at a fountain built into a Roman
sarcophagus: a common sight in nineteenth-century Italy, but a pictorial motif that
stressed the close links between modern life and the ancient world that foreign visitors to
Italy found so fascinating (Colour Plate 26). The simplicity of the painting's title is in itself
noteworthy. It is impossible to study Turner's watercolours without observing that many
of them were engraved and published in books with titles like *Picturesque Views in England
and Wales* or *Picturesque Views on the Southern Coast of England*. What is not generally
spotted is the extreme rarity of Turner's own use of the word 'view' in the titles he gave to
his exhibited oil paintings. Two of the handful of oils that were so designated were directly
based on accurate sketches made on the spot by another person (*View of the Temple of*

Jupiter Panellenius . . . Painted from a sketch taken by H. Gally Knight, Esq. in 1810, RA, 1816; *View from the Terrace of a Villa at Niton, Isle of Wight, from Sketches by a Lady*, RA, 1826). Two others were commissioned by a picture dealer who must have specified that he wanted straightforward topographical scenes, for in each case this was what he received (*View of the High-Street, Oxford* and *View of Oxford from the Abingdon Road*, both RA, 1812).[46] Other examples are few and far between. Turner's marked disinclination to use the word 'view' for his exhibited oils suggests that he believed it should really be reserved for works of a topographical nature.

The *View of Orvieto* thus proclaims itself as a painting in which imagination has played a comparatively minor part, and this is confirmed by Turner's sketchbooks themselves. He had made many sketches of Orvieto on its hill as it is seen from the plain, studying it avidly from its first appearance in the distance, as he approached it from the north-west, until he was far away and it disappeared out of sight. Several of these small and hasty sketches include material that appears in the final painting. Some show bridges in the middle distance, while in others a structure in the foreground seems to be labelled 'Fountain' (Plate 148).[47] Turner's further development of the fountain motif may be traced to an additional influence (or influences) on his mind, which will be discussed in a moment. However, the presence of an actual fountain in his on-the-spot sketches reveals the reality which provided a springboard for such a development. It is equally significant that Turner's very first sketch of all shows a two-arched bridge between the spectator and the hilltown almost exactly as in the painting itself (see Plate 146). The *View of Orvieto* was closely based on what Turner himself had recently seen and it was clearly intended to recreate his own feelings on his 'Prima visa of Orvieto'. Even if the fountain and the bridge were not seen from the same spot, both had a basis in reality, and Turner's title for his painting at the 1830 Royal Academy, *View of Orvieto, painted in Rome*, left the British spectator in no doubt that it had been painted while the scene was fresh in the artist's mind.

The composition of the *View of Orvieto* is basically Claudian in its approach and looks back to Turner's last Italian landscape, *The Bay of Baiae* of five years earlier (Colour Plate 20). But the *View of Orvieto* is noticeably simpler in every respect: the hills are fewer and their outlines are less complex; one tree, not two, interrupts the sky; the distant landscape merges into the air rather than standing out from it; there is a narrower range of tones in the foreground and middle distance, and they melt into one another in a continuous progression, unlike the restlessly interchanging lights and shadows of *The Bay of Baiae*. Some of these differences are due to the *View of Orvieto* being only about a quarter the size of *The Bay of Baiae* (a similar comparison could be made between *Regulus* and the very much larger *Decline of the Carthaginian Empire*: Colour Plate 27 and Plate 8). However, part of the simplification must be attributable to the fact that the *View of Orvieto* was painted very quickly in order to stop people 'gabbling'. It was noted in 1830 that 'when these pictures [the *View of Orvieto* and *Pilate washing his Hands*] were sent to the Academy, it was difficult to define their subject; and that in the four or five days allowed . . . they have been got up as we see them'.[48] Since even today the *View of Orvieto* is quite thinly painted, it must originally have been considerably more ethereal and vaporous than it now appears.

Although its misty hills and overgrown valleys contain an air of magic and mystery, the *View of Orvieto* also partakes of the down-to-earth. In the foreground two Italian peasant women are washing clothes and filling earthenware vessels at a fountain made from a Roman sarcophagus (Colour Plate 26). To develop this scene Turner drew on his own experiences in a variety of ways. First, as was mentioned in Chapter 4, he invented a marine frieze for the basin of the fountain, devising it out of his recollections of those he had sketched in the Roman museums in 1819. It has also been suggested that the painting looks back to a passage in Rogers's *Italy*.[49] The poem 'The Fountain', which was actually illustrated by Stothard, not by Turner himself, begins:[50]

It was a well
Of whitest marble, white as from the quarry;

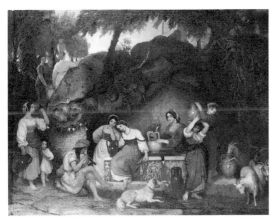

150. Joseph Severn, *The Fountain*, 1828, Royal Palace, Brussels

And richly wrought with many a high relief,
Greek sculpture — in some earlier day perhaps
A tomb, and honoured with a hero's ashes.
The water from the rock filled and o'erflowed;
Then dashed away, playing the prodigal,
And soon was lost. . . .

It is not impossible that Turner recalled these lines while he was painting the *View of Orvieto*, even though Rogers mentions nothing so mundane as washing and, in any event, describes a specific and well-known fountain, near Mola di Gaeta, on the way from Rome to Naples.[51] But he probably had a stronger stimulus even nearer to hand. Turner's letters from Rome in the autumn of 1828 show that he was in close touch with the many British painters and sculptors who were, by now, working there.[52] These included Keats's friend Joseph Severn who was just then finishing work on an Italian genre scene, *The Fountain*, which was greeted with much acclaim from his fellow-countrymen in Italy (Plate 150).[53] This painting shows a group of *contadine* who have come to collect water from a fountain whose basin, like that in Turner's picture, is a Roman sarcophagus, and Severn makes an emphatic connection between ancient and modern. One of his *contadine* is posed exactly like one of the maidens on the sarcophagus, while the jugs held by the real women and the sculptured women are identical. There is one further similarity between the two paintings. Severn's women are listening to a young boy playing music on a pipe; Turner's painting also introduces a musical reference into its still air — a lute lying on the ground at lower right. All in all, Severn's *Fountain* could have contributed a great deal to Turner's speedy transformation of his rough sketches of Orvieto into an exhibitable painting.

Regulus (Colour Plate 27) provides a sharp contrast to the *View of Orvieto*. Far from being a painting executed on the spur of the moment, it was very carefully thought out as a work of art and it took for its theme a story which had fascinated Turner's mind and imagination for at least fifteen years. The first aspect of *Regulus* to strike the spectator is that, like several of Turner's earlier and larger classical history paintings, it is a light-filled seaport composed in the manner of Claude. Indeed, it is even more Claudian than Turner's harbour scenes usually are, for most of the buildings are massed on one side, being balanced by a group of ships on the other: this was an arrangement of which Claude had been particularly fond. The composition of *Regulus* reflects that of several of Claude's paintings to which Turner had devoted close study in the Louvre in 1821,[54] but above all that of the *Seaport with the Villa Medici* which he had sketched in the Uffizi in 1819 (see Plates 101 and 102) and would certainly have been keen to look at again on his way to Rome in 1828.

The composition of *Regulus* immediately suggests to the viewer that the painting is an embarkation scene and it is not surprising that early writers on Turner — including Ruskin, Thornbury and Eastlake — assumed that its subject was the famous, and much painted, departure of Regulus from Rome.[55] However, this assumption may not have been correct, for both the published engravings of *Regulus* stated in their titles that the city from which the hero was embarking was actually Carthage.[56] These titles are an embarrassment to the art historian. Did the first engraver make a mistake which somehow escaped Turner's careful eye? Did Turner in later life become vague over the details of the story? Or did he deliberately conflate Regulus' celebrated embarkation from Rome with the one from Carthage that had preceded it? And were Ruskin, Thornbury and Eastlake all unaware of the engravings or did they choose to ignore them? To understand their reading of Turner's painting, the spectator must first hear the story of Regulus and appreciate the full significance of his embarkation.

Marcus Atilius Regulus was one of the commanders of the Roman expedition against Carthage in the First Punic War (264-241 BC). In 255 BC he was taken prisoner. Five years later, when the Carthaginians had suffered a reverse, they sent him back to Rome to negotiate peace, on condition that he would return to Carthage if the negotiations failed. The Roman Senate was keen to accept the peace proposals but Regulus persuaded it to

reject them and to continue the war. He himself kept his promise to return to Carthage, an act which was bound to lead to his own death at the hands of the Carthaginians, and in due course he was cruelly tortured until he died.[57]

By Turner's day many artists had painted scenes from this story and their depictions fall into two distinct categories. From the early Renaissance to the seventeenth century the emphasis was always on Regulus' torture and death, either because the artist was illustrating a compendium of 'great lives'[58] or because he was working in a circle that was specifically interested in Stoicism. To the latter group belongs Salvator Rosa's *The Death of Atilius Regulus* (Plate 151) which was shown twice at the British Institution's summer exhibitions of Old Masters, in 1816 and, more significantly in the present context, in 1828.[59] In the eighteenth century, however, the emphasis changed. In line with intellectual and artistic movements of the day, painters used the story of Regulus as a moral *exemplum* of patriotism and self-sacrifice. What mattered were his love of his country, his utter indifference to his own fate, his insistence that Rome's goal must be victory. The critical moment in Regulus' life was that in which he turned a deaf ear to all the entreaties of his family and friends and left Rome to return to Carthage, as he had bound himself to do. This theme was widely treated throughout Europe and in every medium. Richard Wilson painted his *Departure of Regulus* in Rome in 1752.[60] Benjamin West painted a huge version of the subject for George III and exhibited it at the 1769 Royal Academy (Plate 152); it was soon published as a mezzotint and the painting itself was lent to exhibitions at the British Institution in 1824 and 1833.[61] Meanwhile the subject had proved equally popular on the Continent. It was the theme set by the French Academy for the *prix de Rome* in 1791, inspiring a number of fervent and Poussinesque compositions; similar neo-classical depictions of Regulus' departure were painted by several Italian artists, including more than one by Vincenzo Camuccini, the leading painter in Rome at the time of Turner's visits and Principal of the Academy of St Luke.[62] The suitability of the story for the theatre was also realised throughout Europe and at least ten stage works about Regulus were published or first performed between *c.* 1740 and *c.* 1840.[63] The title of one of the British plays — *The Inflexible Captive, A Tragedy* by the moral and religious writer Hannah More, the friend of Garrick, Reynolds and Johnson — shows clearly the intensity which now surrounded the name of Regulus.

151. Salvator Rosa, *The Death of Atilius Regulus*, *c.* 1652, oil on canvas, 60 × 85½ in., Virginia Museum of Fine Arts, Richmond, Va.

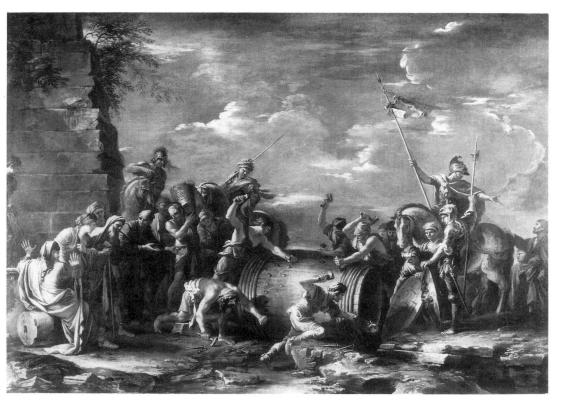

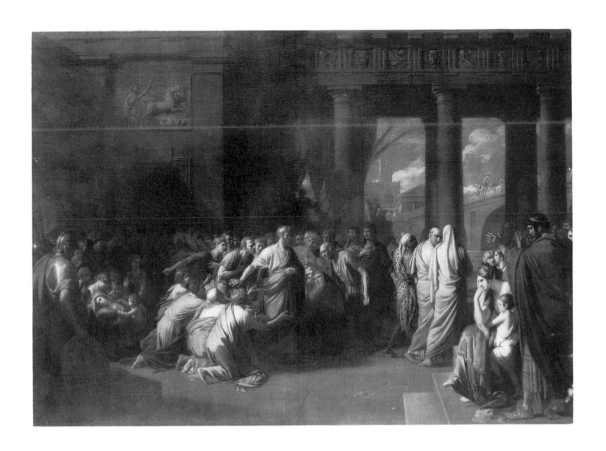

152. Benjamin West, *The Departure of Regulus*, 1769, oil on canvas, 88½ × 120 in., Her Majesty The Queen

Turner was well aware of the contemporary moral dimensions of the Regulus story: quite early in his career he wrote a list of stirring potential subjects in his 1786 edition of Goldsmith's *Roman History* which includes 'Regulus return'.[64] Since this same list also includes the subject of Hannibal crossing the Alps which Turner exhibited in 1812, it must surely predate that year. It could very well be contemporary with his verses in the *Devonshire Coast No. 1* sketchbook of *c.* 1811 which stress Regulus' unshakeable patriotism and heroic self-sacrifice:[65]

> O powerful beings, hail whose stubborn soul
> Even o'er itself to urge on self-control.
> Thus Regulus, who every torture did await
> Denied himself admittance at the gate
> Because a captive to proud Carthage power,
> But his firm soul would not the Romans lower.
> Not wife or children dear or self could hold
> A moment's parley, — love made him bold
> Love of his country; for not aut beside
> He loved but for that love he died.

Despite these clues from about 1811, Turner's 1828 painting seems at first glance to have no connection with the *exemplum virtutis* of Regulus. Its unusually brief title does not mention a departure; there were no explanatory verses accompanying the painting when it was exhibited in Rome in 1828 or in London in 1837; no actual embarkation seems to be shown; and it is sometimes even said that Regulus himself is not present. The modern belief is that the painting is 'about' light and that it puts the spectator in the place of Regulus.[66] One of the tortures he suffered was having his eyelids cut off, being shut up in a dark prison, and then being brought out into bright sunlight which instantly blinded him.

This suggestion accounts both for the supposed absence of Regulus himself and for the overwhelming force of the sunlight that dominates the picture (mostly in fact the product of the 1837 repainting: in 1828 the main colours in the sky would have been red and yellow rather than white).[67] However a number of points must be brought against it. First, it

147

would have been very uncharacteristic of Turner to make human physical suffering or torture the central theme and *raison d'être* of a painting. Second, his deep admiration for Claude's ability to paint the beauties of sunlight makes it inconceivable that he would have based *Regulus* so closely on Claude if his real subject was the sun's power to inflict injury. *Regulus* seems rather to be a painting in which Turner is vying with Claude on the latter's own ground and its intrinsic beauty argues against its being concerned with evil and destruction. It gleams, it sparkles. It is full of wonderfully varied light effects, as when a pale-coloured building is seen against a strongly blue sky, strange towers emerge from the haze of the distance and sunlight plays gently on classical architecture. When *Regulus* was exhibited in London in 1837 one critic described it as a 'gorgeous assemblage of splendid hues' and went on: 'who could have painted such a picture but Mr. Turner? What hand but his could have created such splendid harmony? Who is there so profoundly versed in the arrangement and management of colours? His sun absolutely dazzles the eyes. Those who have never beheld that orb in other climes, undimmed by the mists and vapours which "tone it down" in our northern regions, will probably think Mr. Turner's representation of it too brilliant. They may depend upon it, they arc wrong'.[68] This reviewer clearly found *Regulus* a beautiful painting — harmonious in its colouring and true to nature. Even today *Regulus* 'warms and lights' its gallery (as one of Turner's contemporaries wrote of the Claude *Seaport* on which it is modelled),[69] and it makes many of Turner's large Italian paintings seem less bright in comparison. The very paint itself proclaims *Regulus* an optimistic and positive painting, a celebration of light and the visible beauties of the world.

Finally, and most importantly, Regulus himself does appear in the painting — at lower left, with both arms raised, in a posture suggesting defeat and in the garments of a slave or captive. Many of the early depictions of Regulus show the means whereby he was eventually killed: he was shut up in a barrel lined with spikes, which was constantly rolled around so that he was deprived of sleep and bled to death.[70] In Turner's painting three or four men approach Regulus with what is clearly a barrel and this corner of the scene looks straight back to the earlier depictions of its theme. Indeed, its formal similarity to Rosa's *Regulus* (Plate 151) suggests that Turner had recently studied that painting at the British Institution in 1828, his eye having been attracted to it by his own long-standing interest in its subject.[71] Turner's depiction of Regulus' death was immediately understood by viewers of his own day. The critic just quoted made the standard complaint that Turner's picture had 'no, or scarcely any, connexion with the subject indicated in the title', but he had to admit that, 'There is certainly a little group of little men, rolling a little spiked cask into a little boat.'

Turner's painting includes a depiction of the final scene of Regulus' life, but it does far more than that. By its composition and the depiction of a harbour scene it also evokes Regulus' earlier resolution and action, the embarkation that led to the self-sacrifice. Turner brings together the whole of the Regulus story in one picture, which must surely be why he avoided over-particularisation in his title and is one reason why the question of which city is depicted is of minor importance. This desire to include many parts of a story in a single painting grew increasingly important to Turner as time went on, so that many of his pictures of the 1830s and 1840s became webs of complicated allusions, all of which were intended to be read by the spectator and added up into a composite whole. A similar amalgamation of motifs is found in the *Vision of Medea*, to be discussed shortly. *Regulus* itself contains numerous allusions beyond those already mentioned. The grand architecture stands for the empires which Rome and Carthage were both building. Their massed fleets adumbrate the naval conflict between them. A stern-faced woman and sobbing child on the right-hand shore represent Regulus' grieving family who had failed to dissuade him from returning to Carthage.

Turner's portrayal of Regulus himself may be analysed in a more detailed way. In an 1819 guidebook to Rome he might have read the following criticism of Rosa's *Regulus*: 'the moment seems to be unfortunately chosen; for the hero is already in the vessel, and his head only appears, without any expression of passion. . . . Had Regulus been painted at the

Colour Plate 26. Detail of *View of Orvieto* (Plate 149)

Colour Plate 27. *Regulus*, 1828, reworked 1837 (B & J, 294), oil on canvas, 35¼ × 48¾ in., Tate Gallery, London

moment before he went into the vessel, there might have been room for a display of that characteristical firmness which so much distinguished the Roman hero'.[72] The writer of this passage was obviously thinking of the more recent, neo-classical paintings of Regulus' departure which consistently showed him towering head and shoulders above a crowd of kneeling, stooping or clinging relatives and friends; his arms were tensed and straight, pressing downwards in a strong and resolute gesture that restrained and counterbalanced the host of uplifted imploring hands. His moral strength was shown by his physical attributes (Plate 152). Turner's Regulus, by contrast, is a victim. He is outnumbered and trapped by his opponents, his hands raised in submission, and he is the complete antithesis to the Regulus whom people expected to see in a painting. But he is a hero to the very end, and despite past and future torments his head is still unbowed.

Turner's *Regulus* is also unlike its neo-classical predecessors in that its hero does not occupy the centre of the stage. Regulus' final torment takes place in a corner of Turner's scene — so much so that it has often been overlooked. This was a deliberate ploy on Turner's part. In his composite depiction of Regulus' career, as in that career itself, the patriotism and self-sacrifice epitomised in his embarkation are the most important thing. These shine out in perpetuity, while the sordid details of his death occupy only a small portion of space and time.

There is overwhelming evidence — both within *Regulus* itself and in Turner's earlier references to the theme — that the *raison d'être* of his painting cannot be the blinding of Regulus as is so commonly believed today. On the contrary, the painting is a double *celebration* of light: the beauties of light itself, for which Turner used a Claudian model as a tribute to that master, and, metaphorically, the *exemplum virtutis* of Regulus. When *Regulus* is interpreted in this way it is easy to understand why Turner chose to paint and exhibit this subject in Rome. Regulus was one of the most celebrated heroes of the Roman republic, with whose story all were familiar. In combining a tribute to the greatest painter of Italian light with a reference to the most morally uplifting embarkation in Roman history, Turner was paying deliberate compliments to his audience and trying to make his art both accessible and pleasing. It was not his fault that their first sight of his work caught them unprepared and they were unable to appreciate it.

The third painting exhibited in Rome was the *Vision of Medea* (Colour Plate 28), of which one critic wrote, 'Suffice it to say whether you turned the picture on its side, or upside down, you could still recognize as much in it.'[73] Today this comment seems obtuse and perverse, for the *Vision of Medea* is not hard to follow. As Thornbury says, 'Medea is performing an incantation attended by the Fates. Above her is the dragon chariot, with her twins. Behind her is Medea again, throwing her murdered children into the burning palace.'[74] In other words, Turner's painting illustrates the final part of the story of the Greek prince Jason and the enchantress of Colchis, Medea, one of the most terrible of all

Colour Plate 28. *Vision of Medea*, 1828 (B & J, 293), oil on canvas, 68⅜ × 98 in., Tate Gallery, London

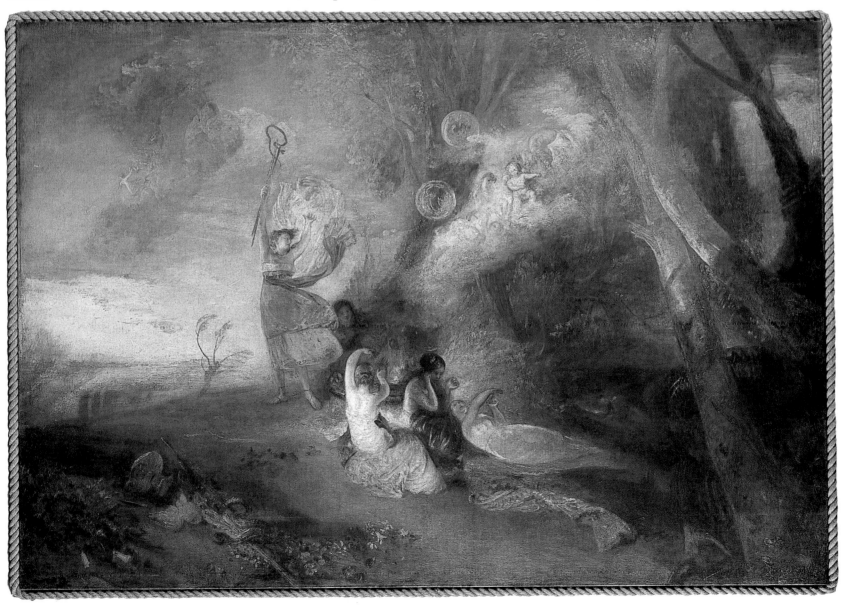

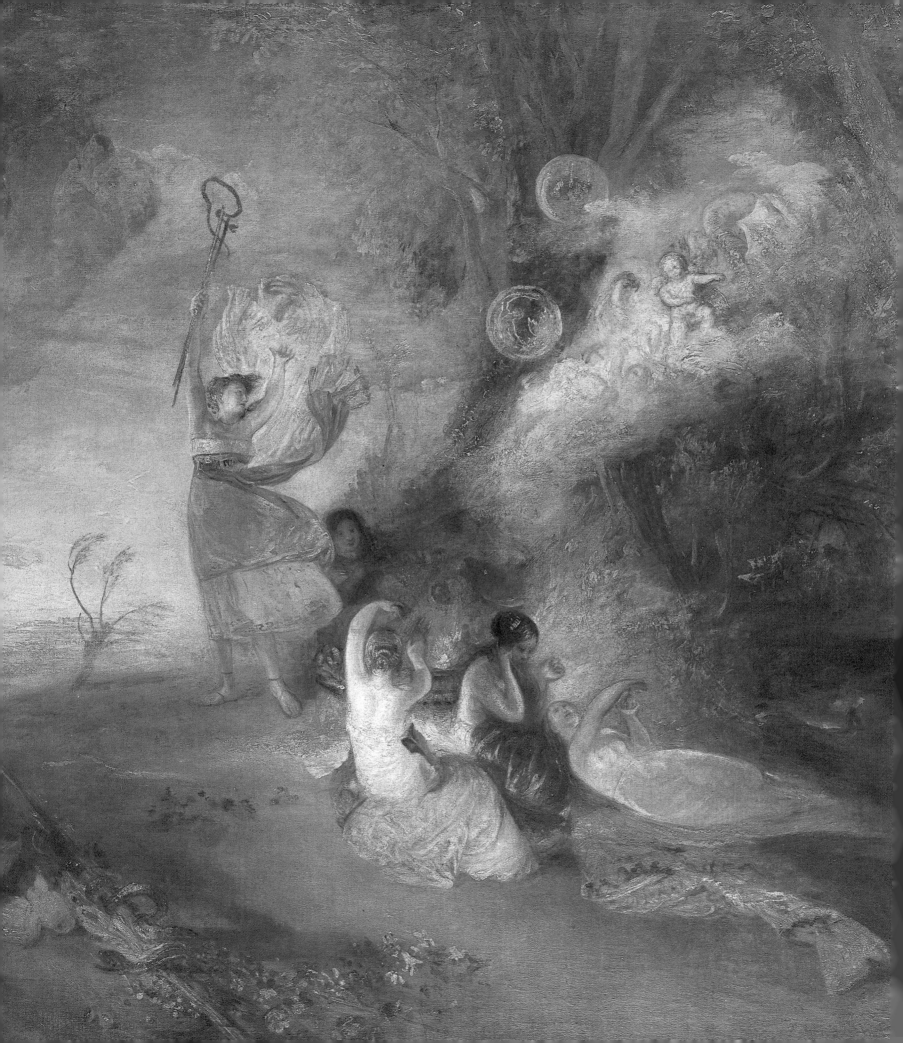

the classical stories about love and revenge. After the recovery of the Golden Fleece through Medea's sorcery, Jason and Medea return from the Black Sea to the Greek mainland. Driven out of Jason's native city of Iolcos in Thessaly, they take refuge in Corinth where the ever-ambitious Jason determines to marry the king's daughter; Medea herself is to be banished. She, however, exacts an immediate ghastly revenge. By the incantation of a magic spell she poisons a robe which she sends as a present to Jason's bride who dies an agonising death on touching it. She then murders the two young children of her own marriage to Jason. As Thornbury realised, Turner evokes both parts of Medea's revenge simultaneously. What is especially notable, however, is that he focuses chiefly on her incantation, an extremely rare subject in art, while introducing the more commonly treated theme of the murder of the children very much as a sideline. Furthermore, he does not represent either part of Medea's revenge directly. His concern is with Medea herself, her power and her passion.

Why did Turner choose to paint this particular subject in the autumn of 1828, on such a large scale, for exhibition to a Roman audience? In classical literature the most famous accounts of Medea's revenge are the tragedies by Euripides and Seneca, but these cannot have been the inspiration or sources for Turner's painting. Euripides' play contains no incantation scene as such, while Seneca's play, which does include this scene, was not among the translations forming Turner's usual sources for classical subjects.[75] A suitable visual precedent is equally hard to find. Turner had sketched the 'Medea sarcophagus' in the Vatican Museums in 1819, but this, like Euripides' tragedy, does not include Medea's incantation among its scenes and it has no visual parallels with Turner's painting.[76] There can be no doubt at all that the *Vision of Medea*, like the *View of Orvieto* and *Regulus*, was inspired by one of Turner's own recent experiences which was still dominating his mind and imagination. This was the highly successful production in London of the recently composed tragic opera *Medea in Corinto*. The plot of this opera was based closely on Euripides' and Seneca's accounts of Jason and Medea in Corinth, as outlined above. Its music was by the Bavarian-born composer Johann Simon Mayr (1763-1845) who lived and worked in Italy. His works were extremely popular in the early nineteenth century but today they are by and large sadly neglected and he is chiefly remembered as the teacher of Donizetti at the Musical Institute in Bergamo.[77] The words of the opera were by Felice Romani (1788-1865) whose more famous libretti include those for Bellini's *Norma* and *La sonnambula* and Donizetti's *L'elisir d'amore*. *Medea in Corinto* received its first performance at the San Carlo opera house, Naples, on 28 November 1813, the first London performance being given by the Italian Opera at the King's Theatre, Haymarket, on 1 June 1826.[78] It was repeated many times during the London opera seasons of 1826, 1827 and 1828, drawing large audiences and receiving many enthusiastic reviews.[79]

Turner's presence at a performance of *Medea in Corinto* at the King's Theatre, Haymarket, in the 1820s is not at all surprising, since both he and other members of his family are known to have been extremely musical.[80] His sketchbooks, correspondence and poetry all display his interest in music and musicians which manifested itself in a variety of ways from the 1790s through to the 1840s.[81] Italian music was certainly among his interests. At this period nearly all British visitors to Italy spent many of their evenings going to the opera for, as Smollett remarked, 'Italy is certainly the native country of this art.'[82] If the thrifty Turner did not indulge in this pastime as often as richer men like William Beckford or Tom Moore, there is at any rate evidence that he went to the theatre on more than one of his Italian trips. A note in one of the 1819 sketchbooks lists the theatres in Milan where music, opera and ballet could be enjoyed, and many years later he made sketches of theatre interiors in Venice.[83]

The success of *Medea in Corinto* in the 1820s was largely due to the appearance in the title role of the Italian soprano Giuditta Pasta (1797-1865), an almost legendary figure in the history of opera who took first Paris and then London by storm during these years. For more than a decade she was, as *Grove's Dictionary* puts it, 'undoubtedly the greatest soprano in Europe, unrivalled in dramatic expression and in the ability to hold an audience

Colour Plate 29. Detail of *Vision of Medea* (Colour Plate 28)

spellbound with depth and sincerity of interpretation',[84] and she starred in operas by many composers including Rossini, Mozart and Donizetti. Today, however, her fame resides mainly in the fact that she was the singer for whom Bellini wrote his two great masterpieces of 1831, *La sonnambula* and *Norma*, and anyone who has heard a really first-rate performance of *Norma* will have an idea of Pasta's genius. But it could in fact be argued that it was chiefly because Pasta had been such an outstanding Medea in the 1820s that Bellini composed *Norma* at all: he certainly provided Pasta with a remarkably similar tragic role.

Many of the leading writers and critics of the 1820s published eloquent testimonies to Pasta's powers. Stendhal devoted a whole chapter to her in his *Vie de Rossini* (1824) and referred overtly to his passion for her in his *Souvenirs d'Egotisme* (published posthumously). 'Barry Cornwall' addressed a long poem to her, calling her goddess, queen, prophetess and angel. In 1825 Hazlitt encapsulated virtually the whole of his thinking about art, whether pictorial or dramatic, in an article on Pasta in the *New Monthly Magazine*; three years later he gave her close attention in an essay that was ostensibly about Mrs Siddons.[85] Comparisons with Mrs Siddons were, indeed, both inevitable and frequent, but Hazlitt went even further: Pasta's natural grandeur led him on to the subject of comparable qualities in Raphael's Cartoons and the Elgin Marbles.[86] The same characteristics in Pasta's acting are praised again and again by the critics: naturalness, lack of affectation, spontaneity, depth of sincerity, ability to *be* a character rather than merely represent it. Hazlitt writes of her 'natural eloquence', 'the perfection . . . of natural acting', 'true nature and true art'. 'She rises to the very summit of her art, and satisfies every expectation by absolute and unbroken integrity of purpose, and by the increasing and unconscious intensity of passion. . . . she neither deviates from the passion nor rises above it, but she commits herself wholly to its impulse, borrows strength from its strength, ascends with it to heaven, or is buried in the abyss. In a word, she is the creature of truth and nature and joins the utmost simplicity with the utmost force.' Pasta had everything that Hazlitt looked for in both painters and performers: boundless creative energy and the capacity to render nature so intensely that it reaches the lofty heights of the ideal.

Hazlitt published the above eulogies of Pasta in the summer of 1828, the very time at which Turner must have seen her memorable rendering of Medea on the eve of his own departure for Italy. During 1829 and 1830 she was absent from the London stage, but her name was rarely off the critics' lips — every operatic performance was measured against hers and usually found wanting.[87] Then, after an absence of three years, she returned to London, and on 12 May 1831 a huge and rapturous audience greeted their long-awaited heroine who chose to make her reappearance in her most celebrated role, as Medea. She had been eagerly expected ever since news of her return was announced in March,[88] and there can be no coincidence whatever in the fact that Turner chose to exhibit his *Vision of Medea* in London for the first time that spring. What is ironic is that in the first week of May the critics were in general antagonistic towards Turner's painting, by the second week of May they were unanimously in raptures over Pasta's Medea itself. When Pasta, on stage, 'delineated the feelings of despair and of motherly affection with force and truth', the critics loved it; when Turner showed this in painting, he was accused of 'extravagance' and absence of repose. Pasta's Medea was a 'unique combination of histrionic genius and vocal excellence'; Turner's *Medea* was 'a mixture of bold genius and monstrous absurdity'.[89] There was no end to the applause for Pasta's 1831 Medea. Her 1820s performances had been highly acclaimed, but in 1831 she was found to be even better than before.[90] By now, alas, Hazlitt was dead, but Leigh Hunt published an article in the *Tatler* which carried on where Hazlitt had left off, extolling the 'wonderful truth' and 'moral beauty' of her Medea: 'She hits the great points and leaves you to feel the rest. Her gestures are voluminous; the tender ones are full of the last soul of love, her threatening or calamitous ones, appalling; there is catastrophe in them, the certainty of doom.'[91]

If the critics were overwhelmed, artists were by no means unaffected. Pasta appeared as Medea in several paintings at the Royal Academy and the British Institution.[92] She was

153. A. E. Chalon, *Giuditta Pasta singing 'Cessate — intesi' in Mayr's 'Medea in Corinto'*, 1825, watercolour, 12¾ × 8 in., Victoria & Albert Museum, London

brilliantly caricatured by A. E. Chalon (Plate 153). C. J. Hullmandel published a series of lithographs after drawings by John Hayter showing her in the various scenes of the opera.[93] A member of the Prinsep family attended a performance in June 1827 and drew pages of tiny sketches (Plate 154). In 1824 Delacroix noted in his journal, 'Médéc m'occupe' and, although his famous painting *Médée furieuse* (Plate 155) was not completed until 1838, there is every likelihood that it was initially conceived and begun under the spell of Pasta's Paris performances of the 1820s.[94]

All these portrayals provide confirmation of the fact that Turner's painting celebrates Pasta's Medea. The same stances and gestures are repeated again and again, as too are the red and white robes, the heavy encrusted belt, the sturdy arms and the generous bosom. What is more, virtually everything that Turner shows in his painting can be found in the incantation scene in the bi-lingual libretto of the opera, published in 1826. A stage direction near the beginning of Act II, scene v, describes Medea's preparations for her incantation thus:[95]

154. James Prinsep, *Giuditta Pasta singing in Mayr's 'Medea in Corinto'*, dated 23 June 1827, watercolour, 4 × 3 in., private collection

> (She hastens to the altar, and kindles the fire;
> she describes a circle with her magic wand, and then begins the spell.)

Turner's Medea stands close to an altar with a glowing fire (Colour Plate 29). She has already begun her spell and raises high a wand embellished with a coiling snake such as can be found in many earlier incantation pictures, for example, Zuccarelli's *Macbeth and the Witches* of 1760. Turner could well have known this work, either through Woollett's large engraving or from its appearance at the British Institution in 1824. Such a wand is a traditional feature in such paintings; it is not an emblematic device that is peculiarly Turnerian.

In the libretto Medea's spell begins with an evocation:

155. Eugène Delacroix, *Médée furieuse*, 1838, oil on canvas, 102½ × 65 in., Musée des Beaux-Arts, Lille

> Thou ancient Night, and Tartarus profound,
> Thou fearful Hecati, ye weeping shades,
> Ye Furies! you who of the infernal realm
> Sit as the keepers, armed with serpents;
> Come to me from the Stygian abodes,
> By this same fire, and our solemn compact.
> (A subterranean sound is heard, the mark of the presence of the shades.)
>
> AIR
> Yes, yes, I hear you; the earth trembles—
> I hear the barking of fell Cerberus —
> I hear the sound of coming pinions,
> You come, ye pallid shades, to me!
> *Subterranean Chorus.* Thy voice has penetrated these abodes,
> We've quitted Acheron to tend on thee.

Turner may have had access to this libretto in Rome in 1828, but it is more likely that he used his memory and imagination for the details for his painting. None the less the painting reflects the libretto closely. On the right one of the 'subterranean chorus' seems virtually to be making her entrance floating upon the river Acheron. The seated figure next to Medea must be her maid Ismene who in Act II, scene iv of the opera has brought to the foot of the altar the robe which Medea is to poison. Turner's chorus are three in number and face in diverging directions, thus following the libretto's reference to the three-headed goddess Hecate. However, they are shown not as the Furies, winged and 'armed with serpents' as Medea describes them, but with the attributes of the Fates (one holds the distaff, one draws the thread and one cuts it with her shears). This is probably because Turner had simply confused the Fates and the Furies. He was not alone in this confusion — Milton had made the same mistake in his 'Lycidas'.

Although Turner's main focus is on Medea's incantation, what he depicts is not a simple representation of a single scene but, as in many of his paintings, 'a composite episode spun from his reading of the whole story'.[96] To start with, he has set the incantation not in the

subterranean cavern specified by the libretto but out of doors, reflecting the final scene in the opera in which, immediately after Medea has announced the deaths of the children, '*A tempest begins, which rages with increasing fury till the end of the drama.'*[97] By a more complicated process he has also imagined that, at the very moment of the spell, Medea's mind is filled with the other part of her revenge — the murder of her children, which takes place offstage later in the opera, and her own triumphant departure in her dragon chariot. It is well known that when Delacroix depicted his *Médée furieuse* he borrowed the composition from a famous engraving after Raphael showing the massacre of the innocents. Turner's insertion of a vision of infanticide into his *Medea* and even his choice of title for the painting may well reflect an awareness of a monumental treatment of the massacre of the innocents which was hard to miss in London in the summer of 1828 and was equally well-known — indeed notorious — in Rome. This was J. B. Lane's 25 by 22 foot *Vision of Joseph*, painted in Rome from 1817 onwards, exhibited there in the 1820s, found offensive by the papal authorities and expelled together with its creator.[98] This suggestion is supported by a comment on the 1831 Royal Academy by one of Turner's fellow-exhibitors, in which the whole idea of a theatrical derivation for the *Vision of Medea* is inherent: 'Turner was also not only strong al solito in talent but in numbers 7 or 8 Pictures were by him. One only was very mad — a Medea raving in the midst of her bedevilments & incantations. You can conceive how Turner would outherod Herod in such matters.'[99] It is also relevant to note that a similar conflation of episodes to Turner's had occurred in Lane's painting itself. This showed the Holy Family peacefully asleep in an inn, side by side with other families whose children Herod's soldiers were in the very act of massacring.[100]

In his verses accompanying the *Vision of Medea* at the 1831 Royal Academy Turner reminded the viewer of the entire Jason and Medea story, from Medea's early success in both love and sorcery to her later rejection and retaliation:

> Or Medea, who in the full tide of witchery
> Had lured the dragon, gained her Jason's love,
> Had filled the spell-bound bowl with Æson's life,
> Yet dashed it to the ground, and raised the poisonous snake
> High in the jaundiced sky to writhe its murderous coil,
> Infuriate in the wreck of hope, withdrew
> And in the fired palace her twin offspring threw.

These lines come from *The Fallacies of Hope*, the fragmentary blank verse poem in which Turner both mocks and, at the same time, emulates the heroic couplets of *The Pleasures of Hope* by Thomas Campbell.[101] They reveal, for the first time, Turner's sympathetic attitude towards his subject: the story of Medea, like those of Dido or Hannibal, appealed strongly to his imagination as an example of the cycle of rise and fall, of victory followed by decline or defeat. His choice of the incantation scene was particularly apt, for at no other point in the opera is Medea's ambiguous position so poignantly emphasised. The powerless wife who cannot retrieve her husband's love, she is still a powerful enchantress who can, and does, exact her revenge. For the Roman audience of 1828 the interest of Turner's painting would have been its familiar classical story and the fact that Mayr's opera and Pasta's interpretation had been — and continued to be — such an outstanding international success. But Turner's own interest in the opera went far beyond the production which he actually attended and Pasta's celebrated appearance as its heroine. His painting is not a theatrical illustration; it is a powerful statement about love and fate, 'the wreck of hope', passion and revenge.

* * * *

Apart from the three works which were exhibited in Rome, Turner also painted a number of other works there: *Palestrina — Composition* (Plate 156), which was probably not finished until after his return to London, and a substantial number of paintings which were never finished at all, many of them no more than large studio sketches.

Palestrina — Composition is painted on an eight-foot canvas, presumably one of those

156

156. *Palestrina — Composition*, 1828-9 (B & J, 295), oil on canvas, 55¼ × 98 in., Tate Gallery, London

which Eastlake had bought to await Turner's arrival in Rome, and is generally agreed to be the picture referred to as 'Lord E's' in Turner's letter of 6 November.[102] When Turner ordered the canvases in August, he declared that 'it would give me the greatest pleasure independant of other feelings which modern art and of course artists and I among their number owe to Lord Egremont that the very first brush in Roma on my part should be to begin for him con amore a companion picture to his beautiful *Claude*'.[103] Turner's phrases are highly significant. The 3rd Earl of Egremont was one of the few aristocrats of his age to patronise and encourage contemporary artists and Turner himself enjoyed a very special relationship with him. He frequently stayed at Petworth House in Sussex in the 1820s and 1830s, living as one of the family and painting in his own studio there. But Lord Egremont also owned the large and beautiful Claude, *Landscape with Jacob, Laban and His Daughters* (Plate 5), which has been referred to several times in earlier chapters of this book. It was of this painting that Turner was reminded on at least two occasions when he first saw the countryside of central Italy in 1819. During the 1820s Turner must surely have told Lord Egremont about this experience, and it is not in the least surprising that in 1828 his patron commissioned him to produce a pendant.

Turner's *Palestrina* and Claude's *Jacob and Laban* are of almost identical size and their subject matter is also very similar: a hilly landscape with a river and a bridge, shepherds, flocks and herds. Having said this, it must be pointed out that the differences between them are greater than their similarities. The landscape on the left of *Palestrina* is far more stern and rugged than any part of the Claude, while this area also has a quite unClaudian feeling of excess and turbulence (partly due perhaps to bad handling of perspective). The right-hand part of *Palestrina* is more reposeful, but here Turner seems to have made little effort to make clear what is depicted (Colour Plate 30), a feature which again strikes a note of discord with Claude's painting. Turner's general handling of the paint in *Palestrina*, his use of impasto, his wild flurries of rich colour, the many areas which have an impressionistic, 'unfinished' appearance — all these make it an unsuitable pendant to

157

Jacob and Laban, and it is easy to understand why Lord Egremont decided not to buy it as planned.

What is the relationship between *Palestrina* and the town of that name in the mountains east of Rome (the ancient Praeneste) and what was Turner's intended meaning in his painting? The bridge, castle and so forth on the left of the painting do not correspond with anything to be seen at Palestrina, but the town in the distance (minimally seen, however) is indeed based upon it.[104] This discrepancy between the real and the painted accounts for Turner's full title, *Palestrina — Composition*, which unequivocally places the painting at the opposite end of the topographical spectrum from the *View of Orvieto*. Turner had almost certainly visited Palestrina himself, though it is not clear whether his visit took place in 1819 or 1828.[105] However, as with the *Vision of Medea*, his concern was not simply to depict what he had seen. A clue to Turner's meaning is provided by his own verses which accompanied the painting at the 1830 Royal Academy:

> Or from yon mural rock, high-crowned Praeneste,
> Where, misdeeming of his strength, the Carthaginian stood,
> And marked, with eagle-eye, Rome as his victim.

This was the first occasion on which Turner used lines from *The Fallacies of Hope* to extend the meaning of a depiction of central or southern Italy and his purpose is clear: Italy is threatened. The most forceful part of the lines is the last phrase of all, 'Rome as his victim'. The verses are curious in two respects: they refer to the Punic Wars, in which Rome did not fall victim to Carthage but emerged victorious; and there was no good historical reason for connecting Hannibal with Praeneste. The 'prati di Annibale' or 'campo di Annibale', from which nineteenth-century visitors to Italy supposed that Hannibal eyed his prey in the manner which Turner so vividly described, were actually near Rocca di Papa in the Alban hills.[106] But the placid and serene beauty of the Alban hills was hardly suitable for the message which Turner wished to present in 1828. It was one thing to use such a landscape to point up the contrast between the devout practices of Roman Catholicism and the lawlessness and banditry which made stern measures as necessary for Pius VII as they had been for Claude's patron, Urban VIII, two hundred years before (Plates 135 and 136). What Turner needed for his oil painting in Rome in 1828 was to show a once-famous piece of classic ground that was visibly the victim of history and circumstance; past its heyday celebrated by Virgil and Horace and now an unimportant rural town dependent on agriculture.[107] Turner must have selected Palestrina as the setting for such a picture because the town possessed the remains of a vast and famous Temple of Fortune — a goddess of whose capriciousness and mutability he was constantly aware. The changing fortunes and reduced status of this one small Italian town spoke eloquently for them all. Just as Turner's Sibyl in *The Bay of Baiae* had been 'the type of the ruined beauty of Italy', so now his Palestrina was the type of the ruined glories of Rome. And what of Hannibal himself? He, too, had had his moment of glory, power and ambition; he, too, 'misdeeming of his strength', had ultimately been laid low.

Turner's unfinished Roman paintings of 1828 fall into two groups. He embarked not only on a large number of landscapes but also on three studies of the female nude, the *Reclining Venus* (Plate 178), *Two Recumbent Nude Figures* and the *Outline of the Venus Pudica*.[108] The first two nudes were painted on very large canvases measuring about six feet by eight, and had the makings of viable finished works, particularly so in the case of the *Reclining Venus*. It is much harder to imagine what kind of finished painting could have incorporated the *Outline of the Venus Pudica*, apparently based on a recollection of the *Medici Venus*.

The influences which led Turner to paint the *Reclining Venus* at just this moment undoubtedly included Titian's *Venus of Urbino* in the Uffizi which Turner's painting echoes both in its general composition and in its arrangement of colour masses. He could have seen the Titian both in December 1819 and on his way to Rome in September 1828. Another influence was probably Canova's *Pauline Borghese as Venus Victrix* which Turner

158

had seen in Rome in 1819. The alertness of Turner's *Venus* is reminiscent of *Pauline Borghese*'s level gaze, and it has also been noted that Turner's interior seems to include a Bonapartist wreath.[109] It is unlikely that Turner saw the statue again in 1828 — it had been difficult of access even in 1819, when he would only have seen it through his friendship with Canova, and by 1828 the sculptor was dead. But in 1828 Turner frequented the studios of a number of British artists in Rome, many of them sculptors. A study of a reclining female nude in one of his sketchbooks suggests that he may well have sketched the models he saw there.[110] This activity, together with his discussions with Eastlake and other artists and his painting of the figures in the *Vision of Medea*, could have led him naturally into painting nudes as well.

The landscape studies vary considerably in nature and function. Three large but roughly painted scenes on canvas similar to that of the *Vision of Medea* are comparable to *Palestrina* both in size and in the type of countryside which they depict (see Plate 156 and Colour Plate 32), and it is possible that Turner made four large composition studies before deciding which one to work up into a painting for Lord Egremont.[111] A group of fourteen medium-sized composition studies of landscapes and coastal scenes includes paintings that can be related in a similar fashion to the *View of Orvieto* and *Regulus*.[112] Many of these sketches include indications of figures. Some would have been suitable for a genre scene such as the *View of Orvieto*, while those in other sketches have an authoritative bearing more appropriate to an historical or mythological subject.[113] Several of the sketches obviously depict imaginary places, while some of those which are based on reality show places in Italy which Turner had not only seen in 1819 but knew well from works by other artists (e.g. Lake Nemi: Colour Plate 31): their origins probably lay in Turner's memory rather than in recent perception.

Nevertheless, many of these oil studies did spring from Turner's recent experiences. The aqueducts or bridges in them almost certainly derive from his fascination with the aqueduct at Nepi, which had been the subject of numerous sketches on his journey to Rome. In *Southern Landscape with an Aqueduct and Waterfall* (Colour Plate 32), for example, the aqueduct is a two-tiered one, as at Nepi. The painting nowadays known as *Ariccia (?)* bears no resemblance to that place, where the viaduct was, in any case, not built until the 1850s: this work, too, was probably inspired by the buildings and countryside at Nepi.[114] Meanwhile the distant blue mountain in a painting known today simply as *Southern Landscape* is an unmistakable depiction of Mount Soracte, whose dramatic silhouette Turner had sketched again and again on his way to Rome.[115] Another of these very large paintings has recently been recognised as depicting the dramatically ruined hill village of Civita di Bagnoregio, a few miles south of Orvieto (Plate 157). Though unfinished, Turner's painting is remarkably true to the spirit of this extraordinary corner of Italy, with its wildly lush vegetation and red-brown earth. The medieval village of Civita perches, in an unbelievably picturesque fashion, on a crag entirely isolated by landslides. Employing his customary poetic licence, Turner omits the church tower and adds a Tivoli-style temple, but his painting still captures the essential appearance of Civita.[116]

Finally, there are a few smaller sketches (in oil on millboard or on muslin mounted on millboard) which have for some years been associated with Turner's 1828 visit to Italy.[117] Many interlocking questions surround these sketches: could they have been painted in 1819 rather than in 1828?; were they painted from the motif, as might be expected in the case of small sketches of this type?; do they all depict Italy? It must be said that the subjects of many of them are not unequivocally Italian, but one, known as *Hilltown on the Edge of the Campagna*, may well depict the subject in its present-day title: it is similar to some of Turner's 1819 sketches. *Seacoast with Ruin, probably the Bay of Baiae* shows the Temple of Venus at Baiae which Turner sketched in 1819 and painted in 1823. It is not impossible that the sketches of these subjects belong to 1819 rather than to 1828, but the questions above are not easy to resolve. If the sketches belong to 1819, they may have been painted from nature. If, on the other hand, they date from 1828, it is more likely that they were painted from memory in the studio.

157. *Italian Landscape: Civita di Bagnoregio*, 1828 (B & J, 301), oil on canvas, 59 × 98¼ in., Tate Gallery, London

Turner produced very few good pencil sketches during his 1828 visit to Rome. The most interesting are those on a group of five pages in the *Rome to Rimini* sketchbook (Plate 158) which later formed the basis for one of his oil paintings. Its genesis is related by Thornbury:[118]

> When Mr. Munro gave Turner a commission for a view of modern Rome from a fine point that included the Tiber and some of the chief antiquities, the artist employed some time in looking for the place indicated, surprising Sir Charles Eastlake, who was with him, by his anxiety to discover some particular spot.
>
> He had been particularly anxious as to what Mr. Munro wanted — 'a copy' or an ideal picture. A 'copy' was asked for, and a copy he did; so faithful, indeed, has the painter been in this beautiful picture, that he has, even at some peril to his success, introduced in the left-hand foreground a long monotonous row of modern houses; but these he has so cleverly varied with slant shadows, that they become pleasing, and lead on the eye to where it should go — the matchless distance.

The mention of 'a long monotonous row of modern houses' on the left enables the subject of Thornbury's story to be identified as *Rome, from Mount Aventine* (RA, 1836; Plate 159). (The complex of buildings forming the hospice of S. Michele was begun by Carlo Fontana but not completed until around 1800.) Eastlake's recollection that Turner moved around whilst establishing his viewpoint is confirmed by the sketches themselves. If these are compared with the views actually seen by the visitor to the Aventine, it is clear that Turner must have stood and sketched in several different spots in the grounds of the Priorato di Malta and S. Alessio.[119]

Colour Plate 30. Detail of *Palestrina — Composition* (Plate 156)

* * * *

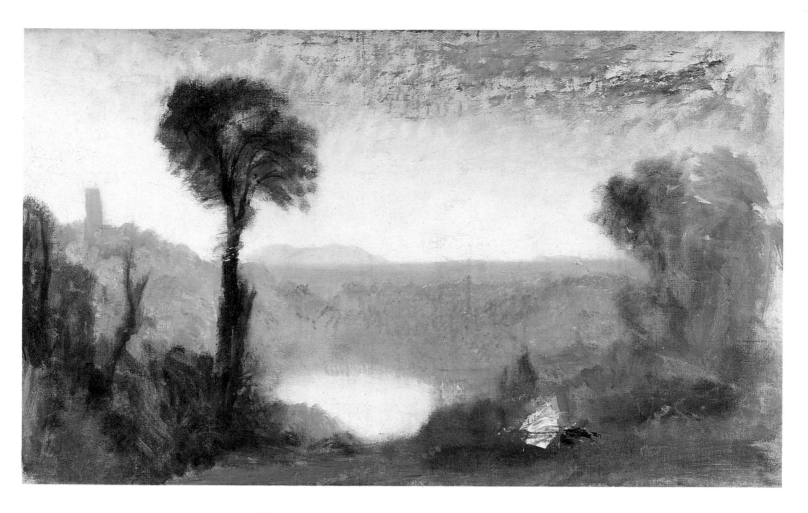

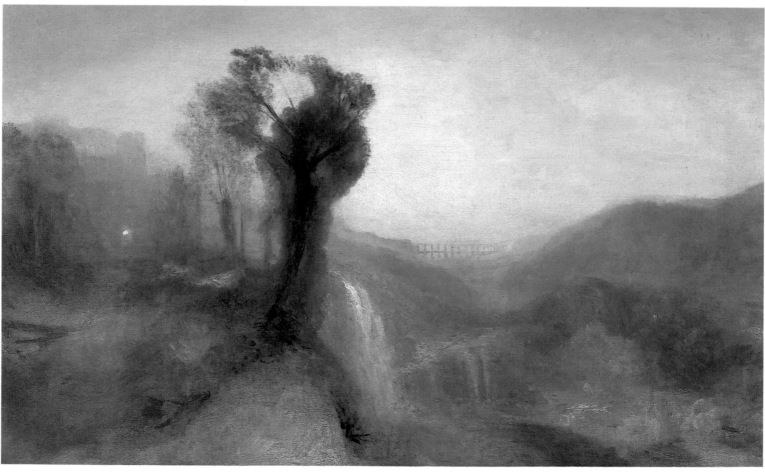

Although most of Turner's attention in Rome in 1828 was focused upon his own art, he still found time for other activities besides painting and gathering material for the future. He returned to enjoy places and works of art that had particularly pleased and interested him in 1819, such as the Forum and Tivoli.[120] On his first visit, he had paid special attention to paintings and sculpture which he believed to be the work of Michelangelo; in 1828 he returned to the Sistine Chapel and found the Prophets and Sibyls 'as grand . . . as ever'.[121] He was, however, very disappointed to find that the *Last Judgment* had 'suffer'd much by scraping and cleaning' and complained that a canopy had been fixed to the wall above the altar so that the figure of Charon was hidden from view. He reported gloomily on this state of affairs to Lawrence in London: 'the rising from the dead and the Inferno are no longer divided by his iron mace driving out the trembling crew from his fragile bark . . . the key note of the whole — sentiment is lost'.[122]

Turner was far more sociable on his second visit to Rome than he had been in 1819, almost certainly due to his friendship with Eastlake who was by now a well-established figure there. Turner's letters of 1828 and 1829 refer to many of his compatriots who were then working in Rome: the sculptors Joseph Gott, R. J. Wyatt, George Rennie, William Theed, William Ewing and John Gibson; the painters Penry Williams, Andrew Geddes, Andrew Wilson and Joseph Severn.[123] He evidently took a good look around their studios as was perfectly normal there. Penry Williams showed him a sketch of Sorrento which he was transforming into a painting for a patron and told Lawrence that Turner had been 'pleased to admire [it] much'.[124] Turner himself repeated his 'very favourable opinion' to Lawrence after his return to England, when he also talked to Wilkie about a copy which Andrew Geddes was making of a Veronese in the Vatican.[125]

The gregarious nature of studio and *trattoria* life among artists in Rome in the early nineteenth century is too well known to require description here, and Turner's three months there can be easily imagined. Sadly, none of his friends recorded any anecdotes about him during this period, though one of them later wrote that he 'made himself very social and seemed to enjoy himself, too, amongst us'.[126] In the 1820s British artists in Rome were extremely interested in the work of the German fraternity, the Nazarenes, an interest which is reflected not only in the writings of Eastlake and Severn, Wilkie and Uwins, but also in the Roman chapters of *Middlemarch.*[127] Turner may well have met some of the Nazarenes themselves through Eastlake or Severn, and he was almost certainly taken to see examples of their work. A list of places in one of his sketchbooks includes the Villa Massimo where Schnorr, Veit, Koch and Overbeck had recently completed a series of frescoes illustrating scenes from the Italian poets.[128]

He also made enquiries, on Lord Egremont's behalf, about an antique male torso, and in December arranged for its purchase.[129] Lord Egremont paid 240 louis for it to a dealer named Maldura or Maldaza with whom Eastlake was negotiating simultaneously on behalf of Jeremiah Harman.[130] When Turner left Rome in January 1829 he made Eastlake responsible for despatching the torso to England, but their subsequent correspondence suggests that things did not go smoothly. In May Turner reported that he had at last had news of the torso and referred to 'the great trouble you had with him Maldaza for which do allow me to offer my thanks for you did quite right'.[131] In August he wrote crossly that, 'De Santis has this month sent the invoice of the Torso which Lord Egremont has had upwards of 2 months[.] this is the way Smith and de Sanctis does business.'[132] Everything ended satisfactorily, however, and Turner asked Eastlake to 'tell Gibson Ld Egremont likes the Marble'.[133] The sculptor had probably advised Turner and Eastlake on its merits and value. For exhibition alongside the fine collection of antique marbles assembled by his father, the 2nd Earl, Lord Egremont had the torso completely restored, probably by J. E. Carew. It appears today in the sculpture gallery at Petworth as a standing Dionysus, accompanied by a panther.[134]

* * * *

158. Rome from the Aventine, 1828 (*Ro to Ri*, 4a-5, 5a-6, 7), pencil, each page $3\frac{7}{8} \times 5$ in.

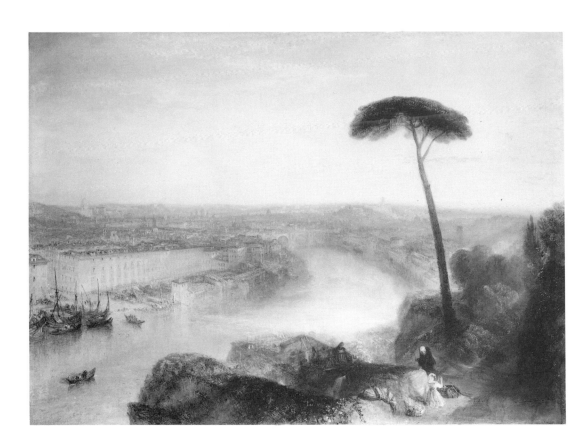

159. *Rome, from Mount Aventine*, 1836 (B & J, 366), oil on canvas, 36 × 49 in., The Earl of Rosebery, on loan to the National Gallery of Scotland

Turner's exhibition of paintings must have closed on Christmas Day and he then made hasty preparations for his return to England. He left Rome on Saturday 3 January 1829, was at Bologna on Thursday 8 January and was off again the following day. He left Milan for Turin on Wednesday 14 January and was at Susa on Tuesday 20 January. In 1829, as in 1820, Turner's homeward journey was not without its problems. On 22 January he was stuck in a deep snow drift in the Alps, an adventure which he later recalled with characteristic good humour and celebrated in a brilliantly comic yet powerful watercolour, *Messieurs les voyageurs on their return from Italy (par la diligence) in a snow drift upon Mount Tarrar*. However, he managed to reach Lyons by 24 January and was back in London by early in February.[135]

One of Turner's 1828-9 sketchbooks contains a manuscript poem which he must have written on the very eve of his departure from Rome since it begins 'Farewell a second time the Land of all bliss.'[136] This was evidently an attempt to match the last poem in Rogers's *Italy*, 'A Farewell', one of those for which Turner had recently provided a vignette, and perhaps also the 'Farewell to Italy' in William Sotheby's *Italy and Other Poems* of 1828.[137] Parts of Turner's poem are illegible or obscure in meaning, but several of its phrases show that, despite all the new experiences of 1828, his basic attitude towards Italy, her history and her countryside, had changed remarkably little. It was to change equally little in the 1830s, as the next chapter will demonstrate. The 'lost greatness of Imperial Rome', referred to in Turner's poem, had been the keynote of *The Bay of Baiae* in 1823 and was to inspire his two 'ancient' and 'modern' pairs of 1838-9. Even closer to Turner's heart, 'that great being of long versed renown ariel Claude' was to influence his Italian paintings right through the next decade and beyond.

Chapter 10

PAST AND PRESENT: TURNER'S ITALY IN THE 1830s

Turner's 1828 visit to Rome proved to be his last. At first he planned to return in the summer of 1829: some of his paintings were left behind for him to finish there and he also got Eastlake to keep an eye on the rooms at 12 Piazza Mignanelli which he had been using in 1828.[1] However, as the time approached, he became less inclined to go. One deterrent was the delay he had experienced in getting his finished pictures back to London. *Regulus* and the *View of Orvieto* were supposed to be shipped home soon after Turner himself left Rome in January, so that they could be exhibited at the 1829 Royal Academy. They did not arrive until three months after the Academy opened.[2] As Turner remarked in May, 'I rather tremble at the heat of July in Rome and what is the use of painting Pictures if I cannot get them safe; it is a sad drawback.'[3] A further reason against departing on a lengthy tour was the increasing frailty of his father who did, in fact, die in September 1829. Turner also contemplated returning to Rome in 1830, but this visit, too, failed to materialise. By the summer of 1830 France and Belgium were in a state of revolution and waves of unrest were felt throughout the Continent.

Turner never saw Rome, Naples or Florence again. He paid three more visits to northern Italy but he did not return to the south. Despite this, the years from 1829 to 1840 saw him producing over a dozen oil paintings of central and southern Italy, and a number of mythological scenes whose settings are palpably based on his own experiences of classic ground. He produced and exhibited more oil paintings of central and southern Italy in the 1830s, when he did not visit these areas, than in the years 1819-29 when he spent two long periods there. The same situation occurred with his Venetian pictures: he painted more than twice as many oils of Venice in the half-dozen years following his last visit in 1840 as in all the years between 1819 and 1840. Turner's increased production of pictures of Venice was partly stimulated by the growth in popularity of Venetian subjects with the British public. However, a comparable argument cannot be applied to his more southerly subjects — topographical, historical or mythological — since these belonged to genres already well established. The paintings themselves suggest that Turner simply enjoyed looking back on his experiences of Italy. Through the act of painting he could give visible form to his memories and at the same time exercise his imagination and intellect. He could re-create an Italy of his own instead of re-visiting it.

The paintings themselves are extremely diverse in both subject and treatment. *Rome, from Mount Aventine* (1836) is a modern, urban panorama, carefully based on a series of detailed sketches made on the spot and faithfully representing a single, actual sight. *Caligula's Palace and Bridge* (1831) is a coastal scene with ruins based largely on fantasy, which was described early on as 'poesy itself' and 'too obviously artificial'.[4] *Childe Harold's Pilgrimage — Italy* (1832) was inspired by Byron and is a composite depiction of the Italian countryside. Ever since its earliest commentators it has been seen as 'an epitome', 'epical' and 'a *résumé*'.[5] The historical landscapes include not only scenes from classical mythology on appropriate pieces of classic ground (*The Golden Bough*, 1834) but also religious subjects in Italian settings (*Tivoli: Tobias and the Angel*, c. 1835?). Two pairs of paintings contrast the ancient world with the modern: *Ancient Italy — Ovid banished from Rome* and *Modern Italy — the Pifferari* (1838) were soon followed by *Ancient Rome;*

Agrippina landing with the Ashes of Germanicus and *Modern Rome — Campo Vaccino* (1839). Since Turner did not revisit central Italy in the 1830s, one would naturally expect that his Italian paintings of these years would draw upon his sketches and memories from 1819 and 1828 and would show a continuity of approach to Italy with his earlier work. Both these assumptions will here be shown to be well-founded. He did make use of his earlier sketches, though not always in ways that might be expected, and his approach to Italy, which had been formed between the 1790s and 1819, changed very little. He never lost the eighteenth-century attitude which combined familiarity with Italy's history and consciousness of her past glories and achievements with reverence for the artistic heritage of classical antiquity. He continued to be influenced by the artists whose work had introduced him to the landscape and buildings of Italy during the 1790s — Claude, Wilson and Piranesi. He remained interested in the morals to be drawn from ancient history or mythology, which had led to earlier paintings such as the Carthage pictures of 1815-17 and *The Bay of Baiae*. This chapter will display the continuity of some of Turner's special interests over his long career and, since a single painting often draws on several of the above sources of inspiration simultaneously, the interrelationships of some of his ideas.

The links between the 1830s paintings and Turner's own sketches of Italy are many and various. It has been seen in earlier chapters that for the large oil paintings deriving from the 1819 visit — *Rome, from the Vatican, The Bay of Baiae* and *Forum Romanum* — Turner relied heavily on his sketches and usually followed them faithfully, but that when he produced the vignettes for Rogers's *Italy* in 1826-8 this was no longer the case. Some vignettes apparently had little or no basis in his sketches, while others followed them with a large degree of artistic licence. Most of the 1830s paintings were produced in the same manner as the Rogers vignettes and it is easy to see why. Turner's 1828 visit had taken him to practically all the places depicted in these paintings but he did very little sketching. His journeys within Italy were scantily recorded in comparison with those of 1819 and much of his time in Rome was spent in his studio. He made only one group of careful and detailed pencil sketches from nature, and these were done in order to fulfil a commission from his friend H. A. J. Munro of Novar for a panorama of the city (Plates 158 and 159). The history of this picture illustrates Turner's current lack of interest in painting straightforward Italian views. He chose a superb vista looking north from the Aventine, he drew nearly five pages of sketches providing a strip-like panorama that was an excellent basis for a painting, but it was not until eight years later that *Rome, from Mount Aventine* was ready to be exhibited at the Royal Academy and handed over to its owner.

Apart from the Aventine sketches, Turner's 1828 visit provided him with practically no material for new paintings. In the 1830s he had either to rely on his memory or, where topographical accuracy was desirable, to return to his 1819 sketches. Many of the 1830s paintings involved a synthesis of motifs, so that the need to be topographically correct was greatly reduced and ingredients could be painted from memory. But not all the paintings were composite idealisations. *Modern Rome — Campo Vaccino* (Plate 174) represents the Roman Forum: both the complexity of its subject and the quantity of its detail suggest that Turner consulted the many sketches he had drawn of the Forum twenty years earlier. Even in this painting, however, poetic licence is well to the fore. The disparity in ground level between the Arch of Severus on the left and the lofty Temple of Vespasian on the right is greatly exaggerated for compositional reasons, while the relationship between the Temple of Vespasian and the façade of the Temple of Saturn behind it is made visually more lively by the latter being depicted facing in the wrong direction. Another picture showing a famous piece of ancient Rome — the Arch of Constantine — involved still less precise recollection. The unfinished depiction of this monument of 'c. 1835?' (Colour Plate 39) incorporates none of the details which Turner had recorded so meticulously in 1819 and even displays uncertainty about the top storey of the arch. One must suppose it to have been painted entirely from memory.

For *Campo Vaccino* and *Rome, from Mount Aventine*, Turner transferred sketchbook material on to his canvas, but this was not the case with most of the 1830s paintings. In

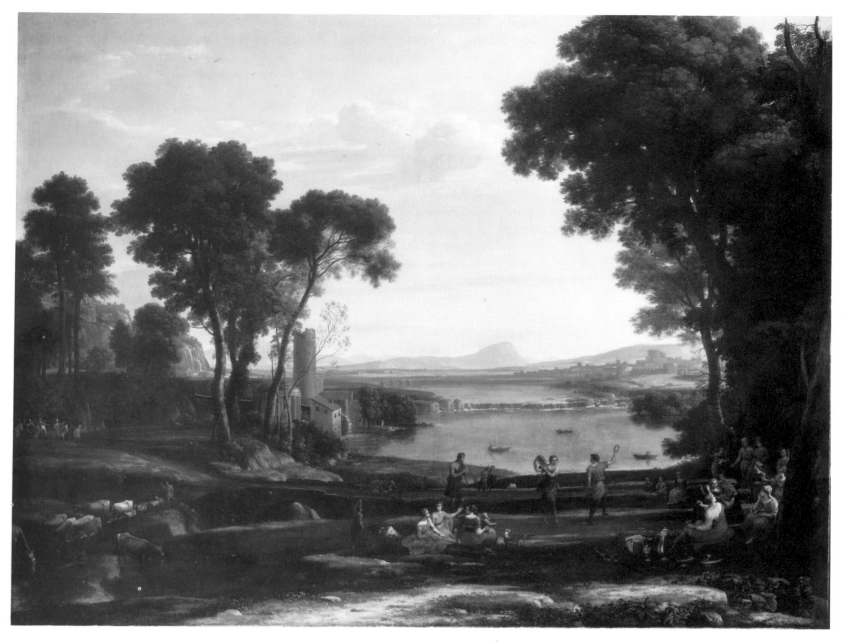

160. Claude Lorrain, *Landscape: The Marriage of Isaac and Rebecca ('The Mill')*, 1648, oil on canvas, 58¾ × 77¾ in., National Gallery, London

Rome in 1828 he had made a number of composition studies in oils, consisting of landscapes, harbours and coastal scenes. The 1830s paintings on the same themes must have been begun in a similar way, with the composition being created on the canvas. However, the process was now taken much further and the theme and details expounded and elaborated. None of the 1828 studies was itself developed into an 1830s painting — their sizes and canvas types would not support this idea[6] — but the finished pictures of the 1830s must at one stage of their creation have looked similar to the unfinished ones of 1828.

The 1830s paintings certainly owe a great deal to the artists who had originally shaped Turner's view of Italy. The name of Claude has occurred frequently in these pages, as a painter whose work prepared Turner for his first sight of Italy and against whose landscapes he judged the Italian countryside itself. Turner's involvement with Claude continued right through the 1830s and his paintings of this period show Claude's influence in numerous ways despite the fact that they are obviously very different from any landscapes painted by Claude himself and a far cry, too, from Turner's early essays in the Claudian style such as *The Festival upon the Opening of the Vintage of Macon* (1803) or *Apullia in Search of Appullus* (1814). The obvious formal debts may be mentioned first. Several of the 1830s paintings employ Claudian compositions, echoing a specific painting or using a typically Claudian scheme. The composition of *Mercury and Argus* (1836), for

instance, is based on a particular Claude which Turner had recently seen.[7] Other paintings follow Claude in a more general way: *Childe Harold's Pilgrimage — Italy* (Colour Plate 35) uses a tall tree to give an idea of distance and a river and bridge to lead the eye gently back, while *Ovid banished* is based on Claude's harbour scenes dominated by the sun. In the two 'ancient' and 'modern' pairs of 1838 and 1839, the group to which *Ovid banished* belongs, Turner copied another of Claude's specialities, the contrasting of different times of day, suggested by colours, in pendant paintings (Plates 171, 172, 173 and 174). Then, too, the very ingredients of Turner's paintings often show the influence of Claude. The basic forms of the countryside in *Childe Harold's Pilgrimage — Italy* are just those that Claude so often shows, as, for example, in one of the Altieri paintings by which Turner was profoundly moved, the *Landscape with the Father of Psyche sacrificing to Apollo* (Plate 4): softly rounded hills billow with trees and bushes, while higher eminences rise in the distance. Turner could have chosen to paint any of the numerous other types of scenery that he had seen in Italy, but for this epitome of Italy he instinctively went straight to the type of countryside which Claude had depicted again and again in his paintings. It is also tempting to regard the foreground scene of Turner's *Childe Harold's Pilgrimage — Italy* (Colour Plate 33) as a recollection of Claude's *Landscape with Dancing Figures*. Turner had studied and sketched one version of this painting in the Doria collection in Rome in 1819 (see Plate 72), while the other version (*The Marriage of Isaac and Rebecca*) was among the Angerstein pictures which entered the National Gallery in London in 1824 (Plate 160). Turner's love of the latter painting is well known. It was shortly before executing *Childe Harold's Pilgrimage — Italy* that he requested in his will that two of his own paintings should hang near this Claude after his death.[8]

In the 1830s Turner also used the Italian landscape as a stage for history paintings. Sometimes a classical or mythological drama demanded an Italianate setting — the *Story of Apollo and Daphne* (1837), for example, is set in a plain resembling that of Paestum.[9] But Turner also used Italy as the setting for events related in the Bible, just as Claude had done in the *Landscape with Jacob, Laban and His Daughters* at Petworth. The titles of Turner's *Landscape: Christ and the Woman of Samaria* (c. 1830)[10] and *Tivoli: Tobias and the Angel* are modern ones, since these unfinished pictures were never exhibited by Turner himself, but their titles may be accepted as correct: *Christ and the Woman of Samaria* is a Claudian

161. Claude Lorrain, *Landscape with Tobias and the Angel* (*Liber Veritatis* 65), pen and wash on blue paper, 7¾ × 10⅜ in., British Museum

162. The Temple of Clitumnus, 1819 (*A to R*, 37a), pencil, 4⅜ × 7⅜ in.

reworking of a theme which Turner had treated in a Poussinesque style for the *Liber Studiorum* in 1819. *Tivoli: Tobias and the Angel* (Colour Plate 38) probably has an even closer link with Claude. Turner would have known from the engravings in Earlom's edition of the *Liber Veritatis* that Claude had used Tivoli material in several of his paintings.[11] One of these drawings (Plate 161) records a painting in which Tivoli forms a background to the subject of Tobias and the Angel. This painting was last heard of at the end of the eighteenth century when it belonged to a British dealer.[12] It is very possible that Turner knew it either directly or via its engraving, and it could well have led him to show Tobias and the Angel against a Tivoli background.

The final way in which the 1830s paintings follow Claude's example is the most interesting, since it marks a break with Turner's practice of the 1820s. Many of the paintings now depict an idealised or composite Italy, one 'made up of bits', as Turner himself had described Claude's art in 1811.[13] High on the left of *The Golden Bough* (Colour Plate 36) the spectator may discern a temple that is based on the Temple of Clitumnus which Turner had sketched in central Italy in 1819 (Plate 162) and which he has here transplanted to the region of Lake Avernus in southern Italy. In *Childe Harold's Pilgrimage — Italy* (Colour Plate 35) the left-hand foreground includes the irregular forms of crumbling Roman brickwork such as Turner had sketched at Hadrian's Villa at Tivoli in 1819 and seen in the same year at Baiae, where the buildings were indeed surrounded and being eroded by water, as in this painting. The Temple of Clitumnus appears again slightly to the left of the central tree. The left-hand hilltop bears buildings similar to a tomb he had sketched in the Roman Campagna in 1819 and an archway he had drawn for *The Antiquities of Pola* in about 1818. The right-hand part has a different source again, being founded, if Ruskin was correct, 'on faithful reminiscences of the defiles of Narni, and the roots of the Apennines'.[14] Turner's bridge combines features from both the bridges at Narni — the huge round arches of the Roman bridge (Plates 30 and 31) and the smaller arches and picturesque tower of the adjacent medieval one. *Cicero at his Villa* (Plate 163) has been shown to derive its overall composition from an 1819 sketch which Turner had made near Tusculum, the site of one of Cicero's country retreats.[15] Nevertheless this painting, too, brings together elements collected from a multiplicity of sources. The vista on the left recalls the view of the Villa d'Este at Tivoli as seen from the Rotunda of the

Colour Plate 33. Detail of *Childe Harold's Pilgrimage — Italy* (Colour Plate 35)

FOLLOWING PAGE
Colour Plate 34. *The Golden Bough*, 1834 (B & J, 355), oil on canvas, 41 × 64½ in., Tate Gallery, London

Colour Plate 35. *Childe Harold's Pilgrimage — Italy*, 1832 (B & J, 342), oil on canvas, 56 × 97¾ in., Tate Gallery, London

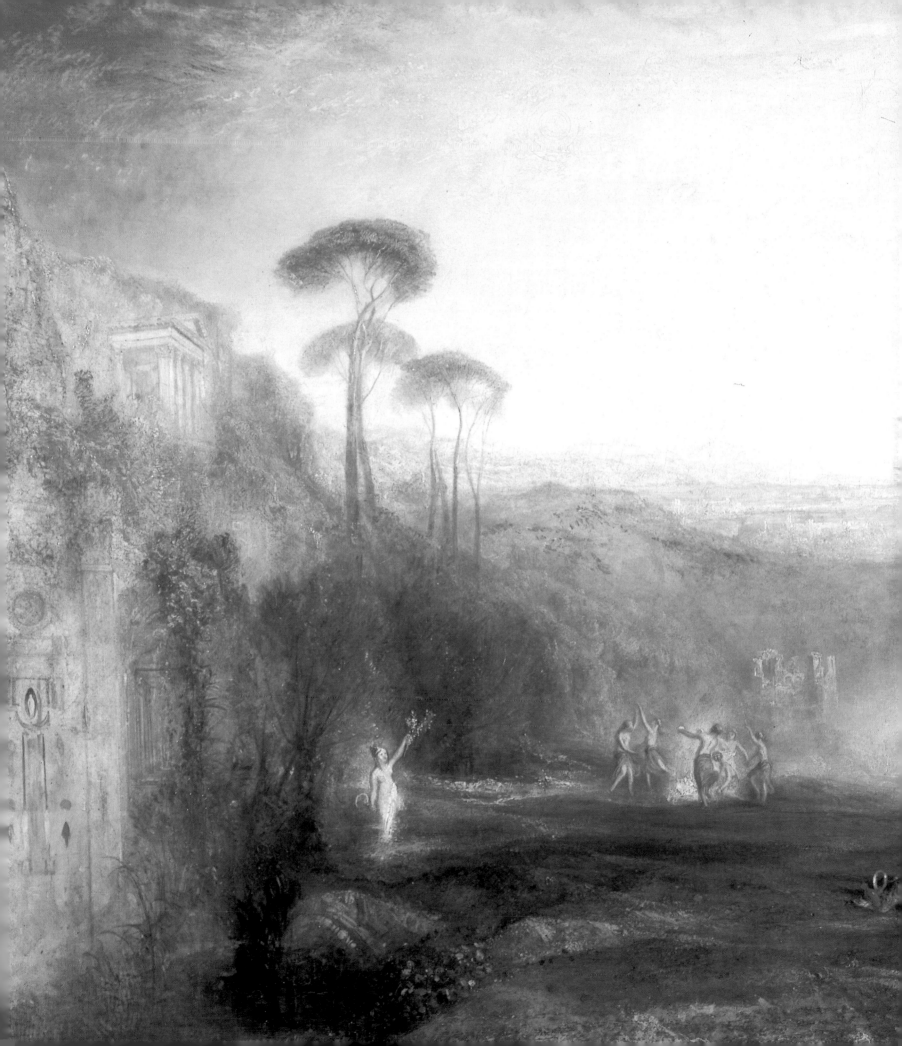

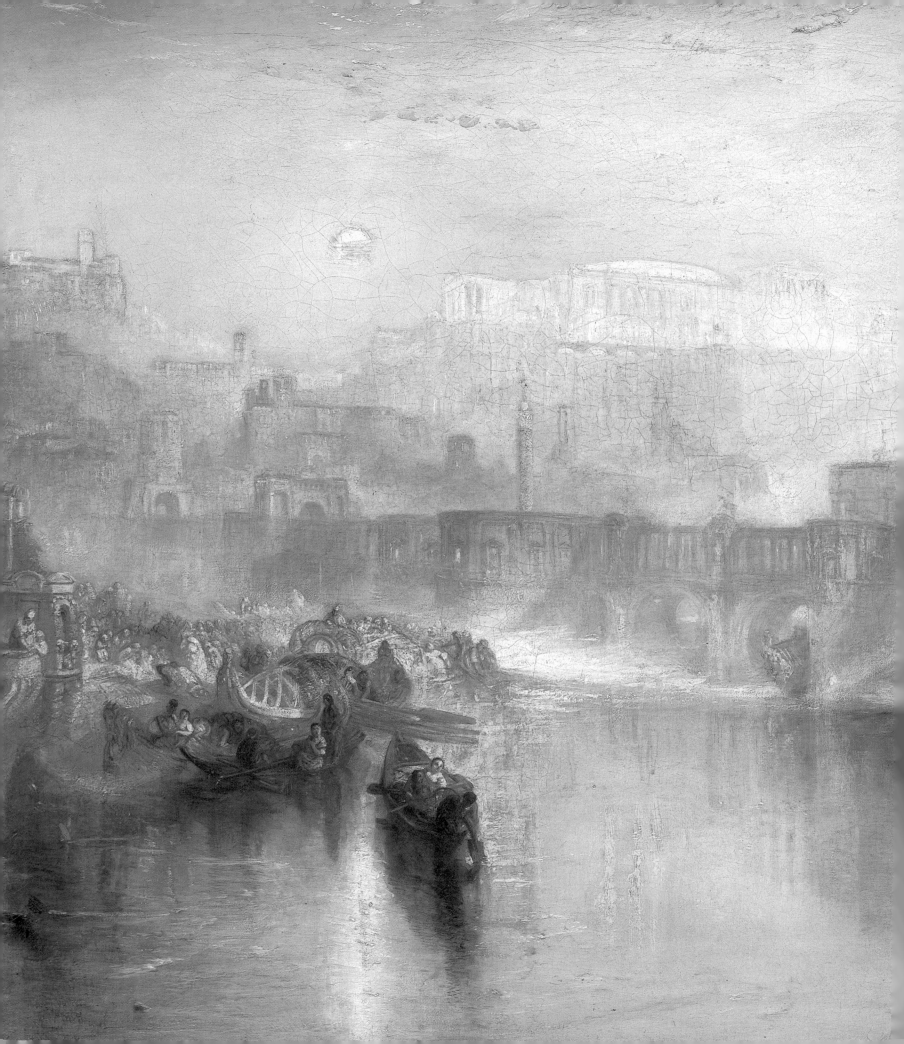

PREVIOUS PAGE
Colour Plate 36. Detail of *The Golden Bough*
(Colour Plate 34)

FACING PAGE
Colour Plate 37. Detail of *Ancient Rome;
Agrippina landing with the Ashes of Germanicus*
(Plate 173)

163. *Cicero at his Villa*, 1839 (B & J, 381), oil on canvas, 36½ × 48½ in., private collection

164. The Tiber and the Campagna, 1819 (*NRCSt*, 35), pencil and watercolour, 10 × 16 in.

165. J. Le Keux after Turner, *Rome from the Farnesean Gardens*, 1820 (R, 150), engraving, 5½ × 8½ in.

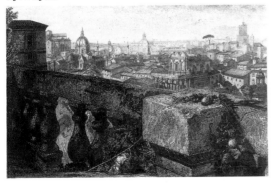

Cypresses, in the gardens where Turner had done so much sketching in 1819. Just to the right of the cypresses appears a large seated statue of Apollo below a pine tree which is based on his 1819 sketch of a celebrated statue and pine in the Barberini gardens in Rome (Plate 42). Behind the statue meanders a river, a pale blue line of water snaking its way through golden fields, just as Turner had depicted the Tiber in his coloured sketches in 1819 (Plate 164). The villa itself is an elaboration of some of the Renaissance villas at Frascati which he had visited in 1819. Even the foreground balustrade, with its pear-shaped balusters, square pier and staffage of fruit, foliage and flowers, derives from his earlier experiences of Italy, albeit at second hand: it copies the balustrade in *Rome from the Farnesean Gardens*, one of his illustrations for Hakewill's *Picturesque Tour of Italy* (Plate 165).[16]

This conflation of motifs and the creation of an epitome of Italy distinguishes the 1830s paintings sharply from those of the 1820s, such as *The Bay of Baiae* or the *View of Orvieto*: the earlier paintings had been based closely on sketches which, if not drawn from a single spot, were at least drawn in a single area. They are also quite different from works showing an accumulation of totally imaginary ingredients, such as *Dido building Carthage* or *The Decline of the Carthaginian Empire*. By the 1830s Turner had built up a vast store of images that were genuinely related to Italy, and he was willing to combine them in his paintings in a way that was new for him and yet entirely in line with what Claude had done.

Childe Harold's Pilgrimage — Italy and *Cicero at his Villa* are not, however, 'Italian capricci' in the usual sense of the term. Turner shows not the famous buildings and sculptures beloved of painters of Italian capricci in the eighteenth century, but typical everyday motifs — a tree, a statue, a ruin, a river. The ordinary spectator would not analyse these two paintings in the detail employed here: he would merely have the sensation of gazing on genuinely classic ground.

Turner's depiction of Cicero was painted in deliberate rivalry with Wilson's *Cicero and his two Friends Atticus and Quintus at his Villa at Arpinum* (RA, 1770), a picture which had fascinated him for several decades. Wilson painted many versions of his composition (e.g. Plate 166), one of which belonged to Sir Watkin Williams Wynn, whose collection Turner studied in the late 1790s; three were exhibited at the British Institution in 1814. It was the

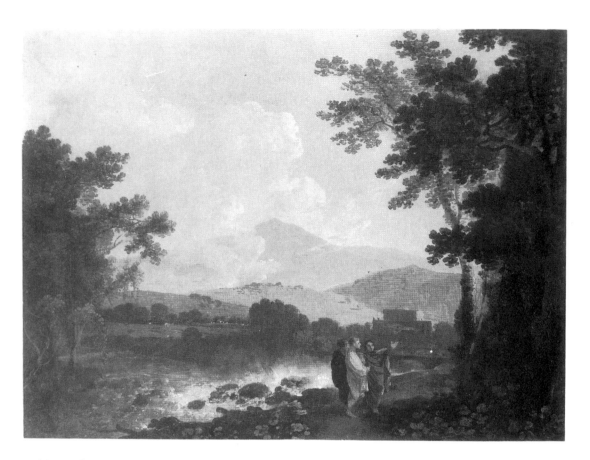

166. Richard Wilson, *Cicero and his two Friends Atticus and Quintus at his Villa at Arpinum,* oil on canvas, size and present whereabouts unknown

subject of one of the plates engraved by Woollett which Turner admired and planned to rival in a series of large engravings in the 1820s.[17] He spoke admiringly of the painting in his 'Backgrounds' lecture in 1811, and when, in 1819, he visited the area of Cicero's Tusculan villa, in the Alban hills, he made a number of notes relating to Wilson and asked himself, 'If Tusculum where is Wilson's Picture taken from'.[18]

Turner's question is, in fact, unanswerable. For one thing, Wilson's painting is largely based on sketches and studies probably made in north Wales;[19] more importantly, it does not depict Cicero's villa at Tusculum at all. It shows another of his villas, that at Arpinum. In 1819, Turner was obviously misled by the fact that some versions of Wilson's painting were known as *Cicero and his Friends at his Tusculan Villa,*[20] but he had clarified the position for himself by 1839, for his own painting omits the specific incident which links Wilson's painting unequivocally to Arpinum. Wilson's subject was a conversation between Cicero, his friend Atticus and his brother Quintus, which is described in Cicero's *De Legibus.* Atticus points to an ancient tree near the villa at Arpinum, the town where both Cicero himself and the famous general Marius had been born, and remarks, 'I recognise this as the very grove, and this oak, too, as the oak of Arpinum, the description of which I have often read in your [i.e. Cicero's] poem on Marius. If that oak still exists, this must certainly be it; and, indeed, it appears extremely old.'[21] Turner's painting, on the other hand, lacks any such motif, while his title deliberately neglects to mention which of Cicero's many villas it depicts. There can be little doubt that the eloquent figure with the outflung arms is Cicero himself, appropriately clad in the *toga praetexta* of a Roman magistrate, while the identity of his companion, seen only from the back, is unimportant.

But Wilson may not have been the only influence at work here: Turner marked with a pencil the line relating to Cicero's Tusculan villa in his 1827 edition of Samuel Rogers's *Poems.*[22] Part of *The Pleasures of Memory* discusses 'the charm historic scenes impart' and describes the traveller's emotions as he treads in the steps of the ancients. Rogers imagines meeting Cicero first in the ruins of his Tusculan villa, then in the Roman Forum:

> Who now but meets him musing, when he roves
> His ruined Tusculans romantic groves?

> In Rome's great forum, who but hears him roll
> His moral thunders o'er the subject soul?

Turner would undoubtedly have noted the second of these lines because it reminded him afresh either of Wilson's picture or of his own wanderings in 1819. None the less, Rogers's juxtaposition of images may well have led Turner to treat Cicero himself in the same conflationary way as he was treating the surrounding landscape: he portrays in a single figure both the dynamic orator of the Forum and the lover of rural repose amongst the hills.

The fortunes of Wilson and Cicero were vividly contrasted by Turner in the 'Backgrounds' lecture: 'In vain did his pictures of Niobe . . . flash conviction of his powers, . . . or the Cicero at his Villa sigh for the hope, the pleasures of peaceful retirement, or the dignified simplicity of thought and grandeur, the more than solemn solitude that told his feelings. In acute anguish he retired, and as he lived he died neglected.'[23] In the later 1830s Turner may have felt a special sympathy for Wilson's plight, since he himself experienced some isolation and decline just then. He was passed over in Queen Victoria's accession honours in June 1837, his close friend and patron Lord Egremont died in November of that year, and in December he himself resigned from the post of Professor of Perspective at the Royal Academy which he had held for thirty years.[24] There is nothing explicit in *Cicero at his Villa* to support this idea, but such a psychological background to the painting is an attractive speculation.

The influence of Claude and Wilson on Turner in the 1830s is beyond dispute. More open to question is the inspiration behind the magnificent architectural ensembles in *Caligula's Palace and Bridge, Ovid banished* and *Agrippina landing with the Ashes of Germanicus* (Plates 170, 171 and 173 and Colour Plate 37). The painting and exhibition of these last two, in 1838 and 1839, may perhaps be connected with Turner's recent resignation as Professor of Perspective: if he was no longer to lecture on architecture and perspective, he may have felt that he could at any rate produce stunning examples of it in his exhibited works. In *Ovid banished* and *Agrippina* Turner may perhaps have been emulating the work of John Martin.[25] It has also been thought that the buildings in both these paintings relate to Turner's interest in contemporary ideas about the restoration of ancient architecture and the work of C. R. Cockerell who specialised in imaginative but learned reconstructions of ancient Rome.[26] Such work may very well have played a part in the genesis of Turner's paintings. However, as far as the presentation of his material is concerned, a far more dynamic influence is that of Piranesi. The Italian's etchings, especially those of the individual buildings of ancient Rome, had helped form Turner's vision of that city long before he went there, with the result that many of the 1819 sketches echo Piranesian compositions, while the 1820 watercolour of the Colosseum was also cast in a Piranesian mould, crowding the page and looming over the spectator. In the 1830s, however, the influence on Turner was not the *Vedute di Roma* but Piranesi's earlier architectural fantasies which were published in the *Opere Varie* of 1750. If one compares the plates in this book with *Ovid banished* or *Agrippina* one finds very much the same approach to the reconstruction of ancient Rome, the same freedom and the same effects. Temples and palaces, columns and bridges are composed into massive and complex piles overburdened with rich decorations, statues and ornamentation (Plates 167 and 168 and Colour Plate 37). While Cockerell's depictions of ancient Rome restored are clean and disciplined, both Turner's and Piranesi's views have a quality of excitement and excess that matches their basis in invention and imagination. They are not only visually comparable but share a common character and emotion. The fantastic ensembles of archaeologically correct buildings in Piranesi's *Opere Varie* were clearly produced, as a recent commentator has written, 'in the sheer pleasure of conjuring up visions or in exercising skill as a violinist in a *cadenza* demonstrates his virtuosity and the technical range of his instrument'.[27] Such a simile also fits the Turner of the 1830s perfectly. An 1832 critic of *Childe Harold's Pilgrimage — Italy* and Samuel Palmer, writing about *Apollo and Daphne* in 1838, both likened Turner's astonishing virtuosity to that of Paganini, while more recently it has been

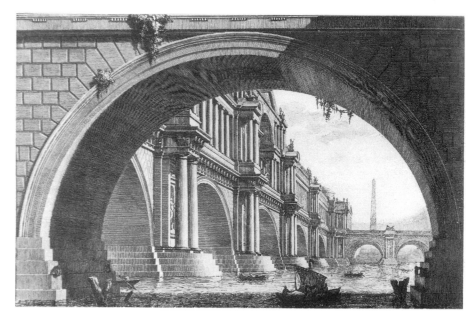

167. G. B. Piranesi, *Ancient Campidoglio,* from the *Opere Varie* (1750), etching, $9\frac{1}{2} \times 14\frac{1}{4}$ in.

168. G. B. Piranesi, *Monumental Bridge,* from the *Opere Varie* (1750), etching, $9\frac{1}{2} \times 14\frac{1}{4}$ in.

169. G. B. Piranesi, *Monumental Roman Harbour,* from the *Opere Varie* (1750), etching, $15\frac{3}{4} \times 21\frac{1}{2}$ in.

suggested that Turner's public demonstrations of painting on Varnishing Days were stimulated by the displays of skill which the violinist gave in London in 1831-4.[28]

A deepening interest in Piranesi in the 1830s would be entirely in keeping with Turner's fidelity to earlier attitudes towards Italy and his continuing exploration of familiar sources, but it might be thought somewhat unusual for its time. Many British artists in Italy in the 1820s, such as Bonington and Eastlake, approached architectural subjects with much greater simplicity. Nevertheless, Turner was not alone among artists of his generation in retaining an appreciation of Piranesi's work. Right up to 1838 J. M. Gandy regularly exhibited Piranesian fantasies at the Royal Academy, while the influence of Piranesi's etchings may also be discerned in the illustrations to two 1840s publications of Turner's friend David Roberts, the *Holy Land* and *Egypt and Nubia*.[29] But the example of Piranesi was far more relevant to Turner's paintings of *Ovid banished* and *Agrippina* than it was to either Gandy or Roberts, for it would be wrong to regard these paintings simply as demonstrations of virtuosity. No one had shown the magnificence of ancient Rome as brilliantly as Piranesi had done in his *capricci*, and the physical grandeur of the ancient city is essential to Turner's argument in both *Ovid banished* and *Agrippina* if the contrast with their 'modern' companions is to be forcefully felt.

But Piranesi had not only envisaged the ancient environment reconstructed in all its magnificence. He also invented half-ruined or half-built extravaganzas so complex as to be barely credible. The same was true of Turner and one may well compare Piranesi's *tour de force*, the *Monumental Roman Harbour* (Plate 169), with Turner's 'piled-up sublimities' in *Caligula's Palace and Bridge* (Plate 170).[30] There can be little doubt that Turner was familiar with this famous print. His painting depicts the grandiose construction with which Caligula bridged the bay between Baiae and Pozzuoli in order to confute the prophecy that he would no more become Emperor of Rome than he would drive his chariot across the Bay of Baiae; and, by juxtaposing the pathetic ruins of Caligula's proud bridge and the simple pleasures of everyday Italian life, it comments on the folly of hubristic endeavours, doomed

170. *Caligula's Palace and Bridge*, 1831 (B & J, 337), oil on canvas, 54 × 97 in., Tate Gallery, London

171. J. T. Willmore after Turner, *Ancient Italy* (*Ovid banished from Rome*) (R, 657), engraving, 17 × 23¾ in. (1842) after the oil painting of 1838 (B & J 375)

172. *Modern Italy — the Pifferari*, 1838 (B & J, 374), oil on canvas, 36½ × 48½ in., Glasgow Art Gallery and Museum

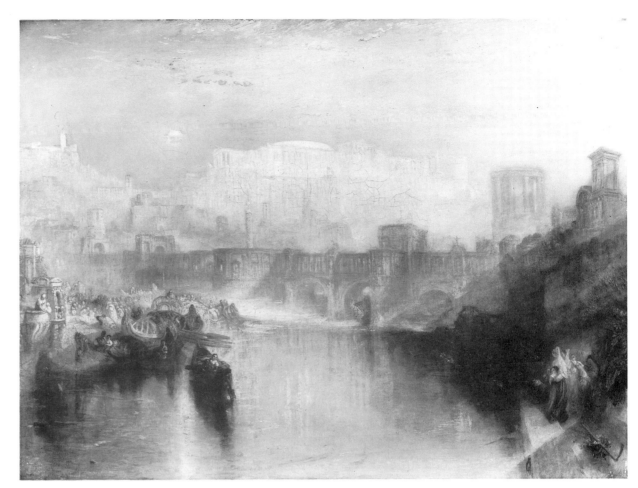

173. *Ancient Rome; Agrippina landing with the Ashes of Germanicus. The Triumphal Bridge and Palace of the Caesars restored,* 1839 (B & J, 378), oil on canvas, 36 × 48 in., Tate Gallery, London

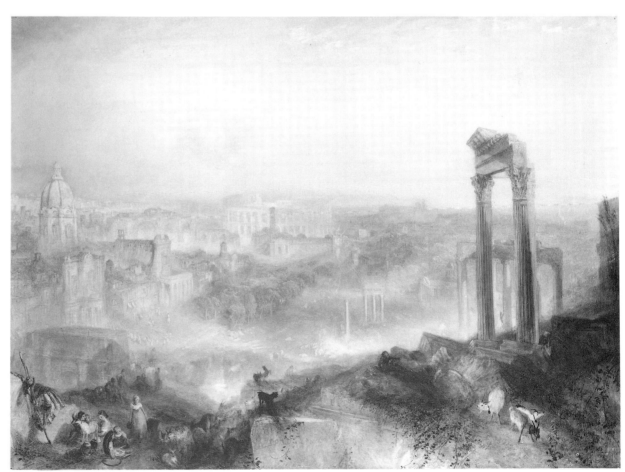

174. *Modern Rome — Campo Vaccino,* 1839 (B & J, 379), oil on canvas, $35\frac{1}{2}$ × 48 in., The Earl of Rosebery, on loan to the National Gallery of Scotland

Colour Plate 38. *Tivoli: Tobias and the Angel, c.*
1835? (B & J, 437), oil on canvas, 35⅝ × 47⅝ in.,
Tate Gallery, London

Colour Plate 39. *The Arch of Constantine, Rome, c.*
1835? (B & J, 438), oil on canvas, 36 × 48 in., Tate
Gallery, London

to crumble.[31] In all these paintings — *Ovid banished, Agrippina* and *Caligula's Palace and Bridge* — the greater the endeavour and achievement could be shown to have been, the greater the contrast with their decline; and what better example of Roman architectural splendour was there for Turner to follow than that of Piranesi?

When *Caligula's Palace and Bridge* was exhibited at the Royal Academy in 1831, it was accompanied by a quotation from Turner's *Fallacies of Hope* referring, as might be expected, to 'monuments of doubt and ruined hopes'. Another line from the same verse mentions 'the Lucrine Lake an inner pool' which echoes the phrase 'the Lucrine lake/A reedy pool' from James Thomson's poem *Liberty*.[32] Thomson's reflections on Baiae and Caligula's bridge must certainly have been in Turner's mind when he painted both *The Bay of Baiae* and *Caligula's Palace and Bridge*. The snake in the former recalls Thomson's description of the area as 'a nest for serpents', while in the latter Turner makes visible the wreck of the buildings which Thomson had only been able to conjure up in words:

> No spreading ports their sacred arms extend:
> No mighty moles . . .

Such verbal and visual echoes are not surprising. Thomson was one of Turner's favourite poets and an important influence from early on in his career right through to this period. His verses on Regulus could well have strengthened Turner's interest in painting that subject.[33] His 'Castle of Indolence' inspired him to paint *The Fountain of Indolence* (or *The Fountain of Fallacy*) (exhibited in 1834 and 1839), a picture which is replete with classical buildings and antique statuary and even includes an echo of Claude in its watermill on the left.[34]

Thomson's *Liberty* discusses Italy at great length and mentions many of the places treated by Turner in his paintings — Tivoli and Palestrina, for instance — but there is no reason to suppose that Turner's paintings of these celebrated subjects were directly stimulated by Thomson's brief references. However, one possible connection between *Liberty* and Turner's paintings is worth investigating. The theme of Part I is 'Ancient and Modern Italy Compared' and Part III deals in a similar fashion with Rome. It has therefore been suggested that the poem provided the *raison d'être* behind Turner's 'ancient' and 'modern' pairs of 1838 and 1839 — *Ovid banished* and *The Pifferari* (Plates 171 and 172) and *Agrippina* and *Campo Vaccino* (Plates 173 and 174).[35] This is an appealing suggestion, for *Liberty* contrasts classical and present-day Italy very vividly and draws from the phenomenon of decline a moral of just the sort that Turner loved — that 'the arts of men fall to ruin when Liberty is banished from the scene'.[36] On the other hand, it might have been a commonplace in Turner's day to contrast ancient and modern Rome and Italy in the way that Thomson had done, so that the influence on Turner was not necessarily that of Thomson. It must also be asked whether the Italy and Rome depicted by Turner correspond to those which are described by Thomson.

The first point may be answered — and, in fact, dismissed — by looking at the guidebooks and travel books on Italy written in the early nineteenth century, such as two of those which Turner is known to have used, Eustace's *Tour through Italy* of 1813 and Sass's *Journey to Rome and Naples* of 1818. Both Eustace and Sass placed great emphasis on the contrast between ancient and modern in Rome but their distinction was fundamentally different from Thomson's. Whereas twentieth-century guidebooks to Rome tend to describe it on a geographical basis, area by area, Eustace, Sass and many others took an historical approach: certain chapters dealt with ancient Rome (i.e. the remains of the classical, pagan city), others with modern Rome (i.e. all the post-classical developments, including the earliest churches).[37] This method was recommended by Eustace because it enabled the tourist to 'keep each object distinct, and take it in a separate view; we first contemplate ancient, then visit modern Rome, and pass from the palaces of the profane, to the temples of the sacred city'.[38] It also stimulated artists to compose richly contrasting scenes. In Samuel Palmer's pair of watercolours, painted in Rome in 1838, *Ancient Rome* shows the Forum, while *Modern Rome* depicts the Renaissance and baroque buildings of

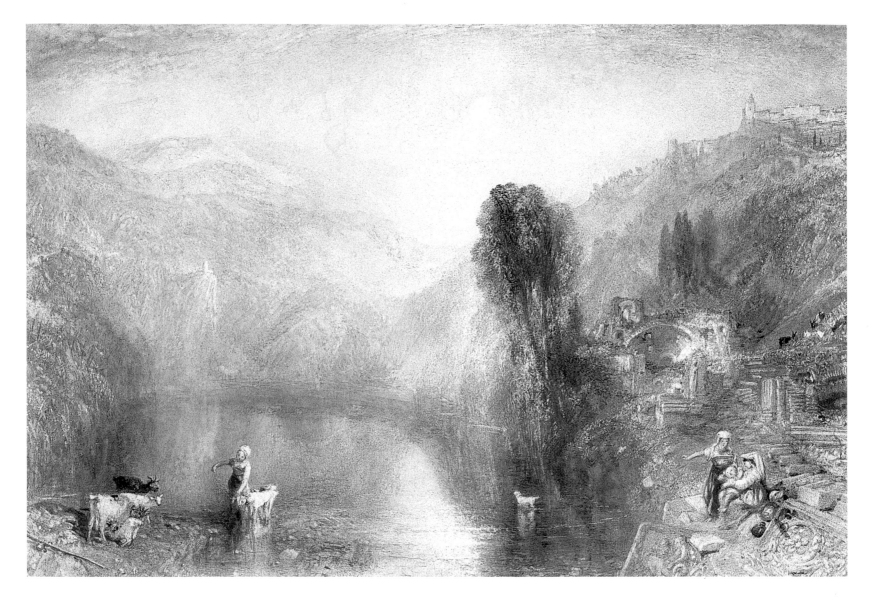

Colour Plate 40. *Lake Nemi, c.* 1840 (W, 1381), watercolour with scraping out, $13\frac{5}{8} \times 20\frac{1}{4}$ in., British Museum, London (Lloyd Bequest)

Piazza del Popolo, with St Peter's seen on the horizon (Plates 175 and 176). In both scenes, the time illustrated is that of the artist himself: the Forum is ruined and desolate, Piazza del Popolo is alive with the revels of the Carnival. Each place is shown just as it might have been described in a contemporary travel book.[39] The rationale behind Turner's pairs of paintings, however, was very different. Whatever else Turner may have picked up from Eustace, he did not copy his system of categorising ancient and modern. While the 'ancient' scenes of 1838 and 1839 depicted the classical city reconstructed, the 'modern' scenes took two pieces of quintessentially classic ground, the Roman Campagna and the Roman Forum, but showed them as they appeared in the artist's own times. In other words, Turner did, after all, use 'ancient' and 'modern' not in the guidebook way but in the poetical way used by Thomson. 'Ancient' meant 'as it was in the heyday of antiquity', 'modern' meant 'as it is today'.

Despite this common approach, however, Turner and Thomson focused on totally different images of Italy and periods of Roman history and they saw the contrast between past and present very differently. Thomson drew a sharp antithesis between an impossibly idealised Roman republic, ruled by the highest standards of virtue, and a thoroughly degraded and debased present. Turner depicted much less of a contrast. He took the Roman empire rather than the republic and showed that, although magnificent visually, it was a place rife with immorality, jealousy, corruption and villainy. Royal Academy visitors would have been well aware that Ovid was banished by the Emperor Augustus because of his love poetry and for an indiscretion which Augustus took as a personal affront. They

184

175. Samuel Palmer, *Ancient Rome*, 1838, watercolour on buff paper over pencil, 15¼ × 22¼ in., City of Birmingham Art Gallery

176. Samuel Palmer, *Modern Rome*, 1838, watercolour on buff paper over pencil, with bodycolour, 15¼ × 22¼ in., City of Birmingham Art Gallery

would also have known that Germanicus died mysteriously on a mission to the East and was probably poisoned on the instructions of his uncle the Emperor Tiberius. Meanwhile, Turner's modern scenes are a long way from Thomson's 'putrid fens', 'noxious glebe' and 'dejected towns,/Where, mean, and sordid, life can scarce subsist.' On the contrary, present-day Italy and Rome, though in ruins, are shown as still very beautiful. The Forum may now be a cow pasture, as Turner's title makes clear, rather than the heart of the western world, but it hardly corresponds to Thomson's description of Rome:

> Beneath the baleful blast the city pines,
> Or sinks enfeebled, or infected burns.

The luxuriance of *The Pifferari* could not be further from Thomson's view of the Campagna:

> 'Tis all one desert, desolate, and gray,
> Graz'd by the sullen buffalo alone . . .[40]

Turner's basic idea of contrasting Rome or Italy, as it once had been, with Rome or Italy, as it now appeared, was close to the conception of Thomson's poem, but neither the content of his paintings nor the contrasts which they draw is the same as Thomson's. The reasons for this are clear enough: Turner had, by the 1830s, taken stock of attitudes which conflicted with the Thomsonian ones. First was the Byronic realisation that the glorious past had also possessed a not-so-glorious side and, conversely, that there was a beauty of its own in the decayed, the ruined and the overgrown. Second was the concept, very prevalent in the early nineteenth century, of the essential unity and continuity between ancient and modern Italy.

The idea that many features in modern Italian life could be traced back to the ancient world received extended treatment in a book owned by Turner which has already been mentioned in earlier chapters, the Rev. J. J. Blunt's *Vestiges of Ancient Manners and Customs, discoverable in Modern Italy and Sicily* (1823), which covered subjects as diverse as religion and food, clothes and agriculture. It was this book that led to Turner depicting Ovid and the *pifferari* in his 'ancient' and 'modern' scenes of 1838, not through any direct comparison which Blunt makes, but through references which were fortuitously adjacent.[41] Blunt compared the modern practice of the *pifferari*, the bagpipers from southern Italy who played before the roadside images of the Madonna, with the ancient custom of decorating, singing and playing music on the pipes to images of the gods. For the Roman custom he cited three passages from Ovid's *Fasti* and *Epistles*. A few pages later, he discussed the ancient use of images of the gods for the protection of shipping and quoted lines from Ovid's *Tristia* about 'the foul weather which he encountered on the voyage to the place of his exile'.[42] These references connect very neatly with Turner's two paintings, but they fail to provide a convincing thematic link between them. Although Blunt drew an analogy between ancient and modern Italian superstitions, this is not related to Ovid's banishment itself, either in the book or in historical fact. Nor are there any overt references to superstition in Turner's painting of Ovid. The most satisfactory explanation of the subject matter of *Ovid banished* and *The Pifferari*, both as individual paintings and as a pair, is a straightforward one, based on what Turner himself wrote and painted. *Ovid banished* illustrates the sun setting upon a rich, repressive and corrupt pagan culture, while *The Pifferari* relates to the birth of a simple, more natural and uncorrupted Christian society on the same soil, a society in which, as Henry Sass had put it, the members 'really seem to be what we should always be, like brothers and sisters'.[43] Practically all the figures Turner depicts in *The Pifferari* are engaged in pious activities and 1838 visitors to the Royal Academy would have known that the *pifferari* themselves only came into the Roman Campagna (and thence into Rome) around Christmas time: their purpose in piping to the images of the Madonna was to ease her labour pains. When Turner's picture was being engraved in the early 1840s he suggested in a letter to William Miller the engraver that in the foreground 'perhaps a child wrapped up in swaddling clothes . . . would increase the

sentiment [?] of the whole', and he marked some foliage in the bottom left-hand corner of an engraver's proof with the instruction 'Make this into a Bird's nest with Eggs.'[44] Both these proposals regarding foreground details were implemented and both make it clear that Turner wanted the engraving to convey, very conspicuously, the idea of new life. The painting itself embodies this idea in its depiction of a radiantly blue and gold spring morning.

The subject of the *pifferari* had been painted by several British artists shortly before Turner, including William Brockedon, Thomas Uwins and David Wilkie.[45] All these paintings reflect the interest in scenes from modern Italian life which had begun during the 1820s among artists such as Eastlake, Callcott, Joseph Severn and Penry Williams and was flourishing in the 1830s.[46] This development has been mentioned in previous chapters where it has been shown to have influenced some of Turner's paintings in the 1820s. It is, of course, unnecessary to suppose that Turner needed his colleagues' example to draw his attention to the possibilities of everyday subject matter. His fascination with such things is evident in countless works throughout his career, whether sketches or finished pictures. His sketchbooks of 1819 show his constant interest in many aspects of Italian life, and he undoubtedly saw (and heard) the *pifferari* for himself when he spent the Christmas of 1828 in Rome.[47] Thus, while it is important to relate *The Pifferari* to the current interests of Turner's contemporaries, the influence of such trends should not be over-emphasised. In the 1830s Turner had many other concerns beside genre, some of which divided him sharply from his colleagues. In 1832 the *Library of the Fine Arts* declared that 'the heroes of antiquity and their virtues are now quite out of date' (a statement which is fully borne out by the Royal Academy catalogues of the 1830s) and it recommended leaving the depiction of Roman history to the French.[48] This advice must have encouraged all the British painters who were busily producing Italian genre scenes, but it did not touch Turner at all. He was occasionally ready to vie with his contemporaries in producing modern scenes but, as the paintings discussed earlier in this chapter demonstrate, he was really far more concerned to pursue his own interests within the traditional field of historical landscape.

If Turner's continuing fondness for classical antiquity distinguished him from his fellow artists in the 1830s, there was one taste which he did share with them, an interest in the poetry of Byron and Samuel Rogers. Turner's paintings reveal a sympathy with Byron as early as 1816, and his friendship with Rogers began about ten years later. The strengthening of his interest in their work during the 1830s was entirely characteristic. What was new was that whereas previously very few other artists had been keen to illustrate these poets, many now began to do so.

The celebrated 1830 edition of Rogers's *Italy* illustrated by Stothard and Turner led the way for cheaper editions with engravings after other contemporary artists. From the 1830s to the 1850s one of the publishers of the 1830 edition, Edward Moxon, issued a small edition with woodcut vignettes not only after Stothard but also after works by other colleagues of Turner. There were landscapes by Callcott, shepherds and *contadine* by Eastlake, animals by Landseer and genre scenes by Thomas Uwins, all very typical products of their times and closely related to the romanticised Italian genre pictures that most of these artists were currently painting in oils.[49] The other development was that paintings based on Rogers's *Italy*, and accompanied by quotations, immediately started appearing at the Royal Academy. Their creators included Richard Westall, Henry Howard, Edward Corbould, William Collins and J. R. Herbert.[50] Sometimes the artists took subjects already illustrated by Stothard or Turner, sometimes they found new subjects of their own, but their interest in illustrating Rogers's *Italy* at all was obviously aroused by the popular — and commercial — success of the 1830 edition.

The corresponding catalyst for Byron illustrations was the poet's death in 1824. Before this date few illustrated editions of his work were published or planned, and few paintings with subjects from his verses were exhibited at the Royal Academy, though Turner himself was active in both these spheres. But Byron's death changed everything. His readers were stunned — many felt as if the moon or the sun had left the heavens — and there was a

tremendous upsurge of public interest in everything to do with him. Illustrated editions of his life, poetry and letters were published, and a large number of artists, including Turner, Samuel Prout, David Roberts, J. D. Harding, A. W. Callcott, Clarkson Stanfield, Copley Fielding and Richard and William Westall, were involved in illustrating them.[51] At the same time, many painters, including Turner, Eastlake, John Martin and William Collins but mostly men of lesser stature, exhibited subjects from Byron at the Royal Academy.[52] Curiously, Turner seems to have been the only artist to make a major contribution simultaneously in both these areas, illustrating Byron not only on commission from publishers but also for his own pleasure — a fact which underlines yet again his undoubted sympathy with many of the poet's sentiments.[53]

The relationship between Turner's literary illustrations and those of other artists is a huge topic which extends far beyond the scope of this book. However, it is relevant to note two points: first, that Turner's basic interest in Rogers's *Italy* and Byron's *Childe Harold's Pilgrimage* canto IV was very much in accord with the taste of other artists in the 1830s; and, second, that his actual paintings were utterly different from theirs. *Childe Harold* was the most illustrated of all Byron's poems between 1815 and 1840, canto IV on Italy being a clear favourite. The lines which Turner chose to accompany not only *Modern Rome — Campo Vaccino* in 1839 but also *Approach to Venice* in 1844 — 'The moon is up and yet it is not night/The sun as yet divides the day with her' — were an adaptation of lines which had been picked out as a good accompaniment to a painting very soon after they were published. By the time that Turner first used them, they had already accompanied three paintings by other artists at the Royal Academy.[54] Unlike Turner, however, these painters had simply used the lines to accompany twilight scenes which were not necessarily connected with either Byron or Italy. They had felt their beauty without going to their heart, while Turner truly shared Byron's feelings towards Rome and Venice, poised between glory and desolation as between day and night. A further difference between Turner's appreciation of Byron and that of other painters is this. The others who exhibited *Childe Harold* themes were content to illustrate particular places or people — the falls of Terni, or Venice, or Childe Harold and his page. Turner's vision was larger. In 1832 he sought to encapsulate the message of canto IV in a single painting depicting an epitome of Italy and taking as his text not a description of a specific place but Byron's salutation to Italy as a whole: 'and now, fair Italy!/Thou art the garden of the world', already quoted in Chapter 1 of this book. Turner's self-imposed role as a sympathetic interpreter of Byron's emotions was far removed from that of the illustrators.

* * * *

Turner's 1830s paintings of Italy received a strong measure of criticism from his contemporaries. The most famous of all these attacks must be that which was published in *Blackwood's Magazine* in 1836, the year that *Juliet and her Nurse, Mercury and Argus* and *Rome, from Mount Aventine* were exhibited at the Royal Academy.[55] The reviewer, now known to have been the Rev. John Eagles, directed most of his insults at *Juliet and her Nurse*, but the other two paintings were also harshly criticised. *Rome, from Mount Aventine* was described as 'a most unpleasant mixture, whereupon white, gamboge and raw sienna are, with childish execution, daubed together'. Eagles's review is chiefly remembered today, however, not for its own content, but because it stung the 17-year-old Ruskin into writing a reply in Turner's defence: initially, a letter to *Blackwood's Magazine*, which Turner advised him against publishing; in the longer run, the five volumes of *Modern Painters* (1843-60).

Although Ruskin's defence of Turner was stimulated by criticisms of three paintings with Italian subject matter, he was later to claim that Turner rarely caught the 'true spirit' of Italy in his paintings, and he dismissed several of the history paintings — *Regulus, Caligula's Palace and Bridge, Ovid banished* and *Cicero at his Villa* — as 'nonsense pictures': 'preposterous accumulations' without any 'wholesome feeling' and 'the worst possible examples of Turner's colour'.[56] The spectator may perhaps sympathise with

188

Ruskin. The meaning of these paintings is often complex or elusive, as this chapter has indicated, and their colour is not always attractive. However, in judging Ruskin's criticisms of Turner, it is necessary to be aware of Ruskin's own attitude towards Italy and the ancient world. His antipathy towards classical architecture (much to the fore in these paintings) is well known. What may perhaps be less familiar is that this distaste extended to antiquity as a whole. In *Praeterita* he recalls how both as a boy and at Oxford he was thoroughly bored by the classics in which he 'neither felt, nor foresaw, the least good'. He acquired from his education the scantiest possible knowledge of Greece and Rome, a situation of which he seems almost to have been proud. He had, he said, 'nominally read the whole Æneid, but thought most of it nonsense'. Describing his first visit to Rome in 1840 he later wrote, 'I had no distinct idea of what the Forum was or ever had been. . . . What the Forum or Capitol had been, I did not in the least care.'[57] Ruskin's attitudes had been formed, as he himself expressed it, by 'Protestantism and . . . Proutism' and were not unique. There must have been a number of early nineteenth-century British visitors to Italy who were hampered, like Dorothea Casaubon in *Middlemarch*, by having been 'brought up in English . . . Puritanism, fed on meagre Protestant histories and on art chiefly of the hand-screen sort'.[58] What matters here, however, is that Ruskin's outlook could not have been more different from that of the self-educated but passionately interested Turner. Indeed, it is questionable whether Ruskin himself was in a position to recognise the 'true spirit' of Italy which he thought had eluded Turner. The gulf between them might have prevented a lesser man from appreciating Turner's Italian paintings at all. However, Turner's pictures seem to have made Ruskin overcome some of his dislike of the classical world and, despite the disparagement quoted above, he was often able to find both beauty and meaning in Turner's landscapes of Italy. His pleasure in *Mercury and Argus* called forth some of his finest writing about Turner, and it is impossible to improve on his poetical exposition of the message of *The Bay of Baiae*.[59] What is more, he was the first person to see the importance for Turner's art of his first experiences of Italy in 1819. In his *Notes on the Turner Gallery at Marlborough House* of 1857 he analysed Turner's career into four periods. It was during the second period, beginning in 1820, that, for Ruskin, Turner's maturity commenced: colour took the place of grey, refinement the place of force, quantity the place of mass.[60] Here he conceded the principle that the greater daring involved in Turner's paintings of the second period led to a higher probability of errors and failure. His discussions of individual pictures in *Modern Painters* show what he regarded as the successes and the failures: on the one hand, *Mercury and Argus*, with its wonderfully coloured sky and mysteriously abundant distance; on the other, the 'preposterous accumulations' and bad colouring of *Ovid banished* and others.

According to Ruskin's analysis in *Notes on the Turner Gallery*, the painter's middle years also saw him freeing himself from the influence of the artists whom he had imitated in his youth, and in *Modern Painters* he sought to demonstrate systematically Turner's superiority over all other artists, including the Old Masters. No one today would find it necessary to denigrate other painters, such as Claude, in order to demonstrate Turner's genius, as Ruskin did, and it is generally recognised that complex relationships existed between Turner's art and the art of the past right through his career. These relationships can be studied in many ways — by taking different periods of Turner's life, or different Old Masters, or the different types of subject matter which he painted. This chapter has shown that Turner's Italian paintings of the 1830s not only take past and present as a recurring theme but are in themselves a continuation of Turner's dialogue with the art of the past where Italy was concerned. This dual nature is hardly surprising in view of Turner's experiences of Italy. In 1819 and 1828 he had been surrounded by layer upon layer of the past: every ancient building and monument recalled the events and personalities of history; the most famous ruins and beauty spots not only spoke to him of antiquity but reminded him of artists whom he admired. He would have wanted his own paintings of Italy to be seen as part of a living tradition.

Epilogue

TURNER AND THE SOUTH

Turner loved Italy as only a northerner can. The story behind this book is, in a sense, that of any love affair: anticipation, realisation, recollection. As a young man in the 1790s, Turner had wept with frustration at his inability to paint like Claude, but he had begun to form his own vision of Italy in the countless evenings at Dr Monro's when he was breathing colour into Girtin's pencil drawings after J. R. Cozens. As a middle-aged man in 1819, he made his own way to Rome, alone, and gave Italy his undivided attention for months at a stretch. As an elderly man in the 1830s, his thoughts were still with Rome and the south, and in his mind he fused his memories with his other intellectual concerns and, above all, his imagination.

Turner was far from being alone among the Romantic generation in treating Italy in this way. His behaviour has a parallel in that of Stendhal who was eight years his junior. Just as a painting like *Forum Romanum* proves, on close inspection, to be much more than a topographical work, so also Stendhal's two narratives, *Promenades dans Rome* (1829) and *Rome, Naples et Florence* (1817/1826) are not the factual accounts they might, at first sight, appear. They are fictions, based on experience. They served to re-create the Italy that Stendhal loved and they enabled him to express his feelings about many aspects of that country — its government, its music, its way of life. But few artists work in a vacuum. If Stendhal and Turner shared many of the same experiences during their months in Italy, they shared them, too, with hundreds of their compatriots. They crystallised and re-created their experiences in their published or exhibited work not only for their own pleasure but in the knowledge that a large section of their public had enjoyed the same views as themselves, attended the same operas, admired the same works of art.

If Turner's experiences in Italy were very typical of the age in which he lived, his changing responses to it provide, as was noted in Chapter 1, a microcosm of his own career. Since his early artistic training was as a topographical draughtsman, his main concern on his first visit to Italy was to fill his sketchbooks with topographical data. He wanted to make his own record of all the famous places. Even the way in which he used the pages of his 1819 sketchbooks reflects his early years. His favourite size of small pocket-sketchbook in 1819 opened to provide a drawing area of $4\frac{1}{2}$ by 15 inches, a horizontal spread comparable to that employed in the books of engraved views that were current in Turner's youth — books such as *Buck's Perspective Views* of 1774. However, as time went on, he grew less and less interested in amassing topographical data and translating it into paintings; his imagination soared higher and higher. A comparison between, say, *Rome, from Monte Mario* (1820) and *Ancient Rome; Agrippina landing with the Ashes of Germanicus* of 1839 (Plates 112 and 173) speaks for itself. When he had to produce his vignettes for Rogers's *Italy* in the late 1820s, his depictions of the famous sights of Rome are conspicuously more imaginative than his watercolours of the same subjects of about ten years earlier (compare Plates 14 and 141). In 1828 he spent most of his time in Rome not sketching but painting in a studio. He thought about the relationship of the past and the present, about Claude and Titian, about stirring moments in Roman history and classical mythology. All these subjects were already dear to him and were to continue to occupy his thoughts for the rest of his life. But his second, and more convivial, visit to Rome strengthened his interests and provided new fuel for his imagination.

In his *Notes on the Turner Gallery at Marlborough House* of 1857 Ruskin provided a masterly analysis of the development of Turner's style over his career as a whole. He particularly emphasised the degree to which Turner's means of expression changed in 1820 and he rightly pointed to the new importance in Turner's paintings thereafter of colour, refinement and abundance. Since Ruskin's day there has been a general recognition that Turner's 1819 visit to Italy played a crucial role in his development as an artist, a recognition which has been accompanied by the widespread feeling that Turner's first visit to Italy disoriented him, that he initially found it very difficult to paint Italy. The question to be asked is: why? This is a question that cannot be answered without reference both to Turner's work as a whole up to the year 1819 and to some of the characteristics of the period in which he lived. The clue lies in the fact that the year 1819 witnessed not only Turner's first visit to Italy but also the appearance of the last two published parts of his *Liber Studiorum*. These two events — Turner's first experience of Italy and the demise of the *Liber* — are far more closely related than is generally realised.

Turner began work on his *Liber Studiorum* in 1806-7 and in June 1807 he issued the first of its fourteen published parts. His inspiration was the series of plates published in 1777 by John Boydell of Richard Earlom's engravings after Claude's *Liber Veritatis* and characteristically he sought to emulate all three of these men simultaneously. He acted as draughtsman and publisher, and frequently as engraver as well. He echoed Claude's title, he copied Earlom's medium (etching and mezzotint) and he intended to follow Boydell's number of plates. There were, however, some important differences between the two publications. In the first place, Claude's *Liber Veritatis* is a book of drawings of paintings already executed. Turner's *Liber Studiorum* was not conceived as a record of previously executed paintings: he frequently produced his designs, or studies, expressly for the publication itself. Second, Claude's book served both to record and to authenticate his paintings and its arrangement is chronological. Turner's book was intended as a public demonstration of his versatile powers and he labelled and distinguished his scenes by subject categories. Most of these were familiar and established genres — Marine, Mountainous, Pastoral, Architectural and Historical; but there was also Turner's own invented category, 'E.P.' (probably 'Elevated Pastoral') which corresponded to what Turner found in the landscapes of Claude himself. Turner's desire to categorise was the direct product of the era in which he was born. Taxonomies and codifications surrounded him on all sides — in the arts, literature and government. One has only to think of Dr Johnson's *Dictionary*, Diderot's *Encyclopédie* or the systems of Alexander Cozens. It was inevitable — given Turner's circumstances and his character — that he should analyse and rationalise his own art in just such a manner as he did.

In Turner's oil paintings up to 1819, there is the same sense of order and system. It is instantly clear that one work is a marine, the next a history painting. A work may take a specific mountain or shipwreck for its subject in order to make a broader statement about mountains or shipwrecks in general — but the painting itself remains in a clearly recognisable subject category. There are, of course, a few obvious exceptions, the most outstanding being *Snow Storm: Hannibal and his Army crossing the Alps* of 1812. These more complex pictures were nearly always sparked off by major events: Turner's own first visit to Switzerland, the war against Napoleon.

With Turner's visit to Italy in 1819 this easy classification comes abruptly to an end. None of Turner's earlier clear-cut categories is right for the three great Italian paintings of 1820-6. *Rome, from the Vatican* pays tribute to Raphael but it is hardly a history painting by eighteenth-century standards; Turner builds on his topographical training in order to recreate the famous sights enjoyed by every contemporary tourist in Rome. *The Bay of Baiae* has its roots in the classical landscapes of Claude, but it is by no means a simple piece of 'Elevated Pastoral'; it represents, recreates and reflects the Baiae of modern tourists. *Forum Romanum* is not a straightforwardly 'architectural' painting; it takes one of the most famous pieces of classic ground, rich in history, meaning and allusion, and, again, presents the scene through the eyes of the tourist. The thought of Italy's great past did not

inspire Turner to paint heroic history paintings, as it had inspired many of his predecessors. The picturesqueness of modern Italy did not divert him into pure genre, as it did many of his contemporaries and successors. Instead, the visible fusion of past and present in Italy, and that sense of continuity which was so much remarked upon by his contemporaries, led him to fuse past and present in his own paintings, as has been seen on many occasions in this book. It led him to mingle his subjects, to create new genres of his own. From 1820 onwards the subjects of his oil paintings become harder and harder to classify. It is no wonder that contemporary critics complained endlessly that they did not know what Turner's paintings were about: they were used to paintings falling into clearly defined genres. They knew what qualities to look for in a history painting or a marine or a topographical scene — but they did not know how to judge a painting that belonged to no known category.

Turner's later paintings became more and more complex. In terms of the pigments on the canvas they became far richer and they were equally rich in meaning. The event which opened the gates for this development was Turner's visit to Italy in 1819. His first direct experience of Italy made it abundantly clear to him that the traditional academic categories and hierarchies were narrow, meaningless and irrelevant and thus classic ground itself unleashed the full power of his Romanticism. The only casualty in this story was the *Liber Studiorum*, which Turner abandoned in the early 1820s. By now his thinking about his own art had undergone radical changes and he simply could not return to the old and worn-out categories, a systematisation that was hollow.

Turner's rejection of traditional ways of thinking is a clear demonstration of the same intellect that led him to paint the complex oil paintings discussed in this book. Time and time again, the discussion has centred not upon what a painting is 'of', but what it is 'about', and it is no accident that the names of many of the greatest writers and thinkers of the age should have been invoked at several points in the discussion of Turner's Italy: Goethe and Stendhal, Byron, Shelley and Hazlitt. The Rev. J. C. Eustace and the Rev. J. J. Blunt may today seem remote and shadowy figures in comparison to these giants, but in their own day they were forces to be reckoned with: Eustace influenced the thinking of thousands of Britons who visited Italy, Blunt crowned a distinguished academic career as Lady Margaret Professor of Divinity in the University of Cambridge. Turner used paint rather than words to express himself, but his intellectual powers were of a stature equal to those of his greatest contemporaries. If he was, in truth, disconcerted by his first experience of Italy, this is in itself a measure of his intelligence; it is only the insensitive, narrow-minded and unintelligent visitor to Rome that is not simultaneously overwhelmed, elated and depressed by his experiences. At the end of each day there, any thoughtful and sensitive visitor must surely feel, 'Too much for months, let alone for a single day. . . . Rome is a world, and it would take years to become a true citizen of it. How lucky those travellers are who take one look and leave.'[1]

But Turner rose to the challenge of Italy. He tackled the most crucial question of all, the one that constantly occupied people's thoughts, the relationship between the ancient and the modern worlds, and he returned to the theme again and again, exploring every aspect of his subject so that there is never any sense of repetition. In Turner's paintings of ancient and modern Italy, the sun rises and sets; magnificent buildings are constructed, stand proudly and crumble into ruin; the cycle of the seasons revolves through a bright spring morning, the luxuriance of summer, an endless autumn; the great figures of the past have their heyday and their downfall, while the humbly born Italians of the present day carelessly enjoy their unparalleled heritage. They are without aspirations, they have no burden of wealth or power, ambition, destiny or responsibility; they have merely inherited 'the garden of the world'. Side by side with this grand theme, Turner focused on individual buildings and places, always stressing their single most important characteristic. His Colosseum, bursting out of its picture space (Plate 118), is the perfect embodiment of the sentiment that 'It is so huge that the mind cannot retain its image'; *The Bay of Baiae* (Colour Plate 20) encapsulates the essence of southern Italy: 'treacherous ground under a

pure sky; ruins of unimaginable luxury, abominable and sad; . . . but then, luxuriant vegetation, taking root wherever it can, soars up out of all the dead matter'. Sensibility and intellect went hand in hand, as when he instinctively reached for watercolour in 'that paradise of Nature', Naples, but for bodycolour among 'the solemnities of Rome'. Had Turner put his thoughts into words, he might easily have written any of the above phrases or, indeed, any of the following:

> everything I have known for so long through paintings, drawings, etchings, woodcuts, plaster casts and cork models is now assembled before me. Wherever I walk, I come upon familiar objects in an unfamiliar world; everything is just as I imagined it, yet everything is new. It is the same with my observations and ideas. I have not had a single idea which was entirely new or surprising, but my old ideas have become so much more firm, vital and coherent that they could be called new.

> [The famous paintings of Rome] are like friends with whom one has long been acquainted through correspondence and now sees face to face for the first time.

> During the day a haze hovers over the earth like that I know from the drawings and paintings of Claude Lorrain, but this phenomenon cannot easily be seen in Nature more beautifully than here. . . . I visited the . . . Gallery, where paintings by Poussin, Claude Lorrain and Salvator Rosa are hung side by side. . . . What one needs to do is to look at them and then immediately look at Nature to learn what they saw in her and in one way or another imitated; then the mind is cleared of misconceptions, and in the end one arrives at a true vision of the relation between Nature and Art.

> [Tivoli] is one of those experiences which permanently enrich one's life.

> It is history, above all, that one reads quite differently here [Rome] from anywhere else in the world. Everywhere else one starts from the outside and works inward; here it seems to be the other way around. All history is encamped about us and all history sets forth again from us.

Among the countless books that have been written about the experience of visiting Italy, there is none more profound than Goethe's *Italian Journey*, the fruit of a journey made in 1786-8, at the age of thirty-seven, and the meditations of the following three or four decades. It is only against such a book, from which all the foregoing quotations have been taken, that Turner's intellectual reaction to Italy can be measured. In their breadth of vision, their seizure of essential truths, their sensitivity and their searching approach towards everything they saw in Italy, Goethe and Turner are certainly equals.[2]

Turner's depictions of Italy itself grew freer, more complex and more personal as time went on; so too did his tributes to the art of the Renaissance. His 1803-5 *Venus and Adonis* (Plate 177) shows his deep admiration for the three Titian paintings about which he spoke so eloquently in his 'Backgrounds' lecture of 1811: the celebrated *Death of St Peter Martyr*, which he had studied intensively in Paris in 1802, and two works he had seen in private collections in England, *Diana and Actaeon* and *Venus and Cupid with a Lute-player*.[3] His unfinished *Reclining Venus*, painted in Rome in 1828 (Plate 178), reflects his recent analysis and enjoyment of the *Venus of Urbino* as he passed through Florence. But when Turner came to paint his *Bacchus and Ariadne* in 1840, under the inspiration of Titian's *Bacchus and Ariadne* which had been bought by the newly formed National Gallery in 1826, his response was altogether different and far more personal (Plate 179). Gone is the joyous mood of Titian's painting, and in its place Turner shows chaos and fear, pursuit and flight. The Bacchic procession does not totter happily from right to left as in the Titian, it tumbles clumsily down the hillside. Ariadne no longer gazes into Bacchus' eyes, as enchanted with him as he so obviously is with her. She flees away from him. For Turner, Ariadne was a tragic heroine, a sister-in-suffering to Dido abandoned by Aeneas, to Medea abandoned by Jason. Turner's Ariadne has been courted, used and then foresaken by Theseus in circumstances very similar to those in which Medea was courted, used and then cast off by Jason; and she now foresees the whole thing happening all over again with her

177. *Venus and Adonis*, 1803-5 (B & J, 150), oil on canvas, 59 × 47 in., private collection

new suitor, Bacchus. Turner gives Ariadne, not Bacchus, the centre of the stage and he makes her look straight at the spectator with a desperate appeal for help.

Turner's own art looks both backwards and forwards. This book has stressed his reverence for antiquity, his love of the paintings of Claude and Wilson, the lessons he learnt from Piranesi, his study of the art of the Renaissance. At the same time, however, Turner's paintings themselves were technically extremely innovatory, as can be seen most clearly in the illustrations in Chapter 10 (or, better still, those paintings themselves). Some contemporary critics responded to the poetical qualities of Turner's Italian paintings of the 1830s, openly revelled in their beauty and praised their truth to nature; but many others complained violently about how far away from nature the paintings had gone. Their colour was described as artificial, meretricious, inharmonious and fatiguing to the eye; their execution was seen as so slapdash and childish that exhibited works were no more than 'spoiled canvasses upon which a painter had been trying out the primative [sic] colours'.[4] In 1831 the *Tatler* ran a series of articles, probably written by Leigh Hunt, which suggested

that Turner was suffering from a disease of the eyes.[5] The reactions of these critics are quite understandable. Nothing could be more artificial, not to say mannered, than the lone and slender pine tree soaring into the sky in *Rome, from Mount Aventine*. No colours could have been further from the customary representation of architecture than the rococo tints of *Campo Vaccino*, with its mauve, red and green Arch of Severus and its lime-green and mauve church of S. Luca e S. Martina. Nothing could be more startlingly light and bright than *The Pifferari* when seen in a room of Old Master paintings. Well might Constable talk of 'tinted steam' in 1836 or *Blackwood's Magazine* complain in 1840 that it had difficulty in making out what was happening in *Neapolitan Fisher-Girls*.[6] Turner's 1830s paintings of Italy grew out of his love and respect for earlier artists, but they also demonstrate, equally strongly, that his deep-seated attachment to tradition was never incompatible with his search for technical advance and personal expression.

Artists respond in a variety of ways to the achievements of earlier generations and Turner's response was, characteristically, complicated. He despaired of equalling his heroes, but he never admired without analysing; he copied, he imitated, he attempted to outclass. He was, from first to last, ambitious. One of the reasons why his Italian oil paintings are not among most people's favourite Turner pictures is perhaps just this — that they are too ambitious, too complex, to be easily accessible. It is one of the ironies of Turner's posthumous career that, in his oeuvre as a whole, it is generally the smaller works and the freest sketches that have won people's hearts; there is only limited appreciation for

178. *Reclining Venus*, 1828 (B & J, 296), oil on canvas, 69 × 98 in., Tate Gallery, London

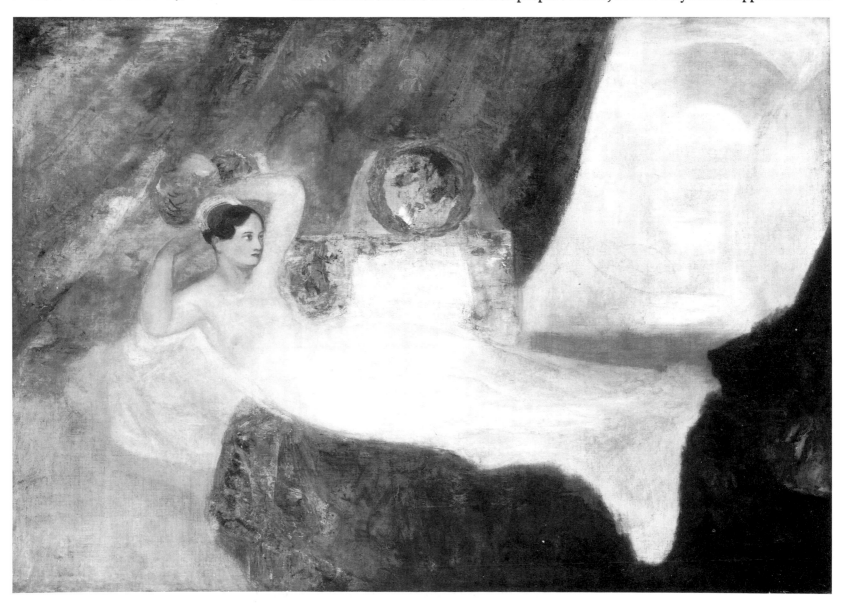

the more complex paintings and the monumental exhibition pieces like *Rome, from the Vatican* and the *Vision of Medea*. Ruskin found it impossible either to like or to understand *Regulus, Cicero at his Villa* and *Ovid banished*, though he was devoted to the vignettes for Rogers's *Italy*. He admired the Turner who embodied 'truth to nature', the Turner who caught what he himself felt to be 'the true spirit of Italy', and most people today would share his views.

There is an appealing simplicity in Ruskin's phrases, but Turner's own attitude to 'nature', the real world, was far from straightforward. His Italian experiences and paintings are not, of course, unique in showing his power to transform and surpass what he had actually seen, in order to reach a more fundamental 'truth to nature', but they do so very well. Again and again on his 1819 tour, he was concerned with recording the sites he visited as precisely as possible. When studying a modern building, he would count its bays or windows; when sketching an ancient building he would make separate careful studies of its capitals, bases and friezes. But these records were only the raw material of his art, a starting point for his imagination. Often he began developing his material almost instantly, for even when he was merely applying washes of watercolour over a pencil sketch he might ignore the pencil lines, changing or adapting the ingredients of his scene. Back home in his studio, he could be bolder still. In *Rome, from the Vatican* he amalgamated sketches from different viewpoints on Raphael's loggia to display simultaneously both the riches within and those without. In *Childe Harold's Pilgrimage — Italy* he employed a whole host of motifs from far and wide to portray an archetypal Italy. When Turner was constructing a painting, he would use the memoranda in his sketchbooks to help him realise what his

179. *Bacchus and Ariadne,* 1840 (B & J, 382), oil on canvas, 31 × 31 in., Tate Gallery, London

imagination demanded for that painting. He took as much or as little of his data as he needed, and he transformed it to suit his present purposes. Sometimes the results can be a little disconcerting, as in his vignette for Rogers's *Italy* in which the Temple of Neptune at Paestum ceases to be an atypical Greek temple and becomes a typical Roman one (Plate 85). Here, however, Turner is not concerned with the niceties of archaeological exactitude but with a far grander theme, that of ancient temples standing firm amid wind and storm. It was not the precise number of columns on the temple that mattered to him — it was the fact that the building had withstood the perils of more than two thousand years.

Through Turner's Italian sketches and paintings one can almost see the final work of art developing under his very hand. When Turner decided to paint *Cicero at his Villa* (Plate 163), ten years after his second visit to central Italy, he must have begun by looking at his *Albano, Nemi, Rome* sketchbook — in order to refresh his memory of the Alban hills or perhaps to glance again at his notes and sketches relating to Wilson. There he found a rough landscape sketch which he then took as the general basis of his composition. But in skimming through the sketchbook he also came upon other reminders of his 1819 tour as well, such as his Roman sketch of the statue of Apollo seated beneath a tall pine tree (Plate 42); some of these, too, found their way into *Cicero at his Villa.*

One can envisage a very different scenario for the creation of *Campo Vaccino* (Plate 174), exhibited in the same year as *Cicero at his Villa.* Turner probably painted the broad essentials of its composition from memory. He must then have consulted his 1819 sketches of the Forum in order to tackle the details and to show the articulation of the individual buildings (note the similarities and differences between the painting and the sketches in Plates 48, 49 and 53). *The Arch of Constantine* (Colour Plate 39) shows exactly the same working process but it was abandoned in midstream. The painting reaches out towards the idea of the arch which Turner wished to convey but it is, architecturally speaking, undeveloped. Had Turner taken it any further, he would have had to consult his 1819 sketches (e.g. Plate 40), but his attention was diverted elsewhere and he did not do so.

The unfinished and unexhibited *Arch of Constantine* and *Tivoli: Tobias and the Angel* (Colour Plate 38) certainly belong to the 1830s, though it is hard to date them precisely within that decade, and it is equally certain that Turner intended them as a pair. Their dimensions are identical and, what is more, they share those dimensions with the two pairs of 'ancient' and 'modern' paintings that Turner did complete in the 1830s and exhibited in 1838 and 1839. Turner must have started thinking about exhibiting such a pair of ancient/ modern Rome or Italy paintings fairly soon after his 1828-9 visit to Rome, but could not bring the project to fruition until nearly ten years later. One may speculate endlessly about the possible intended meanings of *Tivoli: Tobias and the Angel* and *The Arch of Constantine.* Do they form a pair of their own, or did Turner experiment at different times in the 1830s with various pairings within the overall group of six? If they are — and always have been — a pair of their own, was Turner matching an Old Testament subject[7] with a New Testament one? It is worth noting the ghost-like central figure, clad in white, in *The Arch of Constantine*, the Roman sarcophagus at bottom left and the crouching or sleeping figures, also on the left. Is this, perhaps, a Resurrection scene, using as its background the Arch of Constantine which commemorates Constantine's victory over Maxentius after he had been converted to Christianity by the vision of the flaming Cross? There is much in the story of Tobias and the Angel to make it an appropriate companion to a painting related to Christ and the Resurrection: its focus on a father and a son and the salvation brought by the latter; the mediating part played by the archangel; the miraculous role of the fish (one of the most common later symbols for Christ). These ideas are no more complex than many of the ideas now generally accepted as lying behind Turner's other, more famous, paintings, but they are — admittedly — uncharacteristic in their theme: although Turner's interest in Roman Catholicism is apparent in many of the paintings discussed in this book — *Rome, from the Vatican, Forum Romanum, Lake Albano, The Pifferari* — he very rarely treated subjects from the Bible itself in his oil paintings. But it may well be for this very reason, the paintings' uncharacteristic subject matter, that Turner felt unable to

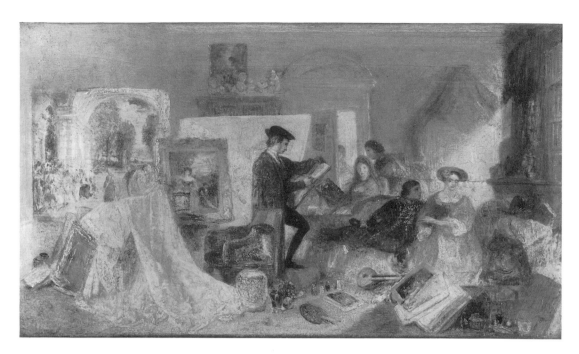

180. *Watteau Study by Fresnoy's Rules,* 1831
(B & J, 340), oil on panel, 15¾ × 27¼ in., Tate
Gallery, London

complete them and pursued instead the more characteristic themes in the 1838 and 1839 pairs, with their focus on ancient Rome and the present day.

Another group of works which it is more profitable to study together than as single paintings are those devoted to the subject of the creative artist. The first was Turner's tercentenary tribute to Raphael, *Rome, from the Vatican* (1820) which was followed by several others in the 1830s. These included *Watteau Study by Fresnoy's Rules* (RA, 1831), *Bridge of Sighs, Ducal Palace and Custom-House, Venice: Canaletti painting* and *Van Goyen, looking out for a Subject* (both RA, 1833).[8] (And, although it depicts an orator, not an artist, *Cicero at his Villa* has much in common with this group of paintings.) *Watteau Study* (Plate 180) has very close links indeed with *Rome, from the Vatican.* Turner's accompanying verses show that its main concern was to demonstrate the functions of black and white in a painting, but the composition of the picture is also very important. Turner shows Watteau standing centrally in the painting, thus obeying another of the rules laid down by the theorist Du Fresnoy in the 1660s, that the most important character in a painting should be placed at its centre. But what is especially interesting is that Watteau's pose is exactly that of the artist in Turner's composition study made in Rome in 1819 (Plate 128): he faces to the right; one arm is outstretched to his drawing board; behind him are pictures and draperies; in front of him are models and bystanders. Turner presumably abandoned the idea of using this composition for his Raphael picture when he fixed on the more specific theme of Raphael and the Fornarina and decided on a really grand picture, not just an interior. The figure arrangement in his sketch was far more appropriate for a small picture on an intimate scale, and this was how he eventually used it in 1831.[9]

But why did Turner portray Watteau, Canaletto and these other artists at all? How far are these paintings celebratory, how far are they autobiographical? The latter dimension to the paintings was first suggested as long ago as 1879, with respect to *Rome, from the Vatican*: 'The artist's intention may have borne some reference to his own honours. He figured in the Catalogue for 1820 as "Professor of Perspective and Member of the Roman Academy of St. Luke," so we have both perspective and Rome in the picture.'[10] Since then, the point has been pressed a lot further and it has been suggested that Turner saw himself as a universal artist comparable to Raphael.[11] This cannot, of course, be proved, but an objective evaluation would hardly support such a claim. Although Turner practised many diverse genres of painting, he did not work in fresco, his incursions into architecture were few and his practical experience of sculpture was minimal.[12] Turner's 'art historical' paintings were inspired, above all, by his sense of history and tradition which has been seen again and again in this book. Just as Addison and Byron, Sir Richard Colt Hoare and the

Rev. J. C. Eustace, Samuel Rogers and countless other Britons loved to tread in the footsteps of the ancients, to brood on the events of the past, to imagine the lives and feelings of the great men of history, so too did Turner. He loved to see and experience just what his predecessors had seen and experienced. His 'art historical' paintings grew out of his admiration for the particular artists whom they portray, but they sprang naturally from the cultural attitudes of his age, the patterns of thinking in which he himself was steeped. It does not matter that the paintings are imaginative rather than historically correct, that neither the artists themselves nor Turner had ever done precisely what the artists in the pictures are shown doing. What matters is that the paintings celebrate experiences which Turner had found exhilarating and which he had shared with the great artists of earlier generations: painting in Rome; living and working in an aristocratic household; recording the beauties of Venice; feeling the swell and surge of the sea.

Turner did not paint specifically 'art historical' pictures about the men he revered most of all — Claude and Wilson. His tributes to them are to be found throughout his work, from youth to old age, and not only in his paintings but also in his writings. A sentence or two from his passage on Wilson in the 'Backgrounds' lecture was quoted in Chapter 10, but Turner's famous description of Claude's art in the same lecture deserves more generous treatment: 'Pure as Italian air, calm, beautiful and serene springs forward the works and with them the name of Claude Lorrain. The golden orient or the amber-coloured ether, the midday ethereal vault and fleecy skies, resplendent valleys, campagnas rich with all the cheerful blush of fertilization, trees possessing every hue and tone of summer's evident heat, rich, harmonious, true and clear, replete with all the aerial qualities of distance, aerial lights, aerial colour . . .'[13] This is the epitome of Claude's Italy: cheerful, warm, fertile, serene, beautiful — rich yet, at the same time, simple. For Turner, however, Italy was a more complex place, as this book has tried to show: grandeur went hand in hand with pathos. As Turner demonstrates on a huge scale in *Caligula's Palace and Bridge*, the mighty ruins that outlast the centuries are themselves, paradoxically, a reminder of the frailty of life, the fragility of all endeavours. In his late watercolour of Lake Nemi (Colour Plate 40), modern Italian life takes its daily course quietly and gently amidst a scene of superlative natural beauty and the scattered remnants of Rome's lost splendour. The spectator may marvel at the beauties of nature, he may mourn the past or muse about the present, he may meditate upon the years between.

Here there can be no hard and fast answer about what Turner wishes the spectator to feel. Modern observers discuss at length the possible interpretations of the most famous of Turner's paintings of this period, notably *The Fighting 'Temeraire'* (1839) and *Rain, Steam, and Speed* (1844). Was Turner for or against 'progress'? How can one reconcile the fact that *The Fighting 'Temeraire'* seems to be an elegy for the passing of the stately and heroic age of sail, while *Rain, Steam, and Speed* celebrates the advent of the age of steam with all its noise and bustle and excitement? The changes, discoveries and inventions of Turner's later years were innumerable and far-reaching — in government, in industry, in science, in the arts. In the 1830s the first railways were opened; the Palace of Westminster was dramatically destroyed by fire; Princess Victoria became queen at the age of only eighteen. The same decade witnessed the passing of the First Reform Act, the Chartist riots, revolutions in France and Belgium, the abolition of slavery, the invention of daguerreotypes and Fox-Talbot's calotypes, Faraday's discovery of the electro-magnetic current, the publication of Pugin's *Contrasts* and Darwin's *Voyage of the Beagle*. Wherever men cast their gaze, they were faced by new areas of conflict, new images of change. Many of them argued and struggled for it or against. But Turner was a poet and in many of his paintings of Italy, as in *The Fighting 'Temeraire'*, he took change itself for his theme. Rome and Baiae could never return to their former glory, but through Turner's art both their grandeur and their ruined beauty are celebrated for evermore.

Abbreviations

The 1819-20 sketchbooks (Turner's titles are shown by *)

ANR	*Albano, Nemi, Rome* (TB CLXXXII)*
A to R	*Ancona to Rome* (TB CLXXVII)*
C and V	*Como and Venice* (TB CLXXXI)
G to N	*Gandolfo to Naples* (TB CLXXXIV)*
It. guide book	*Italian guide book* (TB CLXXII)
M to V	*Milan to Venice* (TB CLXXV)*
NPR	*Naples, Paestum, and Rome* (TB CLXXXVI)
NRCSt	*Naples: Rome. C. Studies* (TB CLXXXVII)*
PASH	*Pompeii, Amalfi, Sorrento and Herculaneum* (TB CLXXXV)*
PFS2	*Paris, France, Savoy 2* (TB CLXXIII)*
R and F	*Rome and Florence* (TB CXCI)*
RCSt	*Rome: C. Studies* (TB CLXXXIX)*
Remarks	*Remarks (Italy)* (TB CXCIII)*
Return	*Return from Italy* (TB CXCII)*
Route	*Route to Rome* (TB CLXXI)*
Simplon	*Passage of the Simplon* (TB CXCIV)*
SRCSt	*Small Roman C. Studies* (TB CXC)*
St P's	*St Peter's* (TB CLXXXVIII)*
T	*Tivoli* (TB CLXXXIII)*
T and R	*Tivoli and Rome* (TB CLXXIX)*
TCLM	*Turin, Como, Lugarno, Maggiore* (TB CLXXIV)*
V Fr	*Vatican Fragments* (TB CLXXX)*
V to A	*Venice to Ancona* (TB CLXXVI)*

The 1828-9 sketchbooks (Turner's titles are shown by *)

C of G	*Coast of Genoa* (TB CCXXXII)
F to O	*Florence to Orvieto* (TB CCXXXIV)
G and F	*Genoa and Florence* (TB CCXXXIII)
L to M	*Lyons to Marseilles* (TB CCXXX)
M to G	*Marseilles to Genoa* (TB CCXXXI)*
O to M	*Orleans to Marseilles* (TB CCXXIX)*
Ro and Fr	*Roman and French* (TB CCXXXVII)
Ro to Ri	*Rome to Rimini* (TB CLXXVIII)
RTM	*Rome, Turin and Milan* (TB CCXXXV)
V and R	*Viterbo and Ronciglione* (TB CCXXXVI)

Other abbreviations

BI	British Institution
B & J	Martin Butlin and Evelyn Joll, *The Paintings of J. M. W. Turner*, 2 vols, 1977, rev. edn 1984
BM, P&D	British Museum, Department of Prints and Drawings
R	W. G. Rawlinson, *The Engraved Work of J. M. W. Turner, R.A.*, 2 vols, 1908 and 1913
RA	Royal Academy
TB	Turner Bequest, as catalogued by A. J. Finberg in 1909
V & A	Victoria & Albert Museum
W	Andrew Wilton, *The Life and Work of J. M. W. Turner*, 1979

Notes

Chapter 1 The lure of Italy

1 Addison (1705), preface.
2 Finberg (1910), plates I and II, pp. 6-8; TB CCCLXXIII-VI; Finberg (1961), pp. 36-40.
3 Tate Gallery, London. B & J, 43, 44.
4 See Woodbridge (1968), fig. 11 and p. 213.
5 On Turner and Claude, see Kitson (1983).
6 Ziff (1963a), p. 144.
7 Finberg (1910), pp. 92-6; Rawlinson and Finberg (1909), pp. 38-9.
8 Sass (1818), p. 56.
9 *Ibid.*, p. 89; Addison (1705), p. 387.
10 Matthews (1822), vol. 1, p. 293; Lady Morgan (1821), vol. 2, pp. 3, 290.
11 *NPR*, 33; *R and F*, 84.
12 Addison (1705), preface.
13 Quoted from Anderson (ed.) (1792-5), vol. 7, p. 180.
14 Matthews (1822), vol. 1, pp. 258-9.
15 Sass (1818), p. 97. For Turner's friendship with Henry Sass (1788-1842, the founder of Sass's Art School in Bloomsbury where Millais and Frith were trained), see Sass's entry in the *DNB*.
16 See Hale (ed.) (1956), p. 62.
17 See Gage (1974), pp. 75-83 and below, pp. 13-14.
18 Eustace (1813), vol. 1, p. viii.
19 Matthews (1822), vol. 1, p. 78.
20 *Ibid.*, vol. 1, p. 213.
21 As Falk (1938, p. 256) surmised, however, the manuscript notes in Turner's copy are not by Turner himself. I would suggest that they may be by William Brockedon. On the influence of Blunt's book on Turner, see below, pp. 126 and 186.
22 See Wells (1974), Chapters 5 and 6.
23 See below, Chapters 8, 9 and 10.
24 Hale (ed.) (1956), p. 9.
25 Lister (ed.) (1974), pp. 168-98.
26 See below, pp. 177-86.
27 Reynolds (1975); Forster-Hahn (1967), pp. 367-82. Turner owned the 4th edn of Reynolds's *Works*, edited by Edmund Malone (1809).
28 Shapiro (ed.) (1972), pp. 87, 97, 71.
29 Haskell (1976), pp. 107-8.
30 Goethe (1985), pp. 72, 108.
31 Gilchrist (1855), vol. 2, p. 108; Farr (1958), pp. 127-8.
32 Cunningham (1843), vol. 2, pp. 190, 163, 168, 170, 175-6, 177.
33 Gotch (1937), p. 272; Lister (1981), p. 49.
34 Gage (ed.) (1980), p. 123.
35 Gage (1974), pp. 75-83.
36 The influence of Piranesi on Turner is clear as early as the watercolour *Ewenny Priory* (RA 1797). For Ducros see Woodbridge (1970), pp. 96-7; London: Wildenstein (1982), nos 22-7, 43-6; London: Kenwood (1985).
37 [R. C. H.] (1815). It can have been of little use to Turner, since it was brief, vague, inaccurate and very out of date, being based on the author's travels of some thirty years earlier.
38 Hoare (1819), preface.
39 *It. guide book*, 17-21a and 4-16a.
40 Turner's notes reflect a number of small changes made in the later editions of Eustace's book: see Powell (1984), pp. 445-6.
41 See the following notes in Turner's sketchbooks:
(1) TB CLXIII, *Artists' Benevolent Fund* (watermarked 1815 and used in 1817-18), 1: 'Cox's Italian Tours'. This refers to Henry Coxe's *Picture of Italy* (1815, 2nd edn 1818).
(2) TB CLXIV, *Guards* (used 1817-18), 60: 'Italian Books Vasi's Book of Rome with 40 Views of Buildings and Plan 12ˢ Bound Reichards Itinerary of Italy view and 3 maps, 10, 6. Bound, Leigh St[rand]'. These references match the publisher Samuel Leigh's advertisement in the *Literary Gazette*, no. 79, 25 July 1818, p. 480. Turner acquired Reichard's book which is now TB CCCLXVII.
(3) TB CLXXI, *Route to Rome* (used in 1818-19), inside front cover: 'Hulmandel Stone drgs of Italy'. This refers to C. J. Hullmandel's *Twenty-four Views of Italy, drawn from nature, and engraved upon Stone*, published in June-July 1818.
(4) TB CXLI, 'Hints River' (used *c.* 1817-18), 17: notes on Italian and French primers.
42 *W*, 495-6.
43 *The Field of Waterloo* (B & J, 138) was exhibited in 1818 with a quotation from canto III.
44 TB CLXXXI, *Como and Venice*, 4-7.
45 See, e.g., Lady Morgan (1821), vol. 2, pp. 334-5; Matthews (1822), vol. 1, pp. 177-9; Stendhal (n.d.), vol. 2, pp. 277-9; Moore (1853), p. 49.
46 Hazlitt (1932), p. 233.
47 Smollett (1806), p. 474.
48 Hazlitt (1932), p. 218.
49 *W*, 700-17, engraved as *R*, 144-61. Turner also produced two other scenes which were ultimately excluded from the publication: *W*, 398 (whose correct title is *The Valley of the Nar*) and a view of the Grand Canal in Venice (Finberg, 1930, plate XII). See Powell (1984), pp. 57-8 and (1985).
50 Receipt in the John Murray archives.
51 Letter from Hakewill to Turner, dated 21 March 1816 (private collection).
52 Nearly all of these drawings are now in the library of the British School at Rome.
53 I.e. Addison's *Remarks on Italy* (1705), John Moore's *View of Society and Manners in Italy* (1781), Eustace's *Tour through Italy* (1813) and Forsyth's *Remarks on Antiquities* (1813). In the end Moore was discarded as a source.
54 See Powell (1982b). The history of Hakewill's *Tour of Italy* now appears to have been even more complex than I thought in 1982, following the discovery (in Finberg's papers) of photographs of watercolours apparently by John Varley, Copley Fielding and J. A. Atkinson which depict scenes ultimately drawn by Turner. These explain Finberg's history of the commission which I (in 1982) was inclined to dismiss; however, they must date from late 1817/early 1818 and do not affect my reconstruction of the events of 1818 from the Hakewill-Murray correspondence.
55 See Ruskin (1878), pp. 23-8. Ruskin owned *W*, 701-2, 708, 711, 715-17.
56 *R*, 146, 147, 149, 153 and 161 were shown in 1821: [Cooke] (1821), nos 47, 265, 263, 306, 280, 51. *W*, 700, 703, 710 and 711 were shown in 1824; 704 and 705 in 1831.
57 *R*, 342-5 and two others not listed by Rawlinson (*Castle of St Angelo* and *The Roman Forum*). Conder also helped himself to the *Vesuvius* discussed in Chapter 6 (Plate 80).
58 Harding's *Cascade of Terni* was engraved by E. Finden in 1833, Prout's by J. T. Willmore.
59 See Thornbury (1862), vol. 2, p. 256, a story quoted from Jones (1849), p. 125.
60 Williams (1831), vol. 2, p. 161.
61 Lawrence MSS, RA, LAW/3/52.
62 Ashby (1925), p. 8, following Bell (1903), E.vii.
63 See the letters in the Lawrence MSS, RA, LAW/3/54 and 63.
64 See Gage (ed.) (1980), p. 243.
65 E.g. TB CXX, V (possibly from TB CLXIII, *Artists' Benevolent Fund* sketchbook); Thornbury (1862), vol. 1, p. 368; *V Fr*, inside front cover; Dr John Percy's Catalogue of Drawings, BM, P&D, M.6.7, p. 72-1. Later on Turner owned Madame de Genlis' *Manuel du Voyageur* (1829), and seems to have used it on his 1830s tours in parts of Germany.
66 Mrs Uwins (1858), vol. 2, p. 240.

Chapter 2 The path to Rome, 1819

1 See Gage (ed.) (1980), p. 80.
2 See also Paris: Centre Culturel du Marais (1981), pp. 105-13.
3 TB CLXXIV, *Turin, Como, Lugarno, Maggiore*; TB CLXXV, *Milan to Venice*; TB CLXXXI, *Como and Venice*; and probably also TB CXCIV, *Passage of the Simplon*. For full details, see Finberg (1909).
4 Public Record Office, FO/610/1, nos 4130 and 4145, dated 17 and 19 August 1819.
5 See Langley (1979), pp. 25-9; Hale (ed.) (1956), pp. 79-80.
6 Gilchrist (1855), vol. 1, p. 63.
7 On Turner's companion of 1802 and the question of his passports, see Powell (forthcoming).
8 Williams (1820), vol. 1, p. 246.
9 Most are marked with English makers' names, e.g. 'J. Whatman', 'A. Lee', etc.
10 *TCLM, M to V, V to A, A to R, T and R, ANR, PASH, NPR, St P's, R and F*.
11 For both paintings, see here, Chapter 8.
12 For such a journey in 1826, see Heywood (1919), pp. 19-30.
13 *PFS2*, 1a.
14 On this whole subject see Hale (ed.) (1956), pp. 74-81.
15 Sass (1818), pp. 84, 338-9; Coxe (1818), pp. xix-xx.
16 See, e.g., Hazlitt (1932), p. 197; Lister (ed.) (1974), pp. 219-20; Heywood (1919), pp. 53, 38, 41, 51.
17 Lister (ed.) (1974), p. 91.
18 Heywood (1919), *passim*; de Beer (ed.) (1951), pp. 72-3.
19 Wake (ed.) (1909), p. 192.
20 Hale (ed.) (1956), p. 77; Reichard (1818), p. 4.
21 Coxe (1818), p. xxiii; Sass (1818), pp. 340-1; Reichard (1818), pp. 5-6.
22 Coxe, Sass and Reichard, *loc. cit.* Sass puts it nicely: 'it limits extortion to one person, instead of extending it to a host'.

23 Lady Morgan (1821), vol. 2, pp. 301, 304; Sass (1818), p. 163.
24 See, e.g., Ruskin's remarks in Shapiro (ed.) (1972), p. 141.
25 De Beer (ed.) (1951), p. 32; Moore (1853), pp. 35, 46.
26 Eastlake (1870), p. 59.
27 Williams (1820), vol. 1, pp. 245-6.
28 Ruskin (1903-12), vol. XXXV, p. 80; one of the sketchbooks used in Italy in 1825-6 by William Hilton: V & A, E. 1681-1935. 91.C.21, especially ff. 74-7, 81-2.
29 Mrs Uwins (1858), vol. 2, p. 240.
30 J. R. Cozens, 1782-3 sketchbooks (Whitworth Art Gallery, University of Manchester); William Hilton, 1825-6 sketchbooks (V & A).
31 E.g. the picturesque walled town of Gradara, long visible on its hill to the right of the road a few miles before Pesaro (V to A, 57).
32 As sketched in V to A, A to R, Route: see pp. 24-35.
33 Mayne (1909), p. 281.
34 Graves (1863), pp. xi-xiii.
35 Armstrong (1902), pp. 96 ff.
36 Armstrong found the story inconsistent with other evidence about Turner, but he accepted it because it came to him from Graves's own cousin who referred him to Stokes's account. One may read between the lines that, because of his acquaintanceship with members of Graves's and Stokes's families, Armstrong felt obliged to include their contributions in his book.
37 [Wilde] (1842); Wilde (1864), p. 6.
38 The dates of Turner's sojourns in Venice are discussed in George (1971).
39 V to A, 21a-4, 86a.
40 Hazlitt (1932), p. 205. For analysis and discussion of Turner's study of Bologna, see Powell (1984), pp. 82-9.
41 This is a good place to note that Finberg made a number of mistakes in identifying the places sketched by Turner both on his way to Rome in 1819 and throughout the 1819 and 1828 tours. All references in the present book are based on the new identifications which form Appendix 2 of Powell (1984).
42 V to A, 53a, 54, 56a. Reichard (1818), p. 326.
43 Kitson (1964), p. 77.
44 Cunningham (1843), vol. 2, pp. 276, 264, 263.
45 V to A, 65a-78a, 79a-82.
46 V to A, 28a-35.
47 [Vallardi] (1818), p. 209; Eustace (1813), vol. 1, pp. 157, 161.
48 A to R, 11a, 12a, 14a, etc. Turner also used the Route sketchbook during his journey: see, e.g., ff. 17a, 19a, 21a, 26a, 36, 7, 18, 33a for sketches of Imola, Cattolica, Senigallia, Loreto, Macerata, Foligno and Spoleto. This suggests that he often consulted Hakewill's instructions and also sketched in whichever sketchbook in his pocket his hand chanced upon.
49 A to R, inside front cover.
50 Route, 26a.
51 Eustace (1813), vol. 1, p. 167; Lady Morgan (1821), vol. 3, p. 214.
52 Leopardi (1953), p. 58.
53 Lister (ed.) (1974), p. 174.
54 Laing (1875), p. 21; Collins (1848), vol. 2, p. 99.
55 Remarks, 96.
56 A to R contains sketches not only of the town seen on its hill (10, 13) but also of the Chiesa della Casa Santa and Palazzo Apostolico (11, 12, 13a-14) and the Holy House itself (29). On the pages of his copy of Reichard's guidebook that deal with Loreto (TB CCCLXVII, pp. 332-3) Turner made a number of notes and small sketches relating to works of art he saw there — the sculptures on the marble screen around the Holy House and the ceramic vases in the pharmacy of the Palazzo Apostolico, which are decorated with classical scenes, supposedly after the designs of Raphael and Giulio Romano — and at the end of the book he wrote a note about the Holy House itself.
57 Lady Morgan (1821), vol. 3, p. 214.

58 'Loreto' is not a misspelling of Turner's but a very common nineteenth-century variant.
59 Gage (ed.) (1980), p. 126; see also Wilkie's comment quoted in Finberg (1961), p. 313.
60 The viewpoint is the bridge at Villa Musone, visible in the foreground.
61 The Athenaeum (no. 83, 27 May 1829, p. 332) described the colour generally as 'extravagant' and noted 'the gleam which crosses and illumines the scene'. The Times (11 May 1829) referred to 'an effect of sunset, the gleams falling on the rocks and the buildings that surmount them'.
62 Athenaeum, loc. cit.; Ruskin (1903-12), vol. III, p. 139.
63 The beauty of the painting in 1829 brought tears to the eyes of Turner's friend Clara Wheeler: see Gage (ed.) (1980), p. 295. Its present darkened state could be due to the incompatibility of pigments used by Turner on it at different times.
64 Lady Morgan (1821), vol. 3, p. 216.
65 [Vallardi] (1818), p. 212; A to R, 16a-28a, 29a-35a.
66 Route, 13. This advice follows that on Florence (11, 12) and precedes that on Rome (13a ff.). Turner abandoned Hakewill's proposed route (Simplon Pass — Lakes — Milan — Genoa — Pisa — Lucca — Florence — Rome — Florence — Bologna — Parma — Mantua — Verona — Venice) in favour of that described by both Eustace and Reichard.
67 A to R, 38a-43.
68 Tate Gallery, London. B & J, 518.
69 Shanes (1984), p. 287. However, neither Shanes nor the revised edition of B & J moves on to query whether the present-day title of B & J, 518 might be a misnomer, a conclusion which I find inescapable.
70 A to R, 38a-79.
71 See, e.g., London: Kenwood (1974). Tivoli, Nemi, Ariccia and Albano are, of course, much closer to Rome and were more accessible to artists based there, whereas the beauty spots along the Via Flaminia would only be seen on journeys to and from Rome.
72 See London: Wildenstein (1982) and London: Kenwood (1985).
73 Some books quoted complete descriptions from Childe Harold canto IV, as H. W. Williams did at the springs of Clitumnus and the Cascade at Terni (1820, vol. 1, pp. 270, 274-5).
74 A to R, 48, 48a, 52, 52a, 55a-7.
75 E.g. the young Anna Jameson (1826, p. 130). Today, alas, the falls are switched on and off, and can only be enjoyed in full spate at certain times of day.
76 A to R, 61a-8 passim.
77 Letterpress in Hakewill (1820).
78 Reichard (1818), p. 313; Starke (1828), pp. 131, 513-16.
79 Eustace (1813), vol. 1, p. 193 (duly noted by Turner in It. guide book, 5); Sass (1818), p. 96; Reichard (1818), p. 300.
80 A to R, 85a-6. Sass (1818), pp. 97-8; Broughton (1859), vol. 1, p. 289; Hale (ed.) (1956), p. 72.
81 Lawrence MSS, RA, LAW/3/73. Farington had been a pupil of Wilson's in the 1760s.

Chapter 3 'Turner's visions of Rome'

1 Ruskin (1903-12), vol. XIII, pp. 297-307, 377-8; Ashby (1925).
2 Ruskin (1903-12), vol. XIII, p. 324 and his comments on the individual sketchbooks recorded in Finberg (1909).
3 Gage (ed.) (1980), pp. 80-1.
4 Turner may perhaps have stayed at Palazzo Poli (the palace that forms the backdrop to the Fontana di Trevi), from which his one letter was written. A number of artists had rooms here both at this date and later (Keller, 1824, pp. 29, 34, 36, 59).
 Chantrey and Jackson arrived in Rome on 13 October and departed, with Tom Moore, on 17 November (Jones, 1849, p. 25; Moore, 1853, p. 74). Turner was absent on his southern tour from c. 10 October to c. 13 November.

5 T and R, ANR, RCSt, NRCSt, SRCSt, V Fr, St P's and R and F. A few notes and sketches relating to Rome also occur in It. guide book, Route and Remarks.
6 ANR, front cover ('Nov 30 1819'), 17 ('Nov 9 1819') 18 ('Nov' 10 1819'), 26 ('11 Nov' 1819'). The three earliest dates show when Turner passed through the Alban hills on his return from Naples to Rome. St P's, inside front cover ('Dec' 2 1819'). An overlap of subject matter suggests that RCSt and SRCSt were used concurrently with ANR and St P's.
7 There are comments on St Peter's in V Fr(2a), sketches of its interior in St P's (83, 84-6) and sketches of its exterior in RCSt (6, 7, 21) and NRCSt (52, 53). The St P's sketchbook ranges from Villa Madama on Monte Mario to Villa Doria Pamphili on the Janiculum and from Villa Medici to Porta S. Paolo.
8 Quoted by Scherer (1955), plate 26; Goethe (1985), pp. 133, 397-8.
9 See Chapter 8, where this type of sketch is discussed in the context of Turner's watercolour views of the city of Rome for Walter Fawkes.
10 Rawlinson and Finberg (1909), p. 39; Finberg (1910), p. 93.
11 Hamerton (1895), p. 178.
12 For example, a view of Trajan's Forum similar to Turner's sketch (ANR, 36a) was engraved by Luigi Rossini in Le Antichità Romane (1819-23) and painted by Ippolito Caffi (1809-66) (Museo d'Arte Moderna, Venice): this view only came into being shortly before Turner's visit, after the French excavated the Forum c. 1812-14, and it immediately joined the repertory of standard views.
13 On this site's popularity with artists, see Hare (1903), vol. 1, p. 311 and vol. 2, p. 35. The lane was also painted by W. Cowan (BI, 1828, no. 165) and by T. H. Cromek (1831: Agnew's Winter Exhibition of Watercolours, 1986, no. 124).
14 V Fr, 78.
15 ANR, 64a.
16 Addison (1705), p. 177.
17 ANR, 52, 57, 65a-6; St P's, 17, 24.
18 V Fr, 52a.
19 RCSt, 43 gives the third line of the inscription on the Arch of Titus as DIVO.TITO.DIVESPASANVIS instead of DIVO.TITO.DIVI.VESPASIANI.F. That on the Arch of Constantine (RCSt, 29; Plate 40) is also not entirely correct, as Ashby observed (1925, p. 26). Among the museum sketches, it is instructive to compare V Fr, 55 with Jones (1912), plate 78; V Fr, 44a with Reinach (1912), vol. 3, p. 391, no. 2; V Fr, 70a with Amelung (1903-8), plates vol. 2, 1.2.
20 In addition to the examples mentioned in Chapter 8, Turner's watercolour of Naples for Walter Fawkes (1820: W, 722) was based on NRCSt, 13 (Colour Plate 15).
21 Wright of Derby: Nicolson (1968), vol. 2, plates 124-75. Maria Graham's Italian sketches: BM, P&D.
22 RCSt, 15, 45; ANR, 45a, 69.
23 Lister (ed.) (1974), p. 121.
24 Wilton (1979), p. 143.
25 Remarks, 99. See here, Chapter 5, note 33.
26 Wilton (1979), p. 142. Ford (1948), pp. 338-41.
27 Farington's Diary, 21 July and 16 November 1799 (BM, P&D, pp. 1604, 1664).
28 London: RA and Tate Gallery (1974), p. 86; London: British Museum (1975), pp. 52-3; Wilton (1979), pp. 143-4. All these accounts, however, rest largely on the evidence of R. J. Graves which is here discredited (see pp. 23-4).
29 NRCSt, 45; RCSt, 33, 35, 36. Ashby (1925), p. 25.
30 Thornbury (1862), vol. 1, p. 230.
31 Ibid., pp. 219-21.
32 Ruskin (1903-12), vol. XIII, pp. 298-9.
33 Letter of 15 November 1819, Sir John Soane's Museum, London.
34 The report from Rome in the London Magazine for March 1820 (vol. 1, no. 3, p. 291) complained that Turner

had permitted nobody to see his innumerable sketches 'not from illiberality, as some thought, but simply because they were too slight to be understood'.

Chapter 4 Study and use of the antique

1 See Haskell and Penny (1981), *passim*.
2 *Ibid.*, pp. 107, 118.
3 *Ibid.*, pp. 91, 99-100, 150.
4 Thornbury (1862), vol. 1, p. 363.
5 Farington's Diary, 9 January 1820 (BM, P&D, p. 7709).
6 *V Fr*, 6a-25, 30-52, 70a, 77. The Vatican Museums were normally open to the public only twice a week (Starke, 1820, p. 338), but it was possible to obtain access at other times by producing a note from Canova (Williams, 1820, vol. 1, p. 343).
7 *V Fr*, 52a-8. Turner began in the Galleria, worked his way along the small rooms from the Sala degli Imperatori to the Sala del Gladiatore and ended up in the Stanza del Vaso.
8 The Arch of Constantine: *St P's*, 18, 20, 21, 22; CXCV(a), H, now inserted in *St P's*; *RCSt*, 29. The Arch of Titus: *St P's*, 18a and 19 show the internal reliefs; *RCSt*, 43 and *SRCSt*, 1 show its east face, i.e. that towards the Colosseum. The Arch of Severus: *ANR*, 33a, 34. The Colonnacce: *St P's*, 15a-16. The Arcus Argentariorum: *ANR*, 45, foot.
 Turner did not sketch the reliefs on Trajan's Column or that of Marcus Aurelius. This may have been partly because of their lack of appeal to early nineteenth-century visitors (see [Eaton], 1820, vol. 1, p. 316; Sass, 1818, pp. 124-5). Furthermore, the reliefs on the triumphal columns are difficult to examine because of their distance from the spectator: both Poussin and Rubens drew their sketches of these reliefs from engravings.
9 E.g. *ANR*, 69a (here Plate 42); *Route*, 13; *V Fr*, 1 (the Sedia Corsini).
10 *R and F*, 34, 91a. *It. guide book*, 30a.
11 TB V, *Drawings from the Antique*, c. 1790-3.
12 See *V Fr*, 10a, 11a, 12a, 16, 16a, 18; 38a, 56a.
13 Wilson: Sutton (ed.) (1968); Wright: Nicolson (1968), vol. 2, plates 126-35.
14 Out of Haskell and Penny's selection of masterpieces, Turner's studies in the Roman museums included only the *Faun* of Praxiteles, the *Antinous*, the *Cupid and Psyche*, the *Venus* and the *Wounded Amazon* — all in the Capitoline (*V Fr*, 57, 56a, 54a). His *Drawings from the Antique* sketchbook had included the *Apollo Belvedere*, the *Mercury/Antinous* and the *Meleager* — all in the Vatican.
15 *V Fr*, 35a-6, 47 and 47a.
16 Sutton (ed.) (1968), facsimile volume, ff. 7, 12, 14-16, 18-20, 23-5, 27. See also the text volume, entries for those pages.
17 Thornbury (1862), vol. 1, p. 364. By 1819, however, the *Apollino* was actually in the Tribuna of the Uffizi; it does not feature in *V Fr*.
18 Richard L. Feigen, Chicago, Illinois; The Duke of Northumberland. B & J, 133-4. The Select Committee on the Elgin Marbles met and examined its witnesses (many of them Turner's friends) from 29 February to 13 March 1816; they published their Report of evidence on 25 March and on 7 June parliament adopted their recommendation to purchase the sculptures for the nation.
19 Jaffé (1977), plates 276, 283-4, 306-7.
20 Irwin (1979), pp. 36, 38, 40.
21 BM, P&D, 1939-8-14-1, 9¾ by 6¼ inches.
22 E.g. Hazlitt (1932), p. 239, or Lamb's remarks in his 'Blakesmoor' in *The Last Essays of Elia*.
23 *V Fr*, 6a, 9, 10a, 11, 19, 19a, 21, 23, 30, etc.
24 Blunt and Friedlaender (1974), nos 315-26 (plates 250-6), many of which Poussin drew from the engravings in the *Galleria Giustiniani*.

25 *V Fr*, 53a-4. Blunt and Friedlaender (1974), no. 352 (plate 268).
26 Gage (ed.) (1980), p. 98. *RCSt*, 43.
27 *St P's*, 18a, 19.
28 *RCSt*, 43; *SRCSt*, 1.
29 *St P's*, 15a-16.
30 TB CXCV(a), H, now inserted in *St P's*.
31 *SRCSt*, 4.
32 See London: Tate Gallery (1982), pp. 37-55.
33 E.g. *ibid.*, cat. nos 67, 76, 108, 110.
34 Turner first studied the Elgin Marbles in August 1806, prior to their public exhibition in Lord Elgin's house in Park Lane from 1807 to 1811 (Gage (ed.), 1980, p. 31). They were then exhibited in Burlington House from 1811 to 1816, when they were acquired for the nation and transferred to part of the British Museum.
 The casts of Lapiths and Centaurs in the hall of Turner's house in Queen Anne Street were recalled by his friend Trimmer (Gage, 1969, p. 256, n. 22) and by W. L. Leitch (MacGeorge, 1884, p. 83); but there is no record of when he acquired them.
35 As found in *V Fr*, 12, 19.
36 Gage (1974), p. 74; see also the entry in B & J.
37 Eustace (1813), vol. 1, p. 567.
38 *V Fr*, 6a, 53, 52a.
39 For a double herm, see *V Fr*, 31. Turner would have seen a number of others elsewhere, e.g. in the collection at Petworth.
40 Smollett (1806), p. 467; [Waldie] (1820), vol. 4, p. 33.
41 'It is said, that Hyperides once defended the courtezan Phryne, who was accused of impiety, and that, when he saw his eloquence ineffectual, he unveiled the bosom of his client, upon which the judges, influenced by the sight of her beauty, acquitted her': Lemprière (1767), s.v. 'Hyperides'.
42 *V Fr*, 32, 54a, 31a, 33, 38a-9.
43 *St P's*, 18.
44 *Remarks*, 3-3a.
45 One may also note that a mural of *Aurora* by Louis Laguerre, clearly deriving from Guido Reni's work, hangs above the grand staircase at Petworth. In Turner's coloured sketch of this staircase (TB CCXLIV, *Petworth Water Colours*, 94) he clearly indicates the red-clad figure of Phosphorus in the painting.
46 Thornbury (1862), vol. 1, p. 315; Gage (1969), p. 131; Wilton (1979), p. 194.
47 Gage (1969), pp. 129-30.
48 *V Fr*, 30a.
49 *Remarks*, 1. Chantrey called on Thorwaldsen on 16 October 1819 (Jones, 1849, p. 28), while Turner was absent from Rome on his southern tour.
50 *Remarks*, 1. Tom Moore and Chantrey visited the statue with Canova on 9 November 1819 (Moore, 1853, p. 68), when Turner was on his way back to Rome.
51 Praz and Pavanello (1976), pp. 127-8. The undraped angels were greatly admired by Stendhal (1959a, p. 62).
52 *St P's*, 67a, 85. Dalmazzoni (1803), p. 24; [Eaton] (1820), vol. 2, p. 240.
53 *SRCSt*, 5. Reichard (1818), p. 66 (the guidebook Turner was using in 1819); Landseer (ed.) (1871), vol. 2, pp. 62-3; Stendhal (1959a), p. 254.
54 *St P's*, 47 and *Remarks*, 85a. [Eaton] (1820), vol. 2, 313; Rogers in Hale (ed.) (1956), p. 222; Weston (1819), pp. 108-9.
55 Starke (1828), pp. 238, 200.
56 Turner's interest in Giambologna: *It. guide book*, 4 (pencil addition, probably made at Bologna, to his notes in ink from Eustace's *Tour* about the *Neptune*); *R and F*, 68a (sketch of the *Fountain of the Ocean* in the Boboli Gardens). On Florence, see here Chapter 7.

Chapter 5 Studying the Old Masters

1 Turner's sketches and comments on the Roman galleries and collections of paintings occur as follows: Barberini:

Remarks, 80, 96-5 (sic); Borghese: *Remarks*, 2a, 3a, 4, 5a; Corsini: *Route*, 13 and *V Fr*, 1a; Doria: *Remarks*, 80a; Pallavicini-Rospigliosi: *Remarks*, 3-3a, 81; Sciarra: *Remarks*, 80, 94; Torlonia: *Remarks*, 1. Palazzo Farnese: *V Fr*, 3; Villa Farnesina: *Route*, 14a and *It. guide book*, 2, 28a. The Vatican loggia: *T and R*, 13a-21.
2 Moore (1853), pp. 47-75; Cunningham (1843), vol. 2, pp. 162-310, 384-425; 423.
3 *V Fr*, 3; *Remarks*, 4.
4 *Route*, 13, 14a and *V Fr*, 3: circle, dot in a circle, cross in a circle.
5 *Route*, 13, 14a; *Remarks*, 4; *V Fr*, 1a.
6 *Route*, 13.
7 *Ibid.*
8 Turner would have seen this painting at the sale of the Italian part of the Orléans collection in London in 1798. See also Gage (1969), p. 204 and Venning (1982), p. 42.
9 Shapiro (ed.) (1972), p. 113.
10 Hazlitt (1932), p. 232.
11 *Ibid.*, pp. 238, 239; Jones (1849), pp. 63-4.
12 Farington's Diary, 1 October 1802 (BM, P&D, p. 8219).
13 *Remarks*, 2a. [Mrs Eaton] (1820), vol. 3, p. 47; Starke (1828), pp. 228-9.
14 TB CXCV, *Perspective Diagrams*, 163, used on 7 January 1811 (Finberg, 1961, p. 174). See also Venning (1983), pp. 46-7.
15 *Remarks*, 2a. The 'Michelangelo' saints: della Pergola (1955-9), vol. 2, nos 142-3. One tourist who attempted to dispute this attribution with the *custode* was H. W. Williams (1820, vol. 1, p. 309). The Venusti paintings (now in Palazzo Barberini): Carpegna (ed.) (1957), p. 62. Other versions of *The Holy Family* are in the National Gallery, London, and the Ashmolean Museum, Oxford.
16 Gage (ed.) (1980), p. 122. Lawrence was particularly interested in the Prophets and Sibyls at this moment, having commissioned William Bewick to make large painted copies of some of them for presentation to the RA (see Landseer (ed.), 1871, vol. 2, pp. 27-30).
17 *Remarks*, 3-3a. Berry (1865), vol. 3, p. 333.
18 Turner studied Raphael Morghen's line engraving of the *Aurora* in Oxford in 1812 (Rawlinson, 1908-13, vol. 1, p. 37); he mentioned it in Perspective Lecture V (1818): Gage (1969), p. 204.
19 E.g., *St P's*, 64, 65, 66a.
20 On this group of sketches, see Ziff (1965), pp. 62-3; Kitson (1983), p. 15, n. 50.
21 Ziff (1963a), p. 144.
22 Ruskin (1903-12), vol. XV, p. 190.
23 Tate Gallery, London. B & J, 307.
24 Moore (1856), vol. 7, p. 149. Cp. Moore (1853), p. 84 where Moore poses the same question to Chantrey himself on their journey back to England (Milan, 30 November 1819) and receives the same answer.
25 *Remarks*, 99. Gage (1969), p. 101 and pp. 245-6, n. 122.
26 TB CCCLXVII, final page and inside back cover, noted by Gage (1969), p. 101 and p. 245, n. 120.
27 Thornbury (1862), vol. 1, p. 176.
28 See note 26; Cunningham (1843), vol. 2, p. 183; cf. Gilchrist (1855), pp. 133-4.
29 Moore (1853), p. 74. On the two academies visited by Turner, see also *London Magazine*, vol. 1, no. 1, January 1820, pp. 46-7.
30 TB LXXXIV, *Academies*, 43, 44, 63, 64, 65.
31 A fascinating glimpse of Turner in this role is provided in Redgrave (1891), p. 57: 'Turner placed a living model, the nearest in quality of form that he could find, alongside the masterpieces of antiquity — a beautiful young girl beside the Venus, a youth beside the Discobolus of Myron, another by the Lizard Killer.'
32 Archives of the Academy of St Luke, Rome, vol. 68, no. 57.
33 Academy of St Luke, Registro delle Congregazioni di Belle Arti, vol. 59, f. 87v, 21 November 1819: 'Furono acclamati in Accad'. di Onore i SSri Giuseppe Rebell Paesista di Vienna; ed il Sigr. Tourner Paesista di

Londra'. Turner's letter to Canova: Gage (ed.) (1980), pp. 80-1.

34 Williams (1831), vol. 2, p. 251.

35 See here, p. 141.

36 These elections are recorded in the Registro delle Congregazioni, vol. 59, f. 61v, vol. 58, f. 46v and vol. 59, f. 70v.

37 The situation is referred to explicitly in Canova's letter regarding Chantrey and Jackson (see note 32).

38 On this whole subject, see Wells (1974).

39 Eastlake (1870), pp. 92-3; Robertson (1978), p. 16. Turner recorded the Grahams' Roman address on V Fr, 81a and later referred to Maria as 'an acquaintance of mine when in Italy, a very agreeable Blue Stocking' (Gage (ed.), 1980, p. 103). Captain Thomas Graham died in 1822; his wife subsequently became famous as Maria, Lady Callcott.

Chapter 6 The landscape of antiquity: Tivoli, Naples, the Alban hills

1 Jones (1951), p. 66.

2 Ibid., pp. 66-7.

3 Hale (ed.) (1956), p. 276.

4 See London: Kenwood (1974).

5 T and R, 41, 42.

6 Williams (1831), vol. 2, pp. 160-1. The latter part of Lawrence's letter, to Samuel Lysons, is quoted in Chapter 1 (p. 18).

7 W, 495, which belonged to Lawrence's friend and patron John Allnutt.

8 Tate Gallery, London. B & J, 44.

9 Hale (ed.) (1956), p. 275.

10 October and May were the two months in which a visit to Tivoli was particularly recommended in contemporary guidebooks, e.g. Starke (1828), p. 250; arriving in Rome when he did, Turner would surely have followed their advice.

11 T and R, 1, 1a, 27a-32.

12 T and R, 32a-6.

13 T and R, 32a-4; 35, 36.

14 T and R, 5a, 9a-13. On the Villa d'Este at this period, see Eustace (1813), vol. 1, p. 426; [Mrs Eaton] (1820), vol. 3, p. 349; Berry (1865), vol. 3, p. 299.

15 Rogers in Hale (ed.) (1956), p. 275 and T and R, 53a; 40, 41a-2, 42a, 47a-8, 48a, 49a, 50, 52a.

16 T and R, 41.

17 T, 1, 2, 6, 7, 9, 10, 12, 16, 20, etc.

18 Farington's Diary, 2 February 1820 (BM, P&D, p. 7721).

19 W, 1169. T and R, inside front cover, 65; T, 44a-7.

20 Ruskin (1903-12), vol. III, p. 243. Turner himself referred to 'the very campagna of Rome' and the 'Sybil Temple' in Modern Italy — the Pifferari: Gage (ed.) (1980), p. 185.

21 Recorded very hastily on Ro and Fr, 33, 34a-5a.

22 [Vieusseux] (1821), p. 25.

23 Lawrence MSS, RA, LAW/3/73; G to N, 22a; ANR, 17, 18, 26. He was definitely back in Rome by 15 November (see here, pp. 70-1).

24 Coxe (1818), pp. 309-13.

25 Turner's visit to Pompeii (recorded on PASH, 2-27) was followed by his journey to Salerno via the inland road through Nocera (29a) and Cava dei Tirreni (30). He returned from Salerno round the Sorrento peninsula (31-65), visiting Herculaneum (80a-95a) on his way back to Naples.

26 See, e.g., Starke (1815), vol. 2, pp. 40-9; Matthews (1822), vol. 1, pp. 228-36.

27 The manuscript note on hotels and restaurants in Naples (V Fr, inside back cover) is not in Turner's handwriting, and must have been written by a chance acquaintance. The establishments it refers to are listed in Coxe (1818), pp. 317-19.

28 Ibid., p. 309; Sass (1818), p. 138.

29 G to N, 2a-11.

30 A few pages of sketches of flat, tree-lined roads (G to N, 12a, 15-17) probably depict this area.

31 G to N, 18a-19, 20-20c, 21a-3.

32 G to N, 23a-4; 24a-5; 25a-6.

33 G to N, 27a; 29a-30; 29.

34 G to N, 16, 21, 21a, 24, 29a, 30; 32a-3, 33a-4.

35 G to N, 37a-90a, inside back cover.

36 W, 712, 697-9. W, 698-9 are datable to 1817-18 through their appearance in W. B. Cooke's accounts: Thornbury (1862), vol. 2, p. 423.

37 G to N, 19a, 26a, 33a-4, 69a-70.

38 The Times, 11 January 1820, p. 2, col. e; Morning Chronicle, 23 December 1819, p. 4, col. a: this eruption began on the night of 25 November.

39 The group comprises NRCSt, 2, 6, 13, 18, 20, 21.

40 Ruskin (1903-12), vol. XIII, p. 379.

41 Ibid., vol. III, pp. 280-1.

42 Manuscript note in Dr John Percy's Catalogue of Drawings, BM, P&D, M.6.7, p. 72-1. For a graphic account of another ascent made in 1819, see Pennington (1825), vol. 1, pp. 566-8.

43 Jewitt (1868), p. 129.

44 Manuscript note cited in note 42 above. G to N, 40a-1 et seq.

45 Wilton (1979), pp. 140, 143. TB CLVIII.

46 Manuscript note cited in note 42 above. Donaldson's account of this event, as related by Percy, certainly has the ring of truth about it: 'White waist-coats were the fashion at that time; but Turner not being provided with one, rambled about & found one at a second hand clothes dealer's shop. The price asked was about 5 shillings. T: thought it too much, & not being able to converse in Italian, he asked D: to accompany him to the shop & try to obtain the waistcoat for a less sum. D: & T:, accordingly, went to the dealer's & succeeded in buying the article for 3ˢ/6ᵈ.'

47 V Fr, 81a.

48 Description from John Murray's catalogue of December 1817.

49 His publications included Swiss Scenery (1820), Views of the Valley of Aosta (1822), Views to illustrate the Simplon Route (1822) and Views to illustrate the Mont Cenis Route (1822).

50 Parts I and II are datable from the John Murray catalogues and the advertisements in the Literary Gazette, but there is much about the history of this book that is obscure.

51 Literary Gazette, no. 159, 5 February 1820, p. 95.

52 Ibid., no. 176, 3 June 1820, p. 367.

53 W, 698-9. [Cooke] (1822), nos 8, 27. Confusion has long surrounded Turner's two depictions of Vesuvius in eruption. Further to the entries in Wilton (1979): (1) The large watercolour (W, 697) cannot have been the version exhibited by W. B. Cooke in 1822, since Cooke names himself in the catalogue as the painting's owner, and W, 697 was owned by Walter Fawkes. The exhibition must have included the smaller version W, 698. (2) W, 699 appeared in the same exhibition. (3) W. B. Cooke was the earliest owner of both 698 and 699. (4) W, 698 subsequently belonged to B. G. Windus (see Friendship's Offering for 1830) and its last private owner before it was acquired by the Williamson Art Gallery was a Mr King.

54 W. B. Cooke to John Murray, 13 July 1827 (John Murray archives).

55 R, 339.

56 Ruskin (1903-12), vol XIII, pp. 428-9.

57 Ibid., vol. XXXV, p. 79.

58 Ibid., vol. XIII, pp. 428-9 and XXXV, p. 79.

59 A further reproduction of Turner's Vesuvius (R, 346) was published in Josiah Conder's Italy (1831) which included pirated versions of several of the plates in Hakewill's Picturesque Tour of Italy.

60 PASH, 2-27.

61 E.g. at the theatre, PASH, 26.

62 Stendhal (1959b), p. 371.

63 Mayne (1909), p. 272; Matthews (1822), vol. 1, p. 255.

64 PASH, 80a-95. Starke (1815), vol. 2, p. 18; Matthews (1822), vol. 1, p. 255; Lady Morgan (1821), vol. 3, pp. 96-7.

65 G to N, 78-90.

66 Eustace (1813), vol. 1, pp. 567-8.

67 PASH, 35a-6, 49a-57a passim, etc.

68 Still in the Soane Museum today, these drawings are the originals for fifteen of the twenty plates in the publication Différentes Vues de quelques restes de trois grands edifices qui subsistent encore dans le milieu de l'ancienne ville de Pesto, issued by Piranesi's son Francesco shortly after his father's death in 1778.

69 TB CXCV, Perspective Diagrams, 100: presumably the drawing of 'the back of the ruins of the Temple of Neptune' referred to in a report of Turner's lecture of 6 February 1816 (Whitley Papers, BM, P&D, vol. XII, T, p. 1560).

70 Route, 17.

71 NPR, 19a, 19b, 29-31a, 42a-3a.

72 Wilton-Ely (1978), p. 118.

73 NRCSt, 7, 12, 22; 3, 25.

74 NPR, 52a. Turner may well have felt an aversion to its 'horrible' subject matter.

75 NRCSt, 10, 24. [Jameson] (1826), p. 260. Samuel Palmer found it 'filthy and uninteresting' (Lister (ed.), 1974, p. 138).

76 NRCSt, 4, 25; G to N, 1, 47, 59a-60, 60a-1; NPR, 3a-7, 8b-11, 69a-70, 81a.

77 NPR, 70; NRCSt, 3.

78 ANR, 1-31a, 80-8a. The dates 9, 10, 11 November are recorded on ANR 17, 18, 26.

79 ANR, 28; 26a, 28a-9, 58, 15a.

80 Jones (1951), p. 55.

81 ANR, 3a-25.

82 Farington's Diary, 2 February 1820.

Chapter 7 Fair Florence

1 On 20 December John Soane the younger, who was still in Naples, wrote to his father that 'Turner is on his way home' (Bolton (ed.), 1927, p. 286).

2 Hale (ed.) (1956), p. 61. Perugia and Arezzo feature on R and F, 57a; 1a, 27, 29a, 81, 88a.

3 Williams (1831), vol. 2, pp. 229-38.

4 R and F, 1, 1a, 24-30, 34a-5, etc. After using the Rome and Florence sketchbook, Turner made sketches of many places in northern Italy and France in the Return from Italy sketchbook.

5 Eustace (1813), vol. 2, p. 216; Mayne (1909), p. 151; Williams (1820), vol. 1, p. 73.

6 Gilchrist (1855), p. 72.

7 Hazlitt (1932), p. 212.

8 Bell (1825), p. 160.

9 R and F, 37, 52a, 36a.

10 Hare (1890), p. 41; Starke (1828), p. 83.

11 Moore (1853), p. 77; Lister (ed.) (1974), p. 215.

12 [Beckford] (1834), vol. 1, p. 204.

13 Simond (1828), p. 103.

14 Moore (1853), p. 77.

15 Some of Zocchi's plates were published in England soon after the book first appeared (e.g. the reduced version of plate I, issued in 1750 by R. Sayer and J. Boydell).

16 R and F, 34.

17 Hazlitt (1932), p. 211. See also Childe Harold's Pilgrimage, IV, xlviii; [Beckford] (1834), vol. 1, pp. 175, 183, 205-6, 209; Matthews (1822), vol. 1, p. 44; [Vieusseux] (1821), p. 71; Moore (1853), p. 36.

18 North-eastern viewpoints: R and F, 59, 59a (Porta San Gallo); 77a-8 (Villa Palmieri); 76a-7 (Villa Guadagni); 30a, 31, 74, 74a-5, 79a, 84 (Fiesole). Eastern: 32a-3, 60a-1 (near Ponte S. Niccolò). South-eastern: 51a-2, 63a-4, 64a (the Monte alle Croci); 61a-2, 62a-3 (S. Margherita a Montici). South-western: 51a, 53 (Boboli Gardens).

Western: 40a, 73a (near Ponte alla Carraia); 66 (Cascine).

19 *R and F*, 76a-7 and 77a-8, both from the north-east.

20 E.g. a sketch on *R and F*, 31 records simply the 'B sky' and 'Blue distance' and 'Yellow'.

21 W, 726-9.

22 R, 319, engraved by Edward Goodall.

23 *R and F*, 51a-2, 63a-4, 64a.

24 When a reduced replica of this scene appeared in the *Amulet* for 1831 (R, 337), it was accompanied by a poem by Laman Blanchard specially written for the occasion; the opening verses are a celebration of Turner's image and the poet then moves on to conventional reflections upon Florence's past glories.

25 And whereas the Hakewill illustration correctly shows Ponte Vecchio and three of the arches of Ponte alla Carraia (Ponte S. Trinita is entirely obscured by Ponte Vecchio from this viewpoint), Turner's memory in 1827 played him false: he showed the three long arches of Ponte S. Trinita instead of Ponte alla Carraia. The 1827 depiction of the centre of Florence is also far less accurate, with Palazzo Vecchio now appearing of monstrous size — perhaps an unconscious reflection of contemporary attitudes towards the buildings of Florence.

26 *R and F*, 32a-3, 60a-1, 66. Moore (1853), p. 36; [Jameson] (1826), pp. 90-1; Mayne (1909), p. 151.

27 Eustace (1813), vol. 2, p. 217; [Beste] (1828), p. 130; Reynolds's comment in Cotton (ed.) (1859), p. 12.

28 Hale (ed.) (1956), pp. 87, 90, 187; Moore (1853), p. 35; *Route*, 11. The building still stands today.

29 *R and F*, 40a.

30 TB CCCLXVII, pp. 58-9.

31 With the other artists, however, it is less clear which of their paintings attracted Turner's attention. By 1819 the Uffizi owned Piero di Cosimo's *Incarnation* and four of his *Perseus and Andromeda* scenes; it is tempting to suppose that Turner's eye was caught by the *Incarnation*, in which the Virgin stands on a stone base with a relief *all'antica*, like those which he had recently been sketching in the Vatican. The Uffizi owned six paintings by Dürer and four by Pontormo. The Raffaelino del Garbo which Turner saw was probably his *Annunciation*.

32 [Florence: Uffizi], (1810), pp. 51-2 and (1819), pp. 63-4. Turner must have been given the date of 1440 for the Baldovinetti by another tourist or the *custode*; nowadays it is dated to *c.* 1453.

33 See Kennedy (1938), pp. 53-60. Cf. de Beer (1951), pp. 95-6.

34 Flaxman's Italian sketchbook, V & A, 2790, ff. 60, 63, 29; [Jameson] (1826), p. 105; Moore (1853), p. 41; Hale (ed.) (1956), p. 198.

35 Gage (1982), p. 24, n. 1.

36 Williams (1820), vol. 1, pp. 107-8.

37 'Date 1631 or 1681 Roma/he died at 82'; today the inscription is read as '1637'.

38 Ruskin (1903-12), vol. III, p. 113.

39 See below, Chapter 9.

40 [Florence: Uffizi] (1810), p. 126.

41 Simond (1828), p. 92 (referring to 1817); the portrait is today generally regarded as the work of Sebastiano del Piombo.

42 Williams (1820), vol. 1, p. 135; Rogers in Hale (ed.) (1956), pp. 190-1; Starke (1815), vol. 1, p. 225.

43 Bell (1825), p. 233. Reynolds: BM sketchbook 12, ff. 55v, 56v, 58v, 59v.

44 Starke (1828), p. 77; Moise (1845), pp. 280-1.

45 The reference to Giotto may be to the Baroncelli altarpiece which is signed 'Opus magistri Jocti' and was admired by Samuel Rogers in 1814 (Hale (ed.), 1956, p. 198). The Donatello crucifix was described as 'celebrated' in one very popular guidebook (Starke, 1828, p. 77), but seems to have attracted little attention; perhaps most observers, like Brunelleschi, found it unpleasantly realistic. Canova's monument to Alfieri came in for some strong criticism almost immediately

after its completion: Williams (1820), vol. 1, p. 133; Broughton (1859), vol. 1, p. 270; Starke (1828), p. 77. Turner's notes seem to include the name Ghiberti — presumably because both Lorenzo and Vittorio Ghiberti are buried in S. Croce.

46 [Vieusseux] (1821), p. 72; [Beste] (1828), p. 162.

47 Starke (1815), p. 230; Pennington (1825), vol. 1, pp. 380-1, fn.; Moore (1853), p. 30; Stendhal (1959b), p. 302.

48 Williams (1831), vol. 2, pp. 221-38; Farington's Diary, 2 February 1820 (BM, P&D, p. 7721).

49 Starke (1828), pp. 522-3, an analysis of a journey comparable to Turner's, made in the winter of 1820.

50 Gage (ed.) (1980), p. 97. Turner's homeward journey coincided with a period of such extraordinarily cold weather in northern Italy that the lagoon at Venice was frozen over (see Comandini, 1900-1, p. 1051), and 'an uncommonly rapid and heavy fall of snow upon Mount Cenis' was recorded (Starke, 1828, pp. 522-3).

51 Farington's Diary, 2 February 1820 (see above, pp. vi and 89).

52 *Ibid.*, 29 December 1819 (pp. 7701-2).

53 One of Turner's rare remarks about Italy is recorded in a letter to John Linnell from Samuel Palmer, written from Rome in February 1838: 'Turner said he did not like Subiaco which is generally reckoned a fine place' (Lister (ed.), 1974, p. 113).

Chapter 8 Poetry and prose: Turner's Italy in the 1820s

1 Gage (ed.) (1980), pp. 253-4. The Swiss views are among W, 365-96; the Rhine drawings are W, 636-86.

2 W, 402, 718-24.

3 Finberg (1961), pp. 251, 257-8.

4 *Ibid.*, p. 259.

5 TB CCXI, 10.

6 Finberg (1961), p. 272.

7 Egger (1931), vol. 2, pp. 105-16.

8 See Hale (ed.) (1956), p. 210; New Haven: Yale Center for British Art (1981), p. 46; also Lister (ed.) (1974), pp. 146, 202, 387.

9 *RCSt*, 12, 33, 34, 39.

10 *St P's*, 1a-2, 2a-3. See also 3a-4, 4a-5.

11 *St P's*, 71a-2, 73; 74a-5, 75a-6, 76a-7. See Reichard (1818), pp. 72-3; Sass (1818), pp. 103-5; Stendhal (1959a), p. 85; Moore (1853), p. 49.

12 *Ibid.*, pp. 104-5.

13 See, e.g., Dalmazzoni (1803), p. 237; Rogers in Hale (ed.) (1956), pp. 216, 233; Moore (1853), p. 52.

14 'Saint Peter's the part by Bernini good in the arrangement of the columns but being very large they convey the idea of greatness away from the facade of the building which being but one Order. tho the attic has in the facia of the pannel a capital, to carry an entablature without supports and the Dome collosal has it certainly is by measure appears to rest upon the Upper cornice and in the most favourable view the columns are cut by it or the cupla has no base so that the Dome in approaching the steps becomes secondary. the *[illegible]* for the *[illegible]* are *[illegible]* are immense pieces and *[illegible]* a trifling pediment masks the front and the openings increase between the pilasters so that two of the windows are *[sketch of window]*': V Fr, 2a. Cf. Hazlitt (1932), p. 235; Rogers in Hale (ed.) (1956), p. 242; Moore (1853), p. 53; Eastlake (1870), p. 62; Etty in Farr (1958), pp. 36, 117; Redgrave (1891), p. 243.

15 Matthews (1822), vol. 1, pp. 92-3; Sass (1818), p. 116; Forsyth (1816), p. 179.

16 Hale (ed.) (1956), p. 209; Hazlitt (1932), p. 234.

17 W, 402. *Return*, 2a.

18 This subject is discussed in more detail in Powell (1984), pp. 228-31. On the Panini painting see Levey (1957) and (1971), pp. 172-5.

19 Finberg (1961), p. 265.

20 Tate Gallery, London. B & J, 245.

21 On the paintings within the painting see Omer (1975); Gage (1969), pp. 93 and 241, n. 71. However, the conspicuous inscription on the large landscape, 'Casa di Raffaello', suggests that the function of that painting may well be biographical and/or related to Raphael's architectural work, rather than a reference to Raphael as a landscape painter, as has formerly been thought.

22 The identical problem faced those wishing to commemorate the Raphael quincentenary in 1983; see Cecil Gould's review of David Thompson's television programmes on Raphael (*Apollo*, August 1983, p. 194).

23 Ruskin (1903-12), vol. XIII, p. 127.

24 Hamerton (1895), p. 171.

25 Yale Center for British Art, New Haven, and Tate Gallery, London. B & J, 50 and 127.

26 See the reviews quoted by B & J.

27 Hale (ed.) (1956), p. 212.

28 Mayne (1909), pp. 205-6; Lady Morgan (1821), vol. 2, p. 358, fn.; Moore (1853), p. 55; Hale (1956), p. 208; Berry (1865), vol. 3, p. 268.

29 Lawrence MSS, RA, LAW/3/39; Davy (1858), p. 227.

30 Davy stayed at the same hotel in Rome as Chantrey (Moore, 1853, p. 47) and he was also a friend of many of Turner's other associates (see the frequent references to him in Farington's Diary).

31 [Eaton] (1820), vol. 3, p. 169. Both Raphael and the Fornarina had lived in the Trastevere area of Rome, depicted in Turner's view of the city. In order to place Raphael exactly where he did, Turner had to move the obelisk slightly to the right (cp. the painting and the sketch).

32 See particularly Gage (1969), pp. 93-4.

33 *Literary Gazette*, no. 152, 18 December 1819, p. 815; *London Magazine*, vol. 1, no. 1, January 1820, p. 88.

34 Gage (1969), pp. 93 and 240, n. 68.

35 Wilson: Constable (1953), plates 73a-5a and pp. 196-7; three of these were lent to the British Institution's exhibition of 1814. Claude's painting (LV 164) belonged at this date to the Duke of Rutland; for Turner's connections with Belvoir Castle, see Gage (ed.) (1980), pp. 69-70, 97.

36 Hale (ed.) (1956), p. 251; Sass (1818), p. 217; Matthews (1822), vol. 1, p. 230.

37 Ruskin (1903-12), vol. XIII, pp. 132-3.

38 *Odes* III.iv.24.

39 Anderson (1792-5), vol. 14, p. 75, fn.

40 See Thomson's *Liberty* in *ibid.*, vol. 9, pp. 242-72; on Baiae: p. 245, lines 290-315.

41 Ruskin (1903-12), vol. XIII, p. 132.

42 Published in the *Indicator*, 10 May 1820.

43 Hartman (1970), pp. 206-12.

44 Anderson (1792-5), vol. 7, pp. 180-1.

45 Lister (ed.) (1974), p. 219.

46 Kitson (1983), p. 12.

47 *G to N*, 77a-8, 78a-9, 82a-9 *passim*.

48 Compare, e.g., B & J, 5 (for the shepherd), 135 (the fruit), 140 (the foreground plants).

49 Thornbury (1862), vol. 1, pp. 228-9.

50 E.g. in a review of *Mercury and Argus* (1836, B & J, 367); Hamerton (1895), p. x; Gage (1969), pp. 145-6.

51 *Edinburgh Review*, July 1839, p. 517.

52 Many of the buildings at Baiae had been submerged by the sea but were still visible beneath the waves, providing yet another unusual and memorable sight for tourists in this area. Rogers in Hale (ed.) (1956), p. 251.

53 Jones (ed.) (1964), vol. 2, p. 61.

54 For Shelley's reading of Eustace, see Jones (ed.) (1944), vol. 1, p. 57; (1947), p. 103; (1964), vol. 2, pp. 54, 89.

55 Lister (ed.) (1974), pp. 208, 211.

56 Dickens (1908), p. 410.

57 Bolton (1927), pp. 357-9, 454-7, 475-81; Summerson (1977), pp. 27, 26.

58 *Ibid.*, Appendix II.

59 E.g. in 1821: Bolton (1927), p. 310.

60 Britton (1834), p. 10.

61 For the history of the museum premises, see Summerson (1977).
62 Bolton (1927), pp. 454-7.
63 Gage (ed.) (1980), p. 101.
64 *SRCSt*, 1, 39a; *RCSt*, 25, 43; *St P's*, 18a, 19, 24, 58-60; *ANR*, 67a.
65 *RCSt*, 38; *St P's*, 17, 23, 23a; *ANR*, 32, 33a-4a, 35a, 49a, 51a-2a, 57-8, 63a, 65a-6.
66 *Literary Gazette*, no. 486, 13 May 1826, p. 298.
67 Gowing (1966), p. 21.
68 Sass (1818), p. 86; Matthews (1822), vol. 1, pp. 106-7, 122-7; Mrs Uwins (1858), vol. 1, pp. 258-62, 275-9, 334-42; Hazlitt (1932), p. 215.
69 *Ibid.*, p. 236. Cf. Moore (1853), pp. 37, 48.
70 Hazlitt (1932), p. 214; Rogers in Hale (ed.) (1956), pp. 235-6, 238-40, 242; Matthews (1822), vol. 1, pp. 109-11, 158-9; Mrs Uwins (1858), *passim*.
71 See Mayne (1909), p. 169 for a contemporary description that complements Turner's painting. Two representations of such processions, which Turner could have known, appear in Pinelli (1819), which would have been in the print shops in Rome at the time of his visit, and Hullmandel (1818), a book which Turner made a note about in his *Route to Rome* sketchbook (see Chapter 1, note 41).
72 Blunt (1823), *passim*; Hazlitt (1932), p. 216; Matthews (1822), vol. 1, pp. 101-4, 158; Morgan (1821), vol. 2, p. 328.
73 W, 727, 730, 731. See Gage (ed.) (1980), pp. 237-8; Shanes (1979), pp. 12-13. For the proposed book on Italy, see *Athenaeum*, no. 84, 3 June 1829, p. 347; *Literary Gazette*, no. 646, 6 June 1829, p. 379.
74 R, 319-21.
75 *Remarks*, 96-5.
76 Turner had also noted Claude's blue-clad figure in his sketch (see here, Plate 71). However, the dress of Turner's *contadina* also corresponds to what could actually be seen in the Alban hills. In 1815 at Velletri Samuel Rogers saw 'Many women in red bodice & blue petticoat, & white head-dress flat as a tile' (Hale (ed.), 1956, p. 273). Turner himself had sketched and written notes on the costumes of the peasant women near Albano in 1819 (see *ANR*, 1a, 2a (showing a skirt marked 'Blue'), 16a (showing a bodice marked 'Red'), 35, 88).
77 See the *Keepsake for 1829*, pp. 80-100. Mary Shelley recounts the story of Maria, a nun of the S. Chiara convent in Rome, and her younger sister, Anina, who loves the brigand Domenico. Her story had all the ingredients to appeal to the romantic imagination: secret meetings of lovers; encounters between soldiers and bandits; disguises, kidnappings and rescues; illness, suffering and death.
78 See Graham (1821), pp. 154-5 and plate opposite p. 208, 'Costume of the Brigands'.
79 Gilchrist (1855), vol. 1, p. 109. It was for Urban VIII that Claude had painted his *Lake Albano and Castel Gandolfo*.
80 Graham (1821), pp. 2-3, 231-7.
81 Sass (1818), p. 138; Gilchrist (1855), vol. 1, p. 72; Matthews (1822), vol. 1, pp. 193-4; Hazlitt (1932), pp. 253-6.
82 *Ibid.*, pp. 199, 253.
83 Wells (1974), pp. 102-7; Robertson (1978), pp. 251-60; Eastlake (1870), pp. 94-5 and 101-2.
84 See Moore (1853), p. 70; Wilkie, letter to Perry Nursey, 28 December 1819, BM, Add. MS 29,991 but cf. Holland (1851), p. 113; Whitley Papers, BM, P&D, vol. XII, T, p. 1567.
85 Mrs Uwins (1858), vol. 1, p. 249; vol. 2, pp. 129-30.
86 1824, no. 185, by D. Dighton; 1832, no. 259, by J. M. Crossland.
87 E.g. 1831, nos 556 and 616.
88 *The Sisters: Literary Gazette*, nos 669, 670 and 671; 14, 21 and 28 November 1829, pp. 749, 765, 781. *Fra Diavolo*: Loewenberg (1978), cols 723-4.

89 Graham (1821), p. 155.
90 Forsyth (1816), p. 120; *Literary Gazette*, nos 142-3; 9 and 16 October 1819, pp. 650-1 and 668-9.
91 Graham (1821), p. 33
92 These four paintings are today at Woburn Abbey, Glasgow Art Gallery and Museum, Leicester City Art Gallery and Cardiff City Hall. Others by Turner's friends on similar themes were RA, 1828, no. 326; 1829, 224, 293; 1830, 285, 381; 1831, 154; 1832, 319, 332.
93 TB CCLXXX, 143-61, 163-7, 193; W, 1152-76. The engravings are R, 348-72.
94 See Hale (ed.) (1956).
95 See Powell (1983).
96 Dyce (ed.) (1887), pp. 157-8.
97 Clayden (1889), vol. 2, p. 127.
98 John Mitford, Notebooks, vol. IX, BM, Add. MS 32,567, f. 265.
99 Finberg (1961), p. 331.
100 Hale (ed.) (1956), pp. 182, 144.
101 Letter of 23 October 1814 (John Murray archives).
102 TB CCLXXX, 149.
103 TB CCLXXX, 146.
104 TB CCLXXX, 163, 193.
105 Rogers (1830), pp. 102-5.
106 TB CCLXXX, 88, 92, 95, 103, 151.
107 Hamerton (1895), pp. 227-8.
108 Ruskin (1903-12), vol. III, pp. 242-3, 307.
109 See *ibid.*, pp. 315; 383-4, 385, 386, 389-90; 429-30, 434, 457-8.
110 TB CCLXXX, 161; *SRCSt*, 1, 44, 47, 48. TB CCLXXX, 166; *T and R*, 78a; *T*, 37, 44-5.
111 TB CCLXXX, 160, 156. *SRCSt*, 9; *R and F*, 30a (but note the dark-clad figure in the foreground of a view from a similar spot: *R and F*, 84).
112 Goodall (1902), pp. 4-5.
113 Clayden (1889), vol. 2, p. 4; Curwen (1873), pp. 352-3.
114 *Athenaeum*, no. 170, 29 January 1831, pp. 75-6.
115 Ruskin (1903-12), vol. XXXV, p. 79.
116 Clayden (1889), vol. 2, p. 5.

Chapter 9 Return to Rome, 1828

1 *O to M, L to M, M to G, C of G, G and F, F to O, V and R* (used on the outward journey); *RTM* and *Ro to Ri* (used in Rome and on the return journey); *Ro and Fr* (used throughout the visit). For full details, see Finberg (1909). In 1909 Finberg named TB CLXXVIII, 'Rimini to Rome', believing it to record Turner's 1819 journey to Rome. Later he changed its title to *Rome to Rimini*, having realised that it in fact relates to Turner's homeward journey in January 1829 (1961, p. 312).
2 *Ro and Fr*, 49a; Gage (ed.) (1980), pp. 118-19.
3 *Ibid.*, p. 119.
4 For more details of this journey, see Paris: Centre Culturel du Marais (1981), pp. 259-300.
5 Gage (ed.) (1980), p. 119.
6 [Beste] (1828), p. 288; Bolton (1927), p. 254.
7 *L to M*, 45; 43a-4, 45a-7.
8 Gage (ed.) (1980), p. 119.
9 Hazlitt (1932), p. 227; Sass (1818), p. 89.
10 *V and R*, 35a-6, 40a, 29; *Ro and Fr*, 47, 50a-1, 55.
11 *V and R*, 14-20.
12 *G and F*, 72a, 82, 84a-5, 86a-8a.
13 See [Beckford] (1834), vol. 1, pp. 192-6; Richardson (1754), p. 327.
14 *G and F*, 31, 59a, 60, 55. Turner was soon to depict S. Maria della Spina again, in a vignette for the 1832-3 edition of the *Works of Lord Byron* (W, 1219); this was based on a sketch by William Page.
15 Notes on *Ro and Fr*, 38a-9; also 39a (the interior of the Campo Santo) and 38 (the useful phrase 'Sarebbe possibile di vedere i quadri').
16 Sass (1818), pp. 79-83; Hale (ed.) (1956), p. 24; Gotch (1937), p. 273.

17 Turner's list is similar to that in the 6th edn (1828, pp. 95-6); he later owned the 7th edn (1829). In the 1830s William Collins regarded Starke as the 'Delphic oracle' of his travelling party in Italy (1848, vol. 2, p. 69).
18 *G and F*, 2a, 3, 18, 38a, 39, 44, 71, 71a, 74, 76a-81.
19 *F to O*, 15, 10a, 16, 17.
20 *F to O*, 30a-7 *passim*; Gage (ed.) (1980), p. 123.
21 Starke (1820), p. 227 and (1828), p. 130; Gage (ed.) (1980), p. 123.
22 *Ibid.*
23 Artaria (1834), p. 348; [Pasquin] (1839), p. 616. Modern scholarship upholds this tradition, which goes back to Vasari (see Hirst, 1981).
24 Richardson (1754), p. 291; Starke (1815), vol. 1, p. 267.
25 *V and R*, inside back cover, inside front cover, 4a, 5, 7a, 43, 45a, 46a. Turner had already studied the work of Vignola in connection with his Perspective Lectures (see e.g., TB CXIV, *Windmill and Lock*, c. 1810-11, 12, 13a).
26 Gage (ed.) (1980), p. 119.
27 Eastlake (1870), pp. 117-33.
28 BM, Add. MS 50,119, f. 1
29 Mrs Uwins (1858), vol. 2, p. 296.
30 Gage (ed.) (1980), p. 119.
31 Letter in Plymouth City Museum and Art Gallery (typed copy in the National Gallery, London).
32 Gage (ed.) (1980), p. 120.
33 Layard (1906), p. 211.
34 Letter to N. G. Philips, 10 February 1829, in Thornbury (1899), vol. 5, p. 148.
35 Thornbury (1862), vol. 1, p. 221. For a hint of the discomforts that led Turner to move from 12 Piazza Mignanelli, see Gotch (1937), p. 279.
36 *London Magazine*, vol. 1, no. 3, March 1820, p. 291. Public disappointment was aggravated by misleading press reports that Turner had been commissioned 'to paint the most striking views of Rome' for the Prince Regent (*Literary Gazette*, no. 148, 20 November 1819, p. 747).
37 Eastlake (1870), pp. 95-6, 111. This painting is now at Chatsworth.
38 *Notizie del Giorno*, no. 50, pp. 3-4. Cf. the similar notes on Turner himself inside the back cover of *Ro to Ri*; these also include the phrases 'Pittore celebrissimo Inglese' and 'Professore di Prospettiva'.
39 *Diario di Roma*, no. 101, p. 23.
40 Thornbury (1862), vol. 1, p. 221.
41 See Eastlake's letter to N. G. Philips: Thornbury (1899), vol. 5, p. 148.
42 Joseph Severn to Thomas Uwins: Mrs Uwins (1858), vol. 2, p. 241. Cf. Andrew Geddes to John Sheepshanks: Laing (1875), p. 22.
43 Broughton (1910), vol. 3, pp. 294-5.
44 Thornbury (1899), vol. 5, p. 148. See also Mrs Uwins (1858), vol. 2, p. 239.
45 Gotch (1937), pp. 279-80; Robertson (1978), p. 36.
46 B & J, 134, 234, 102, 125.
47 *F to O*, 32, 32a, 33, 37, 37a (bridges); 30a, 34 (fountains). Note, in this last sketch, the woman in the hitched-up skirt.
48 See B & J, 332.
49 Ziff (1980), p. 169.
50 Rogers (1830), pp. 175-6.
51 *Ibid.*, p. 176, fn.
52 Gage (ed.) (1980), pp. 120-1, 130-2 (which mentions 'Mr and Mrs Severn').
53 Begun c. 1825 and today in the Royal Palace in Brussels. According to Sharp (1892, pp. 151-2), a second version belonged to the Marquis of Lansdowne. See Mrs Uwins (1858), vol. 2, pp. 241-2.
54 For all Turner's sketches after Claude, see Ziff (1965).
55 Ruskin (1903-12), vol. III, p. 241; Thornbury (1862), vol. 1, p. 330; Wornum (n.d.), p. 182.
56 R, 649 (*Ancient Carthage — The Embarcation of Regulus*, engraved by Daniel Wilson, 1840); 723 (*Regulus Leaving Carthage*, engraved by S. Bradshaw, 1859).

57 *Oxford Classical Dictionary*; Goldsmith (1769), vol. 1, pp. 243-7. In modern times doubt has been cast on parts of this story, but it is told here as it was generally known in Turner's day.

58 E.g. the prints by Hans Sebald Beham, illustrating Valerius Maximus, and C. Mansion, illustrating Boccaccio's *I casi degli huomini illustri* (French edn of 1476).

59 BI, 1816, no. 93; 1828, no. 18.

60 Wilson's painting was in Ireland throughout Turner's lifetime and no variants or engravings after it are known, but Turner could well have been aware that Wilson had painted this particular subject in Rome.

61 Millar (1969), p. 131 (no. 1152, plate 121). BI, 1824, no. 143; 1833, no. 15.

62 E.g. Charles Thévenin (Ecole des Beaux-Arts, Paris); L. Lafitte (Ecole des Beaux-Arts, Paris); Jacques-Augustin Pajou (1793 Salon); Camuccini (*Le Storie di Attilio Regolo*, 1811 for the Casa Capelletti; *Il Congedo di Attilio Regolo*, 1824, Palazzo Altieri); Raffaele Possiglione (Museo di Capodimonte, Naples).

63 Mix (1970), pp. 61-2.

64 Vol. II, inside front cover.

65 TB CXXIII, 90a.

66 Gage (1969), p. 143.

67 See *ibid.*, p. 169. The red and yellow can still be discerned today beneath the lighter pigments of 1837.

68 *Literary Gazette*, no. 1046, 4 February 1837, p. 74.

69 Lady Morgan (1821), vol. 2, p. 152.

70 E.g. those by Georg Pencz, Ripanda, Antonio Fantuzzi, Nuremberg School (1521) (Photographic Library, Warburg Institute, s.v. 'Regulus').

71 What is more, the appearance of both Rosa's *Regulus* and Wilson's at the BI on no less than four occasions between 1816 and 1833 may well have contributed to Turner's later decision to exhibit his own *Regulus* there rather than on his more usual ground, the RA.

72 Weston (1819), p. 170. By then, however, the painting had actually left the Colonna palace for the Earl of Darnley's collection, so Turner would not have seen it in Rome.

73 Quoted by Gage (1969), p. 104.

74 Thornbury (1862), pp. 319-20.

75 Euripides, *Medea*, lines 780-9 merely constitute a statement of intent; Seneca, *Medea*, lines 740-842.

76 *V Fr*, 49a.

77 Recently, however, Mayr has inspired the foundation of the 'Mayr+Donizetti Collaboration' by John Allitt and Ian Caddy and his works are beginning to be performed, broadcast and recorded. See Allitt (1985).

78 Loewenberg (1978), col. 635.

79 *Gentleman's Magazine*, July 1826, vol. 96, p. 71; *The Times*, 24 July 1826, p. 2, col. f; *New Monthly Magazine*, 1 July 1826, vol. 18, pp. 279-80; 1 August, 1 September 1828, vol. 24, pp. 344, 393.

80 Monkhouse (1879), pp. 84, 68; Falk (1938), p. 40.

81 See Livermore (1957a), pp. 170-9; Gage (ed.) (1980), pp. 83, 222; Lindsay (ed.) (1966), poems 37, 56. A sketch of the 1790s (TB XLIV, *Miscellaneous*, W) has recently been reidentified as depicting the King's Theatre, Haymarket.

82 Smollett (1806), p. 460.

83 *M to V*, 1a; TB CCCXVIII, *Venice: Miscellaneous*, 4, 17, 18.

84 Sadie (1980), vol. 14, p. 287.

85 Stendhal (1970), chapter 35 and (1975), *passim*. See also the frequent references to her in the volumes of his correspondence. Cornwall (1851), pp. 173-4. Hazlitt (1902-6), vol. 7, pp. 324-35 and vol. 11, pp. 381-4.

86 *Ibid.*, vol. 7, p. 329. Conversely, classical sculpture could — and did — remind viewers of Pasta: the Niobid group in the Uffizi led Stendhal's thoughts to her portrayal of Medea about to kill her children (1959a, p. 169).

87 See, e.g., *Literary Gazette*, no. 642, 9 May 1829, p. 309; no. 653, 25 July 1829, p. 492; no. 697, 29 May 1830, p. 356; no. 699, 12 June 1830, pp. 389-90.

88 *New Monthly Magazine*, 1 March 1831, vol. 33, p. 119.

89 *Literary Gazette*, no. 747, 14 May 1831, p. 317; *ibid.*, no. 746, 7 May 1831, p. 299; *New Monthly Magazine*, 1 June 1831, vol. 33, p. 259; *Gentleman's Magazine*, May 1831, vol. 101, p. 448.

90 See also *The Times*, 13 May 1831, p. 3, col. b. Her impact was equally great on those who had not seen her Medea, e.g. the young Fanny Kemble (see Kemble, 1878, vol. 3, pp. 18, 84).

91 Leigh Hunt's *Tatler* article of 13 May 1831 is reprinted in Houtchens and Houtchens (ed.) (1950), pp. 267-9.

92 These paintings were RA, 1827, no. 427, *Madame Pasta, as Medea* by John Hayter, present whereabouts unknown. RA, 1828, no. 241, *Madame Pasta as Medea* by H. Singleton, present whereabouts unknown. The RA of 1827 also included *Madame Pasta* by Miss Hayter (no. 686). BI, 1828, no. 298, *Medea* by John Hayter (possibly identical to RA, 1827, no. 427). RA, 1832, no 68, *Medea meditating the Murder of her Children 'Miseri pargoletti'* by Henry Howard, present whereabouts unknown (the reference is to a particularly celebrated moment and aria in the opera), also exhibited at the BI in 1833 (no. 147). John Hayter exhibited another *Medea* (with different measurements from his 1828 exhibit) at the BI in 1833 (no. 107).

 For a greater range of artistic and literary references to Pasta, see the more detailed accounts in Powell (1982a) and (1984). A particularly nice reference occurs in Emily Eden's *The Semi-attached Couple* (written *c.* 1830 and recently reissued). The fiercely controlled anger of a female character is evoked simply by the words, 'She resembled very much Pasta, in *Medea*' (1979 Virago edn, p. 145).

93 For reviews of the lithographs see *Literary Gazette*, no. 496, 22 July 1826, p. 461; no. 537, 5 May 1827, p. 284. A set of the lithographs is owned by the author; one was reproduced in Powell (1982a).

94 On this point see Powell (1982a).

95 [Romani] (1826), p. 45.

96 Gage (1968), p. 681, referring to B & J, 451.

97 [Romani] (1826), Act II, scenes iv and v; Act II, scene xiv.

98 *DNB* entry for J. B. Lane; *Gentleman's Magazine*, July 1828, vol. 98, ii, pp. 61-2; *New Monthly Magazine*, 1 May, 1 July 1828, vol. 24, pp. 207, 298-300. The painting was exhibited at the King's Mews, Charing Cross.

99 Richard Westmacott the younger, letter to N.G. Philips, 28 July 1831, in Thornbury (1899), vol. 7, p. 70.

100 Visconti (1827).

101 Turner's use of verses from the *Fallacies of Hope* to accompany paintings treating the subjects of Love and War picks up two important themes in Campbell's poem, while there are also echoes in the presentation of these themes; compare, for example, Turner's verses accompanying *Hannibal crossing the Alps* and Campbell's passage in Part I on the capture of Warsaw and the massacre at Prague. Turner's *Vision of Medea* is (*inter alia*) a spirited riposte to Campbell's lines in Part II:

 While Memory watches o'er the sad review
 Of joys that faded like the morning dew;
 Peace may depart — and life and nature seem
 A barren path, a wildness, and a dream!
 But can the noble mind for ever brood,
 The willing victim of a weary mood . . .
 (1837, p. 24)

102 However, B & J note that the canvas on which it is painted is not the same type as those of the other pictures painted in Rome.

103 BM, Add. MS 50,119.

104 See Davies (1959), p. 102.

105 This point is discussed in Powell (1984), p. 331.

106 As Turner himself knew perfectly well from Eustace (1813, vol. 1, p. 449); cf. Turner's own note in *It. guide book*, 12.

107 Virgil, *Aeneid*, VII, 683-5 (see Ruskin, 1903-12, vol. XXXVI, pp. 441-2); Horace, *Odes*, III, iv, 21-4 (the same ode that had supplied Turner with 'liquidae placuere Baiae' in 1823).

108 Tate Gallery, London. B & J, 296-8.

109 Gage (1968), p. 679, n. 21.

110 *Ro to Ri*, 46a.

111 Tate Gallery, London. B & J, 299-301.

112 Tate Gallery, London. B & J, 303-16.

113 In particular, B & J, 307.

114 B & J, 305.

115 B & J, 299. For Mount Soracte see *V and R, passim*, together with Powell (1984), Appendix 2.

116 Civita is not mentioned in Starke (1828) but it is noted in Starke (1836): it crept on to the tourist map just after Turner had discovered it. The sketches on which he based his painting must have been on the lost pages of *F to O*; those connected with it by B&J in *V and R* actually depict Mount Soracte.

117 Tate Gallery, London. B & J, 318-27.

118 Thornbury (1862), vol. 1, pp. 231-2.

119 Furthermore, Turner's list on *Ro and Fr*, 2a, of good viewpoints around Rome (Villa Lante, Villa Mellini, Villa Doria Pamphili, Villa Madama) may well be connected with his earlier deliberations concerning a good place from which to sketch Munro's view.

120 *V and R*, 23, 32a-3, 33a (around the Forum); *Ro and Fr*, 30, 31a-2, 33, 34a, 35, 35a (Tivoli and its neighbourhood).

121 Gage (ed.) (1980), pp. 122-3.

122 *Ibid.*

123 *Ibid.*, pp. 120, 132.

124 Wells (1974), p. 192.

125 Williams (1831), vol. 2, p. 241; Laing (1875), p. 23.

126 Leslie (1860), vol. 2, p. 205.

127 Laing (1875), p. 23; Vaughan (1979), pp. 35-40; Mrs Uwins (1858), vol. 1, pp. 174, 181, 264; vol. 2, pp. 182, 331; Cunningham (1843), vol. 2, pp. 199, 223, 277-8. *Middlemarch*, Book II, chapters 19-22.

128 *Ro to Ri*, 1.

129 Gage (ed.) (1980), p. 124.

130 Eastlake to Harman, letter of 14 February 1829 (City Museum and Art Gallery, Plymouth, typed copy in the National Gallery, London).

131 Gage (ed.) (1980), p. 127; see also p. 125.

132 Here quoted from BM, Add. MS 50,119, in order to preserve the correct sequence.

133 *Ibid.*

134 Michaelis (1882), p. 600.

135 *RTM*, inside front cover; W, 405; Finberg (1961), p. 311; Gage (ed.) (1980), pp. 125-6. The analysis of Turner's journey in Paris: Centre Culturel du Marais (1981) should be viewed with extreme caution.

136 *Ro and Fr*, 8a-9, partially transcribed in Gage (1968), p. 682.

137 Sotheby was friendly with many of Turner's associates, including Rogers, Scott, Moore and Lawrence.

Chapter 10 Past and present: Turner's Italy in the 1830s

1 Gotch (1937), p. 280; Gage (ed.) (1980), pp. 128, 131.

2 Gotch (1937), p. 280; Gage (ed.) (1980), p. 132.

3 *Ibid.*, p. 127.

4 *La Belle Assemblée*, vol. 13, January-June 1831, p. 289; Hamerton (1895), p. 257.

5 *Fraser's Magazine*, vol. 5, February—July 1832, p. 717; Thornbury (1862), vol. 1, p. 320; Hamerton (1895), pp. 257-8.

6 See B & J, notes on 302-17.

7 National Gallery of Canada, Ottawa. B & J, 367. See Kitson (1983), p. 14.

8 Finberg (1961), pp. 330-1.

9 Tate Gallery, London. B & J, 369.

10 Tate Gallery, London. B & J, 433.

11 E.g. LV, 65, 81, 190.
12 Röthlisberger and Cecchi (1975), no. 129. LV, 65.
13 Ziff (1963a), p. 144.
14 T and R, 32a-5a; G to N, 80-90; A to R, 37a; SRCSt, 44, 47-8; R, 162. Ruskin (1903-12), vol. XIII, p. 145.
15 Chubb (1981), pp. 417-18.
16 T and R, 9a-13, 36a-9; ANR, 69a; NRCSt, 35; ANR, 27.
17 Gage (ed.) (1980), pp. 86-8.
18 Ziff (1963a), p. 147; ANR, 15a, 26a, 28a-9, 58.
19 Solkin (1983), p. 407 and plates 15 and 16.
20 Chubb (1981), p. 418 and n. 6.
21 Quoted by Solkin (1983), p. 407.
22 Chubb (1981), p. 418; TB CCCLXVI, p. 19.
23 Ziff (1963a), pp. 146-7.
24 Chubb (1978), part 2, chapter 4, n. 25.
25 Herrmann (1975), p. 47.
26 Gage (1983), pp. 59-60; Gage in Paris: Grand Palais (1983), pp. 132-3.
27 London: Hayward Gallery (1978) p. 24.
28 The 1830s references are noted under B & J, 342, 369; Gage (1969), pp. 169-70.
29 Bendiner (1983), pp. 69 and 79, n. 18.
30 The phrase comes from Hamerton (1895, p. 257).
31 As Gage has already pointed out (1974, p. 82), Turner adopted the popular view that Caligula's bridge had been a permanent structure rather than a temporary one; he shows it as being built of stone rather than as a bridge of boats, and he also conflates it with another structure nearby, the mole separating the Lucrine Lake from the sea.
32 Anderson (ed.) (1792-5), vol. 9, p. 245.
33 Ibid., pp. 251-2.
34 Beaverbrook Foundations, on loan to the Beaverbrook Art Gallery, Fredericton, New Brunswick. B & J, 354, 376.
35 Livermore (1975b), pp. 81-2.
36 Ibid., p. 81.
37 Eustace (1813), vol. 1, chapters 10-17; Sass (1818), chapters 8-9.
38 Eustace (1813), vol. 1, p. 207. The study of Rome by regions was criticised not only by Eustace but also by another very influential writer, Forsyth (1816, p. 130). Forsyth was one of the sources used by Hakewill for the

letterpress of his Picturesque Tour of Italy, and many people, including Shelley, regarded his Remarks on Antiquities as superior to Eustace's Tour (see Jones (ed.), 1964, vol. 2, pp. 54, 89).
39 On these paintings see Lister (ed.) (1974), pp. 109, 120, 122, 123, 124, 127. Palmer later heard from John Linnell about Turner's exhibits at the 1838 RA and was keen to know 'the point of difference' between the two scenes: 'was it in the figures or buildings or both?' (ibid., p. 152). Unfortunately Lister does not give Linnell's reply.
40 Anderson (ed.) (1792-5), vol. 9, p. 243.
41 Gage (1968), p. 682, n. 38; Gage (1983), p. 58.
42 Blunt (1823), pp. 21-4, 31.
43 Sass (1818), p. 86.
44 Gage (ed.) (1980), p. 185; Rawlinson (1908-13), vol. 2, p. 340.
45 RA, 1824, no. 482; Mrs Uwins (1858), vol. 2, p. 26 (c. 1827); RA, 1829, no. 298, and see Wilkie in Cunningham (1843), vol. 2, p. 194. There were also a number of pifferari scenes at the BI: 1831, nos 27 and 379; 1833, no. 470; 1834, no. 335; 1835, no. 208.
46 See, e.g., RA, 1830, nos 8, 18, 38, 44, 113, 233, 285, 381, 525, 599, 987. During the 1830s there were nearly always 20-30 Italian genre scenes of this type every year at the RA.
47 The pifferari figure very prominently indeed in contemporary travel literature; if they were quaint and picturesque to the eye, they were far from easy on the ear. Rogers in Hale (ed.) (1956), p. 224; Matthews (1822), vol. 1, p. 145; Lady Morgan (1821), vol. 3, pp. 7-8; Stendhal (1959a), pp. 78-9.
48 Vol. III, no. 16, May 1832, pp. 421, 422.
49 Such editions appeared in 1839, 1844, 1856, and probably several other years as well.
50 RA, 1832, no. 36; 1837, no. 275; 1840, no. 909; 1841, nos 384 and 410. See also RA, 1835, nos 1006 and 1066; 1838, no. 494; 1840, no. 786.
51 See The Byron Gallery (1833); Brockedon (ed.) (1833).
52 From 1825 to 1840, nearly fifty paintings with Byron subjects and/or quotations were exhibited at the RA, whereas between 1815 and 1824 there had been only about a dozen such works there.
53 Turner's 1820s illustrations for engraving in Lord

Byron's Works (1825) are W, 1211-18; his illustrations for the 1832-3 edition are W, 1219-35.
54 RA, 1819, no. 922, Evening: Moon-rising by 'R.T.'; 1822, no. 173, Evening: Pirates landing their cargo, and a female captive by A. B. Johns; 1829, no. 295, Scene on the river Aar, near Thun, Switzerland — twilight by S. J. Stump.
55 Quoted in the entries for B & J, 365-7.
56 Ruskin (1903-12), vol. III, pp. 241-3.
57 Ibid., vol. XXXV, pp. 140, 193, 270-1, 272.
58 George Eliot, Middlemarch, Book II, chapter 20. Ruskin (1903-12), vol. XXXV, p. 276. See also his denigration of Rome as an artistic centre (vol. III, p. 83) and his regret at the influence of Italy upon Wilson (vol. III, p. 189).
59 Kitson (1983), p. 14. See B & J's entry for 230.
60 Ruskin (1903-12), vol. XIII, pp. 127-31.

Epilogue: Turner and the south

1 Goethe (1985), pp. 139, 149.
2 Ibid., pp. 137, 188, 175, 129, 139, 174, 347, 345, 154. For the relationship between Goethe's thought and Turner's in an entirely separate area, that of colour, see the various discussions of B & J, 404 and 405 and, most recently, Gage (1984).
3 See Ziff (1963a).
4 See under B & J, 337, 342, 365-7, 374-5, 378-9, 381, 387-8.
5 Whitley (1930), p. 213.
6 Quoted by Reynolds (1969), p. 150 and by B & J under 388.
7 Or, for Protestants, one from the Apocrypha.
8 Tate Gallery, London; Tate Gallery, London; Frick Collection, New York. B & J, 340, 349, 350.
9 For further detailed discussion of Turner and Watteau, see Whittingham (1985).
10 Hamerton (1895), p. 171.
11 Gage (1969), p. 93; Wilton (1979), p. 146; Ziff in Paris: Grand Palais (1983), p. 30.
12 For Turner as a sculptor, see Once a Week, vol. 6, 1 February 1862, p. 163. For his work as architect, see Youngblood (1982).
13 Ziff (1963a), p. 144.

Bibliography

Addison, Joseph (1705), *Remarks on Several Parts of Italy, &c. In the Years 1701, 1702, 1703*, London.

Allitt, John (1985), 'Mayr — a Composer due for Revival', *ILEA Arts Review*, Autumn, p.4.

Amelung, Walther (1903-8), *Die Sculpturen des Vaticanischen Museums*, 4 vols, Berlin.

Anderson, Robert (ed.) (1792-5), *A Complete Edition of the Poets of Great Britain*, 14 vols, London.

Armstrong, Sir Walter (1902), *Turner*, London.

Artaria, E. and P. (1834), *Nuovissima guida dei viaggiatori in Italia . . .*, 3rd edn, Milan, Mannheim, Vienna and Florence.

Ashby, Thomas (1925), *Turner's Visions of Rome*, London.

Batty, E. F. (1820), *Italian Scenery. From Drawings made in 1817, By Miss Batty*, London.

[Beckford, William] (1834), *Italy: with Sketches of Spain and Portugal*, 2 vols, London.

De Beer, G. R. (ed.) (1951), *A Journey to Florence in 1817* by Harriet Charlotte Beaujolois Campbell, London.

Bell, C. F. (1903), 'Turner and His Engravers', in Charles Holme (ed.), *The Genius of J. M. W. Turner*, London, Paris and New York.

Bell, John, (1825), *Observations on Italy*, Edinburgh and London.

Bendiner, Kenneth (1983), 'David Roberts in the Near East: Social and Religious Themes', *Art History*, vol. 6, no. 1, March, pp. 67-81.

Berry, Mary (1865), *Extracts of the Journals and Correspondence of Miss Berry*, ed. Lady Theresa Lewis, 3 vols, London.

[Beste, H. D.] (1828), *Italy as It Is*, London.

Blunt, Anthony and Friedlander, Walter (1974), *The Drawings of Nicolas Poussin*, catalogue raisonné, vol. 5, London.

Blunt, Rev. John James (1823), *Vestiges of Ancient Manners and Customs, discoverable in Modern Italy and Sicily*, London.

Bolton, Arthur T. (ed.) (1927), *The Portrait of Sir John Soane, R.A.*, London.

Britton, John (1834), *Brief Memoir of Sir John Soane, R.A. F.R. & A.S. Professor of Architecture, in the Royal Academy, etc. etc. etc.*, London.

Brockedon, W. (ed.) (1833), *Finden's Landscape and Portrait Illustrations, to the Life and Works of Lord Byron*, 3 vols, London.

Broughton, Right Hon. Lord (1859), *Italy: Remarks made in Several Visits from the Year 1816 to 1854*, 2 vols, London.

Broughton, Right Hon. Lord (1910), *Recollections of a Long Life*, 4 vols, London.

Butlin, Martin and Joll, Evelyn (1977; revised edn 1984), *The Paintings of J. M. W. Turner*, 2 vols, New Haven and London.

Byron, Lord (1832-3), *Works of Lord Byron*, 17 vols, London.

The Byron Gallery; a Series of Historical Embellishments to Illustrate the Poetical Works of Lord Byron (1833), London.

Campbell, Thomas (1837), *The Poetical Works of Thomas Campbell*, London.

Carpegna, Nolfo di (ed.) (1957), *Catalogue of the National Gallery, Barberini Palace, Rome*, Rome.

Chubb, W. J. J. (1978), 'J. M. W. Turner's History Paintings', MA Report, Courtauld Institute of Art.

Chubb, William (1981), 'Turner's "Cicero at his Villa"', *Burlington Magazine*, vol. CXXIII, no. 940, July, pp. 417-21.

Clayden, P. W. (1889), *Rogers and His Contemporaries*, 2 vols, London.

Collins, W. Wilkie (1848), *Memoirs of the Life of William Collins, Esq., R.A.*, 2 vols, London.

Comandini, Alfredo (1900-1 and 1902-7), *L'Italia nei cento anni del secolo XIX, giorno per giorno illustrata, 1801-1825* and *1826-1849*, Milan.

Conder, Josiah (1831), *Italy*, 3 vols, London.

Constable, W. G. (1953), *Richard Wilson*, London.

[Cooke, W. B.] (1821), *Exhibition of Engravings, by Living British Artists . . .*, London.

——— (1822), *Exhibition of Drawings, No. 9, Soho-Square, 1822*, London.

——— (1824), *Exhibition of Drawings, No. 9, Soho-Square 1824*, London.

Cornwall, Barry (1851), *English Songs, and Other Small Poems*, London.

Cotton, William (ed.) (1859), *Sir Joshua Reynolds' Notes and Observations on Pictures, . . . being Extracts from his Italian Sketch Books . . .*, London.

Coxe, Henry (1818), *A Picture of Italy . . . (1815)*, 2nd edn, London.

Cunningham, Allan (1843), *The Life of Sir David Wilkie*, 3 vols, London.

Curwen, Henry (1873), *A History of Booksellers. The Old and the New*, London.

Dalmazzoni, Angelo (1803), *The Antiquarian or the Guide for Foreigners to go the Rounds of the Antiquities of Rome*, Rome.

Davies, Martin (1959), *National Gallery Catalogues: The British School (1946)*, 2nd edn, London.

Davy, Sir Humphry (1858), *Fragmentary Remains*, ed. John Davy, London.

Dickens, Charles (1908), *American Notes (1842)* and *Pictures from Italy (1846)*, London and New York.

Dyce, Alexander (ed.) (1887), *Recollections of the Table-Talk of Samuel Rogers*, New Southgate.

Eastlake, C.L. (1870), *Contributions to the Literature of the Fine Arts, Second Series, with a Memoir compiled by Lady Eastlake*, London.

[Eaton, Mrs C.A.] (1820), *Rome in the Nineteenth Century*, 3 vols, Edinburgh.

Egger, Hermann (1931), *Römische Veduten*, Vienna.

Eustace, Rev. John Chetwode (1813), *A Tour through Italy . . .*, 2 vols, London.

Falk, Bernard (1938), *Turner the Painter: His Hidden Life*, London.

Farr, Dennis (1958), *William Etty*, London.

Finberg, A. J. (1909), *A Complete Inventory of the Drawings of the Turner Bequest*, 2 vols, London.

——— (1910), *Turner's Sketches and Drawings*, London.

——— (1930), *In Venice with Turner*, London.

——— (1961), *The Life of J. M. W. Turner, R.A. (1939)*, 2nd edn, Oxford.

[Florence, SS. Annunziata] (1864), *Il tesoro degli affreschi toscani con illustrazione, vol. 1, Gli affreschi dei chiostri della SS. Annunziata di Firenze*, Florence.

[Florence, Uffizi] (1810), *La Galerie impériale de Florence*, Florence.

——— (1819), *Galerie impériale et royale de Florence*, new edn, Florence.

Ford, Brinsley (1948), 'The Dartmouth Collection of Drawings by

Richard Wilson', *Burlington Magazine*, vol. XC, no. 549, December, pp. 337-45.

Forster-Hahn, Franziska (1967), 'The Sources of True Taste: Benjamin West's Instructions to a Young Painter for his Studies in Italy', *Journal of the Warburg and Courtauld Institutes*, vol. 30, pp. 367-82.

Forsyth, Joseph (1816), *Remarks on Antiquities, Arts, and Letters during an Excursion in Italy, in the years 1802 and 1803* (1813), 2nd edn, London.

Gage, John (1968), 'Turner's Academic Friendships: C. L. Eastlake', *Burlington Magazine*, vol. CX, no. 789, December, pp. 677-85.

——— (1969), *Colour in Turner: Poetry and Truth*, London.

——— (1974), 'Turner and Stourhead: the Making of a Classicist?', *Art Quarterly*, vol. XXXVII, no. 1, Spring, pp. 59-87.

——— (ed.) (1980), *Collected Correspondence of J. M. W. Turner*, Oxford.

——— (1982), 'Turner and the Greek Spirit', *Turner Studies*, vol. 1, no. 2, pp. 14-25.

——— (1983), Picture Note on *Ancient Italy — Ovid banished from Rome, Turner Studies*, vol. 3, no. 1, pp. 59-60.

——— (1984), 'Turner's Annotated Books: Goethe's *Theory of Colours*', *Turner Studies*, vol. 4, no. 2, pp. 34-52.

Genlis, Madame de (1829), *Manuel du Voyageur*, new edn, London.

George, Hardy (1971), 'Turner in Venice', *Art Bulletin*, LIII, pp. 84-7.

Gilchrist, Alexander (1855), *Life of William Etty, R.A.*, 2 vols, London.

Goethe, J. W. (1985), *Italian Journey (1786-1788)* trans. W. H. Auden and Elizabeth Mayer, Harmondsworth.

Goldsmith, Oliver (1769), *The Roman History*, 2 vols, London.

Goodall, Frederick (1902), *The Reminiscences of Frederick Goodall, R.A.* London and Newcastle.

Gotch, Rosamund Brunel (1937), *Maria, Lady Callcott*, London.

Gowing, Lawrence (1966), *Turner: Imagination and Reality*, New York.

Graham, Maria (1821), *Three Months passed in the Mountains East of Rome, during the year 1819* (1820), 2nd edn, London.

Graves, R. J. (1863), *Studies in Physiology and Medicine* ed. W. Stokes, London.

Hakewill, James (1820), *A Picturesque Tour of Italy from Drawings made in 1816-1817*, London.

Hale, J. R. (ed.) (1956), *The Italian Journal of Samuel Rogers*, London.

Hamerton, P. G. (1895), *The Life of J. M. W. Turner, R.A.* (1879), London.

Hare, Augustus (1890), *Florence*, 3rd edn, London.

——— (1903), *Walks in Rome*, 16th edn, 2 vols, London.

Hartman, Geoffrey H. (1970), *Beyond Formalism: Literary Essays 1958-1970*, New Haven and London.

Haskell, Francis and Penny, Nicholas (1981), *Taste and the Antique: The Lure of Classical Sculpture 1500-1900*, New Haven and London.

Hazlitt, William (1902-6), *The Collected Works of William Hazlitt*, eds A. R. Walter and Arnold Glover, 13 vols, London.

——— (1932), *The Complete Works of William Hazlitt*, ed. P. P. Howe, vol. 10 (including *Notes of a Journey through France and Italy*), London.

Herrmann, Luke (1975), *Turner*, London.

Heywood, Robert (1919), *A Journey to Italy in 1826*, privately printed.

Hirst, Michael (1981), *Sebastiano del Piombo*, Oxford.

H., R. C. [Richard Colt Hoare] (1815), *Hints to Travellers in Italy*, London.

Hoare, Sir Richard Colt (1819), *A Classical Tour through Italy and Sicily*, 2 vols, London.

Holland, John (1851), *Memorials of Sir Francis Chantrey, R.A.*, Sheffield.

Houtchens, L. H. and Houtchens, C. W. (eds) (1950), *Leigh Hunt's Dramatic Criticism 1803-1831*, London and Oxford.

Hullmandel, C. J. (1818), *Twenty-four Views of Italy*, London.

Irwin, David (1979), *John Flaxman 1755-1826*, London.

Jaffé, Michael (1977), *Rubens and Italy*, Oxford.

[Jameson, A. B.] (1826), *A Lady's Diary*, London.

Jewitt, Llewellynn (1868), 'J. M. W. Turner. Some Interesting Relics connected with him', *Art Journal*, VII, p. 129.

Jones, Frederick L. (ed.) (1944), *The Letters of Mary W. Shelley*, 2 vols, Norman, Oklahoma.

——— (ed.) (1947), *Mary Shelley's Journal*, Norman, Oklahoma.

——— (ed.) (1964), *The Letters of Percy Bysshe Shelley*, 2 vols, Oxford.

Jones, George (1849), *Sir Francis Chantrey, R.A., Recollections of his Life, Practice, and Opinions*, London.

Jones, H. Stuart (ed.) (1912), *A Catalogue of the Ancient Sculptures preserved in the Municipal Collections of Rome. The Sculptures of the Museo Capitolino by members of the British School at Rome*, 2 vols, Oxford.

Jones, Thomas (1951), 'Memoirs of Thomas Jones', *Walpole Society*, vol. XXXII, 1946-8.

Keller, Enrico (1824), *Elenco di Tutti gli Pittori Scultori Architetti . . . esistenti in Roma l'anno 1824*, Rome.

Kemble, Frances Ann (1878), *Record of a Girlhood*, 3 vols, London.

Kennedy, Ruth Wedgwood (1938), *Alesso Baldovinetti*, New Haven.

Kitson, Michael (1964), *J. M. W. Turner*, London and New York.

——— (1983), 'Turner and Claude', *Turner Studies*, vol. 2, no. 2, pp. 2-15.

Laing, David (1875), *Etchings by Sir David Wilkie, R.A. . . . and by Andrew Geddes, A.R.A.*, Edinburgh.

Landseer, Thomas (ed.) (1871), *Life and Letters of William Bewick (Artist)*, 2 vols, London.

Langley, Michael (1979), 'A Pass from the King', *Illustrated London News*, Christmas issue, pp. 25-9.

Layard, George Somes (1906), *Sir Thomas Lawrence's Letter-Bag*, London.

Lemprière, J. (1767), *Bibliotheca Classica, or a Classical Dictionary . . .*, 3rd edn, London.

Leopardi, Giacomo (1953), *Canti*, Milan.

Leslie, C. R. (1860), *Autobiographical Recollections*, ed. Tom Taylor, 2 vols, London.

Levey, Michael (1957), 'Panini, St Peter's, and Cardinal de Polignac', *Burlington Magazine*, vol. XCIX, no. 647, February, pp. 53-4.

——— (1971), *National Gallery Catalogues: The Seventeenth and Eighteenth Century Italian Schools*, London.

Lindsay, Jack (ed.) (1966), *The Sunset Ship. The Poems of J. M. W. Turner*, Lowestoft.

Lister, Raymond (ed.) (1974), *The Letters of Samuel Palmer*, 2 vols, Oxford.

Lister, Raymond (1981), *George Richmond, A Critical Biography*, London.

Livermore, Ann Lapraik (1957a), 'Turner and Music', *Music and Letters*, April, vol. 38, pp. 170-9.

——— (1957b), 'J. M. W. Turner's Unknown Verse Book', *Connoisseur Year Book*, pp. 78-86.

Loewenberg, Alfred (1978), *Annals of Opera 1597-1940*, 3rd edn, London.

London: British Museum (1975), *Turner in the British Museum: Drawings and Watercolours*, ed. Andrew Wilton.

London: Hayward Gallery (1978), *Piranesi*, ed. John Wilton-Ely.

London: Kenwood (1974), *British Artists in Rome 1700-1800*, ed. Lindsay Stainton.

——— (1985), *Images of the Grand Tour: Louis Ducros 1748-1810*, Editions du Tricorne, Geneva.

London: Royal Academy and Tate Gallery (1974), *Turner 1775-1851*, eds Martin Butlin, John Gage and Andrew Wilton.

London: Tate Gallery (1982), *Richard Wilson*, ed. David H. Solkin.

London: Wildenstein (1982), *Souvenirs of the Grand Tour*, ed. Denys Sutton.

MacGeorge, A. (1884), *Wm. Leighton Leitch, Landscape Painter*, London.

Matthews, Henry (1822), *The Diary of an Invalid* (1820), 3rd edn, 2 vols, London.

Mayne, John (1909), *The Journal of John Mayne during a Tour on the Continent . . . 1814*, ed. John Mayne Colles, London.

Michaelis, A.T.F. (1882), *Ancient Marbles in Great Britain*, trans. C. A. M. Fennell, Cambridge.

Millar, Oliver (1969), *The Later Georgian Pictures in the Collection of Her Majesty the Queen*, 2 vols, London.

Mix, Erving R. (1970), *Marcus Atilius Regulus: Exemplum Historicum*, The Hague and Paris.

Moise, F. (1845), *Santa Croce di Firenze*, Florence.

Monkhouse, W. Cosmo (1879), *Turner*, London.

Moore, John (1781), *A View of Society and Manners in Italy . . .*, reprinted in *The Works of John Moore, M.D.*, 7 vols, ed. Robert Anderson, vol. 2, Edinburgh, 1820.

Moore, Thomas (1853), *Memoirs, Journal, and Correspondence of Thomas Moore*, ed. Lord John Russell, vol. 3, London.

——— (1854) and (1856), *Memoirs, Journal and Correspondence of Thomas Moore*, ed. Lord John Russell, vols 5, 6 and 7, London.

Morgan, Lady (1821), *Italy*, 3 vols, Paris.

——— (1824), *The Life and Times of Salvator Rosa*, 2 vols, London.

New Haven: Yale Center for British Art (1981), *Classic Ground. British Artists and the Landscape of Italy, 1740-1830*, ed. Duncan Bull.

Nicolson, Benedict (1968), *Joseph Wright of Derby*, 2 vols, London.

Omer, Mordechai (1975), 'Turner and "The Building of the Ark" from Raphael's Third Vault of the Loggia', *Burlington Magazine*, vol. CXVII, no. 872, November, pp. 694-702.

Paris: Centre Culturel du Marais (1981), *Turner en France*, ed. Maurice and Jacqueline Guillaud.

Paris: Grand Palais (1983), *J. M. W. Turner*, Editions de la Réunion des Musées Nationaux, Paris.

[Pasquin, A. C.] (1839), *Valery's Historical, Literary, and Artistical Travels in Italy*, Paris.

Patch, Thomas (1770-2), *The Life of Masaccio*, Florence.

Pennington, Rev. Thomas (1825), *A Journey into Various Parts of Europe . . . during the years 1818, 1819, 1820 and 1821 . . .*, 2 vols, London.

Della Pergola, Paola (1955-9), *Galleria Borghese. I dipinti*, 2 vols, Rome.

Pinelli, Bartolomeo (1819), *Istoria Romana*, Rome.

Powell, Cecilia (1982a), '"Infuriate in the Wreck of Hope": Turner's *Vision of Medea*', *Turner Studies*, vol. 2, no. 1, pp. 12-18.

——— (1982b), 'Topography, Imagination and Travel: Turner's Relationship with James Hakewill', *Art History*, vol. 5, no. 4, pp. 408-25.

——— (1983), 'Turner's Vignettes and the Making of Rogers' *Italy*', *Turner Studies*, vol. 3, no. 1, pp. 2-13.

——— (1984), 'Turner on Classic Ground: His Visits to Central and Southern Italy and Related Paintings and Drawings', PhD thesis, Courtauld Institute of Art.

——— (1985), 'Turner's Venice', *Turner Society News*, no. 38, November, pp. 6-8.

——— (forthcoming), 'Turner's Travelling Companion of 1802: a mystery resolved'.

Praz, Mario and Pavanello, Giuseppe (1976), *L'opera completa di Canova*, Milan.

Rawlinson, W. G. (1908, 1913), *The Engraved Work of J. M. W. Turner, R.A.*, 2 vols, London.

Rawlinson, W. G. and Finberg, A. J. (1909), *The Watercolours of J. M. W. Turner*, London, Paris and New York.

Redgrave, F. M. (1891), *Richard Redgrave, C.B., R.A. A Memoir*, London.

Reichard, M[onsieur H. A. O.] (1818), *Itinerary of Italy; or, Traveller's Guide . . .*, London. Turner's copy, with notes and sketches made in 1819, is TB CCCLXVII.

Reinach, Salomon (1912), *Répertoire de Reliefs Grecs et Romains*, vol. 3, *Italie-Suisse*, Paris.

Reynolds, Graham (1969), *Turner*, London.

Richardson, J. (1754), *An Account of the Statues, Bas-reliefs, Drawings and Pictures in Italy, France, &c. with Remarks*, 2nd edn, London.

Robertson, David (1978), *Sir Charles Eastlake and the Victorian Art World*, Princeton.

Röthlisberger, Marcel and Cecchi, Doretta (1975), *L'opera completa di Claude Lorrain*, Milan.

Rogers, Samuel (1830), *Italy, A Poem*, London.

[Romani, Felice] (1826), *Medea in Corinto. (Medea in Corinth), A Tragic Opera, In Two Acts. The Music by Signor Maestro Mayer. As represented at the King's Theatre, Haymarket, June 1, 1826. The translation by W. J. Walter*, London.

Ruskin, John (1878), *Notes by Mr Ruskin on his Collection of Drawings by the late J. M. W. Turner, R.A.*, London.

——— (1903-12), *The Works of John Ruskin*, ed. E. T. Cook and Alexander Wedderburn, 39 vols, London.

Sadie, Stanley (ed.) (1980), *The New Grove Dictionary of Music and Musicians*, 20 vols, London.

Sass, Henry (1818), *A Journey to Rome and Naples, performed in 1817; Giving an Account of the Present State of Society in Italy; and containing observations on the Fine Arts*, London.

Scherer, Margaret R. (1955), *Marvels of Ancient Rome*, New York and London.

Shanes, Eric (1979), *Turner's Picturesque Views in England and Wales*, London.

——— (1984), 'The True Subject of a Major Painting by Turner identified', *Burlington Magazine*, vol. CXXVI, no. 974, May, pp. 284-8.

Shapiro, Harold (ed.) (1972), *Ruskin in Italy: Letters to his Parents 1845*, Oxford.

Sharp, William (1892), *The Life and Letters of Joseph Severn*, London.

Simond, L. (1828), *A Tour in Italy and Sicily*, London.

Smith, John, Byrne, William and Emes, John (1792, 1796), *Select Views in Italy*, 2 vols, London.

Smollett, Tobias (1806), *Miscellaneous Works*, ed. Robert Anderson, vol. V (including *Travels through France and Italy*), Edinburgh.

Solkin, David H. (1983), 'The Battle of the Ciceros: the Politics of Landscape in the Age of John Wilkes', *Art History*, vol. 6, no. 4, pp. 406-22.

Sotheby, William (1828), *Italy and Other Poems*, London.

Starke, Mariana (1815), *Letters from Italy*, 2 vols, London.

——— (1820), *Travels on the Continent*, London.

——— (1828), *Information and Directions for Travellers on the Continent*, 6th edn, London.

——— (1836), *Travels in Europe*, 9th edn, Paris.

Stendhal (n.d.) *Promenades dans Rome*, 2 vols, Paris.

——— (1959a), *A Roman Journal*, ed. and trans. Haakon Chevalier, London

——— (1959b), *Rome, Naples and Florence* (1817), ed. and trans. Richard N. Coe, London.

——— (1970), *Life of Rossini (La Vie de Rossini*, 1824), ed. and trans. Richard N. Coe, London.

——— (1975), *Memoirs of an Egotist (Souvenirs d'Egotisme*, 1892), ed. and trans. David Ellis, London.

Summerson, John (1977), *A New Description of Sir John Soane's Museum*, London.

Sutton, Denys (ed.) (1968), *An Italian Sketchbook by Richard Wilson RA*, 2 vols, London.

Thornbury, Walter (1862), *The Life of J. M. W. Turner, R.A.*, 2 vols, London.

—— (1899), *The Life of J. M. W. Turner* (1862), extra illustrated 13 volume edition of John Platt, now in the British Library, Tab. 438.a.1.

Uwins, Mrs (1858), *A Memoir of Thomas Uwins, R.A.*, 2 vols, London.

[Vallardi, G.] (1818), *Itinerario italiano . . .*, 10th Milanese edn, Milan.

Vaughan, William (1979), *German Romanticism and English Art*, New Haven and London.

Venning, Barry (1982, 1983), 'Turner's Annotated Books: Opie's *Lectures on Painting* and Shee's *Elements of Art*' (1) and (2), *Turner Studies*, vol. 2, no. 1, pp. 36-46 and vol. 2, no. 2, pp. 40-9.

[Vieusseux, A.] (1821), *Italy, and the Italians in the Nineteenth Century: or Letters on the Civil, Political & Moral State of that Country, Written in 1818 and 1819*, London.

Visconti, P. E. (1827), *Descrizione di un quadro rappresentante la visione onde S. Giuseppe è avvertito di fuggire in Egitto dipinto dal Sig. Giovanni Bryant Lane*, Rome.

Wake, Lucy (ed.) (1909), *The Reminiscences of Charlotte, Lady Wake*, Edinburgh and London.

[Waldie, Jane] (1820), *Sketches Descriptive of Italy in the Years 1816 and 1817*, 4 vols, London.

Wells, Kathleen M. (1974), 'The Return of the British Painters to Rome after 1815', PhD thesis, University of Leicester.

Weston, S. (1819), *Enchiridion Romae*, London.

Whitley, W. T. (1930), *Art in England 1821-1837*, Cambridge.

Whittingham, Selby (1985), 'What You Will; or some notes regarding the influence of Watteau on Turner and other British artists' (1) and (2), *Turner Studies*, vol. 5, no. 1, pp. 2-24 and vol. 5, no. 2, pp. 28-48.

[Wilde, W. R. W.] (1842), Memoir of R. J. Graves, *Dublin University Magazine*, vol. XIX, no. cx, February, pp. 260-73.

Wilde, Sir W. R. W. (1864), *Biographical Memoir of the late Robert J. Graves, M.D.*, Dublin.

Williams, D. E. (1831), *The Life and Correspondence of Sir Thomas Lawrence, Kt.*, 2 vols, London.

Williams, H. W. (1820), *Travels in Italy, Greece, and the Ionian Islands*, 2 vols, Edinburgh.

Wilton, Andrew (1979), *The Life and Work of J. M. W. Turner*, London.

Wilton-Ely, John (1978), *The Mind and Art of Giovanni Battista Piranesi*, London.

Woodbridge, Kenneth (1968), 'The Sacred Landscape Painters and the Lake-garden of Stourhead', *Apollo*, September, pp. 210-14.

—— (1970), *Landscape and Antiquity: Aspects of English Culture at Stourhead 1718 to 1838*, Oxford.

Wornum, Ralph (n.d.), *Descriptive and Historical Catalogue of the Pictures in the National Gallery. . .*, revised by C. L. Eastlake, London.

Youngblood, Patrick (1982), 'The Painter as Architect: Turner and Sandycombe Lodge', *Turner Studies*, vol. 2, no. 1, pp. 20-35.

Ziff, Jerrold (1963a), '"Backgrounds, Introduction of Architecture and Landscape": A Lecture by J. M. W. Turner', *Journal of the Warburg and Courtauld Institutes*, vol. 26, pp. 124-47.

—— (1963b), 'Turner and Poussin', *Burlington Magazine*, vol. CV, no. 724, July, pp. 315-21.

—— (1965), 'Copies of Claude's Paintings in the Sketch Books of J. M. W. Turner', *Gazette des Beaux-Arts*, vol. LXV, pp. 51-64.

—— (1980), review of Butlin and Joll, *Art Bulletin*, vol. LXII, no. 1, March, pp. 166-71.

Index

214

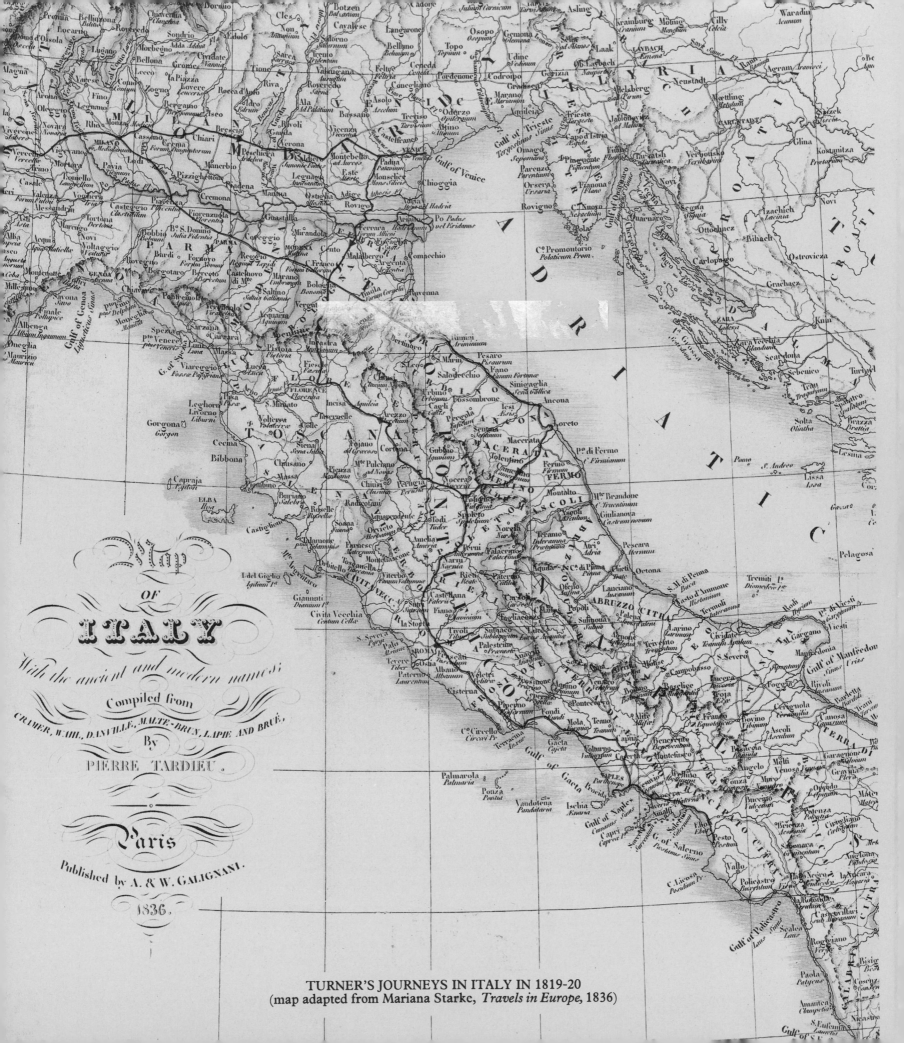

TURNER'S JOURNEYS IN ITALY IN 1819-20
(map adapted from Mariana Starke, *Travels in Europe*, 1836)